Ian Wilson

LOST WORLD
OF THE KIMBERLEY

Extraordinary glimpses of
Australia's Ice Age ancestors

ALLEN&UNWIN

IAN WILSON has been a professional author since 1979 and has published more than twenty books, including *The Turin Shroud, Jesus: The Evidence,* and *The Blood and the Shroud.* He emigrated to Australia in 1995 and lives in Brisbane.

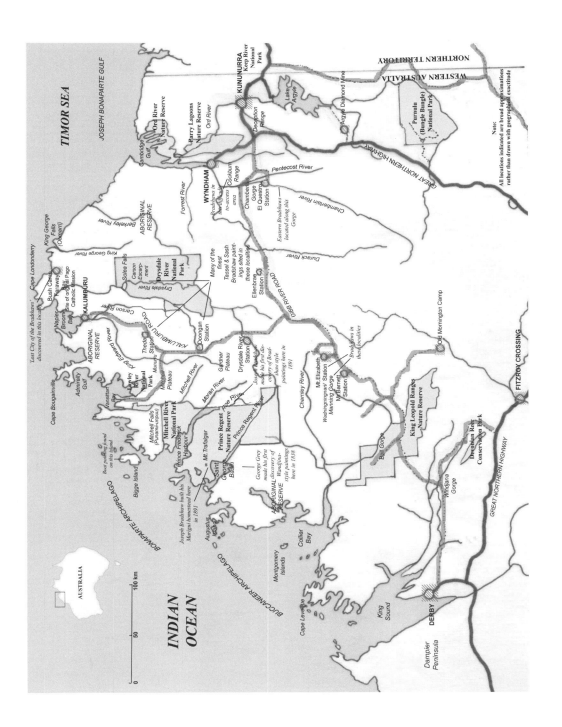

First published in 2006

Allen & Unwin
83 Alexander Street
Crows Nest NSW 2065
Australia
Phone: (61 2) 8425 0100
Fax: (61 2) 9906 2218
Email: info@allenandunwin.com
Web: www.allenandunwin.com

National Library of Australia
Cataloguing-in-Publication entry:

Wilson, Ian, 1941- .
Lost world of the Kimberley.

Bibliography.
Includes index.
ISBN 1 74114 391 8.

1. Rock paintings - Western Australia - Kimberley. 2.
Aboriginal Australians - Western Australia - Kimberley -
History. 3. Kimberley (W.A.) - Antiquities. I. Title.

759.0113099414

Set in 12/15 pt Bell MT Regular by Midland Typesetters, Victoria
Printed by South Wind Production, Singapore

10 9 8 7 6 5 4 3 2 1

CONTENTS

AUTHOR'S PREFACE

In 1994 my wife Judith and I visited Australia for the first time at the invitation of the Sydney Writers' Festival. In the course of a brief but unforgettable tour we so fell in love with the country and its lifestyle that we applied to emigrate, and after due process moved house from Bristol, England to a pleasant suburb of Brisbane, Australia.

It was a decision that many of our friends and acquaintances greeted with near disbelief. 'But you're a historian!' they exclaimed. 'What on earth are you doing going to a country that has no history?' Now, ten years on, perhaps this book will help set to rights some of those all-too-prevalent misconceptions.

This said, the extremely ancient, enigmatic and so talented paintings that form my subject are not of the stuff immediately to be put on every future tourist itinerary. Even by Australian standards the still scant-explored Kimberley region where the paintings are located is remote, vast, and almost completely lacking in any of the normal tourist amenities. And as anyone who manages the trip quickly appreciates, that is the way it also needs to stay.

But these paintings exist in literally tens of thousands across an area almost the size of Spain. And an awareness and even partial understanding of them is arguably fundamental to our understanding of the whole history of humankind in its Ice Age infancy. Unless there is some fatal flaw to the dating of these paintings, back at a time when most of Europe lay deep beneath ice sheets a people in Australia were creating elaborate garments for themselves, building ocean-going boats, cultivating root crops and enjoying a rich ceremonial life. Not least, they were creating figurative paintings of verve and talent that surpasses all other of the world's rock art, and would not be seen again until the rise of the ancient Egyptian and Near Eastern civilisations. Though in tackling this subject I have strayed into the field of the prehistorian, rather than the historian, in this particular instance I make no apology. The paintings in question are so full of details of the remote era from which they derive that they actually represent a far more vital and vivid documentary source than could any dry or dusty chronicle.

Two most redoubtable women qualify as equal first among the individuals to whom this book is indebted. My wife Judith has been at my side through 38 years of marriage and 28 years of my book writing, but this particular book has undoubtedly demanded more from her than anything previously. Hanging out of helicopters and crawling beneath narrow rock overhangs to photograph paintings in wild terrain is not for the fainthearted. But Judith coped magnificently to create the great majority of photographs reproduced in this book, as well as making interpretative drawings, checking the text, and innumerable other chores. No less invaluable has been the help of archaeologist Lee Scott-Virtue of Kimberley Specialists, Kununurra. Most cheerfully and capably she took on the tasks of being our expedition leader, guide, cook, bush lore specialist and driver throughout the full-scale four-wheel drive expedition that was demanded by our need to view the remotely located paintings at first hand. She has similarly been a tower of support and strength throughout.

Amongst others to whom I am indebted are Joc Schmiechen for checking the book manuscript, directing me to important sources that I had missed, and very freely volunteering his wealth of first-hand knowledge and photographs; Russell Willis of Willis's Walkabouts for generously allowing use of his photographs and data in Chapter 12; John Bradshaw for supplying the photograph of his great-uncle Joseph Bradshaw, and for checking the chapter describing Bradshaw's discovery; Adrian Parker for supplying the photograph of the panel discovered by Bradshaw; Slingair helicopter pilot Tim Anders for introducing us to the previously undocumented rock painting sites of Reindeer Rock and Wullumara Creek; Bruce and Robyn Ellison of the Faraway Bay Bush Camp for making it possible for us to access hitherto undocumented rock art sites on the Kimberley's north-west coast; Steve McIntosh of Faraway Bay for guiding us to these sites; and Pawel Valde-Nowak of the Institute of Archaeology, Kraków, Poland, for providing difficult-to-obtain data on Poland's unique Ice Age boomerang. My warmest thanks, also, to the following people for innumerable other crucial points of assistance: sculptor John Robinson of Yeovil, Somerset, England; Len Zell, author of the excellent *Guide to the Kimberley Coast*; Ian Levy; Christopher Chippindale; John Taylor of Tasmania; John Presser of Tasmania; David

Owen, author of *Thylacine*; Dr Stephen Wroe of the University of Sydney; Tim McIntyre of the University of Queensland; Dr Michael D. Coe of Yale University; Jean-Michel Chazine of the University of Marseille; Dr John Prag from Manchester Museum; Dr Robert Paddle of the Australian Catholic University; Dr Lawrence Blair; Dean Goodgame; Barrie Schwortz; Ju Ju 'Burriwee' Wilson; photographer Peter Eve; Aboriginal artist Warren Djorlom; Helen Bunning; Grahame Walsh; Nadia Donnelly of Kununurra Visitor Centre; Sheryl Backhouse; Barry Hart; James Sokoll; Ian Thomson; Vrony Kern; Ian Holmes; Philip Courtenay of ADFAS; Adriennne Alexander; Natasha Pearson of Lord's Kakadu and Arnhemland Safaris; Conrad Stacey; Jean-Claude Bragard; Petra Collier; Brisbane City Library (in particular the ever-helpful staff of our local mobile library); University of Queensland Library; the Mitchell Library, Sydney. And not least among all these, Patrick Gallagher, Managing Director of Allen & Unwin, Sydney, for giving the project the vital push-start of a book commission, and for being so patient and understanding during its long gestation.

Authors can make all kinds of gaffes and mistakes in putting together a book manuscript, and this author is certainly no exception. A good publisher provides a suitably literate and eagle-eyed copy editor to spot these errors. In fulfilling this all too often unsung task, Karen Ward has not only been one of the very best whom I have come across, she has also made a number of helpful constructive suggestions. I am deeply grateful to Karen and to Allen & Unwin editor Jeanmarie Morosin for all their care and their patience steering this book towards publication.

In the case of my attempted interpretations of the Bradshaw paintings, whatever errors these may contain will be entirely from my own shortcomings, and I will welcome all suggested corrections to these. The intention of this book is not in any way to provide some sort of definitive authority on the subject. Rather, it is to open it up to the widest possible, intelligent debate.

Ian Wilson
Moggill, Queensland
July 2005

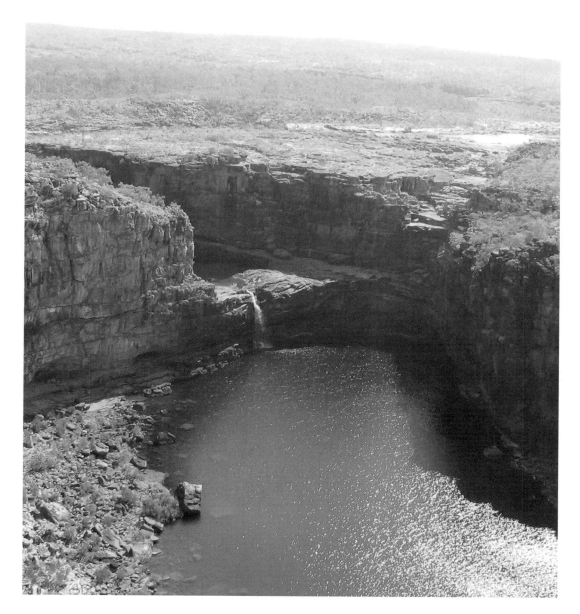

The Mitchell Falls during the late Dry season

CHAPTER ONE
Drop-in at Reindeer Rock

Idly watching the shadow of our helicopter's rotors spinning across the parched and unpopulated landscape a hundred feet below, it struck me that whoever invented the boomerang has to have been the discoverer of the same gyroscopic principle by which our helicopter was staying aloft. Yet has anyone ever credited Australian Aboriginal people with pioneering the science of aerodynamics?

There were four of us crammed that day into the tiny Bell JetRanger helicopter—our guide, Lee Scott-Virtue, an archaeologist in her mid-fifties; our pilot, Tim Anders; and my wife Judith and I. We had been travelling at a little over 100 knots above the Mitchell Plateau in the remote and rugged Kimberley region of north-western Australia. The helicopter's doors had been removed to give us extra visibility, and as we banked steeply, held in only by our lap belts, we were viewing immediately below us the Mitchell Falls. When swollen to full force by 'Wet season' rains these falls rank as one of Australia's most magnificent natural wonders, cascading spectacularly over a large ledge, then disappearing through a sinkhole in the rock, to reappear down five giant steps to a large pool at the bottom of the gorge. During the four months of the year when it is possible for campers with the hardier kind

of four-wheel drive vehicles to reach this part of the Kimberley, Tim Anders bases himself, his young wife and baby in a very makeshift tent 'heliport', providing scenic helicopter flights to and from the otherwise unmanned camping area.

But it was now Friday 17 September 2004, one of the very last days of Tim's season, by which time the Kimberley's notorious 'Dry' had reduced the falls to the merest trickle. For us this was in no way a disappointment. Our plan was to walk back down from the 3000-metre elevation, studying some of the ancient rock paintings that are to be found along the route. Our interest particularly centred on a type named 'Bradshaws' after Melbourne-born land speculator Joseph Bradshaw, who quite accidentally discovered the first examples in 1891. Though even today no-one knows exactly how many of these paintings are scattered across the Kimberley, according to some esti-mates there are at least 100 000.[1] And although no-one can be sure exactly how old they are, their very plenitude in a region that today, as for tens of millennia, stays uninhabitable for much of the year, argues for their dating from an earlier time when the Kimberley's tropical climate was considerably more equable. That time was during the Ice Age, that is, something in excess of 20 000 years ago. This would set them in the same era as the very oldest of Europe's cave paintings. Potentially, therefore, they are of incalculable signif-icance for our understanding of how, when and where the world's earliest cultures originated.

The Bradshaws differ from their European counterparts in being painted mostly on open rock features, rather than in caves, and representing human figures, rather than animals. But what human figures! Depicted with almost Michelangelesque virtuosity, many wear elaborate paraphernalia that include sashes, string skirts, anklets and armlets, a far cry from the crude animal skins normally associated with the Ice Age. Some sport elaborate, exaggeratedly long, wizard-like headdresses, raising interesting questions concerning the origin of the concept of wizards. Many carry boomerangs, some quite styl-ishly shaped, raising the issue of where and how far back in time the world's first boomerangs originated. If the paintings really do date from the Ice Age, they are much advanced than even the very best western counterparts for their visual insights into humankind's everyday lives at such an early time.

Particularly intriguingly, a few are depicted in boats that—subject to the paintings genuinely dating back to the Ice Age—hold serious claim to being the oldest depictions of boats known from anywhere in the world. At a lecture held in Brisbane, four months before this Kimberley adventure, Grahame Walsh, Australia's foremost expert on the Bradshaws, had shown a slide of a high-prowed and thereby potentially ocean-going vessel carrying no less than 29 crew and passengers. Despite this painting's importance from a number of perspectives, Walsh steadfastly declined to disclose its location, and in this same vein refused to provide a photograph or even a working drawing for comparative research purposes.

As we hovered above the Mitchell Falls that September day the question that Lee Scott-Virtue suddenly put to pilot Tim was therefore rather more loaded than it might have appeared. Even though Lee was seated right next to Tim, she had to press her intercom button in order to be heard above the clatter of the rotors.

'Tim, has anyone come across any *boat* paintings around here recently?'

As we were all wearing headphones, Tim's response came over loud and clear.

'Sure, Lee, there's been a boat painting found not very far from here.'

'Is it a site that Grahame Walsh has visited?'

'No.'

This immediately ruled out that the painting could be the one Walsh had presented in his Brisbane lecture. Even so, the rarity of any Bradshaw depicting a boat made any opportunity to view a fresh example highly appealing.

'How long would it take for us to get there?' enquired Lee.

'About ten minutes. We've got enough fuel, but I must be back at the falls for another booking at 3 p.m.'

We quickly calculated that that would give us only about twenty minutes on the ground. After momentarily weighing up the sizeable extra dollar sum needed to cover the further kilometres, Lee took my breath away with a decisiveness that I had not seen from her before.

'I've made an executive decision. Let's go for it,' she pronounced.

Tim lost no time radioing his change of destination, then set a course northward. After a few minutes of following the meandering Mitchell River we

found ourselves descending over a buff-coloured, oval-shaped area about the size of a football field. At its western side a typical Kimberley sandstone rock outcrop could be seen curving round the oval to form a natural half-amphitheatre. Carefully selecting a suitable patch of clear, level ground, Tim brought the helicopter gently down. Within seconds of clearing the rotor blades, all four of us were dashing over about 50 metres of rough, rocky ground that was liberally covered with stands of sorghum grass taller than ourselves.

A minute or so later we arrived at the rock outcrop that we had seen from the air. Facing us was a vertical and surprisingly regular slab of King Leopold sandstone, around eight metres long and topped by a narrow, lengthwise overhang, just the sort of wall surface and accompanying weather protection that we knew the Bradshaw artists to favour for their paintings. Quite typically, and consistent with the Bradshaws' theoretical great age, it was difficult at first for us to make out much more than some discolourations. On this particular huge boulder, the protective overhang was too narrow to keep the wall surface dry during the Kimberley's notoriously intense 'Wets'. And because it faced east, it inevitably had received

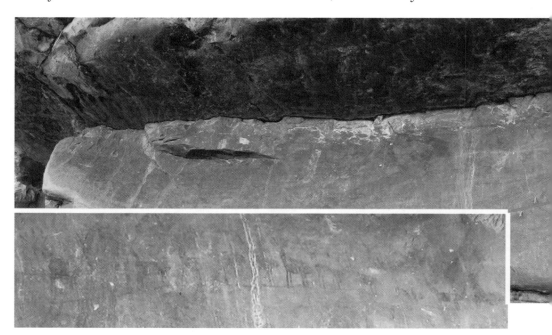

thousands of years of direct exposure to the Kimberley's equally intense morning sun.

Yet somehow the slab still bore some vestiges of ancient painting. Almost immediately, one word—'Reindeer!'—from the direction of Lee and Tim sent me scurrying over to where they were pointing. There, running from the slab's northern end, was a vanishingly faint painted row of at least eighteen four-legged animals, each of these essentially identical to the other, and set along a regular, almost straight line as if they were looking over the brow of a ridge. Unbelievably, the creatures' heads were ornamented with what certainly appeared to be reindeer-like horns. The straight line running beneath them associated them with examples of a late phase of Bradshaw paintings that Walsh called 'Clothes Peg', still purportedly dating from before the end of the Ice Age.

'Reindeer in Australia before European settlement—impossible!' was my immediate snort, only to receive Tim Anders' typically laconic rejoinder.

'If it *looks* like a reindeer, it probably *is* a reindeer.'

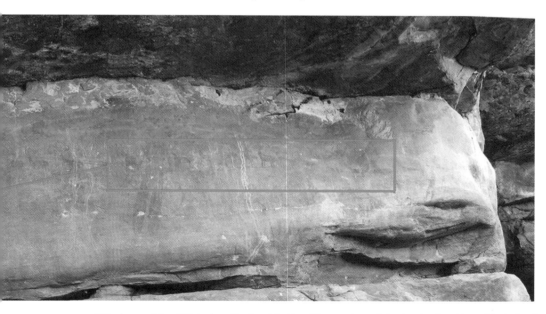

The huge slab of Reindeer Rock with (detail) a section of the intriguing line of 'reindeer'

Little did we know how prophetic his words were to be, nor how important a find this was to our whole understanding of the Bradshaw enigma.

As there was no known traditional Aboriginal name for this particular rock outcrop, and as there were probably no more than half a dozen Europeans who had ever seen it before aside from ourselves, it seemed natural for us to label it 'Reindeer Rock', whatever might be the true species of the creatures that are depicted on it. Because Judith was the only bearer of a camera on this particular day, she began the difficult but now vitally urgent task of taking photographs. Meanwhile Tim pointed out what seemed to be some shadowy human figures at the far right of the line of reindeers.

'Do you think those are hunters?'

It was impossible to say.

Wallace's line: hooved mammals to the west of this, marsupials to the east

For as we stood in no little perplexity in front of the painted panel we were confronting a problem that will be encountered time and again in the course of this book. That is, how to come to some *reasonable* understanding of images that have a serious claim to having been painted tens of thousands of years ago, and are often frustratingly faint, yet even so retain sufficient tantalising detail to invite some intelligent speculative interpretation.

In the case of the 'reindeer', zoologically the one certainty is that no variety of deer, let alone anything as cold-clime as reindeer, is thought to have made its way to Australia throughout the entire time that our human species has walked this planet. Back in the nineteenth century the great naturalist Alfred Russel Wallace marked on the map a line separating the Old World's placental mammals from the marsupial or pouched varieties that chiefly characterise the mammals found in Australasia.[2] For placental mammals such as deer, Wallace's line stops at the Philippines, Borneo and Java—broadly the furthest bounds of the South-East Asian continent back in the Ice Age. Even though the sea levels then were significantly lower than they are now, there has always been sufficiently wide a water barrier to prevent the continent's fauna from crossing into Australasia and vice versa. And no deer bones have ever been found in any ancient context on the Australasian side of Wallace's line.

So the Reindeer Rock 'reindeer' pose just two serious alternatives. Either they are not reindeer and represent some as yet unknown and unidentified native Australian species still to be recognised by zoology. And that seems unlikely. Or they are at least some variety of deer, in which case back in the Ice Age there must have been much greater communications between the deer-roaming parts of Asia and the then inhabitants of Australia than might be expected for a people all too commonly dismissed as the most primitive of hunter-gatherer savages. Such communications would have required ocean-going boats capable of traversing at least 100 kilometres[3] of open sea, the minimum distance that has always separated Australia and Asia even when sea levels were at their lowest.

Cue therefore for our obvious next question to Tim Anders: where was this boat painting that he had brought us to this site specially to see?

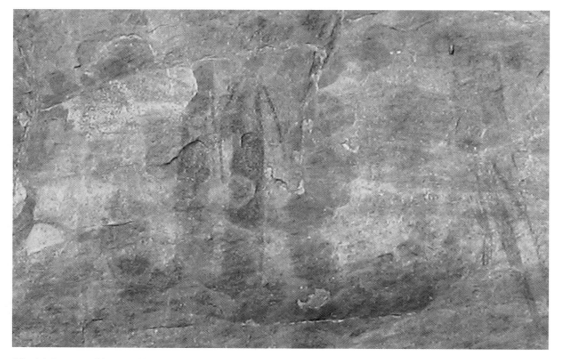

The high-prowed boat with standing figures on the north side of the slab at Reindeer Rock

Tim quickly led us in a right-hand direction to what turned out to be simply the north wall of the same massive slab bearing the 'reindeer'. And there, this time quite unmistakably, was an image of a boat, around a metre high, its prow and its stern delicately curved in the manner suitable for negotiating the open ocean. Disappointingly, unlike the 29 occupants of the vessel that Grahame Walsh had shown during his Brisbane lecture, this particular example had just four figures. These were standing rather top-heavily upright, and like the line of 'reindeer' their style suggested them to be of the late Bradshaw phase known as 'Clothes Peg', when the artists' rendition of figures lost a lot of their earlier naturalism.

Nonetheless, exactly as in the case of the reindeer, the panel was highly important in its own right. In both cases their features suggested early links with societies well beyond Australia. Throughout island South-East Asia there survive to this day ancient cults that are centred on depictions of 'boats

of the dead'. In these depictions, four or five figures typically stand rather impractically upright on a vessel with upturned ends at prow and stern. And their origins stretch way back before the coming of religions like Islam and Hinduism—back to South-East Asia's remotest antiquity.

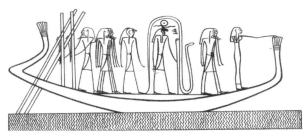

Egyptian tomb painting of 'Boat of the Dead'. From the tomb of pharaoh Tuthmosis III at Thebes

The ancient Egyptians, whose own origins are mysterious, likewise repeatedly depicted four or five figures standing up in crescent-shaped boats among the scenes of the 'Book of the Dead' painted on the walls of the tomb of every pharaoh. Again, the origins of these paintings stretch back well before ancient Egypt's first dynasties. So should such parallels be dismissed as mere coincidences? Or could we be looking at something of real significance for how, when and not least where all the old civilisations—European, Near Eastern, Far Eastern, even possibly American—may have originated? Rather than Australia having been a remote backwater unconnected with the rest of the world, back in Ice Age times might its role and its intercontinental connections have been markedly more advanced than currently supposed?

As a historian with a lifelong enthusiasm for art and art history, I was certain that these enigmatic Bradshaw paintings, little known as they are, and located in such a sparsely visited region of Australia, posed the most tantalising mystery. They positively cried out to be better understood. Each of them, in its way, offered a window back into a remote time in our past when documents as such did not exist. The very medium that the artists used, a 'canvas' of solid rock, bespoke their far-sightedness in their wishing to communicate something of themselves to later generations.

So who were these Bradshaw people? When did they live? What happened to them? In order for us even to begin to be able to 'read' what these paintings might have been trying to tell us, first it was important to determine what has been discovered about them so far.

CHAPTER TWO
Early rock art encounters

The Kimberley is the region of north-west Australia in which the Bradshaw paintings are located. Outstandingly beautiful, it is so remote and so difficult to reach even for adventure-loving Australians that far more of them have visited far-flung Europe than this part of their own 'backyard'. Officially extending some 422 000 square kilometres, one-third greater than the entire United Kingdom and only a little smaller than Spain, its bounds are broadly the Ord River to the east, the Timor Sea to the north, the Indian Ocean to the west, and the Great Sandy and Tanami deserts to the south.

The Kimberley's coastline is extremely rugged, with many deceptively beautiful bays, inlets and islands that are notorious for tides with treacherous currents and whirlpools. Anyone venturing into the sea seriously risks their life from attack by sharks and by enormous estuarine crocodiles. The months from June to October are the Kimberley's Dry season, when daytime temperatures reach the mid-30s° Celsius (90° Fahrenheit) even at the height of winter, and there will be not a drop of rain. November to May, by contrast, are the monsoonal Wet, with some parts receiving rainfall exceeding 1400 millimetres. Tropical cyclones, accompanied by 300 kilometres/h winds, are

prevalent between January and March, making even the few dirt roads impassable. As one early explorer described a typical January day:

> . . . there came on a tremendous squall of wind, rain, thunder and most vivid lightning. The pealing echoes of the thunder as they bounded from height to height and from cliff to cliff, was awfully magnificent; whilst the rugged mountains which had just before looked golden in the bright light of the setting sun were now shrouded by gloomy mists and capped with dark clouds, from which issued incessant and dazzling flashes of lightning. During this grand and terrific elemental convulsion our little boat was driven powerless before the blast.[1]

Not unexpectedly, therefore, European exploration in the Kimberley got off to a slow start. The first serious coastal mapping was by a Napoleonic-era French captain, Nicolas Baudin, to whose nervous 1801 expedition the Kimberley's coastline owes such names as Bonaparte Archipelago and Joseph Bonaparte Gulf. Once the British had well and truly trounced Napoleon a far more thorough coastal survey was undertaken by Australian-born rear admiral Phillip Parker King. Patriotically, he saw to it that two major Kimberley peaks were given the names Mount Trafalgar and Waterloo, with two equally impressive rivers named the King George and the Prince Regent. Then with the growth of the first small townships these were likewise given British names—Derby, Broome and Wyndham—while later still, during the 1880s, the Kimberley itself became named after the then British colonial secretary, John Wodehouse, first Earl of Kimberley.

Even to this day, however, the Kimberley's c.29 000 population—half of them white, half Aboriginal people and in total no more than that of one small town—remains almost entirely clustered around still very modest-sized townships at its eastern and western extremities. There are just a few others scattered at cattle stations and Aboriginal communities elsewhere. Rio Tinto operate an open-cut diamond mine, the world's largest single producer, at the Kimberley's eastern extremity. Otherwise, almost the entire region consists of a vast empty wilderness of sandstone and basalt rocks that were laid down some 1.8 billion years ago. This has been scoured into stunning

Typical Kimberley rock outcrop embellished with painted figures, Gumboot Creek

gorges and cascades by numerous rivers and creeks that are lively during the Wet season, but dwindle to intermittent lengths of still water during the Dry. All major volcanic activity has happened along tectonic plate lines that lie comfortably to Australia's north, in Indonesia and New Guinea, so the Kimberley's geological landscape has undergone remarkably little change throughout that long period, making its surface rocks amongst the oldest to be seen anywhere in the world.

Everywhere those surface rocks are littered with thousands of rock outcrops similar to Reindeer Rock, ranging widely in scale from hut to hyper-market proportions. Many of them are bizarrely shaped and in a wide palette of colours, so that the human imagination almost instinctively forms them into huge prehistoric creatures. And not just one, but several culturally differ-ent human groups who early wandered the Kimberley undoubtedly regarded them with similarly imaginative fascination. Whether on a rock outcrop, on a canyon side's vertical 'wall', or on some overhanging boulder's 'ceiling', wherever the surface provided a suitably flat, light-coloured 'canvas', early artists felt impelled to decorate them with dramatic painted embellishments.

Such is the Kimberley's isolation, however, that not until several decades after the cities of Sydney and Melbourne were already flourishing did the first European come face to face with these paintings. In any event, the sites he found were far from the oldest of those that would later come to light. It was during the Wet of 1838 that a young British army lieutenant, George Grey, was leading a small party of troops on one of the very first inland surveys of the Kimberley, when the group found their progress halted by a precipitous range of sandstone rock not far from the Glenelg river that they had just discovered. Grey, who was in great pain from a spear wound inflicted during an attack by local Worrora tribesmen, was anxiously scrutinising the broken rocks for any viable through-route when in his own words:

> I suddenly saw from one of them a most extraordinary large figure peering down upon me. Upon examination, this proved to be a drawing at the entrance to a cave, which, on entering, I found to contain besides, many remarkable paintings . . . It would be impossible to convey in words an adequate idea of this uncouth and savage figure . . . Its head was encircled

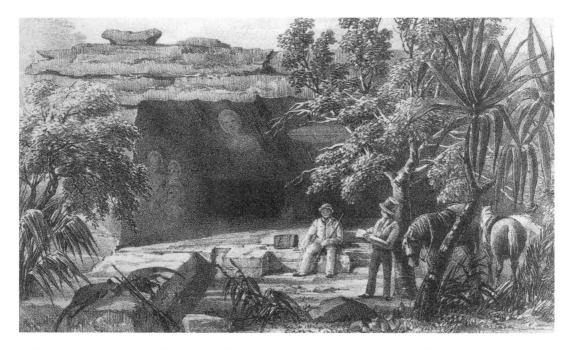

George Grey's 1838 expedition to the Kimberley at the site where they discovered their first example of the region's ancient rock paintings. From a contemporary engraving

by bright red rays something like the rays which one sees proceeding from the sun, when depicted on the signboard of a public house . . . the face was painted vividly white and the eyes black . . . ; the body, hands and arms were outlined in red, — the body being curiously painted with red stripes and bars.[2]

Three days later Grey's party came upon another cave with similarly extraordinary figurative art works:

The principal painting . . . was a figure of a man ten feet six inches in length, clothed from the chin downwards in a red garment, which reached to the wrist and ankles; beyond this red dress the feet and hands protruded, and were badly executed. The face and head of the figure were enveloped in a succession of circular bandages or rollers, or what appeared

to be painted to represent such. These were coloured red, yellow and white; and the eyes were the only features represented on the face. Upon the highest bandage or roller, a series of lines were painted in red, but although so regularly done as to indicate that they had some meaning, it was impossible to tell whether they were intended to depict written characters or some ornament for the head.[3]

Grey made several on-the-spot colour sketches of the paintings which he included in his journals of his adventures, remarking in a footnote that they most reminded him of the Biblical prophet Ezekiel's account of the art of ancient Babylon and Assyria.[4] This was particularly because the figures appeared to him to be wearing full-length clothing, quite unlike the 'perfect state of nature'[5] of the contemporary Aboriginal people whom he was encountering. Grey added: 'Whatever may have been the age of these paintings, it is scarcely probable that they could have been executed by a self taught savage. Their origin therefore must still be open to conjecture.'

George Grey's sketch of the second figure his party found in March 1838

Grey's journals were published in London in 1841, complete with his sketches, and although more than a century would elapse before any westerner would again reach his sites,[6] his drawn indications of writing on the second figure's headdress aroused some particularly intense further speculation. One late-nineteenth-century expert, Thomas Worsnop, recognised this as the script of ancient Red Sea traders, the lettering reading, 'I am a great personage'.[7] At much the same time Canadian Professor John Campbell interpreted the letters as archaic Japanese characters meaning

'hopeless number is . . .'. When combined with the 62 circles drawn alongside the figure the message read 'the number of the hopeless ones is 62', clearly some early shipwrecked Japanese trying to communicate their plight. In the early 1970s, when space travel was at its most topical, best-selling author Erich von Daniken trumped all previous interpretations by identifying the figures as extraterrestrials.[8]

Sadly, it is all an object lesson in the pitfalls that can await anyone attempting a too quick interpretation of the rock art of pre-European Australia. For the 15 000 or so Aboriginal people in the Kimberley today—most of them of the Worrora, Ngarinyin and Wunambal peoples whose forefathers were dispossessed of their original lands—the paintings that Grey came across are their 'Wandjina'[9] spirit ancestors. These are said to have come from the rain clouds, and to have returned to them at the end of their lives, at one and the same time metamorphosing into the paintings that represent them. Painted Wandjina faces invariably lack mouths, Aboriginal people believing that any depiction of a mouth would destroy the painting's potency and bring on unrelenting rain.[10] Literally thousands of Wandjina and Wandjina-related paintings are to be found scattered on rock outcrops right across the north-west Kimberley, the Worrora people's versions even being represented amongst the giant figures that were held aloft in the 'Awakening' segment that was part of the Sydney 2000 Olympic Games opening ceremony. What George Grey had interpreted as the figures' 'clothes' and their white faces were merely decorative body and face paints. Likewise what he had perceived as writing were the Wandjina artists' attempts at representing leaves.

The real irony of such undue focus on the Wandjinas, however, is that these figures are relatively recent, and by western artistic standards rather less advanced than those of another major style to be found in the Kimberley, the Bradshaws. The Joseph Bradshaw after whom these paintings came to be so inappropriately and insensitively named was born in Essendon, Victoria, Australia in 1854. Though the stories told about him include that he served as first mate on a British India sailing ship,[11] research by his great-nephew John Bradshaw indicates that his true water experience extended to little more than rowing a dinghy on his local river. During the late 1800s, however, by which time Bradshaw styled himself as an 'investment agent',[12] he was

Typical Kimberley Wandjina paintings, similar to the kind found by George Grey

one of a number of profit-hungry investors being lured by the Western Australian government to part with 500 pounds in return for 'blind' leases entitling each to a million acres of the Kimberley for setting up sheep or cattle stations. Because such arrangements meant dispossessing Aboriginal people of their traditional lands, it was fully understood that leaseholders would enter their territories suitably armed, ostensibly for self-protection, but tacitly to enforce their 'rights'. And Joseph Bradshaw was certainly an individual of this mould, as all too evident from a vivid description of him and his companions written by his cousin Aeneas Gunn:

> Our party was armed to the teeth. Every man had his cartridge belt filled with death-dealing polished brass cases . . . Revolver pouches, with blue steel butts protruding from their flaps, lay on the hips . . . and rifles were stacked by the table . . . He [Bradshaw] had at one time faced a mob of blackfellows, single handed, with a small bulldog revolver . . . and in a hundred sinister situations he had proved himself a block of resolute courage.[13]

Joseph Bradshaw (1854–1916), discoverer of the first paintings bearing his name

In October 1890 Bradshaw received the appropriate official paperwork for his particular million-acre section of the Kimberley, and in March of the following year he and his brother Frederick arrived by boat at Wyndham, the north-west coast's main port, with the aim of hiring helpers, a team of horses, and suitable supplies, in order to reach their property and make their first visual appraisal of it. On the brothers' arrival they found that Wyndham, where they had intended to spend a few days procuring horses and provisions, had just been devastated by one of the Kimberley's notorious cyclones. Even so, they managed to gather together sufficient provisions for their needs, and rode off westwards accompanied by four hired helpers. Exactly as Grey had experienced four decades before, the ruggedness of the Kimberley's terrain and its notorious stands of tall, prickly spinifex grass proved exceptionally difficult for both men and horses. In a small, black-covered diary that Bradshaw kept of his expedition's progress he recorded in his neat handwriting, 'The grass seeds from the tall spear grass were something frightful. I was literally stuck full of them from head to foot.'[14] Adding to the party's unease were some distinctly unfriendly looking local Aboriginal people who insisted on shadowing them throughout.

However, on the afternoon of 16 April 1891 Joseph and his brother were following the line of what they had wrongly deduced to be the Prince Regent River when they found this to open out into a gorge with a large rocky pool. On the gorge's west side, according to the description that Bradshaw gave in a lecture to Melbourne's Royal Geographical Society later that year:

The walls . . . were adorned with native paintings, coloured in red, black, brown, yellow, white and a pale blue. Some of the figures were life-size,

the bodies and limbs very attenuated, and represented as having numerous tassel-shaped adornments appended to the hair, neck, waist, arms and legs; . . . The most remarkable fact in connection with these drawings is that wherever a profile face is shown the features are of a most pronounced aquiline type, quite different from those of any natives we encountered. Indeed, looking at some of the groups, one might almost think himself viewing the painted walls of an ancient Egyptian temple.[15]

Like Grey before him, Bradshaw made on-the-spot drawings of what he had found, one of these being reproduced as an accompaniment to the text of his lecture when the Australian Royal Geographical Society published this in 1892.[16] This drawing, together with Bradshaw's description of the terrain in which the paintings were located, made possible the rediscovery, as recently as 1997,[17] of the original site found by him. It was not, as he had supposed (and never sought to correct), on the Prince Regent River, but instead on the Roe River further to the east. In an era lacking not only satellite technology, but even basic maps for the Kimberley, Bradshaw had made a 50-kilometre miscalculation. Now, however, thanks to the availability of photographs of the site, it is possible to check Bradshaw's recording standards as well as his navigational capabilities.

Joseph Bradshaw's original sketch of the 'native paintings' that he and his companions found, thereupon becoming the first European discoverers of the style of paintings that bear Bradshaw's name

On one of these panels—which quite typically had been embellished by different groups imposing their own images to supersede what had been done before them—can be discerned at least four figures that are quite unmistakably of what has become described as the Bradshaw type.

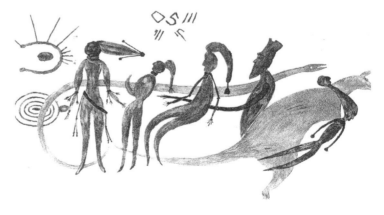

The first figure, at furthest left in Bradshaw's copy, is of an individual with a long, feminine-looking hairstyle or headdress tapering towards the right. He or she seems to be looking towards the left, though what survives of the paintwork makes it impossible to be sure whether the face is in profile or front-facing. The headdress ends in what Bradshaw referred to as 'tassel-shaped adornments', a pair extending rather oddly back inwards, that is, towards the head. The body seems to be facing mainly frontwards, with arms extended at either side and the legs slightly apart. Two or three more 'tassels' dangle from each elbow, likewise from the waist down to the ankles, though rock surface erosion has destroyed whatever may have existed of the feet.

Two similarly coiffured but slightly smaller figures stand immediately to the first individual's right, their hair likewise tapering to the right though lacking discernible tassels. However, the most remarkable figure is the one at furthest right, nearly twice the height of the others, and seemingly impossibly propelling himself or herself through the air, arms to the sides, in what

The first Bradshaw painting discovered by Joseph Bradshaw and rediscovered within the last decade

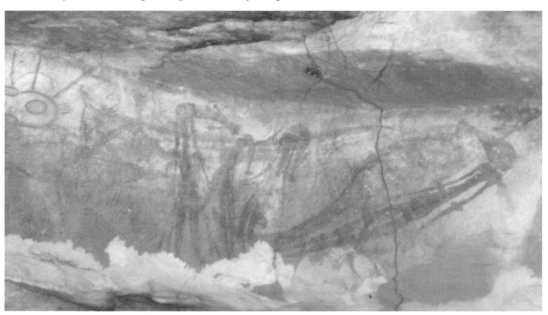

can only be construed as a 'floating' pose. Superimposed on these figures are later, large depictions of animals, the most prominent being an apparent kangaroo looking almost as if it is riding on the back of the 'floating' figure. Bradshaw rightly recognised it as 'drawn in fresher colours' and thereby 'more recent' than the human figures.

More puzzlingly, Bradshaw also drew in a fifth human figure, an aquiline-nosed old man with a high hat and long beard standing immediately to the left of the 'floating' individual. This is one that if it ever existed in Bradshaw's time, is today impossible to make out in photographs. He also included what he described as certain 'alphabetical characters, somewhat similar to those seen by Sir George Grey . . . many miles westward on the Glenelg River'. And it is seriously questionable whether these 'alphabetical characters' were real blemishes to which he gave his imagination rather too free a rein, or whether perhaps he resorted to deliberate invention in order to match his discovery with that by Sir George Grey.

What is certain, from the known course of subsequent events, is that back in 1891 Bradshaw had some rather more pressing personal objectives than rock paintings, however unusual these latter might be. Within a few weeks of his return to Melbourne he married a 30-year-old musician, Mary Guy, and little more than a month later was whisking her aboard the steamer *Catterthun* on a one-way voyage to Darwin. On their arrival, a newly acquired schooner, *The Twins*, was waiting loaded with all necessary supplies, including Mary's beloved organette (a small harmonium), to take them westwards to the coastal inlet where their Kimberley property's homestead was to be built—on Mount Waterloo's slopes at the mouth of the true Prince Regent River. To Joseph Bradshaw's credit this homestead was indeed built, and named 'Marigui' in Mary Guy's honour as the first white woman ever to have dared set foot in such a remote part of north-west Australia.[18] However, such were the difficulties of the Kimberley's climate and isolation that in less than three years the enterprise was abandoned and the homestead dismantled. Bradshaw turned to better prospects in the Northern Territory, ultimately to die of gangrene in Darwin in 1916, never, it would appear, having devoted any further attention to the paintings which carry his name.

Throughout the first three-quarters of the twentieth century the amount of research into the type of paintings that Bradshaw had discovered was negligible, the rare exceptions mostly being on the part of priests working at the Kimberley's various mission stations. Letters written in 1905 by a Trappist monk, Nicolas Maria Emu, who died in 1915, show that he must have come across some paintings similar to those found by Bradshaw, but he never left any proper record of these. Another missionary, Father Nicholas of the Benedictine monks' Pago Pago mission station on the Kimberley's northern coast, apparently made sketches of some local Aboriginal rock paintings amongst which can be discerned some 'Bradshaw' type figures. But his album containing these was never published, nor did it even reach a public collection. Around the year 1919 a Melbourne-based entomologist, Gerald Hill, came across a few examples in the environs of the same mission. But Hill's watercolour sketches, mixed indiscriminately amongst more conventional records of Aboriginal rock art, disappeared into the vaults of the South Australian Museum in Adelaide.[19]

In the 1930s a German rock art hunting expedition, even though liberally funded by the Hitler regime, and inspired by the writings of veteran anthropologist Leo Frobenius, was scarcely a whit more productive. Admittedly its avowed purpose was to study the Wandjina paintings, but of the other paintings that they came across, Agnes Schulz, one of the two women illustrators, merely remarked that towards the end there were some which were 'smaller, of human shape, not white-grounded, monochrome in red ochre, sometimes with a light contour'.[20] Only thanks to the second woman illustrator, Katharina Lommel, who sketched some examples, can we be sure that these were Bradshaws. But in fairness to the Germans, their Aboriginal guides positively discouraged them from taking an interest in any such figures, dismissing them as worthless.[21] And it was precisely because Aboriginal people offered no meaningful name for the paintings that Schulz adopted the name Bradshaws,[22] one which, for all its Anglo-Saxon inappropriateness, has stuck, and has therefore reluctantly but realistically been perpetuated here.

Also in fairness to the Germans it was another of their ilk, Father Ernest Worms, who after the Second World War went further than anyone before

him in focusing attention on the Bradshaws. Awarded the Iron Cross for his bravery during the First World War, Worms subsequently took up a vocation as a Pallottine priest, one of his tutors during his training being Professor Herman Nekes, a priest with an unusually strong enthusiasm for anthropological studies. When in 1931 the Pallottine fathers sent Worms out to the Kimberley the region already had a number of pioneering missions—Pago Pago, Kalumburu, Kunmunya, Watjalum and Forrest River. However, whereas the great majority of other missionaries, whether Catholic, Pres-byterian or Anglican, were determined to impose their own 'superior' western culture upon Aboriginal people, Worms, to his considerable credit, was of a different mould. Recognising that the old, tradi- tional Aboriginal culture was in his own time disappearing at an astonishing rate, Worms

Father Ernest Worms, a pioneer in serious study of the Bradshaw paintings

applied himself to learning all he could from those who had lived its ways, before their memories became lost forever.

A natural linguist, Worms quickly learned several Aboriginal languages, commanding such respect among Aboriginal people that he was accorded the title *Ibala* or great elder. There are apocryphal stories of his attending some of the most 'pagan' of Aboriginal 'bora ring' or stone circle rites. Likewise he would reportedly go walkabout in the bush to return weeks later half-naked, deeply sunburnt and breathless with excitement, having given away most of his clothes in return for the hospitality and the anthropological insights that had been extended to him.

Having in the course of such journeys come across sufficient of the Bradshaws to whet his interest, in 1953 and 1954 Worms undertook successive expeditions specifically to search for those paintings located in the most central and extreme northern parts of the Kimberley. At this stage there was not even a single dirt road into the interior, so he flew by

light plane to the centrally located Gibb River Station, and from there proceeded to explore northwards on foot. Quickly he learned where to find the paintings:

> . . . in caves and on ledges, in lonely sandstone recesses hidden behind hedges of tropical vegetation, on scattered rock pillars in silent groves of cypress pines (*Callitris verrucosa*) and on high outcrops of rock with magnificent vistas, across coloured gorges, of the blue stretches of the glittering Timor Sea.[23]

From the examples that he came across he quickly recognised the need to redefine understanding of what 'Bradshaw' paintings actually were, Joseph Bradshaw himself having been more than a little slapdash and inventive in his reporting.

Thus whereas Bradshaw had spoken of the paintings being executed in a number of colours, Worms rightly insisted that the overwhelming majority were in monochrome—'only . . . dark ochre'. Whereas Bradshaw had reported some of the figures as 'life-size' Worms noted the great majority, albeit with certain exceptions, measured as little as 20 centimetres. Likewise, the 'features of a most pronounced aquiline type' which Bradshaw had made so much of in order to emphasise that the paintings could not be Aboriginal work, Worms conscientiously reported he found 'in only two groups, perhaps because the facial lines of others had grown indistinct'.[24] Particularly noteworthy to Worms was the extreme delicacy with which the Bradshaws had been executed. Instead of the giant forms that so characterised the Wandjina figures, the Bradshaws were:

> . . . rather elflike creatures, tiny, delicate and fragile. The crude method of finger daubing could not possibly have been employed in drawing these elegant and minutely finished fairies. Only fine brushes, made of crushed or chewed grass stalks could have produced the trim curves of the muscles, the fluttering pendants dangling from the armpits and loins, and the feathery armlets.[25]

In 1955 Worms wrote an authoritative article for the anthropological journal *Anthropos* in which examples of Bradshaw paintings feature prominently.[26] Like all others before him, he seems to have decided that the paintings were too faded, too indistinct, and too interfered with by later overpaints to reproduce clearly via the then prevailing black and white photography method, so he made his own sketches. Also in his verbal descriptions he declined to use the label Bradshaws, preferring instead *giro giro*, the term used by his Aboriginal informants. But as he was careful to point out, these same informants, just like those who had acted as guides to the Frobenius expedition, disregarded the Bradshaws completely:

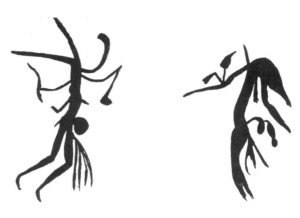

Father Worms' sketches of two of the Bradshaw figures he came across during his 'walkabouts'

> My companions on the first expedition were East Ngarinyin[27] men; on the second, some Kwini[28] and Gulari. The Ngarinyin showed an active interest in their numerous Wandjina paintings, which they had continued to retouch . . . As for the bushman-like miniature rock paintings [i.e. the Bradshaws] for which I was searching, none of the three groups evinced the slightest interest in them.[29]

During the 1960s Dacre Stubbs, an England-born professional photographer who with his wife Pauline and young son had migrated to Australia shortly after the Second World War, encountered much the same disinterested reaction from Aboriginal people in the Kimberley. A former racing car enthusiast who had become fascinated by Australian rock art, the adventure-loving Stubbs took his family on expeditions to the Kimberley where, on coming across examples of the Bradshaws, they tried to find anyone who might be able to shed some light on the paintings' origins. As he told a journalist:

> We have done a lot of enquiring among Aborigines living around the sites, and all of them refuse to admit any connection with these drawings. They don't even refer to them, as they do to some of their own earlier types, as Dreamtime drawings. They say they are drawings which have just existed there and they don't account for them in any way whatsoever . . . In many cases Aborigines don't seem to *see* the Bradshaws . . . We've actually taken the hand of an Aboriginal observer and traced out the Bradshaw painting we're speaking of with his finger, but the Aboriginal has often seemed confused, as if he wasn't aware that this is actually a drawing. It does not belong to him. It's out of his consciousness.[30]

Noting how the Bradshaws repeatedly lay beneath other paintings, Stubbs, like Worms before him, recognised that the Bradshaws had to be extremely old. In a book that he wrote on the generality of Australian prehistoric art, published in 1974,[31] he remarked that 'undoubtedly they represent the oldest paintings to be found on the continent'. But just how old were they—even to the nearest few millennia? As late as the early 1970s there remained considerable ignorance and uncertainty regarding when the first human settlers had arrived in Australia. But as the twentieth century entered its final quarter, a new and very different researcher was about to apply his considerable energies to these same issues.

Some of the stencilled imprints of hands and boomerangs, as created by early Aboriginal peoples at Queensland's Carnarvon Gorge, which so fascinated the young Grahame Walsh

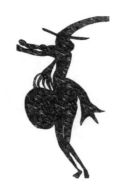

CHAPTER THREE
Modern-day encounters

Throughout the first three-quarters of the twentieth century, the technology to make any accurate dating of the Bradshaw paintings simply did not exist. The general understanding was that the very earliest any humans could have arrived in Australia was around 7000 BC when the western world's earliest known towns, such as Jericho, and Çatal Hüyük in southern Turkey, had already been founded. This would make the Kimberley's Bradshaw paintings younger than the end of the Ice Age, and of little special significance.

During the 1960s and early 1970s knowledge of the chronology of prehistoric societies around the world began to be revolutionised by radiocarbon dating, the scientific method of determining the age of organic materials by measuring the decay of their mildly radioactive carbon 14 component. Even so, the method as then available demanded large quantities of sample, and with Australian archaeologists being few in number, its usage was comparatively light. As a result, Australia continued to be widely perceived as a 'young' continent supposed to have received its human colonisation later than everywhere else, including even America. This belief was such that when in 1979 Welsh-born immigrant archaeologist Rhys Jones[1] began predicting that the first

human settlement in Australia would eventually be dated to as far back as 50 000 years ago, most of the world's archaeological fraternity, including Australia's, shook their heads in disbelief.

But for more than a decade now Rhys Jones' estimate has been recognised as a near certainty, even erring on the side of caution. In 1990 traces of human occupation found at Malakunanja, a rock shelter in northern Australia's Kakadu National Park, became firmly and reliably dated to between 50 000 and 60 000 years ago, at which time most of Europe consisted of empty icefields. Very significantly, all levels of Malakunanja's occupation, even the very earliest, showed evidence of the use of painting pigments, quantities of ochres being found, some with unmistakable indications of their having been ground for use as paints.[2] Quite independently, the latest genetic studies reconstructing our first human ancestors' migrations after leaving their African 'cradle'[3] have suggested the same c.60 000 BC period for the arrival of the first humans in Australia. Inevitably this raises the question: if the fact that Wandjina paintings are invariably found superimposed over Bradshaws necessitates that the latter are older, exactly how old *are* the Bradshaws in the suddenly very lengthy overall scheme of Australia's prehistory?

In the late 1960s, Western Australian Museum professional archaeologist Ian Crawford came across some paintings of the Bradshaw type amongst Wandjinas that he was studying in the environs of the Kimberley's King Edward River, also around the Kalumburu mission to the north.[4] Crawford made some careful sketches, and suggested that the distinctive, multi-barb variety of spear seen depicted in some examples strongly indicated them to date before the introduction of quite different, leaf-shaped stone spears into Australia, a development which archaeologists estimate to have happened before 2000 BC. But how long before that date were the Bradshaws painted? As a hard-pressed, working academic Crawford opted to concentrate his energies more on the Wandjinas, while direct initiatives by other archaeologists have all too often been frustrated not only by the Kimberley's terrain and climate, but also by some fearsome political obstacles. Whereas Western Australian politicians may obligingly ease the red tape for a mining company wanting to exploit the Kimberley's mineral resources, they can be altogether

more bureaucratically obstructive when a vote-penniless archaeologist is making the exploration application.

Accordingly it would be an individual without any university education, the earlier-mentioned Grahame Walsh, who more than a quarter of a century ago boldly stepped forward to take up the research of the Bradshaws—a subject that almost the entirety of Australian academics had relegated to their 'too hard' basket.

Born in 1944, Grahame Leslie Walsh grew up with two sisters twenty years older than himself on a cattle station between the west Queensland towns of Roma and Injune. Even today this area is very 'outback' compared to the ribbon of trendy urban sprawl that hugs the southern Queensland coast. Acquiring an early enthusiasm for archaeology from his mother, who read to him books on the subject, Walsh was thirteen when an elderly cattle-hand took him to see some ancient Aboriginal paintings, including imprints of hands and boomerangs, located on a sandstone rock face in Queensland's beautiful Carnarvon National Park. The experience so enthralled him that it continued to burn in the back of his mind as a subject that he would one day take up more fully.

Then at the end of June 1977 he resolutely gave up what had been a promising enough early career as a newspaper photographer, and took on the lowest grade of job in Carnarvon National Park—in his words 'mark one *zamia*[5] nut raker'—specifically to be able to work in the same environment where he had been shown the rock paintings. Before actually starting at Carnarvon he also undertook his first rock art hunting photographic expedition into the Kimberley, a journey which by road from Queensland necessitates five full days of hard driving even to reach the area, quite aside from the gruelling on- and off-road conditions to be tackled on arrival. When he was setting off on one such expedition in 1988 his vehicle was involved in a head-on collision with another travelling on the wrong side of the road. He suffered extensive injuries and had to spend months in hospital. But, undaunted, he continued to make the Kimberley venture an annual one, and for up to three months at a time, continuing to this day.

In the course of these annual expeditions Walsh, like Worms before him, sought out and questioned a number of elderly Kimberley Aboriginal people.

Among these was Billy King, elder of the West Kimberley Kupumgarri Aboriginal Community, who reaffirmed what both Father Worms and the Frobenius expedition members had been told, that Aboriginal people living in the same area as the Bradshaw paintings simply do not recognise them as anything to do with their own culture. As King would later state for the record:

> We would like to know the truth of where the Bradshaws came from, all of us old people, so we are very happy that Grahame and his people are finding out. We don't go near them ourselves. It does not break our law, because Bradshaws are not part of our law, we don't know nothing about them . . .[6]

But faced with the very considerable fuel, vehicle and photographic materials costs accrued by his expeditions, Walsh also did not neglect to court those in white society who might be well-heeled enough to help his cause. In 1989, when photographing at a rock art site in the upper Hann River region to the Kimberley's south, he happened to strike up a conversation with a group of visitors from England that included Australian-born sculptor John Robinson. As an artist, and with an already established affection for the Kimberley, having worked there as a young cattle drover, Robinson needed little persuasion of the Bradshaws' appeal. He and his wife Margie had some influential international contacts, as a result of which in 1991 and again in 1992 Walsh found himself guiding to Bradshaw sites groups that

Grahame Walsh on location.
He has been conducting annual expeditions to the Kimberley since 1977, amassing an unrivalled collection of photographs of Bradshaw paintings

included not only the Robinsons but UK Economic Research Council chairman Damon de Laszlo, American Robert Hefner III, prominent Melbourne stockbroker Bruce 'Dasher' Dyson, and others. These were so impressed by what they saw that they decided to put up funds for a special Bradshaw Foundation which would publish Walsh's first full book on the subject, inclusive of the best of his photographic labours.

Fired by such support, Walsh continued his annual expeditions while preparing that volume. On each of the expeditions between 1989 and 1993 he was accompanied by one or more field assistants, who no doubt were provisioned with Walsh's trademark expedition food choices. As he himself gains some satisfaction from telling, when provisioning a three-month field trip he buys from the local supermarket a bulk supply of the cheapest brand of canned tuna, then consumes these straight from the tin, with little more than rice and Weet-bix to supplement such a diet.

And while dull food may have been just one of the discomforts to be expected from a Walsh-led Kimberley expedition, another was the very real hazard that any suitably exhaustive exploration of the region necessarily entails. Behind the trusty Toyota Land Cruiser which is the one type of vehicle that those 'in the know' recognise as tough enough to stand up to Kimberley conditions, Walsh tows a trailer carrying two quad 4×4 motor-bikes by which to rove across terrain that would otherwise be accessible only by arduous foot-slogging. These also double as power generators and provide a vital emergency transport backup.

However, as Judith and I would experience during our 2004 expedition, there are certain circumstances in which travel by helicopter or by light plane is the only viable option, despite its expense, and in the Kimberley such means of transport are never without their attendant risks. In August 1990, when Walsh and his field assistant for that year, Nic Parrot, were taking off in an amphibious aircraft to cross the Admiralty Gulf on the Kimberley's north coast, the pontoon flipped in a heavy swell, sending the plane crashing into the sea. Walsh, who is a non-swimmer, was unconscious when Parrot and the pilot managed to drag him from the sinking craft, a rescue which Walsh acknowledges 'unquestionably saved my life'.[7]

Despite having incurred some damage to the left side of his brain, Walsh recovered to go on three more of his annual expeditions, then in 1994 expectantly awaited the Bradshaw Foundation's publication of his magnum opus *Bradshaws: Ancient Rock Paintings of North-west Australia*, the first-ever full book on the subject.[8] Even though only 1500 copies were printed, these were on high quality paper, with 99 full-colour plates, and were quickly snapped up by art aficionados, wealthy collectors and the more exclusive libraries. But on publication, the previously cordial relationship between Walsh and Robinson abruptly and acrimoniously ended, though he continued to accept favours from other of the foundation's benefactors. Among these was Dame Elisabeth Murdoch, mother of media tycoon Rupert Murdoch and a still feisty octogenarian immensely wealthy in her own right. On being told that Walsh's quad motorbikes were breaking down during his expeditions, she immediately bought him a new pair.

Another highly influential woman to enter Walsh's life during this phase was Maria Myers, socialite wife of top Melbourne QC Allan Myers, one of Australia's leading barristers. Like others before her, Myers had found herself positively amazed on seeing examples of Bradshaw paintings at first hand in the Kimberley.

> On that first visit I saw the Bradshaws, I thought to myself that we don't understand this country at all—who's been here, what its history is. The sophistication of the art was evident, but how unfamiliar the adornment is, at least in the Australian tradition. I felt an explanation that was new to what we've always understood as Australian history was hovering just before us.[9]

A third supporter to surface at much this same time was Susan Bradley, a high-profile Kimberley politician who in 1998 formed a 'Kimberley Foundation' to channel all future funding on Walsh's behalf following his disagreement with the Bradshaw Foundation. With the luxury of such a galaxy of Australia's rich and powerful backing him, Walsh was able to put together a new 464-page full colour volume, *Bradshaw Art of the Kimberley*, for the production of which he was subject to none of the normal commercial

publishers' editing constraints, and thereby able to act with virtually a free hand on every detail.

This book was published in the year 2000, in a special landscape format edition again limited to 1500 copies, with over 600 colour photographs, an equivalent number of text figures, and suitably embellished with silver and gold 'watermarks' and imitation crocodile skin binding.[10] Its price of A$295, though small change for the world's wealthy 'limited edition' aficionados, instantly put it beyond the reach of most book buyers, even had it been made available through the standard retail trade, which it had not. Such a high purchase price likewise made it too expensive for most public lending libraries, the university library in Walsh's own home state of Queensland purchasing just a single copy, and that for its strictly reference-only section housing books that are too rare or costly ever to be allowed on general loan.

It is an extraordinary irony, therefore, that Grahame Walsh, even though he is the very antithesis of any head-in-the-clouds dilettante, has almost exactly matched the geographical inaccessibility of the Bradshaw paintings by making his superb photographs—the unrivalled fruits of his 25 years of hunting Kimberley rock paintings—almost equally inaccessible to any average citizen.[11] This is a tragedy not only for all Australians, for whom the Bradshaws form a priceless part of their country's national heritage, but also for the international community at large, to whom the Bradshaws deserve to be altogether better known than they are at present.

So exactly what insights have Walsh's books revealed concerning the Bradshaws? First, they have established that rather than just 'Bradshaws' and 'Wandjinas', the Kimberley has undoubtedly witnessed a series of distinctively different artistic styles that have successively waxed and waned during its near forty millennia of known human occupation.[12] To Walsh's considerable credit, he has methodically tried to sort these styles into a reliable chronological sequence, using simple observation of which style repeatedly superimposes which, no easy task when they are frequently jumbled one atop another on a single rock face.

According to Walsh's scheme the Kimberley's very oldest artistic phase, possibly, though not necessarily, that of the very earliest human arrivals in Australia, bears the label Archaic Epoch. With this early epoch Walsh

A simplified version of the periods to which Grahame Walsh has ascribed the various rock art styles found in the Kimberley, based on data and diagrams in both his 1994 and 2000 books. It should be noted that in his 2000 book he appears to have changed his mind about ascribing the Clawed Hand period to the Aboriginal epoch

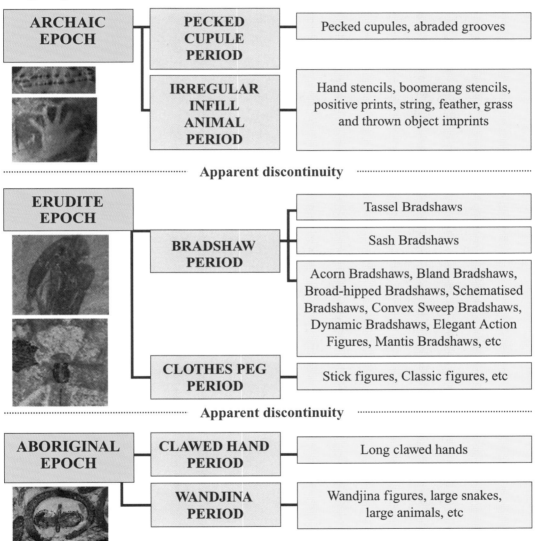

| **ARCHAIC EPOCH** | **PECKED CUPULE PERIOD** | Pecked cupules, abraded grooves |
| | **IRREGULAR INFILL ANIMAL PERIOD** | Hand stencils, boomerang stencils, positive prints, string, feather, grass and thrown object imprints |

Apparent discontinuity

ERUDITE EPOCH	**BRADSHAW PERIOD**	Tassel Bradshaws
		Sash Bradshaws
		Acorn Bradshaws, Bland Bradshaws, Broad-hipped Bradshaws, Schematised Bradshaws, Convex Sweep Bradshaws, Dynamic Bradshaws, Elegant Action Figures, Mantis Bradshaws, etc
	CLOTHES PEG PERIOD	Stick figures, Classic figures, etc

Apparent discontinuity

| **ABORIGINAL EPOCH** | **CLAWED HAND PERIOD** | Long clawed hands |
| | **WANDJINA PERIOD** | Wandjina figures, large snakes, large animals, etc |

associates what are widely termed 'pecked cupules'. These are groups of often a hundred or more circular depressions pounded onto rock faces seemingly for some kind of ritualistic rather than utilitarian purpose,[13] though exactly what this might have been is far from clear. Highly intriguingly, such cupules are to be found not only in the Kimberley, but also to its west in the Pilbara and to its east in Arnhem Land. Even more intriguingly, they are found well beyond Australia, even as far afield as Europe, Africa, the Middle East and India, the Indian examples certainly being of Ice Age vintage.[14]

Also to this Archaic Epoch Walsh has ascribed some—though far from all—large depictions of animals, birds and fish, some of these seeming to represent species which became extinct tens of thousands of years ago. Broadly contemporary with these, Walsh associates certain delicately sten-cilled imprints of large boomerangs, likewise some—though again far from all—stencilled hand imprints similar to those that so impressed him at the Carnarvon National Park. Also to around this same period he links strange imprints that look as if they were created by someone throwing clumps of string or grass high up beneath otherwise inaccessible rock overhangs. Collectively these different early groups of images Walsh defines as belong-ing to the 'Irregular Infill Animal Period', this mouthful of a label being one that his critics have least warmed to.

After a 'period of discontinuity' by which the Archaic Epoch terminates, Walsh labels the succeeding epoch the Erudite, this being the one that includes all the so-called Bradshaws. According to Walsh, sequence-wise these show no sign of any formative phase, instead suddenly appearing with fully developed virtuosity, suggesting that the Bradshaw people must have spent a developmental stage somewhere else prior to their arriving in the Kimberley. But just to further complicate matters the Bradshaw period is not just one clear, simple phase, but a whole series of distinctive style groups, some of these major art forms in their own right.

This is particularly so in the case of the first and earliest of the groups, which Walsh labels as 'Tassel' Bradshaws, an absolutely classic example being the near metre-high figure that is reproduced opposite, as an interpretative drawing after a Walsh photograph. According to Walsh this is one of several similarly graceful human forms 'on the shallow hanging face of a sizeable

outcrop',[15] the figure's defining tassels being those that can be seen dangling from a band or belt at its waist. Such waist-hung tassels, possibly ceremonial rather than functional, are the mark of all Bradshaw figures that belong to this group, figures notable also for elbow bangles, for wrist bands, for elaborate hairstyling and, above all, for quite extraordinary artistic virtuosity, often being delineated with extreme delicacy and attention to anatomical proportioning. As we will discover, frequently accompanying such Tassel Bradshaws are depictions of delicately crafted boomerangs, two being visible alongside this particular figure's (spectator's) left hand. And besides Tassel Bradshaws being the first of the Bradshaw style groups, they are also numerically the most prolific, existing in literally tens of thousands of examples across the Kimberley.

The next most numerous group Walsh labels as 'Sash' Bradshaws, of which the 76 centimetre figure reproduced on page 38 is one of the most representative examples, as well as one of the most outstanding. Self-evidently indicating the figure's 'Sash' classification is the huge three-pointed sash hanging from the back of the waist band, seemingly rather more of an ornamental or ceremonial accessory than the rectangular apron hanging at the front. Intriguingly, figures sporting such distinctively shaped sashes are far from exclusive to Australian rock art, being found—whether coincidentally or otherwise—in as yet sparsely studied prehistoric rock

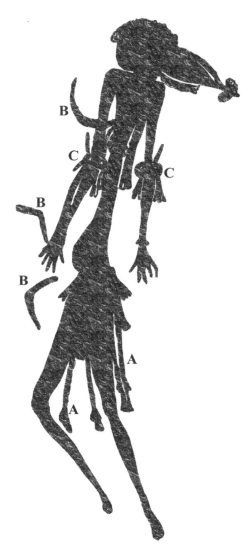

Example of the painting style Walsh has dubbed Tassel Bradshaws, after the tassels (A) dangling from the figure's waist. Note also the boomerangs (B) and ornamental armlets (C)

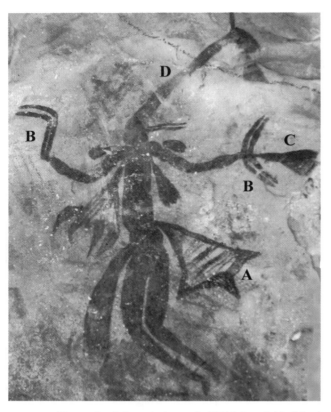

Example of the painting style Walsh has dubbed Sash Bradshaw, after the large tassel (A) hanging from the figure's waist. Note also the paired boomerangs (B), 'dilly' or collecting bag (C) and 'wizard' headdress (D)

paintings of Thailand[16] and also much further afield, amongst the famous 'Tassili' rock paintings of the Algerian Sahara.[17] A little less 'ceremonial' about this particular figure is its extravagantly tall 'wizard hat' headdress, one that is also repeatedly found in association with figures of Tassel Bradshaw type. And again denoting a strong continuity between Tassel and Sash Bradshaws, this particular figure can be seen to be carrying two matching pairs of beautifully crafted boomerangs, one pair distinctively crescent-shaped, the other altogether more angular in shape. Both can be readily matched to more modern-day varieties of boomerang, and thereby indicate that, whoever the Bradshaw people were, they had already developed as much proficiency in boomerang-making as the much later Aboriginal bands first encountered by Europeans.

The further, and mostly later in sequence, Bradshaw art style groups that Walsh lists include 'Acorn' Bradshaws, 'Bland' Bradshaws, 'Broad-Hipped' Bradshaws, 'Schematised' Bradshaws, 'Stick' Bradshaws, 'Miniature' Bradshaws and many more. There are also 'Eastern' Bradshaws, a group distinctive for being found only in the Eastern Kimberley. Among the more interesting are 'Dynamic' Bradshaws and 'Elegant Action' Bradshaws in which the 'tassel and sash' style ceremonial gear largely disappears, the figures now being depicted in stylish seated and kneeling poses, and also in

lively running action mode. This style group has particularly close parallels with early rock paintings in Arnhem Land where George Chaloupka, curator of the Northern Territory's museum in Darwin, has labelled them 'Dynamic Figures'. While some of Walsh's 'Dynamic' and 'Elegant Action' figures still carry boomerangs, spears are now their altogether more common accompaniment. Surviving museum examples of such spears show that these had a business end barbed with quartz flakes glued on with a strong gum,[18] a variety of spear commonly called multi-barb. A typical 'Elegant Action' figure is shown below.

Still within the Erudite Period, but thought by Walsh to belong to a positively late phase of this, are figures that he labels as of the 'Clothes Peg' group; figures that are again numerically very prolific, and with several sub-group variants. A typical Clothes Peg is reproduced here on page 40. In this group the figures still occasionally sport a waist-hung tassel-like attachment and are rarely without at least one multi-barb spear somewhere around them, both factors suggesting some continuity with the Bradshaws' Sash and Elegant Action phases. But dramatically and emphatically absent is the slenderness and the shapeliness that was so striking about their preceding 'pure' Bradshaw counterparts. The elaborate 'wizard' and similarly outlandish forms of hair-dressing disappear equally as emphatically. Instead Clothes Pegs are defined by an altogether more 'toy soldier' style of representation in which the figure's legs resemble tree trunks,

Example of the painting style that Walsh describes as Elegant Action in which the figures are engaged in lively action and they lack the tassels and sashes of the earlier phases of the Erudite Epoch

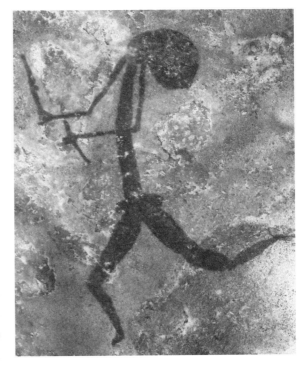

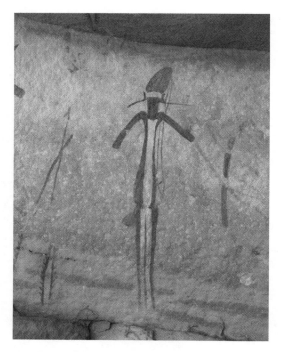

Example of the painting style Walsh has dubbed Clothes Peg. At bottom left of the picture are spears of the multi-barb type often associated with Clothes Peg figures

the arms matchsticks, and the hairstyle something that sometimes misleadingly resembles a bowler hat due to the disappearance of facial detail. Even so, the figures are not without a certain stylistic panache all of their own. And they can often have a bichrome or multichrome colouration to them that is either absent from, or long gone from, the Bradshaws.

After another posited period of discontinuity Walsh's Kimberley art styles sequence begins its final phase, the 'Aborigine Epoch', with a 'Clawed Hand Period'. This features depictions of clawed hands looking as if straight out of a 'Hand of Dracula' movie—except that the artist may well have had in mind the paw of a large reptile such as a goanna. This period is relatively poorly represented by actual examples and Walsh's description is unnessarily judgmental: 'Clawed Hand Period art is technologically grossly inferior to the earlier art periods; suggesting the appearance of a new culture and marking the commencement of the Aborigine Epoch.'[19] Finally, in Walsh's sequence, there occurs the Wandjina Period, with its now familiar owl-faced figures that so startled the pioneering nineteenth-century explorer George Grey. And of course the Wandjinas were without any doubt the work of ancestors of present-day Aboriginal people of the Kimberley, even so having their own succession of stylistic phases falling outside the scope of Walsh's books.

Accordingly, Walsh had constructed a quite reasonably convincing—if not necessarily definitive—working sequence for all the different art styles that are present in the Kimberley, much as different pottery styles

can be sequenced for a similar purpose in post-Ice Age archaeology. His assemblage has to be acknowledged as a major contribution to the subject, and it is one that he had already largely put together at the time of his first book's publication.

But what he still needed was at least some broad indication of the chronology that pertained to each of the epochs that he had so patiently defined. And, as widely recognised amongst archaeologists, there is as yet no method that can be considered truly reliable for dating rock art. This is because the ochre that is the main ingredient in most pigments lacks the vital organic components, such as wood, bone, or flax, upon which conventional radiocarbon dating chiefly relies. A further factor is that in the case of almost all Bradshaws so much time has elapsed since their creation that even if the original paint were, say, blood—which would be suitable for carbon dating—a hard silica coating has formed over the paint surface, bonding it into the rock and making any sampling near impossible.

Even so, Walsh tried his best to get around this problem using two different approaches. First, having formed a temporary alliance with the archaeology department at James Cook University in Townsville, Queensland, in 1995 he led archaeologist Alan Watchman to a site south of Kalumburu in the Kimberley. There Watchman used a portable dental drill to extract 'rock surface crust' samples from different rock art features theoretically representative of all three of Walsh's 'epochs'. Watchman duly sent these samples to the radiocarbon dating facility at Lucas Heights, New South Wales, which uses the latest, state-of-the-art accelerator mass spectrometry radiocarbon dating technique as used on the Turin Shroud. However, when the results came back, the New South Wales laboratory had dated 'oxalate accreted red paint' from a late stick-like Bradshaw to circa 2000 BC, older than 'calcium oxalate crust' from pecked cupules, which were dated to around the time of Julius Caesar. Similarly, 'silica accreted red paint' from three Tassel Bradshaws, which should have been older than the stick-like example, was dated to circa 500 AD, well within the era archaeologically certain as that of the Wandjina. By any standards the dating, which Walsh should have anticipated had lacked any firm rationale from the outset, could only be considered worthless.

An exasperated Walsh accordingly turned to Bert Roberts of Australia's La Trobe University, a specialist in optically stimulated luminescence dating, who during this book's preparation created headline news for his work on the so-called 'Hobbit', or miniature human, bones found on the Indonesian island of Flores. In 1997 Roberts journeyed with Walsh to a site in the Kimberley where a rock painting of one of the Tassel/Sash Bradshaw 'wizard hat' figures was overlaid by a fossilised mud dauber wasp's nest. This time Walsh was working from a perfectly sound theoretical base: that whatever date Roberts might arrive at for the formation of the mud wasp's nest, the Bradshaw figure beneath this had to be older. Necessarily using his instruments in pitch darkness, Roberts painstakingly extracted grains of sand that were deeply embedded in the nest. Then he took these back to his Melbourne laboratory where he had high-tech apparatus to measure how far back in time the wasp's nest grains had last been exposed to light. The result that he arrived at was circa 17 500 BP or, in layman's language, approximately 15 500 BC. To Walsh's great relief and satisfaction, this meant the Bradshaw painting was definitely Ice Age, even in the unlikely event that the wasp had begun its nest-building as early as when the paint was still wet.

But a disturbing feature of Walsh's 2000 *Bradshaw* book is that while he fair-mindedly reproduces short articles by Alan Watchman and by Bert Roberts, each very dryly describing their procedures and the results that they obtained, he devotes frustratingly little attention to the glaring discrepancies between the two specialists and their methods, even though the optically stimulated luminescence technique has suffered its fair share of glitches. And in the case of the Bradshaw paintings the question whether they do or do not date from before the end of the Ice Age is hardly a minor matter.

Also it is a pity that Walsh does not use his wealth of photographs of Bradshaw figures properly to build a hypothetical picture of the Bradshaw peoples' society, their food habits, their social order, their religion, their trade and communications, the materials they used for their garments, their male–female relations, and much more. For instance, a number of the Tassel figures, including the one that is reproduced in this chapter, strike me instinctively as female, irrespective of the presence or otherwise of breasts. And a

number of others to whom I showed such figures reacted likewise. But Walsh in his book emphatically declares this and 99 per cent of all other Tassel and Sash Bradshaws as male without any attempt properly to explain his reasons to the reader.

Equally frustrating is that Walsh provides nowhere within his book, or indeed anywhere else within the public domain, adequate locational information for the hundreds of paintings that he reproduces; either the actual geographical location or the environmental setting. For the most part we are expected to accept of any painting simply that it is from 'somewhere in the Kimberley'—much like our being presented with the great gold face mask of Pharaoh Tutankhamun, and being expected to want to know nothing more than that it came from 'somewhere in ancient Egypt'. Other authors, when writing about equivalent rock art elsewhere around Australia, or in Africa, or in Thailand, or in Europe, have invariably identified each artwork by the site, or at the very least the district where it was found, not least because this makes it so much easier to refer between one artwork and another. But Walsh deliberately withholds such information.

For me, as I became more and more fascinated by the Bradshaws, so my frustration grew that this man, who otherwise seemed so heroic and positive, was actually holding the subject back. I badly wanted to visit the Kimberley to view the paintings for myself. But first I wanted to contact him and to question him about these issues.

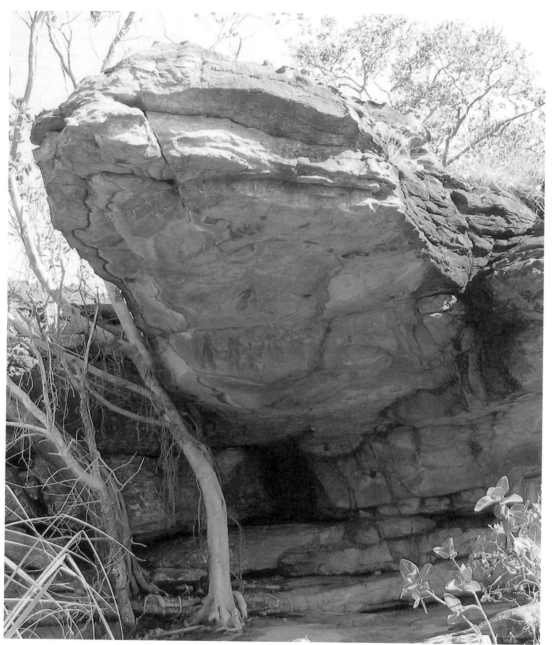

Another typical Kimberley rock outcrop of the kind used by prehistoric artists for their rock paintings

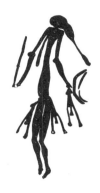

CHAPTER FOUR
Twenty-nine in a boat

It had been back in 1999 that I first became alerted to the Bradshaw paintings—indirectly, and from a source on the other side of the world. BBC executive producer Jean-Claude Bragard, with whom I had once worked in England, sent me videotape of a documentary that he had recently completed, *Hunt for the First Americans*. The mystery that this documentary tackled concerned certain skulls—the oldest found anywhere on the entire American continent—that were turning up at prehistoric sites in Brazil, South America, often in association with lively rock paintings.

Radiocarbon dating tests on some of these skulls were finding them to be significantly earlier than the post-Ice Age period when, according to the standard textbooks, the first humans had crossed into North America via the then land bridge connecting Siberia and Alaska. They were also different from the anthropological type normally associated with those who had made that crossing, Mongoloid big game hunters who were the ancestors of today's American Indians. According to Walter Neves, a specialist at São Paulo, Brazil, some of the skulls had distinctively Australian Aboriginal physiognomies. But how, way back in the Ice Age, could Australian Aboriginals—who were surely never a maritime people?—have travelled all the way across 17 000 kilometres of the open Pacific to reach South America?

This was the BBC documentary's cue to introduce Grahame Walsh, who was filmed crossing the Kimberley landscape by small helicopter. On Walsh's arrival at a clearly remote but otherwise unidentified rock outcrop he proudly led the camera to a rock wall bearing a quite reasonably distinct 40-centi-metre long painting, reddish in colour, depicting four men with frizzy hair paddling a canoe. On the basis of Bert Roberts' recent optically stimulated luminescence dating, Walsh declared this painting as of Bradshaw type, thereby scientifically determinable as being at least 17500 years old, and quite possibly the world's oldest known boat painting. And because the canoe had an upturned prow and stern, this strongly suggested that it had been designed for open sea conditions. Walsh's statements, and some footage of boat-versatile Tiwi people of Bathurst and Melville islands to the Kimberley's north-east, enabled Bragard's TV program to argue that Australian Aboriginal peoples could have crossed the Pacific to America during the Ice Age—well before the arrival of today's 'native Americans' ancestors.

At around this same time I was working on a book for which Walsh's painting would have been a useful, though far from essential, illustration, so I wrote to him at an email address that Bragard's assistant Petra Collier kindly supplied, only to receive no reply. At that stage I had not even the remotest idea where in Australia he might live, and this continued until I happened to read a short article in a local newspaper publicising his 2000

Interpretative drawing of the Kimberley boat painting that Grahame Walsh showed in the BBC TV documentary Hunt for the First Americans. *This Walsh described as the oldest depiction of a boat known anywhere in the world*

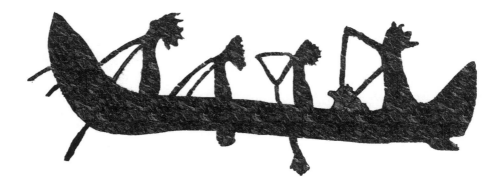

book. According to the article, he lived in a Brisbane suburb no more than a quarter of an hour's driving distance from my home. But as there was no G.L.Walsh for this locality listed in the Brisbane telephone directory, clearly he opted to be ex-directory.

Even so, from my beginning to dip into Walsh's books the idea of researching and writing a book about the Bradshaws kept growing in appeal. In May 2003 Allen & Unwin publishers in Sydney helpfully came up with an advance encouraging me to develop the project. And at almost exactly this same time, during socialising after a lecture that I had given in Brisbane, a member of the audience asked me what subject I would be tackling next.

'The Bradshaw rock paintings of the Kimberley,' I told her. 'Have you heard of them?'

'Heard of them?' she responded. 'Grahame Walsh was a neighbour of ours. Would you like to meet him?'

Within weeks Judith and I were duly invited to a dinner party where we met Grahame Walsh a couple of days before he left for his 2003 season expedition.

The discussion I had with Walsh that evening was frustratingly unproductive. When I expressed my intention to try to visit some of the Bradshaw paintings in the not-too-distant future, Walsh offered me not the slightest helpful suggestion for how best I might do so, or even which areas of the Kimberley might prove most fruitful. This despite his pointing out that this season would almost certainly be his last.[1]

During the remaining months of 2003 I had too much background reading and research to catch up on to even consider trying to get to the Kimberley that year. However I might attempt it, this would have to wait until 2004. That same October an article appeared in the *Weekend Australian* describing how Walsh had hosted the now 92-year-old Elisabeth Murdoch on her first-ever visit to the Bradshaws, during which she was whisked around the Kimberley in helicopters.

One of the paintings that she was taken to see was an obviously new discovery of Walsh's: 'A Bradshaw period depiction of an ocean-going boat, high-prowed, with no fewer than 29 occupants.'[2] Although no photograph of the painting in question was included in the article, even this bald description

immediately had me on the edge of my seat. As no historical tradition of boat-building in anything like these proportions has ever been recorded among Aboriginal people, this had to be of considerable significance for understanding the Bradshaw people as seriously ocean-going early Australians.

Part of my ongoing research was to gather images of the earliest boat depictions from all around the world for comparison with the one that Walsh had shown during Bragard's TV documentary. So I was more than anxious to gain some sight of what this particular 'new' example looked like. Early in April 2004 I learned that Grahame would be lecturing on the Bradshaws at a rather exclusive art circle function in Brisbane the following week.[3] Although theoretically this lecture was not open to the public, with a little adroit diplomacy I might gain admission.

To Walsh's great credit his lecturing style proved to be light years better than the dense and dull 'academic' tone that he has used for his Bradshaw books.[4] Without a glitch he projected a generous and impressive array of digital images of Bradshaw paintings. A significant proportion of these were not familiar to me from his books, apparently having been discovered more recently. Among them was a Bradshaw figure holding an axe head hafted into its handle. While numerous stone axe heads have come down from the Stone Age, invariably their handles have been long ago eaten away by termites. So to see an original attachment arrangement was a particularly valuable window into prehistory, much like the Bayeux Tapestry is for the day-to-day items that were used in England and France during the time of William the Conqueror.

Far more importantly, however, and exceeding all my expectations, Walsh actually showed a photograph of the Bradshaw 29-occupant boat painting that had been mentioned in the *Weekend Australian* article. Because, just as in the case of our Reindeer Rock example, the painting itself showed up only very faintly against the background colour of the rock, Walsh quickly switched to an interpretative drawing that he had sketched on-site which showed its details rather more clearly. Nevertheless for me it was quite obviously just the sort of evidence that I was looking for to indicate the Bradshaw people's precocious advances in early boat-building.

Snatching a brief after-lecture moment with Walsh I learned from him that he was just about to go on his 2004 expedition, despite his previous

information to me that the 2003 expedition would be his last. With the Kimberley's Wet season in its final days and my own trip to the region needing urgently to be organised, I asked him whether he might be able to spare me an hour or so to help me with certain questions that had cropped up in the course of my research. A meeting was duly arranged for mid-morning on Saturday 1 May at his home.

On my arrival Walsh was preoccupied with his computer system, which was apparently proving inadequate to cope with his million-plus collection of photographs, his life's work, and undoubtedly the world's largest and most definitive recording of Bradshaw paintings. In much the same negative mood that I had encountered on our first meeting, he spoke of his being minded to have the entire collection destroyed within 24 hours of his death, a remark that within months he would repeat publicly in an SBS television documentary.

Anticipating time constraints, I therefore quickly launched into my prepared questions. Aiming to convey to him that this was a subject to which I wanted to contribute something, I tried to get him to discuss why he was so insistent that the overwhelming majority of Bradshaw Tassel and Sash figures *had* to be male. After all, he could hardly deny that the Bradshaw artists characteristically omitted depicting details of sexual anatomy on their figures—quite unlike later Aboriginal artists, who unambiguously depicted such things. There was also no certainty that Bradshaws ever included facial details. So surely the artists' omission of breasts, particularly in such an obviously slim people, should not be assumed to determine maleness?

As I went on to point out, many Bradshaw figures exhibited distinctive postural traits, such as a splaying out of the legs below the knees, which when seen, for example, in ancient Egyptian art positively typified the depiction of women. And it so happened that in these particular Bradshaw figures the hairstyles repeatedly took forms that we would today identify as female, while conversely, in those figures where such posturing was absent, the hairstyles were of the 'wizard hat' variety that I had no problem accepting as male. If such criteria were accepted, the proportion of female to male Bradshaw figures would become much more evenly balanced. Even so, in no way did I feel insistent upon such gender distinctions. If Walsh had a sound, rational reason for why I was wrong, I simply wanted him to explain this to

me. To my intense disappointment that explanation—and the attendant lively discussion of other topics that I had similarly hoped for—simply never came. Then it was on to the next question.

This concerned the so hugely significant Bradshaw painting depicting a boat with 29 occupants that he had shown at his Brisbane lecture. I explained to him the research that I was doing on the very early development of sea-going boats as depicted in prehistoric paintings. I showed him a reference sheet that I had prepared illustrating the different early forms of these found around the world, including ones from the Niah caves of Borneo, from Thailand, from the Indus civilisation and from prehistoric Egypt. In order to help me build up a picture of how the Bradshaw boats related to these, I asked him if he could allow me a copy—purely for research purposes at this stage—of the photo or the interpretative drawing that he had shown during his Brisbane lecture. He flatly refused this request.

It was scarcely the outcome I would have wished for. I had been looking for us to achieve a rapport whereby he might hopefully suggest some way of our meeting up during his coming season in the Kimberley, when he might lead me to a representative selection of Bradshaw sites, much as he had done for Dame Elisabeth Murdoch. Failing this, and given that we lived in such close geographical proximity, I had hoped that he might at least allow me to study some images from his photographic collection that were pertinent to the lines of enquiry I was following. At the very end of his Brisbane lecture the convenor had actually asked for volunteers willing to help Walsh sort this collection, and I had left my contact details—only to receive not even a word of acknowledgement. Throughout my 25 years of researching and writing books on a variety of topics I had been used to busy individuals, often of professorial status, liberally exchanging ideas and sharing research papers, photographs and references. But Walsh clearly did not follow these conventions.

And once I was without his cooperation, the catch-22 was that I lacked any four-wheel drive vehicle, the necessary driving experience, and bush camping skills by which Judith and I could make our own explorations of the Kimberley. And even if I could overcome such impediments, Walsh's deliberate withholding of location details left me with precious few clues as to where we should look for the paintings in a region nearly the size of Spain.

A trawl of the Internet revealed further setbacks. From the scant locational information that I had been able to glean, most significant Bradshaw paintings seemed to be concentrated in the north-western part of the Kimberley. For traversing this there are just two dirt roads, the Gibb River which runs from the Kimberley's eastern border town of Kununurra westwards towards Derby, and the Kalumburu which runs northwards from this towards a small Aboriginal community and mission station. Scattered along these routes, negotiable only during the Dry, are huge, leased livestock stations of the kind that Joseph Bradshaw had tried so hard to set up, namely the famous El Questro on the Gibb River Road, and the Theda, Doongan and Drysdale stations along the Kalumburu. It was always the tradition of these establishments to be visitor-friendly, supplementing their farming income by offering guided tours to any prehistoric rock art sites that might lie within their station's million-acre bounds. Four-wheel drive enthusiasts such as the Range Rover Club therefore put them on their itineraries, and because such groups sometimes illustrated their websites with some of the Bradshaw paintings they had been shown,[5] I knew that Theda possessed some particularly outstanding examples.

But now El Questro was almost alone in continuing to be open and welcoming.[6] The word was that Theda and Doongan had recently been acquired by Grahame Walsh's wealthy patrons Maria and Allan Myers. Susan Bradley was operating these stations on their behalf. And they were henceforth shutting their doors to all outsiders. The Koeyers, who leased Drysdale station, were adopting much the same policy. And although I knew there to be some Bradshaws on land controlled by Aboriginal people, today's Aboriginal people, just like those encountered two generations ago by the Lommels and Father Worms, tended to be interested in showing nothing but Wandjina figures. As Walsh himself had remarked, in 23 years of expeditions to the Kimberley 'Aboriginal informants' had guided him to Bradshaws on merely two occasions, and even then because of their misinterpreting them.[7]

With such mounting problems, in some desperation I contacted Kununurra's Visitor Centre for what they might recommend as the best way for Judith and me to see some kind of in-depth number of Bradshaw

paintings in the Kimberley. In the event it was their Nadia Donnelly whose advice proved crucial. She informed me that there were some Bradshaw paintings still accessible, and that a company called Kimberley Specialists[8] had the right people to guide us to them.

At first there was no reply from my enquiry to Kimberley Specialists. Indeed, as the days turned into weeks I was getting near to deciding that I was beating my head against a brick wall even attempting to research this so impossible subject. Then in the nick of time came a phone call from Lee Scott-Virtue who, it transpired, was Kimberley Specialists' key guide, Bradshaw-wise.

Lee immediately apologised that she had been unable to respond sooner. She had been away on one of the many field trips that she conducts annually as a means of generating the income that she needs to fund her research. She introduced herself as a veteran archaeologist based year-round in the Kimberley. Coincidentally, a female assistant of hers was a Miriwung Aboriginal woman named Ju Ju Wilson! Lee said she was familiar with a good number of Bradshaw painting locations, and was willing to take us by four-wheel drive vehicle to a number of sites that remained accessible. There were some paintings along the Chamberlain Gorge, which we could access by boat via the El Questro station. There were others on the King Edward River and on the Mitchell Plateau, the latter of which we could reach via a track leading off from the Kalumburu Road. On our return journey we might take in further paintings at the Manning Gorge, accessible from the Mount Barnett Station. We would have to camp, and to do some strenuous cross-country hikes, but she would take charge of all the driving and provisioning. She also recommended that we might include a stay at a unique, remotely sited mini-resort called the Bush Camp at Faraway Bay on the Kimberley's northern coast, where she had personally discovered Bradshaws and near which there was an amazing site, a veritable 'Lost City of the Bradshaws', only recently discovered and not yet known even to Grahame Walsh.

In the course of that single telephone conversation, Lee had immediately armed me with a great deal more locational information on the Bradshaw paintings than I had derived from all my long months of studying Grahame

Walsh's writings, and my so unproductive meetings with him. Within just a few days we fixed on mid-September, close to the end of the Kimberley Dry season when there would be fewer other campers, and Lee would be able to devote more time to our visit.

The intervening months were full of preparation. Given Grahame Walsh's refusal to make his photographs available it was going to be important for us to use the expedition to build a collection of our own Bradshaw photographs that would keep us independent of needing to ask Walsh's permission for anything. Judith had agreed to take charge of all photography, upgrading to a digital camera, with a card capacity sufficient to take several hundred images without downloading. The Kimberley Dry season's swirling dust, the general lack of electrical power and the need to travel light all combined to discourage us from travelling with a laptop. We also needed to equip ourselves with the right clothing and accessories, Lee's list of 'must-bring' items including broad-brimmed hats, backpacks, water bottles, sun

Lee Scott-Virtue, the Kimberley resident and professional archaeologist who agreed to take us to sites of Bradshaw paintings

block, insect repellent, tough walking shoes and canvas sock protectors for withstanding the Kimberley's notorious spinifex grass.

On 14 September we took a late evening flight from Brisbane to Darwin, where we had to wait several hours overnight for the short early morning flight that would take us on to Kununurra, the Kimberley's eastern gateway. At Kununurra a cheery and immensely capable-looking Lee was waiting, and within minutes she was energetically finding spaces for our luggage in the already crammed, expedition-toughened Toyota Land Cruiser that was to be our transport, office, food store and general lifeline for the next several days. Our getting up close and personal with the Bradshaws was about to begin.

CHAPTER FIVE
Hands of time

As Lee drove us from the airport into Kununurra's central area, the first impression of the town was scarcely an appealing one. Huddled into areas of shade there were small groups of very black-skinned Aboriginal people sitting on the ground with various items of refuse scattered around them. At a supermarket Lee collected our fresh meat supply for the trip and loaded this into the huge ice-filled insulated container that would be our fridge. Then, as we left Kununurra and headed westwards along the Gibb River Road, the human habitation and the bitumen road surface ended, and we began experiencing our first taste of Kimberley red dirt—literally. As we quickly discovered, whenever there was even a single vehicle just ahead of us, we drove into a thick cloud of dust and near-zero visibility, and much the same happened when a vehicle came from the opposite direction. Thankfully the Kimberley's general emptiness beyond Kununurra meant that such occurrences quickly petered out. Even so, we were already grateful that we had chosen to travel so late in the season.

Within a few kilometres we began seeing the first of what would be many Kimberley boab trees, which grow 'wild' only in this part of Australia. With their commanding height and their vast bottle-shaped trunks these are

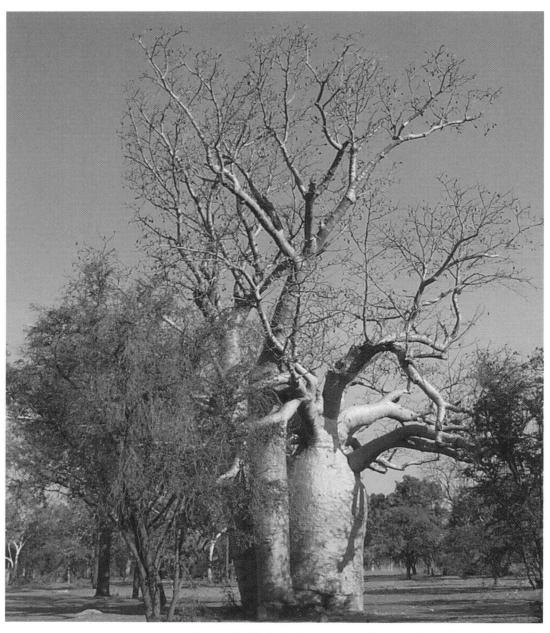

One of the Kimberley's many magnificent boab trees, some of these older than the time of Christ. Their origins are in Africa

utterly distinctive amongst the small, drought-resistant stringy-bark and other eucalypts that form the Kimberley bush country's prime vegetation. The broader a boab's trunk, the older the tree, some living Kimberley specimens having begun their life before the time of Jesus, thereby ranking among the oldest living things throughout the entire Australian continent.[1]

Intriguingly, the only other part of the world where similar trees are to be found lies across the other side of the Indian Ocean in eastern Africa and on the island of Madagascar, where the baobabs *Adansonia digitata* and *A. madagascariensis* are genetically very close to Australia's boab *A. gregorii*. Before the science of plant genetics had reached its present level of expertise, it was widely supposed that the Kimberley boab must have originated when Australia split from Africa as part of the disintegration of the primaeval Gondwanaland super-continent somewhere around 100 million years ago.[2] But recent genetic studies have shown that this thinking simply cannot be right—the Kimberley boab is genetically much too close to its African cousins, which themselves seem of relatively recent evolution, to have stayed so little changed over so long a period.[3]

Only two serious alternatives therefore present themselves. Either a Madagascan baobab nut was wafted on ocean currents across 8000 kilometres of the Indian Ocean to the Kimberley, there to spill its seeds and spawn the present boab tree colony. This is far from impossible, for eggs of Madagascar's huge, long-extinct elephant bird are known to have made much this same journey, a specimen having been found on a Western Australian sand dune as recently as 1993.[4] Or—as has been suggested by Australian bush tucker expert Les Hiddins[5]—prehistoric families fleeing rising sea levels on Madagascar could have loaded their boat with baobab nuts as a food supply and transported them across the Indian Ocean on one of the greatest migration journeys of prehistory.

In favour of this latter argument, the baobab/boab nut's white pith is both very palatable—somewhat like coconut, as Judith and I can confirm—and highly nutritious, providing an excellent source of vitamin C to ward off scurvy for anyone venturing on a long sea voyage. While the nut remains unopened, its long-term storage properties are excellent, staying fresh throughout many months. And upon the ocean voyagers' arrival at their

destination there would have been great incentives for them to plant the seeds that they would have spat out as inedible along the way. For not only do the nut pods of the boab make useful containers, the tree's fibres are excellent for rope and string-making,[6] and its gums and resins are ideal for all kinds of fixative and adhesive purposes, from fastening the bindings of axes, to embedding the quartz barbs in a multi-barb spear. In the light of one recent genetic study suggesting that the boab arrived in Australia within the last 30 000 years, that is, well within the era of human colonisation, the case for its human introduction—perhaps in the form of pods carried on one of the varieties of boats illustrated in the Bradshaw paintings?—is far from incredible.

Lee suddenly turned the Toyota sharply off the Gibb River Road at an only faintly defined rough track that we had not even noticed. As she bumped us jarringly but confidently along this for about a kilometre, a long line of cliffs came into view. These she introduced as the Kimberley's Deception Range, the northern part of a 'Great Barrier Reef' that formed 350 million years ago. Stretching for a thousand kilometres, it has left towering cliffs of Devonian sandstone which, once human populations moved into the area, they quickly began using as art galleries. Lee pointed out that according to Grahame Walsh's totally inadequate map showing the broad limits of Bradshaw paintings' distribution, there should be no Bradshaws in this part of the Kimberley. And undeniably nothing has survived there from Bradshaw times in the volume and of the quality that we would shortly be finding further west. Nonetheless even this far east she could already show us an example.

Lee brought the Toyota to a halt under the shade of a lone boab, at a point where the approach to the cliffs could be seen to slope steeply upwards amidst stands of dense vegetation rather more tropical in character than the stringy-bark bushland through which we had so far been driving. As we alighted into the strong sunshine Lee immediately donned her broad-brimmed hat, shouldered a bulky backpack, handed us ours, and schooled us in the simple but life-saving essentials that we should routinely carry even when exploring only a short stroll from the vehicle. Besides the mandatory hat, most important was a full water flask, and we quickly learned to appreciate the necessity as well as the luxury of regularly recharging ours from

the two multi-gallon ice-filled insulated water containers that 'cluttered' easy access to the Toyota's rear passenger compartment. The fuller backpack that Lee carried included a comprehensive first aid kit, satellite phone and yet more water in case of emergency. As in our own state of Queensland the bushwalking drill was never to put an unprotected hand or foot into any rock crevice, also to walk deliberately and with a certain degree of noise so that snakes could hear our approach and slither harmlessly away.

With Lee moving briskly ahead of us, we pushed our way through the dense vegetation, and clambered upwards along a track which brought us into a circular, near equally densely vegetated area that the cliff face surrounded. Sweeping her hand the breadth of the cliff face Lee pointed out that there was Aboriginal rock art all around us. She then led us on a steep scramble up onto a ledge that provided the only vantage point from which to view the art at relatively close range.

As we studied the rock face, immediately obvious was that this was a site where there had been human visitation and artistic endeavours dating back over a long period. Readily recognisable scratched onto a pillar-like formation were pronounced grooves which immediately reminded me of ones found far to the south, deep in the Koonalda Cave, a prehistoric source of flint and water on the otherwise bleak and featureless Nullarbor Plain. At Koonalda it was possible to date these grooves to approximately 20 000 years ago.[7] So were these Deception Range examples from around the same time? The associated presence of pecked cupules, which Grahame Walsh's sequencing repeatedly dated to the earliest, or Archaic, epoch, certainly made this possible.

Alongside the grooves and the cupules there were 'negative' stencil hand imprints of the very same kind that had so fascinated the thirteen-year-old Grahame Walsh when his elderly cattle-hand mentor had taken him to Queensland's Carnarvon Gorge back in the 1950s. Judith and I had bush-walked to this Carnarvon Gorge site in 1995, and these Kimberley examples could immediately be seen to be strikingly similar. Among Aboriginal people of even recent times one simple hand-imprinting method was to dip the hand in ochre, then apply it to the wall surface, resulting in a mere 'positive' print. But the markedly more sophisticated method that had been used by many of these Kimberley artists, and by their Queensland counterparts, was to suck

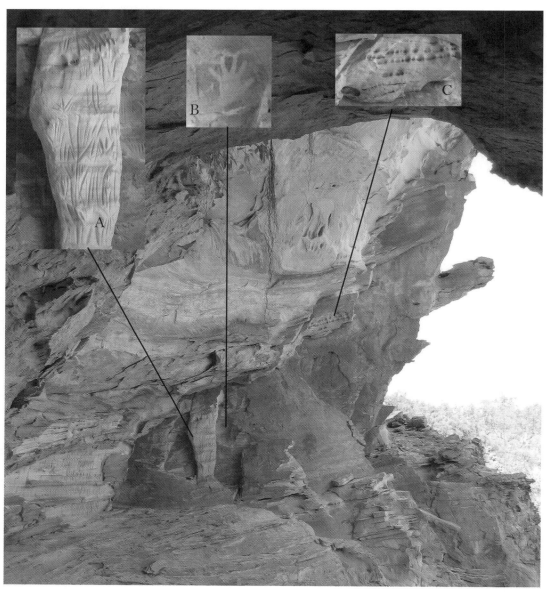

Art styles, some examples of which date back to 30 000 years ago, all on the one outcrop in the Deception Range west of Kununurra. (A) Grooves similar to examples in South Australia dating back to circa 20 000 years ago; (B) Negative hand stencils similar to European examples dating back 30 000 years; (C) Pecked cupules, again one of the world's oldest known art forms, with examples found as far afield as India and Scandinavia

up a quantity of ochre pigment and hold this in their mouth. Then they would blow or spit it out over a hand—either their own or someone else's—held against the rock face, thereby creating a perfect, ochre-framed 'negative' of the hand.

According to Grahame Walsh the similar handprint examples that he found at undisclosed locations in the Kimberley dated to the earliest Archaic, or pre-Bradshaw, and epoch, and are therefore—theoretically at least—quite definitely of Ice Age vintage. Supporting such an early dating, hand imprints of near-identical type, some in contexts very credibly datable as far back as 30000 BC, have been found all over the world—a breadth of distribution as yet far from satisfactorily explained.

Thus while Australian hand imprints dating to the Ice Age era have been found relatively nearby, in Australia's Northern Territory[8] and in Queensland,[9] other examples have been found in Borneo,[10] and also in the Pech Merle cave in the Quercy region of southern France, and in the Gargas cave in Spain.[11] Both of the latter locations have been firmly dated as inhabited well over 20000 years ago. Yet other examples have been found in their hundreds on the walls of prehistoric sites in Patagonia, Argentina.[12] Because

Examples of stencilled hand prints found right across the world. Some, though not all, examples can be firmly dated back to the Ice Age. The phenomenon of mutilated fingers, as in example H, is also found across the world

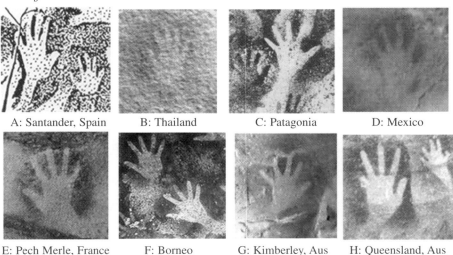

A: Santander, Spain B: Thailand C: Patagonia D: Mexico

E: Pech Merle, France F: Borneo G: Kimberley, Aus H: Queensland, Aus

such sites can include handprints of women and children as well as adult men, the general thinking is that they were a kind of signature, like an Ice Age visitors' book.

It is curious enough that this art form should be found so widely spread across the world and at such early dates. But a further oddity is that a small but significant proportion of examples exhibit missing thumbs or fingers, as if these were severed during some kind of ritual mutilation. And again examples recur right across the world, the practice continuing in some places until very recent times, as in the case of the long-isolated Dani tribe of Irian Jaya (now Papua), New Guinea, among whom women have traditionally suffered the amputation of one or two fingers to mark the death of a close relative.[13]

So are we just to dismiss it as a coincidence that such an unusual combination of customs—hand imprinting and finger mutilation—should have been practised at much the same very early time right across the world? Or might trans-global communications back in the Ice Age have been rather better than anyone has so far dared suppose? At the very least we are beginning to see that Australia can hardly have been quite the primitive back-water in Ice Age times that it is still widely assumed to have been.

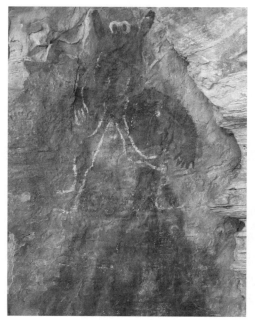

'Ulu' warning figure, of the kind that Australian Aborigines close to modern times used in sorcery, and as a warning to intruders not to trespass into their sacred sites

While we continued surveying the rock face soaring above and around us we noticed at a low level a crude human figure, delineated in white, against the red of the sandstone. This looked as if it was of relatively recent origination, and Lee confirmed it as a so-called 'Ulu figure' that Aboriginal people of the immediately pre-European contact era used when practising sorcery, principally with intent to harm an adversary.[14] A larger figure in red lay dimly visible beneath this, the white appearing to

have been for 'touching up' the older one's magic, and a little higher up there were a couple of faint 'stick' figures.

But the figure that Lee was proudest to point out to us, inaccessibly high and showing up frustratingly faintly at what would be the 'testicle' of a very phallic-looking rock spur, was our very first Bradshaw. Given the single figure's distance from us and the degree of weathering that it had suffered, Tassel Bradshaw was our best guesstimate of its classification within the Walsh scheme. But quite unmistakably it was a Bradshaw, with a barely discernible tall hat and propelling itself forward as if from a rocket-launcher, rather like a human cannonball. And equally unmistakably—as well as uncannily—it was in the identical 'floating' pose of the largest figure on the first-ever Bradshaw panel that Joseph Bradshaw himself had discovered over one hundred years before us. Yet that example lay a good 300 kilometres west of us, on the other side of the Kimberley. This made instantly obvious something that Walsh's 'disclose no locations' policy had hitherto served to conceal: that at whatever period the Bradshaws were created (and an Ice Age date still needed more confirmation), much the same iconography prevailed over a considerable geographical distance. This immediately suggested the Bradshaws as belonging to a culture that had existed at a time of widespread peace during which the same religion, the same cultural themes and the same high artistic standards could be spread and practised across an extensive region, possibly throughout several millennia.

As Judith resourcefully began tackling how best to photograph this so awkwardly located figure, this raised the question of how the original artist had managed to reach the rock to perform their artistry. Looking around us there was evidence of some

Lone Bradshaw 'floating' figure high up on a rock spur in the Kimberley's Deception Range. Iconographically the figure is of the same type as that on the panel found by Joseph Bradshaw on the banks of the Roe River 300 kilometres to the west—evidence that a standardised culture prevailed over a considerable distance

substantial rock fall. These caused Lee to suggest that an earlier configur-
ation of the rock may have provided rather greater accessibility than prevails
at the present day. But as I gazed out at the lower-lying area which the rock
platform overlooked, it also struck me how ideal this platform would have
been as a natural stage for religious and other ceremonial purposes. It posi-
tively shouted 'Sermon on the Mount'. Anyone with a strong voice and a
theatrical disposition would have made quite an impression upon an assembly
of humbler folk gathered below, with the paintings and the other historic
artwork as an absolutely superb backdrop.

In which regard, Lee confidently interpreted this particular Deception
Range site as one that would have been used, certainly by relatively recent
groups of Aboriginal people, for their 'increase' ceremonies. A central feature
of traditional Aboriginal religion, increase ceremonies were performed to
promote those natural species, such as edible plants, birds and animals, that
were regarded as vital for human existence. The ceremonies were held at
certain key locations where particular Dreamtime ancestral heroes were
believed to have left behind a vital essence which the appropriately conducted
rite could cause to rise up and work its fertility magic.[15]

So was our seminal 'floating' Bradshaw figure something of this kind?
Does this mean that there may have been a somewhat closer genetic connec-
tion between the Bradshaw people and later Australian Aboriginal people
than either Grahame Walsh or most living Aboriginal people normally
suppose?

Whatever the answer, already very apparent to me was that Grahame
Walsh's expectation that such paintings could somehow be studied without
proper reference to their locations was like expecting it to be possible to
write a dissertation on Venice without mentioning its canals. Intrinsic not
only to the culture of Australian Aboriginal people, but to the thinking of all
rock painting peoples, is the strongest sense of identity with, and affinity to,
the living landscape that lies around them. For them every major tree, every
strange-shaped rock outcrop, every waterhole might have as much signifi-
cance as our churches and cathedrals. This thinking has been expressed by
one recent writer, Howard Pedersen, working in partnership with Bunuba
elder Banjo Woorunmurra:

Land for Aboriginal people was economically vital in that it supplied food and resources for shelter, hunting equipment and a range of other tools. But it was the *religious significance* that was all consuming. *People, land, animals and the ancestral life were bound together in a spiritual web.* In this world, enriched and sustained by ceremonial business; land title-deeds were not transferable pieces of paper but immutable sacred songs, boards and rites.[16] [italics mine]

And in the case of this Deception Range area, in complete contradiction to Grahame Walsh's repeated insistence in his photo captions that one rock art location after another was 'unsuited for human habitation',[17] this had undoubtedly been an area that both Bradshaw and later peoples had visited and revisited over countless millennia. As Lee was particularly anxious to convey to me, bone dry, barren and empty though the site unquestionably looks today, millennia ago it was very different—a positive 'Garden of Eden'. The central, today rather jungle-like, area onto which the platform looked out would have had waving palms and a sparkling lake, all frequented by a natural larder of abundant bird and wildlife.

To illustrate this further Lee drove us a kilometre or so northwards to show us a second site which even in relatively recent Aboriginal times was noted for its eels, a huge specimen of which Aboriginal artists had delineated on its rock walls. These creatures, always a great delicacy for Aboriginal peoples, lived in a large billabong or lake area that is today all but invisible, but which early Australian peoples would have visited seasonally throughout countless millennia. At a third site there still survives—just—a grove of the beautiful fan palm, *Livistona eastonii*, which Lee insisted that we should keep in our mind's eye as the sort of verdant cladding that this east Kimberley landscape would have had back at the time of the Bradshaw people.

So far we had been in the Kimberley less than half a day. But already some faint glimpses of its so tantalising past were beginning to clarify and to come alive.

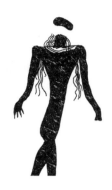

CHAPTER SIX
'Mother' and her 'dogs'

For those who manage to get to the Kimberley, the places of absolutely jaw-dropping beauty are the gorges, Australia's Grand Canyons. Rising from an arc of southerly ranges, the region's many rivers have cut spectacular channels in the ancient rock formations throughout millions of years. Undeniably one of the most 'touristy' of these gorges, because of its relatively easy access from Kununurra, is that of the Chamberlain River, which flows from the King Leopold Ranges northwards to the Cambridge Gulf and the Timor Sea. The gorge part of the river runs through the territory of the famous El Questro.

Until 1990 El Questro was a working cattle station of the kind that Joseph Bradshaw had dreamed of. Then, with the most commendable environmental sensitivity, Englishman Will Burrell, a 22-year-old former London city slicker, together with his very environment-minded Australian wife Celia began transforming it into a private wilderness park. While still producing some 5000 head of cattle annually, today the station offers every variety of visitor accommodation from five-star exclusivity at 'The Homestead' to fifteen dollars a night camping under the stars. Amongst the visitor facilities that the Burrells have introduced are silent, battery-powered

boats that can be hired to enjoy the scenery without the noise of their, or anyone else's, outboard motors. And it was one such a self-drive boat that Lee had arranged to enable us to view along the Chamberlain just some of the Bradshaw and other early paintings. As we would learn, some of these paintings Grahame Walsh had scattered in his book under the bald label 'Eastern Bradshaws', disclosing neither their location nor the surely pertinent information that they were in the environs of a major river.

As that afternoon, under a relentlessly cloudless sky, we glided effortlessly upstream, the empty landscape around us had a surreal, Dali-like quality much as if we were floating into a dream. At this late stage of the Dry season there were precious few signs even of wildlife. We were some 270 kilometres south of the most northerly part of the present Kimberley coastline, which climatologists know extended considerably further northwards during the Ice Age. As Lee remarked, the ruggedness of the surrounding terrain meant that the Bradshaw people must surely have made their way here by river, much as we were doing, except by their own paddle power. Some thirty minutes after the start of our journey, a long platform of rock came into view on the Chamberlain's eastern bank, and it was into this natural harbour that Lee nudged the boat's prow, cut its engine and tied up.

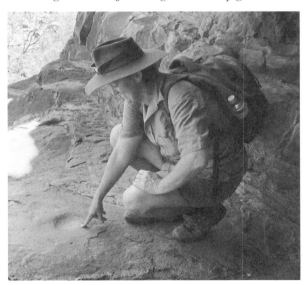

Lee pointing out the depression in the rock platform where countless generations of artists ground their pigments

We had strolled only a few paces southwards along this naturally 'paved' riverbank when it suddenly became obvious what we had come to see. Along the gorge's subtly rust-shaded sandstone cliff sides there was a cathedral-size area of rock that some age-old geological or river action

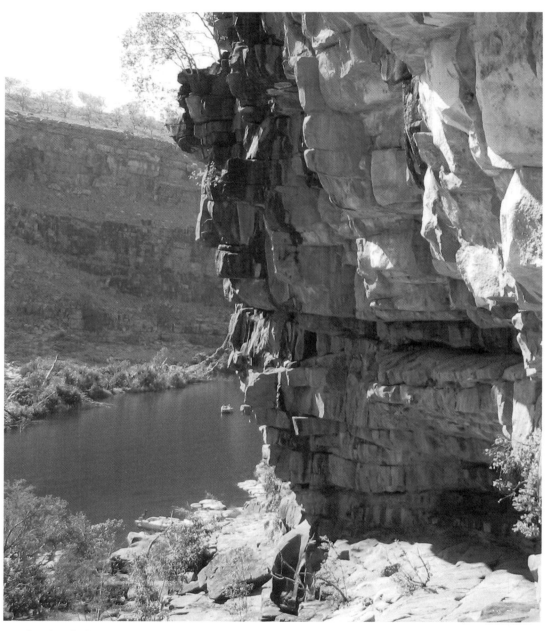

In the Chamberlain Gorge, this naturally 'paved' area of riverbank leads to the area with the rock paintings

had sculpted to form a huge overhang, soaring like the canopy of a vast opera house stage. Even from a distance there were tantalising glimpses of rock paintings, and at the foot of the canopy an uneven and narrow second rock platform, much higher than the one at riverside level, invited us to get closer to these.

Moments after we had none-too-elegantly scrambled our way up onto this second platform I almost stepped into a saucer-sized depression on the rock floor, only avoiding it on recognising its likely nature. As Lee immediately confirmed, this was one of the spots where countless generations of artists had ground their pigments for creating the very paintings that we were about to see. For a moment I thought rather wistfully of those lithe, brown-skinned artists—like myself as a practising life-painter, students of the human form—and silently asked their forgiveness for my belonging to an intruding, alien culture that had so traumatically changed their descendants' way of life forever.

Further along, painted onto the vertical face of the rock wall, we came upon our first Wandjina-style figures. Relatively crudely executed, and

At bottom left of the picture, a tiny figure of the Bradshaw variety, dwarfed by the cruder, more recent Wandjina figures at right

generally far less impressive than those discovered by George Grey, their presence nonetheless indicated that the quite definitely Aboriginal people responsible for them recognised this place as one of great spiritual power—even though it would seem to have been an altogether more important location for the Bradshaw people.

For here, at first almost unnoticed by us because of the deliberately dominating Wandjina figures, we came upon our second Bradshaw, again faint, yet nonetheless quite unmistakable because of its so distinctive long 'wizard' headdress and tassel waist attachments. Even more faintly, to this figure's right there were vestiges of some smaller figures, also of the Bradshaw type. According to one otherwise apocryphal story told by Aboriginal people about Bradshaw paintings, a little bird had made them by pecking the rock with its beak until it bled, then used its beak to paint the paintings with its blood.[1] And seeing the 'toucan's beak' shape of the head-dress on the main Bradshaw figure, and the figures' general small size, it was easy to understand how this story could have arisen.

As Lee had warned, these Chamberlain Bradshaws were artistically far from the best quality, Grahame Walsh likewise describing them as more 'basic' and with less ornament.[2] But now that I was able to get 'up close and personal' to these particular examples—in this instance, within easy touching distance—I was able to see for myself a feature that previously I had only read about. This was that whatever pigment the artists had used, it seemed to have become bonded into the rock surface much as Renaissance artist Michelangelo's famous frescoes had become part of the plaster of Rome's Sistine Chapel. It was as if the painting had been given some kind of laminate coating, which was one reason why it has always been so difficult to extract paint samples from Bradshaw paintings for radiocarbon dating purposes. And this also immediately set me pondering how the Bradshaw artists could have had such skill and such far-sightedness to choose painting methods and materials that would last for so many millennia.

Underlining this was an experiment that I recollected having been conducted during the late 1990s by archaeologists at the University of Bristol, England. Attempting to check on how western Europe's Stone Age artists had managed to create paintings of similarly enduring quality, the

Bristol University archaeologists had mixed red ochre and charcoal pigments with water, then daubed this mixture onto slabs of local sandstone and limestone. After their painting each slab's second side in the same way, they had then set these at an angle of 45 degrees against the courtyard wall, and left them exposed to England's rain, wind and occasional sun. Four months later they were able to report the washing away of 'almost all traces' of the daubing on the slabs' upper sides, while even the more protected undersides had become badly deteriorated, with some again 'completely disappeared'.[3] In the case of the Bradshaws, often little more than a relatively shallow rock overhang has served to protect the paintings from the Kimberley's annual round of scorching sun during the Dry and torrential rain during the Wet. Yet somehow these latter paintings have survived, albeit often faintly, arguably throughout many millennia of such punishment.

As yet there is no easy, ready-to-hand explanation for why this should be so. All that can be said is that in all likelihood the Bradshaw artists cleverly experimented with the natural gums and resins that they found in the plants around them to give their pigments the optimum impermeability and adhesion to the rock. As for the 'laminate coating', this may well have been purely fortuitous. Tiny wind-blown sand particles tend to accrete as a siliceous, glass-like coating on rocks during prolonged periods of intensely dry climatic conditions. If the Bradshaw paintings truly belong to the Ice Age, the Kimberley certainly underwent such a period not long after the Bradshaw artists would have created their artworks. As we will discover in a later chapter, these circumstances may not only have greatly aided the paintings' long preservation, they may also ultimately help determine their Ice Age dating.

But for us as we now precariously bottom-shuffled our way along a narrow ledge at this Chamberlain Gorge site there were more Bradshaw figures to be studied. Here we realised Grahame Walsh had undoubtedly bottom-shuffled his way before us, for I readily recognised these particular examples from his 2000 book.[4] They comprised two large figures with neither tassels nor sashes, and with elongated, flat-topped headdresses—quite different from the more usual Bradshaw 'wizard hat' we had seen further back—that were lying side by side horizontally. But in that book

The 'Great Mother' figure at the optically highest point of the Chamberlain Gorge canopy. Note how this superimposes more ancient hand stencils. Note also the row of animals at bottom left, following the direction of the 'Mother' figure's arm

Walsh had neither reproduced nor mentioned a third figure of much the same size, and which certainly looked as if it had been painted at the same time. This too was depicted as lying horizontally, but head-to-head with the first two. What did this strange arrangement signify? Lee pointed out that in Aboriginal art the depiction of any figure in horizontal mode usually signified death. But whereas Aboriginal sacred sites often include niches where dead bodies are buried, there was no indication of anything so funereal at this very open and so stage-like Chamberlain Gorge location.

More Bradshaw figures with the long falling-back hair that I rightly or wrongly interpreted as feminine could be seen painted some way further up on the rust-hued walls. There were also hints of numerous other such figures, though properly distinguishing what was human from nature's handiwork would have needed rope ladders and rather more time than we had available to us.

But readily visible yet higher up, and to me by far the most interesting of all these Chamberlain Gorge Bradshaws, was another figure of the long falling-back hair variety. This was significantly larger than the others, and obviously quite deliberately sited at what was optically the 'opera house' canopy's very highest point. Again Grahame Walsh had included this figure in his 2000 book,[5] though purely as an example of superimposition, the figure having been painted over some Archaic Epoch 'negative' handprint stencils of the kind I described in the previous chapter.

However, while this superimposition was important for indicating that the handprints in question genuinely dated from the earliest art phase, to me this very strategically sited figure deserved to be accorded much greater attention in its own right than Walsh had given it. For a particularly fascinating aspect was the way that its arms were splayed out at an angle from the sides of the body in the shape of the Roman capital letter 'A'. This was a gesture which, along with another 'elbows bent' variant, I was already long familiar with as denoting the 'Great Earth Mother', the ancient, all-powerful female fertility deity who went under a bewildering variety of names.[6] Way back in the darkest mists of Old World prehistory she was *the* primaeval, universal Supreme Being until overthrown by upstart male supremos such as the Jewish 'Yahweh' and the Greek Zeus. The A-line pose of the arms mimicked the basic shape of a fir tree, it being commonly a tree (one spin-off of which survives as the traditional May Day maypole) with which the universal Mother was directly identified.[7] Lithuanian-born scholar Marija Gimbutas, who died in 1994, devoted her life's work to tracing the cult of this same Supreme Female across the widest swathe of Europe, North Africa and Asia.[8]

Minoan statuette associated with the ancient cult of the 'Great Mother', showing the identical 'A' pose of the arms

While it seemed very far-fetched to suppose that this same Great Earth Mother's cult could somehow have stretched all the way to Australia, even so I could not help being aware of another deep-rooted aspect of this particular cult—that she was perceived as a 'Mistress of the Animals'. Arguably this perception had its roots in the ancient role of female shamans and witchdoctors in domesticating animals, for artists' depictions of the Great Mother frequently showed her exercising authority over serpents, over lions and over all manner of other creatures great and small. In much the same context I could scarcely avoid noticing that extending on directly from the line of this Chamberlain

Gorge figure's arms was a line of four-legged animals. These were every bit as intriguing as the stylistically related line of 'reindeer' that we would shortly encounter some 280 kilometres further west at Reindeer Rock.

To give Grahame Walsh due credit, he too had noticed this same line of animals. In his 2000 book, even though he cropped the overall scene to show just one, he remarked:

> [They] are from a much more recent culture. They appear to be dingoes, suggesting they have been painted within the last 4000 years.[9]

Now if the creatures really are dingoes, such a late dating is the only available verdict because it has become increasingly firmly recognised that the dingo arrived surprisingly late into Australia, the latest DNA findings suggesting at around 3000 BC.[10] The general supposition is that either a single pregnant female or a small pack of the animals were brought over from Asia by the same last wave of pre-European immigrants who introduced the leaf-shaped stone spear.

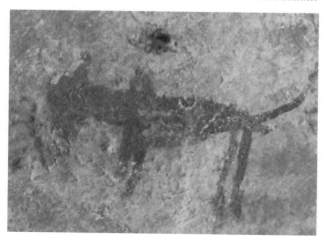

One of the animals seen in a line descending from the Great Mother's arms on the Chamberlain Gorge ceiling. Grahame Walsh supposed them to be dingoes, but the feature below the tail suggests the now extinct thylacine, popularly known as the Tasmanian tiger, in which the penis projected backwards in this manner

But from the general coloration and worn condition of the 'dingoes' that are depicted on the Chamberlain Gorge canopy, these looked for all the world as if they had been painted at essentially the same time as the Great Mother figure and belonged to the same scene. Inevitably, this raises the question of whether Walsh was right to identify them as dingoes. Might they represent some similar four-legged dog-like creature that had preceded the dingo on the Australian continent?

Right there and then at the Chamberlain Gorge, Lee's unhesitating opinion was that we were looking not at a line of dingoes but of thylacines or 'Tasmanian tigers', a now extinct species of striped, dog-like marsupial.[11] Long indigenous to the Australian continent, thylacines were wiped out on the Australian mainland very soon after the dingo's arrival, almost certainly ruthlessly exterminated by the latter. And we might have had little clear idea of what they looked like but for their substantially lengthier survival on Tasmania, Australia's southernmost major island which became separated from the Australian mainland shortly after the end of the Ice Age, and which dingoes never reached.

Sadly, it took only a little over a century of European settlement on Tasmania for the Tasmanian thylacine to be hunted to extinction, the last known specimen dying ignominiously in squalid conditions at a then run-down and bankrupt Hobart Zoo in 1936.[12] But the species had nonetheless lasted sufficiently long to be recorded in a few now precious photographs

Rare photograph of one of the last thylacines. Although the species died out on the Australian mainland some 5000 years ago, a remnant population survived on Tasmania, only to be exterminated like vermin on the arrival of Europeans

and to be studied by zoologists, from which data there is much to recommend the correctness of Lee's interpretation.

For besides the thylacine having had four legs, a long, stiff tail and a kangaroo-like face, all readily discernible in those painted on the Chamberlain Gorge ceiling, the male of the species' most characteristic feature—indeed, positively signatory of its marsupial status—was the siting of its penis posterior to the scrotum, pointing backwards where it projected beneath the tail. And the Chamberlain Gorge examples unmistakably depict just such a feature, on the strength of which interpretation alone they have to date before the Australian mainland extinction of the thylacine, thereby being definitely in excess of, rather than less than, 4000 years old.

This point being at least provisionally established, another odd and intriguing feature of the Chamberlain Gorge's painted thylacines is what looks like a box being carried at the neck end of their backs—almost as if they had been fitted with mini-backpacks. Is it possible that the Bradshaw people might have domesticated the thylacine, in the manner of the later worldwide domestication of dogs? In support of this seemingly fanciful possibility, nineteenth-century botanist and Royal Society fellow Ronald

Painted on a separate rock at the Chamberlain Gorge site, what appears to be another depiction of a thylacine with some kind of attachment to its shoulders. This has a very close parallel in the example from the Northern Territory seen on page 77

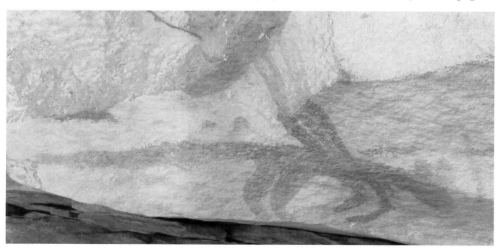

Campbell Gunn certainly claimed to have tamed no less than three thylacines, remarking, 'It seems far from a vicious animal, and the name Tiger or Hyaena gives a most unjust idea of its fierceness.'[13]

Fanciful though this again might seem, on a quite separate boulder at this same Chamberlain Gorge we found a Bradshaw-style painting of a single four-legged creature that was yet more readily identifiable as a thylacine than those in the line on the canopy ceiling (see page 76). This too had some kind of attachment at its shoulders, one which still only fully made sense when seen side by side with another clearer example (see below) found over 400 kilometres further to the east, at the Landa prehistoric rock painting site in the Northern Territory. In the case of this latter painting, Northern Territory museum curator George Chaloupka has unhesitatingly identified the creature as a thylacine.[14] And the neck attachment he equally unhesitatingly identified as a 'dilly bag', that is, the sort of receptacle that hunter-gatherer peoples carried for collecting edible and other useful items that they might find in the course of a day's foraging. So could a cute, backpack-carrying thylacine have been domesticated by the Bradshaw people as their era's equivalent of the modern-day supermarket shopping trolley?

At Landa in the Northern Territory, some 400 kilometres from the Chamberlain Gorge, there is an ancient rock painting of a creature unhesitatingly identified as a thylacine by George Chaloupka

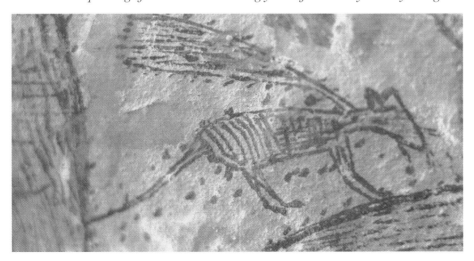

Whatever the true identification of the Chamberlain Gorge figure and its line of four-legged animals, that September afternoon we had been in the Kimberley less than 24 hours, yet we had already seen the enormous value of our viewing such paintings in their geographical setting. After taking advantage of the El Questro station's proximity, sampling (and enjoying) its evening meal and accommodation facilities, the next morning we headed on due westwards. For many kilometres we travelled just south of the Cockburn Range, an imposing escarpment that the redoubtable Captain Philip Parker King had sketched from the deck of his survey vessel *Mermaid* in 1819.[15] Six hundred metres above the surrounding plains, this sandstone and shale escarpment actually comprises two linked, steep-sided plateaux that forcibly reminded me of a Conan Doyle 'Lost World'. As Lee drove, she remarked that the Cockburn Range's inner terrain contains a significant number of Bradshaw paintings, which she was able to gauge from a preliminary expedition in 1988. However, the only practical access to it is on foot, demanding mountaineering skills and a long and arduous expedition all to itself.

As the Cockburn Range's western slopes trailed gently from our view, we skirted the vast salt-flat flood plain of the Cambridge Gulf, an arm of the Timor Sea which as recently as 8000 years ago had been a freshwater lake, only to fall victim to post-Ice Age rising sea levels. One of the bigger rivers running into this gulf is the Pentecost, and because this lacks any bridge, all vehicles have to ford its considerable breadth as best they can at Bluey O'Malley's Crossing, which we now approached. During the Wet season the water levels are often too high and strong even for the best-equipped four-wheel drive vehicles, but at this late stage of the Dry, Lee negotiated it with ease, at the same time strongly advising against our alighting halfway to take photographs. As is the case along most of the Kimberley's coastline and its larger waterways, this stretch of the Pentecost, and indeed the entire length of the river northwards, is a haunt of huge, estuarine 'salties' or saltwater crocodiles,[16] the world's largest living reptile and living relics of the era of the dinosaurs. Australian media report with painful frequency horror stories of fatal and near-fatal attacks by these monsters, which can reach 6 metres long, weigh up to a tonne, and strike with formidable speed and force. Even in the upper reaches of the river, freshwater crocodiles[17] take over whatever

territories the 'salties' leave them, though the 'freshies' are neither so large nor so fearsome as their estuarine cousins.

On eventually reaching the junction of the Gibb River and Kalumburu roads, we headed northwards on this latter, and had travelled only a short distance when Lee detoured off-road to take us to a striking-looking rock outcrop. This, she explained, did not have any Bradshaw paintings, but she wanted to show us an example of the sort of cultural vandalism to which all the Kimberley's rock art is currently prone. As we approached the rock outcrop we saw that it had been painted with Wandjinas, but ones of such execrable crudeness that the work could only have been carried out very recently, by total amateurs, using modern, artificial materials.

As Lee explained, the root problem lies in a quite different philosophy that pertains to traditional Aboriginal art compared to what we expect in our so-called 'western civilisation'. In the case of the latter it would be unthinkable for anyone to walk into London's National Gallery or New York's Metropolitan, get out a box of paints and begin touching up a Leonardo da Vinci or a Rembrandt. But in the case of the Kimberley's Aboriginal people, whenever a Wandjina painting began to show some ill effects from time and from its exposure to the elements, then it was positively expected that suitably trained and initiated individuals would repaint the figure to maintain its freshness and potency. Those individuals would belong to the tribes who were descended from the Wandjina—principally the Ngarinyin, Worrora and Wunambal. It was equally understood that these people would be ultra-careful to use only traditional painting materials, and to follow the strict guidelines for form and colour prescribed by their artistic forebears.

But now that Aboriginal people are mostly gathered in small modern townships, the Wandjinas are, inevitably, falling into a greater disrepair than at any time before in their entire history. As a result, in 1987 the Australian federal government awarded a $108 000 grant for retouching work to be carried out on certain of the more badly eroded examples. While the spirit behind the grant was well-meaning enough, in practice its implementation became deputed to certain bureaucrats who simply recruited a group of seven unemployed Aboriginal youths from the south-western Kimberley town of Derby (outside the sphere of the Wandjinas' traditional descendants), gave

them a supply of brushes and tins of Dulux paint, and told them to go off and get the job done. There was not the slightest consultation with those people who had at least some true claim to being the Wandjinas' traditional guardians.

All too predictably, the result was catastrophic. In the words of art specialists Judith Ryan and Kim Akerman:

> Instead of being conserved through re-touching, the original images were painted over and replaced with new, acculturated versions. Eight special places were irrevocably spoilt, for seemingly altruistic motives.[18]

And the outrage was felt well beyond the circles of white academics. Aboriginal elder Billy King—whom we noted earlier to have offered much support to Grahame Walsh in the course of his researches—was so incensed that he very solemnly pronounced that the seven youths responsible for this sacrilege would all die. According to Lee's Aboriginal associate Ju Ju Wilson, every one of those young men who had carried out the repainting work is indeed now dead. For anyone who has developed even a little awareness of the traditional Aboriginal psyche, stories of this kind are not to be taken lightly.

But such ill-controlled repainting was far from the sole cause for concern. As we resumed our journey northwards in the direction of Kalumburu, suddenly the normal hot, dry freshness of the Kimberley air began turning acrid. A grey haze fogged the relentless blue of the sky. Acre after acre of the trees that we were passing could be seen to be all too obviously blackened by fires that could only have happened within the last months, or even days. Then we came to trees that were still ablaze. During the long months of the Dry it is inevitable that some of the Kimberley's tinder-dry vegetation will be kindled by lightning strikes. But as Lee pointed out to us, this was not the season for such storm activity. These fires were the result of human activity—and whoever had been lighting them had been doing so along this road not many hours ahead of us.

Again the problem has its roots in another time-honoured facet of the Aboriginal way of life, one that was undeniably good and laudable back in its day—except that that day has long gone. For it is an undoubted fact that Aboriginal people, not only in the Kimberley but all around the Australian

Thoughtless destruction of the Kimberley's fragile ecosystems. A deliberately lit bushfire blazing uncontrolled along the road to Kalumburu

continent, have *always* used fire as a method of controlling excessive vegetation growth in the landscape around them. Core samples have been taken from ancient sediments that have been collected at several different points all around Australia, showing that rainforest blanketed much of the continent undisturbed until a period around 60 000 years ago[19] when, in the words of South Australian Museum director Tim Flannery:

> Suddenly the number of microscopic charcoal fragments present in the sediment increases rapidly. At the same time almost all fire-sensitive species . . . abruptly vanish and are replaced with fire-promoting plants such as eucalypts. This abrupt change is unique in the 700 000 year-old history of the deposit and does not correspond to a change in climate.[20]

The strong inference is that this widespread burning should be attributed to the arrival of the first human beings in Australia, the date neatly coinciding

with other indications of this event's timing from archaeology and from DNA sequencing. And certainly, from when the very first European explorers began reaching Australia, burning of the landscape was virtually the first Aboriginal activity that they noticed.

Thus in 1623 Jan Carstensz, the Dutch navigator who named Arnhem Land, reported that smoke from Aboriginal burning made it difficult to distinguish the northern Australian coastline. In the late eighteenth century Captain James Cook, watching Aboriginal burning as *Endeavour* cruised Australia's eastern coastline, described what he was seeing as 'This continent of smoke'. Nineteenth-century Australian explorer Ernest Giles, the first westerner to discover rock art in the deserts of central Australia, remarked:

> The natives were about, burning, burning, ever burning; one would think they were of the fabled salamander race, and lived on fire instead of water.[21]

Exactly as in the case of the repainting of the Wandjina, there was in fact a very strong logic behind this practice. As the early nineteenth-century pioneering explorer Thomas Mitchell expressed it:

> Fire, grass and kangaroos, and human inhabitants, seem all dependent on each other for existence in Australia; for any one of these being wanting, the others could no longer continue. Fire is necessary to burn the grass, and form those open forests, in which we find the large forest kangaroo; the native applies that fire to the grass at certain seasons, in order that a young green crop may subsequently spring up, and so attract and enable him to kill or take the kangaroo with nets . . . But for this simple process, the Australian woods had probably contained as thick a jungle as those of New Zealand or America.[22]

Early European settlers, on stopping Aboriginal people in their burning activity, soon found their cattle becoming lost in the dense brush that quickly formed where previously there had been pleasant open woodland. One early nineteenth-century colonist, Lieutenant Henry Bunbury, readily admitted that local westerner pastoralists simply could not 'burn with the same judgement and good effect'[23] as Aboriginal people. Modern-day archaeologist Rhys

Jones has accredited Aboriginal people as having formulated a properly thought-out farming method, which he has called 'fire-stick farming'.[24] Also very apparent is that specifically to avoid their fires damaging their sacred rock paintings, in the past Aboriginal people were very careful not to allow vegetation that might get caught up in such blazes to grow too close to the paintings. Over many thousands of years they thereby ensured the survival even of those paintings, such as the Bradshaws, with which they did not feel a cultural affinity wherever these lay painted alongside their own, such as the Wandjina.

But today, with so many Aboriginal people now living in towns, those wise old 'caretakers' of the rock paintings are gone. The bushfires that blight the landscape for the visitor all along the Kalumburu Road are being lit by bored youths who no longer have direct sustenance needs from, or any proper feeling of responsibility for, the beautiful, ancient land that their ancestors cherished so deeply. The once sparkling creeks and waterholes are becoming choked with fire debris. The Kimberley's traditional most beautiful and most worthwhile trees simply cannot take the so oft-repeated fire assaults, and are already ceding to scrub that within decades can only give way in its turn to desert. And everywhere in the midst of all this same so vast, so fragile, so impossible-to-police landscape, there lie thousands of defenceless Bradshaws, priceless artworks arguably in greater danger than they have ever been since the days of the Ice Age.

It was impossible for me not to see in a quite new light the brushwood camp fire that Lee quickly had merrily burning for us that evening. For on our reaching a camping area where a rough track leads off from the Kalumburu Road towards the Mitchell Falls, we pitched our dome tents, set up a table and chairs, and on the banks of yet another of the Kimberley's rivers, the King Edward, enjoyed a delicious cooked meal that was a very far cry from Walshian tinned tuna. As Lee pointed out, the dearth of information concerning the locations of the Bradshaw paintings was cloaking, and diverting attention from, the true and greatest danger that they face in our time.

Suddenly this seemingly so innocent rock art detective trail upon which we had embarked was turning out to carry rather weightier responsibilities than we had anticipated.

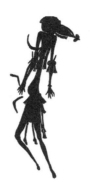

CHAPTER SEVEN
'Breadbaskets' and puppets

As we breakfasted by the King Edward River early morning on Friday 17 September, I reflected that we had now been 48 hours in the Kimberley. We had already reached its heart, yet the Bradshaws that we had seen so far were few in number and far from the finest quality. And it was not as if there were no examples along our previous afternoon's fire-blackened route northwards up the Kalumburu Road. Towards its northern end the road runs parallel with, albeit some 40 kilometres west of, another of the Kimberley's great south-to-north running rivers, the Drysdale, which is known from non-Walshian sources to have some high-quality Bradshaws in its environs. The intervening land belongs to the Doongan cattle station, whose entrance we had passed, where Lee was confident, from the general gossip passing between Kimberley tour operators, that Grahame Walsh had found many of the superb quality paintings he had published in his books. And before arriving at our camping ground we had also skirted the south-western borders of Theda station, where I knew from old Internet-published tour group reports that there was an exceptionally fine, and particularly fascinating, Tassel Bradshaw.

This was a panel painting that Grahame Walsh had published in both his books.[1] Painted in a deep mulberry hue—found repeatedly associated

with Bradshaws of the finest artistry—it consists of nine figures, each around half life-size, each with tassels dangling from the waist and scarf-like nets hanging from the neck, standing in an irregular line. Each figure faces left, its legs slightly splayed from the knees downwards, its left arm limp at the side, its right arm raised above the head and bent back over the raised forehead. This arm gesture is one that in some Old World art—most notably that of Minoan Crete—denotes worship of a deity. Artistically the figures' long limbs and their slim bodies are superbly modelled. Each has long hair trailing down the back, gathered up in a pompom at the ends. This is the hair-style that—particularly when it is associated, as here, with legs splayed out below the knees—I rightly or wrongly interpret as feminine.

The prevailing impression created by the panel is that it represents some kind of ritualistic dance, causing me to label it, purely for my own reference purposes, the 'Nine Dancers'. But this same thinking also aroused the specu-lation that it might have formed the backdrop to a ceremonial area in which nine live dancers performed just such a dance. At the back of my mind was

The 'panel of nine dancing Tassel Bradshaw' figures located on the land of the Theda cattle station, closed to all outside visitors since 2002

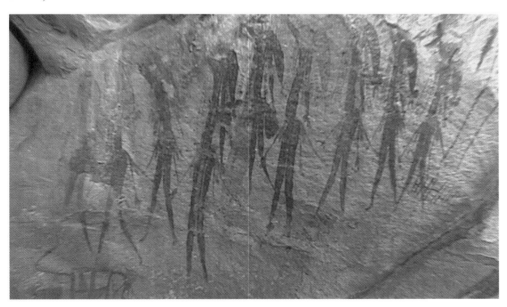

the knowledge that on the Indonesian island of Java, north-west across the Timor Sea from the Kimberley, there is performed to this day a dance by nine identically dressed female dancers honouring the great 'Goddess of the South Seas', Loro Kidul.[2] The dancers' costumes are traditionally decorated with a net pattern. The origins of this dance—and the very widespread cult of the powerful, multi-faceted goddess for whom it is performed[3]—stretch deep back into the mists of South-East Asian prehistory. They are way, way older than the waves of Hinduism, Buddhism and most recently Islam that have since successively gained their holds on the Indonesian islands during the last three or four thousand years.

Inevitably it was essential to see this 'Nine Dancers' painting at first hand in the environmental setting for which it had been created, with the added annoyance that Grahame Walsh (for whom the figures are in any case male) had provided no helpful information about that setting. And the problem, as earlier noted, was that the Theda station where it is located had, along with the neighbouring Doongan, been acquired by Walsh's wealthy patrons Maria and Allan Myers. This acquisition had blocked the only road access to those Bradshaws located in the otherwise publicly owned Drysdale River National Park, the latest published touring map of the Kimberley all too dismally noting: 'Theda Station ... is no longer providing facilities for visitors and access to Drysdale River National Park is not permitted.'[4]

Accordingly, six weeks before we left Brisbane for the Kimberley, having established from Lee that we would pass Theda's doorstep, I thought it worthwhile writing to Maria Myers to ask her if she might allow us to visit, even for as little as an hour, the 'Nine Dancers'[5] art site, knowing it to be located on her property. I stressed to her my having some particularly compelling research reasons for making this request. However, after a delay of two weeks the response came back:

Dear Mr Wilson
I regret not being able to accommodate your wish to see the Bradshaw panel depicted on page 371 of Grahame's book as your bona fides are particularly creditable and a field I especially admire. With best wishes, Maria Myers[6]

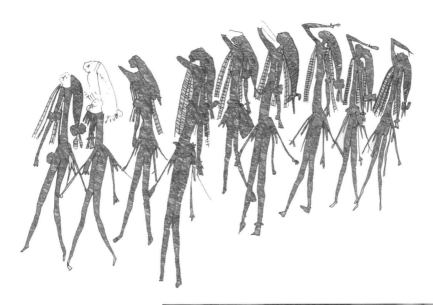

Above: an interpretative drawing of the nine dancing figures panel on Theda. In Grahame Walsh's view, these figures are all males. If, however, they are females, then quite possibly highly relevant is the ancient dance of nine maidens, peformed on the Indonesian island of Java, in honour of the 'Goddess of the South Seas', Loro Kidul. Seen at right are two early photographs of performances of this dance, sometimes referred to as the Bedoyo Ketawang. Note that in both photographs the dancers are performing in costumes decorated with a distinctive net pattern. Note also the great similarity of the hairstyles of the dancers in the upper picture to those Bradshaw figures interpreted here as possibly feminine

Mildly encouraged that she had turned me down with at least tepid warmth I immediately tried a second, stronger and more directly personal appeal. Quoting from her own widely publicised self-proclaimed reasons for her interest in the Bradshaws,[7] I pointed out that if she upheld her refusal she surely needed to explain why she was actually blocking serious research on those very same questions to which she said she wanted to know the answers. This time her response was swift:

> Dear Ian the only way to protect Kimberley rock art is to keep the where-abouts unknown. The availability of handheld GPS and the presence of tour operators we have learnt leads to unauthorised visits. Sincerely, Maria[8]

Despite a final, last-ditch plea from me, assuring her of my shared concern for the Kimberley rock art's protection—and even offering her full power of veto over anything that I might write about the Theda panel—the correspondence terminated in silence from her end. So in our modest fact-finding expedition we were therefore obliged to manage as best we could from those paintings of the highest quality that remained accessible. And those that we were about to see this morning, which certainly promised to be of the highest quality, were not on any white station-lessees' lands, but in the ancestral territory of the Wandjina-venerating Wunambal people.

After breaking camp and reloading the Toyota for the rough track leading onwards towards the Mitchell Falls, we did not have far to drive. Within two kilometres from where we had camped there came into view, just to the track's north, a jumble of typical Kimberley low sandstone outcrops readily recognis-able as of the kind commonly chosen by the Bradshaw people for their rock paintings. This particular site was hardly a secret one. The Wunambal people call it Munurru, freely describe it as an 'art site',[9] and are happy to publish photographs of their Wandjina paintings that are located in its environs. The Australian archaeologist Ian Crawford published images from this site, includ-ing Bradshaws, complete with location information, as long ago as 1977.[10]

As we clambered out of the Toyota and quickly gathered up photo-graphic and survival gear, the ever sharp-eyed Lee pointed out to us some

brolgas, large, long-legged grey birds of the crane family, that were wading about a hundred metres away amidst an idyllic setting of screw palms[11] and other exotic-looking vegetation. Called *Warnmarri* by Aboriginal people, brolgas frequent the wetlands right across northern Australia and have a spectacular courtship dance during which they bow and bob and stretch their long necks back and forth with the greatest style and elegance. The King Edward River that Munurru adjoins is another of the Kimberley's great south-to-north flowing river systems, and as Lee pointed out its relatively flat surrounds in this locality get positively swampy in the Wet, surviving even well into the Dry. This pattern would have been all the more marked during earlier millennia. Like the more eastern Deception Range site that we had visited two days earlier, Munurru would have resembled an Eden-like oasis, providing a well-stocked ready-to-hand larder for small-game hunters, even for those armed with the most modest-sized of boomerangs.

With Lee striding confidently before us, we wove our way amidst a bewildering maze of outcrops until arriving at a section where an east-facing, smooth-surfaced and very vertical rock wall, protected by a wide overhang, stood before a flat area of open space. On this rock wall, though long faded from exposure to morning sunshine, had been painted some impressively large Bradshaw figures (see overleaf) that I quickly recognised from Walsh's books.[12] They were in the same mulberry colour that had been used for Theda's 'Nine Dancers', and executed with much the same very high standard of artistry. Sadly, it was impossible any longer to distinguish the entire scene, parts having been badly abraded by what looked to have been deliberate pounding. This, and direct, intensely strong sunshine, set Judith the most daunting of tasks trying to get the best possible photographic record. But despite such difficulties, one half life-size figure in particular was discernible enough to be both impressive and highly instructive.

Dress-wise the figure was of the variety Grahame Walsh has dubbed Sash Bradshaw, in this instance definitely arrayed in best 'special occasion' finery, with armlets at the elbows and Mercury-like[13] 'wings' at the ankles. At the back, dangling from the waist could be seen what is either an elaborate multi-pointed sash or a bunch or muff[14] at the ends of the arms. The upper hand was holding a small, matching pair of boomerangs. Of these so

The east-facing 'Bagman' panel at Munurru, with its beautifully delineated Sash Bradshaw figures. By far the most striking is the figure at furthest right, seen with his head stretched awkwardly back, yet arms flung forward. In his hands he is carrying paired, crescent-shaped boomerangs and a dilly bag. Note also the very large bag or basket-like contraption that is being carried from waist height, further supported by straps from the shoulders. Other figures in this same scene also seem to have similar large bags or baskets. An interpretative drawing of the panel is at right

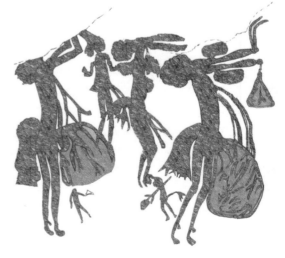

Aboriginal instruments, also frequently depicted in paintings of the Tassel and Sash Bradshaw type, this delicately crescent-shaped pair was much the best representation that we had yet come across. They reminded me that tracing the ancestry of the boomerang as far back as possible surely had an important bearing on the quest that we were embarked on. The figure's lower hand was holding a dilly bag, the hunter-gatherer collecting bag of the kind that only the previous day we had seen associated with the Chamberlain Gorge thylacines.

In common with the artistry of so many other Bradshaws, this particular figure was represented in the midst of lively and beautifully observed, if still enigmatic, action. The upper part of the body could be seen to be leaning slightly backwards, with the head most awkwardly tilted 90 degrees back, yet with the arms extended forwards in exactly the opposite direction. From the painting's poor condition it was almost impossible to tell whether the face was front-facing or seen in profile, but whichever was the case the hairstyle seemed to be frizzed,[15] rather than of either the 'wizard hat' variety that I associated with Tassel and Sash Bradshaw males or the 'long hair swept back' variety that I associated with females. As in the case of the Theda 'Nine Dancers' painting, the impression was that the individual was caught up in some particularly joyous dance, conceivably perhaps even imitating that of the brolgas.

The figure's most striking feature, however, was a huge, bag-like contraption that he[16] carried at the front of his body and which ballooned out to well below his knees. 'Dancing Balloon' happens to be the iconographic label that Walsh has applied to this particular painting, while declining to offer any detailed suggestion for what the 'balloon' might actually represent.[17] The pity also is that Walsh has further omitted to reproduce, or even to mention, the several rather poorer condition figures that exist to this same panel's left, figures that the artist[18] certainly seems to have intended as part of the same overall scene. Walsh thereby robbed his readers of any awareness that at least two of these figures are similarly sporting large 'balloons' (or as I would much prefer to call them, large bags or baskets), strongly suggesting that these objects must have held some considerable significance for the Bradshaw people.

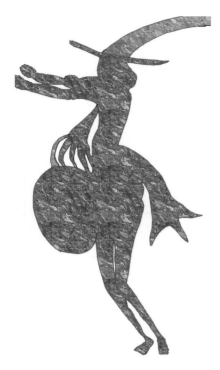

Interpretative drawing of an unlocated Sash Bradshaw photographed by Walsh. This clearly indicates that the large bags or baskets were supported by some strap-like arrangement

Pointedly indicating that the bag-like objects quite definitely weighed much more than any 'balloons' was the fact that the one carried by the main figure was not being supported only from his waistband, as indicated by Walsh's interpretative drawing.[19] Rather, it was additionally supported by straps attached to the figure's shoulders, which Walsh omitted to show in his drawing.[20]

Accordingly if, as seems likely, Walsh's 'balloon' actually comprises a large bag or basket containing something heavy, what evidence do we have that 'primitive' early Australians were ever capable of manufacturing such large-scale containers? Thankfully this presents absolutely no problem. At the time of the first Europeans' arrival in Australia the purportedly 'savage'[21] Aboriginal people living in the continent's north, also on Tasmania, were making excellently crafted bags and baskets from leaves of the screw palm, stands of which, it will be recalled, we had noted when observing the brolgas, at our approach to this very Munurru site. The procedure for making the bags was to gather fronds of the palm while these were still green, use fingernails to extract and split the centre strip, and from this strip form a length of fibre which they would gather into bunches. After the maker had dried these fibres in the sun they would either dye them or leave them in their natural colour, then twine them into bags or baskets in the traditional warp-weft manner that is the basis of all true weaving.[22] They were even very capable of making the twining loose or tight according to their requirements.

From museum specimens of such bags and baskets as woven by relatively modern era Aboriginal people,[23] it is possible to see that their appearance readily corresponds with those being carried by Munurru's

Bradshaw 'Bagman', the main figure's bag even being hatched in the semblance of a weave. This suggests that if the Bradshaw paintings really do date back to the Ice Age, Aboriginal Australians' bag or basket-making skills can claim a particularly long lineage. And such a lineage is perfectly credible, as more and more indications of basic weaving/basketry skills that date back into the Ice Age have recently been coming to light internationally, quite independently of more localised Australian considerations. For example, US-based archaeologists Olga Soffer and Elizabeth Barber have uncovered compelling evidence of garments on certain female figurines from the European Ice Age. Soffer in particular, on her re-examining some pieces of fired clay unearthed at the Pavlov I Ice Age site in the former Czechoslovakia, has discovered negative impressions unmistakably made by some kind of textile or basketry dating as far back as 26 000 years ago.[24]

Aboriginal basket acquired in Bowen, Queensland, by nineteenth-century German naturalist Amelie Dietrich, and now in a museum in Leipzig, Germany. Such baskets were often crafted from fibres of the Pandanus spiralis, *or screw palm, specimens of which grow in the vicinity of Munurru*

All of this gives rise to the next question—if the Bradshaw people manufactured large bags or baskets, what might they have wanted to carry in these to justify the special attention, and the attendant ceremonial status, that would appear to have been accorded to them in this and in other related paintings? Here, while a substantial degree of guesswork is unavoidable, one certainty is that at least as early as 13 000 years ago Australia's inhabitants had developed ways of preparing certain plants for human consumption, the processing of which involved the use of large bags or baskets.

One of the plants processed in this manner was the cycad, the plant responsible for Grahame Walsh's Carnarvon Gorge 'zamia' nuts, and in the Kimberley found in two varieties, one adapted to the soils overlying

sandstone,[25] the other to the slightly lusher soils overlying basalt.[26] Amongst the world's most ancient living plants,[27] cycads characteristically have large cones bristling with long, hard-shelled nuts. When fresh the nut kernels are full of starch that offers an excellent, nourishing source of carbo-hydrate—the downside being that they are also deadly poisonous and carcinogenic on reaching the intestine and interacting with its bacteria, bringing about cancer[28] and near immediate liver failure.

However, also quite certain is that surprisingly far back in Australia's past, Australian Aboriginal peoples had developed ways of eliminating cycad toxins, ways that involved the use of bags. Their procedure was to slice or to crush the cycad kernels, place them in a lightly meshed bag immersed in running water, and then leave them thus leaching for up to a week, the water-soluble toxins and the carcinogens becoming safely washed out by this process. After drying, the kernels would then be ground into a paste, wrapped in paperbark, and baked as cycad 'bread'.

That this practice dates as far back as the Ice Age has been positively confirmed by the Australian archaeologist Moya Smith. Excavating in the early 1980s at a rock shelter near Esperance on Western Australia's southern coast, Smith came across the remains of a cycad nut processing pit that could be reliably dated to at least 13 000 years ago.[29] As evidence of the subsequent long-term continuity of the practice, George Grey, the first European discov-erer of Wandjina paintings, found an identical pit still in use during his 1837 expedition.[30] To this day in Arnhem Land, to the Kimberley's east, specially constructed sieve-type bags are made from pandanus fronds specifically for the sluicing of cycad palm kernels.[31]

Given the detoxification and 'bread'-making procedure's antiquity and its life-sustaining qualities we might expect to find a lot of 'magic' and ceremony associated with it back in the prehistoric past, and even relatively recently. In this regard, it is anthropologically certain that over thousands of years the serving up of this 'bread' was celebrated at special ceremonies, attended by large gatherings of people, that were held far across Australia, from Arnhem Land to the Carnarvon Range of central Queensland. So back in the Ice Age did the 'Bradshaw' elders at their cycad 'harvesting' ceremonies celebrate with a special brolga-like dance, during which they gyrated, fitted up with 'bread-

baskets' loaded with the magically detoxified 'bread', before the contents of these baskets were then distributed to all present?

It seems worthwhile to suggest at least some such constructive inter-pretation for this Munurru 'Bagman' painting. But it is also not the only possible explanation. For again dating back to very ancient times there was another similarly staple Kimberley food source, the processing of which again involved the use of bags. This food source was the yam, the western Pacific's equivalent of the potato, except that it had—and still has among some peoples—rather more of a cult status. For just like cycad nuts, round yams[32] are highly poisonous when they are left unprocessed. Aborigines call them 'cheeky' yams for this very reason, a lesson that one of Joseph Bradshaw's aides, Hugh Young, learned the hard way. As related by Bradshaw's cousin Aeneas Gunn:

> Mr. Young . . . on one occasion . . . had unearthed some yams that bore a strong resemblance to common potatoes, and when served up, looked as innocuous . . . [He] had only swallowed one mouthful with evident relish when he exhibited all the symptoms of aggravated poisoning and had I not been by to administer emetics, I might have lost a valued mate . . . [33]

Exactly as in the case of cycads, when the first Europeans arrived in Australia they found that Aboriginal people right across the continent had an already long-established method of eliminating the yam's poisonous proper-ties, and that this involved the use of bags. Donald Thomson, who most admirably photographically documented Arnhem Land Aboriginal people around the middle of the last century, wrote in the 1950s:

> Yams were used all through Arnhem Land and always after roasting in the ashes the outer skin was rubbed or washed off and the tuber finely sliced or grated . . . After the yam had been reduced to coarse flakes *it was placed in a bag* and soaked for about twelve hours. Then the water was squeezed or drained out and the pulpy mass eaten. It was regarded as very good food—'Sweet, that one!'[34] [italics mine]

Again exactly as in the case of cycads, the successful detoxification of the yams was celebrated by singing and dancing, rites that are still observed amongst the Tiwi people of Melville Island, a north Australian island lying in the Timor Sea immediately north-east of the Kimberley. Known as the *Kulama* ceremony, according to one modern-day description:

> . . . during the cooking [of the yams] dancers re-enact the first *kulama* in *dances* of birds, the crocodile, the turtle, buffalo and shark. The final scenes occur after the yams are cooked and *placed in a basket*. Initiates are ornamented with *neck rings and armbands*. Senior men in the *kulama* paint their faces, bodies, hair and beards with elaborate designs, and the yams are eaten in accordance with ritual custom.[35] [italics mine]

Does not all this sound rather reminiscent of what we see on the Munurru 'Bagman' Bradshaw? Particularly intriguingly, while both round yams and long yams[36] grow wild in northern Australia, they are not native to the continent. Just as we inferred earlier of the boab, they appear to have derived from deliberate human introduction from elsewhere, most likely Indonesia, where they are endemic. So could the incoming Bradshaw people actually have introduced them, carrying them from across the Timor Sea in one of those so elusive sea-going boats? Does this give us a point of origin for the Bradshaw people?

Whatever the answer, the 'Bagman' painting was not the only high-quality Bradshaw that awaited us during that morning's explorations of Munurru. As we turned around from viewing it, immediately opposite but at some 80 metres distance could be seen another distinctive sandstone rock formation. Walking towards this, we saw that it featured a pale-coloured west-facing section of rock wall, protected by an overhang, that provided so perfect an artist's 'canvas' that you could believe it had been specially prepared for that purpose (see page 98). On our getting closer, I immediately recognised the painting as bearing another Bradshaw scene that Grahame Walsh had repeatedly reproduced in his books.[37] Indeed, he had good reason to do so because with the exception of some very localised damage it was in near mint condition. Adding to the painting's familiarity was that Walsh and

Dame Elisabeth Murdoch had been photographed standing in front of it for the article about their partnership that had appeared in *Weekend Australian* magazine the year before.[38]

The scene comprised four large figures, three of them of Walsh's Tassel Bradshaw type. This thereby distinguished them from the Sash type of the main 'Bagman' figure across the way. However, the fact that the figure second from the left had a tassel on one side and a sash on the other rather diminished Walsh's insistence that Sashes and Tassels were chronologically distinct.[39] Coloration-wise, the figures were definitely different from the 'Bagmen's' mulberry hue. The two at the furthest left were painted in a chocolate and raw umber bichrome as if their bodies were decorated with vertical stripes of body paint, while the two at the furthest right were in a single tone and rather more reddish in hue. Style and composition-wise, however, they could all easily have been created at one and the same time.

The way that the two left-hand figures' long hair trailed downwards into a pompom made me instinctively identify them as female. The larger of these, at furthest left, also sported pendulous features either side of the body that conceivably—though with the Bradshaw people's fondness for accessorising, far from necessarily—might indicate breasts. For me, far stronger as a gender-determinative feature was the arrangement of the two figures' legs, their upper thighs being represented close together, but splaying out from just above the knees downwards. This was a characteristic that my life drawing experience had taught me to pertain rather more to women's deportment than to men's. By my same homespun gender differentiation, this particular panel's single male was the 'wizard-hatted' figure third from the left, suggested particularly by the upright nature of his headgear. He reminded me of the cartoon 'Wizard of Id' and if the Bradshaws had a pantheon of deities I would cast him as god of mischief.

But this was a painting that, as in the case of the 'Nine Dancers', I had particularly wanted to view for a very special reason—in this instance to inspect at close hand the face of the 'female' figure second from the left. One of the most frustrating and still unexplained features of the Bradshaw paintings is that despite the high standards of figure representation, also the ever-intriguing accessories that the figures carry, details of facial features such

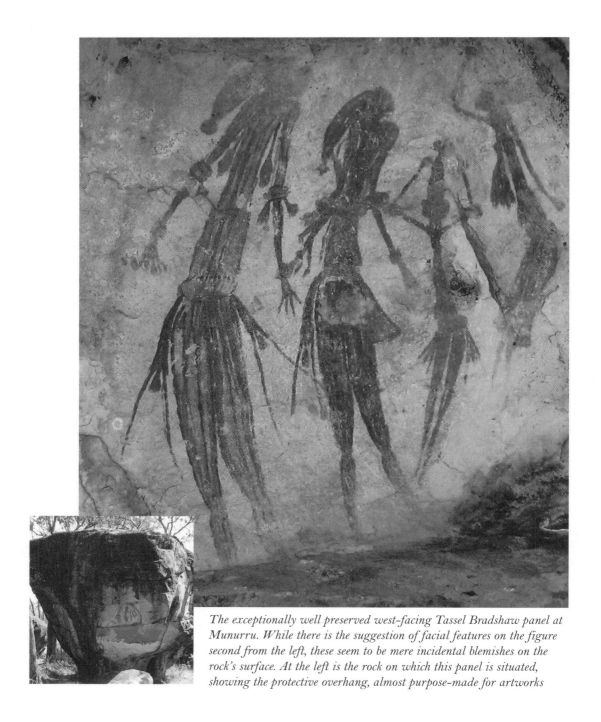

The exceptionally well preserved west-facing Tassel Bradshaw panel at Munurru. While there is the suggestion of facial features on the figure second from the left, these seem to be mere incidental blemishes on the rock's surface. At the left is the rock on which this panel is situated, showing the protective overhang, almost purpose-made for artworks

as eyes, nose and mouth are almost invariably absent. Inevitably, this raises questions: were these originally painted in some separate colour, which time has persistently eroded away? Or did the artists, for some as yet unfathomable reasons, perhaps never ever include facial details in the first place?

The particular interest of the figure that I now scrutinised—just as if it hung in an art gallery—was that Walsh's photographs showed the facial area to have some markings on it which conceivably could be surviving indications of a mouth and eyes. Equally conceivably they could be mere blemishes on the rock which the imagination merely formed as facial features. To my satisfaction, though not without some accompanying sadness, there really could be no doubt that the 'mouth' and 'eyes' were nothing more than blemishes on the rock. Yet this painting was otherwise in quite remarkable condition, even, most unusually, with two different tones of colour still preserved. So was it possible that the Bradshaw artists deliberately omitted what our modern-day humanity normally regards as our most interesting features, our faces, just as more recent Aboriginal artists omitted Wandjinas' mouths?

While Lee and I were debating such issues, Judith was patiently going about photographing the same painting, its west-facing aspect making her task much more straightforward than it had been in the case of the 'Bagmen'. Quite unexpectedly in this instance, however, Judith's photographs would actually prove more valuable than our on-site observations of the originals.

For it was while later studying the photographs back in Brisbane that I spotted a feature that had eluded all of us when actually on site. All of the three left-most figures can be seen wearing at their elbows some kind of quite elaborately constructed armband. Such armbands at the elbow are a commonplace ornamental feature on Tassel and Sash Bradshaw figures, taking a variety of forms and often supplemented, as here, by some sort of tassel. But in the case of the figure at second left (the same one with the imaginary facial features), there seemed to be some anomaly at the (spectator's) left armband. Dangling from this were some appendages that did not seem to make sense in relation to the other armlets. And it was while I was still pondering this problem in close-up on the computer screen that Judith came up behind me and said with her usual devastating immediacy, 'It's a small figure. Look, you can see the two feet!'

Did the Bradshaw people create puppets? At left, detail of the west-facing panel at Munurru showing what appears to be a tiny figure tucked into the woman's arm. At right, detail from a Tassel Bradshaw panel published by Walsh, again showing what appears to be a puppet or mannikin strangely close to the figure's arm. In both instances the main figures appear to be female by the criteria adopted in this book

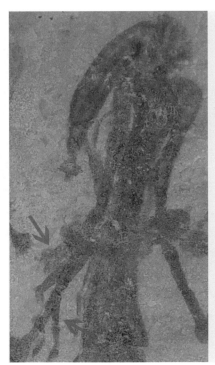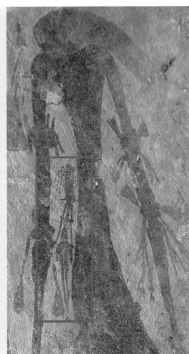

It was a compelling insight. The feet were attached to legs belonging to some sort of miniaturised representation of a human being that the 'woman' had tucked into her armband. But what even Judith did not realise at that moment was that her deduction raised an immediate link with a whole genre of Bradshaw paintings on which Grahame Walsh had noted there to be a small figure located by the elbow of a larger one.[40] Some of these showed the figures to be dressed identically to full-size human beings of the Tassel and Sash Bradshaw type, and repeatedly the small figure was very close to the elbow of the larger figure. But only this Munurru panel, with its miniaturised figure actually tucked into the armlet, made it possible to construe that the figure was some kind of three-dimensional mannikin or puppet.

What Judith's observation had opened up was that the Bradshaw people had created miniaturised replicas of human beings, even complete with identical 'clothing'. But for what purpose? For ritual magic, as in the age-old

witchcraft practice of sticking pins in such figures? Or for some kind of entertainment? My mind went back to the famous Wayang shadow puppets that are an ancient and very cultic form of entertainment on the very same Indonesian island of Java with which I had associated the 'Nine Dancers' figures.

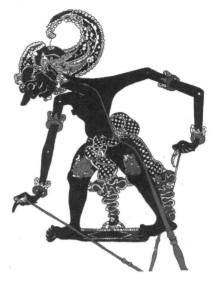

Today Wayang puppets—always elaborately accessorised in much the same mode as the Bradshaw figures—mostly perform episodes from Hindu epics like the *Ramayana* and *Mahabharata*, reflecting the fact that, at an early period in Java's history, invasions from India caused its peoples to be converted to Hinduism. But the puppetry itself did not come over from India with the Hindus. It seems to have been already present on Java, perhaps again originally pertaining to that very same ancient cult of 'Goddesss of the South Seas' Loro

Wayang puppet of Java. Does the tradition of creating these trace back to the Bradshaw people?

Kidul for whom the 'Nine Dancers' dance was performed.

So did the Bradshaw people, like the early Javanese, perhaps use mannikin figures to create shadow plays? Might the very fact that the Bradshaw figures so consistently have no faces be because the artists intended to present them more as shadows rather than as fully detailed individuals?[41] Could Australia's Bradshaw people and those early Javanese have been rather more closely connected than anyone has previously thought possible?

At the very least our face-to-face confrontation with that morning's Bradshaws was raising a host of half-formed questions needing further evaluation. But we were still relatively early on in our Kimberley journey. And even despite so many major sites being inaccessible to us, there was still much more Bradshaw rock art waiting to be explored.

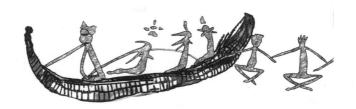

CHAPTER EIGHT
Boat design pioneers

From Munurru we rejoined the very rough, strictly four-wheel drive track that led on to our destination for that day, the Mitchell Falls. 'Mitchell' is of course the region's 'white' name, early twentieth-century discoverer Robert Easton having named the main river after Western Australian premier Sir James Mitchell, following which the surrounding plateau and waterfalls complex likewise received the name. For the local Wunambal people, the falls area has long been rather more colourfully known as Punamii-unpuu, the place where snakes 'meet and show each other'.

Punamii-unpuu's rich variety of wildlife—50 mammal species, 220 bird species and 86 kinds of reptiles and amphibians—includes some of Australia's deadliest snakes, the taipan, the king brown and the death adder. The snakes whom the Wunambal had in mind, however, were the mythical Wungurr who travelled with the Wandjina to make rivers and creeks, and who helped create all living things. To Wunambal people, Punamii-unpuu is an area of the greatest spiritual power and significance where the spirits of the dead and of the yet-to-be-born lurk along its tracks and waterways. Peril awaits any outsider moving through it who might behave in any way disrespectfully towards these spirits' presence.

The steep, dusty climb up to the Mitchell Plateau was heavily corrugated, every metre subjecting the hard-pressed Toyota to a fresh pounding. Much of the basalt of which the plateau comprises has been weathered to form bauxite,[1] from which aluminium can be extracted, a perennial temptation for mining entrepreneurs to exploit. When we had reached about halfway Lee stopped for us to take in the view at an overlook known as Miyalay by Aboriginal people. Immediately in front of where we stood the land sloped steeply away, and as far as the eye could see stretched a forest of the same *Livistona* fan palms that we had come across only in isolated pockets further to the east. Nurtured by the up to 1600 millimetre rainfall that the Wet dumps in this particular part of the Kimberley, the valley we were looking over includes a river that Aboriginal people know as the Dorre, whites the Lawley. Lee pointed out that if the Bradshaw people had truly lived back during the Ice Age (as she indeed believed), this sort of palm-studded landscape was what they would have known throughout much of the Kimberley, except that then it would have had much more of a protective canopy from taller eucalypts.

A couple more hours' hard driving later, we pulled into the Mitchell Falls camping area, where suddenly we found ourselves with other human company, almost unwelcome because we seemed to have left it so long behind. Though it was a campground without on-site staff, some six camping vehicles were widely scattered around, and from somewhere nearby there was the chatter of helicopter rotors.

Making our way to Tim Anders' impromptu tent 'heliport', its entrance encouragingly marked by a buffalo skull, we arranged with his wife, who had their baby with her, a flight for around 2 p.m. The plan was for us to take the standard tourist ten-minute helicopter ride to the top of the falls, then make our own way back to the campground via a relatively easy walking track that Lee knew to have a number of art sites along its route. And it was of course while we were actually airborne during that flight that Lee asked Tim the crucial question about the whereabouts of any Bradshaw boat paintings— leading to our flying there and then to the Reindeer Rock site described in the first chapter.

For us to have been able to drop down so unexpectedly into that hitherto unrecorded site and view paintings entirely new to Bradshaw scholarship

was one of those never-to-be forgotten life experiences. At the time our huge frustration was the very limited time that we could stay on-site due to Tim's later booking, also the eye-watering number of dollars that drain away for every minute that any so far-flung helicopter and its pilot are on charter out in the Kimberley.

And another concern was that this was the sole occasion throughout the trip when Lee, necessarily travelling light for the helicopter journey and not having expected to come across anything new, had not brought along her camera as a backup. Everything therefore depended on Judith doing the very best photographic job that she could within the mere twenty minutes that we had on the ground. In the event she produced images of the greatest technical skill and clarity. A digital stitching facility on her Canon camera enabled her, on our return to Brisbane, to put together high-definition images by which the substantial lengths of Reindeer Rock's 'reindeer' and 'boat' panels could be studied uninterrupted in one continuous sequence.

But however hard we studied those images back in Brisbane they remained enigmatic. Though on-site we counted at least eighteen of the 'reindeer', closer scrutiny of the photographs revealed some 26, the regularity with which they were spaced enabling the presence of otherwise indistinguishable individuals to be inferred. But what were they? From

Detail of the line of 'reindeer' on Reindeer Rock with (below) the author's very tentative interpretative drawing of the same

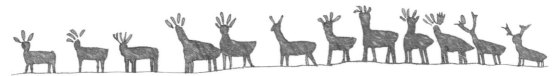

background reading, I discovered that amidst the forests of the Indonesian island of Sulawesi (formerly known as the Celebes), between Borneo and Papua New Guinea, there lurks a little-known species of pygmy buffalo called the anoa. Currently endangered because of Sulawesi's over-intensive forest clearances, the anoa is horned, it has a mountain[2] as well as a lowland[3] variety, and it bears a passing resemblance to a deer. But its short straight horns are nothing like those of the reindeer-like variety depicted on Reindeer Rock, and it lives singly, or in pairs, never in herds.

I was aware that back in the Ice Age there had probably existed some varieties of deer on the then much more substantial South-East Asian landmass which is today fragmented into the islands of Indonesia. Certainly archaeological reports mentioned finds of deer bones among the food debris at early habitation sites. With so much more mainland they would have been able to wander as far south as the landmass then allowed. But until a last-minute breakthrough to be described later, I had no idea whether any species as apparently magnificently antlered as those on Reindeer Rock existed either back then or now. Besides which, anyone living in Australia's Kimberley would still have needed to brave at least one open-sea voyage of over 100 kilometres to have been able to view them.

And quite aside from the puzzle concerning how an Ice Age artist in Australia managed to see a deer, perhaps of even greater interest is a feature that, though unremarkable to the modern-day mind, in the field of rock art is positively revolutionary. This is the long, thin, very regular line that has been drawn at the animals' feet, creating the impression that they were standing on some kind of ridge. Outside the field of the Bradshaws, to the best of my awareness no such ground or base line has ever been found in the entire corpus of traditional Aboriginal art. Again to the best of my awareness (and certainly to Grahame Walsh's also),[4] nor has anything similar been found anywhere throughout the rest of the world's prehistoric art—until the rise of the first great civilisations, when ancient Egyptian artists began setting such lines at the feet of human figures.[5]

Within the field of the Bradshaws, however, our Reindeer Rock line does have one significant counterpart. Walsh in his 2000 book includes a painting, created in the distinctive mulberry colour, depicting two rows of what he

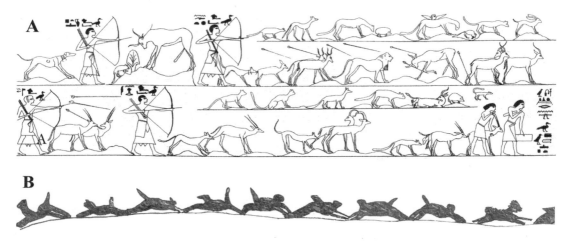

Simple idea though it may seem to set a ground line beneath human or animal figures, in all the history of the world's art it was the ancient Eyptians who had seemed to first come up with this artistic device, as in this scene (A) from a 12th Dynasty tomb. All the more surprising, therefore, to find the same device used for our Kimberley line of 'reindeer'. Also in the case of a Kimberley painting of a line of cat-like animals repro- duced here (B) as an interpretative drawing after a photograph by Grahame Walsh

calls 'cat-like' animals.[6] Drawn vertically rather than horizontally onto a 'vertical rock face', and in some instances facing each other, these have an identical ground line running along their feet. Much as in the case of our 'reindeer', identifying the species of these animals is a real puzzle. The domestic cat, it should be understood, never existed in Australia prior to its introduction by Europeans. In the absence of any better suggestion from Walsh, our best candidate, though far from entirely satisfactory, would be the quoll, a cat-like marsupial carnivore which although in the Kimberley is today represented only by the northern quoll,[7] certainly had other now extinct varieties in earlier millennia.

But while there are any number of rock art depictions which create similar wildlife identification problems, it is that single, simple line drawn under the animals' feet which potentially sets a major new benchmark in world art history—always assuming that the Bradshaw paintings really do belong to the Ice Age. It bespeaks a mind looking to order and design, a mind but a hairsbreadth from conceiving that closely related artistic concept, the

landscape. It is as if the Bradshaw people, tucked away in their 'backwater' Australia, were somehow reaching out towards much the same artistic level of competence that the ancient Egyptians had achieved when their civilisation began its rise, except that the Bradshaw people were seemingly many millennia earlier. Reindeer Rock's pioneering ground line makes all the more important that we should know the location of Walsh's cat-like equivalent, in order to make some better evaluation of where the idea might have originated. But such location information is of course the very type of data that Walsh so resolutely withholds, while remarking:

> Ongoing research will hopefully identify a wider range of surviving examples incorporating figure/base line relationships, permitting an understanding of its origins.[8]

If the so groundbreaking 'reindeer' image on Reindeer Rock's eastern face continued to cause some major head-scratching, the boat panel at the rock's northern end was no less perplexing. Poorly preserved though the panel's artwork is, no-one can seriously dispute that its most distinctive feature is a boat with distinctively high prows fore and aft. Such a shape immediately distinguishes it from all known Aboriginal boats of mainland Australia as reported at the time of European settlement, also the type of similar simple raft or hollowed-out log that can mostly be expected from any people living at the lowest level of water transport development. The shape also positively links it to the Bradshaw boat painting which Grahame Walsh presented as the world's oldest known boat in the BBC TV documentary *Hunt for the First Americans*.[9] For even though the figures on the Reindeer Rock panel are standing up in the boat, whereas those in Walsh's unlocated example are seated, there is a strong similarity in coloration and style, and the boats' upswept stern and prow is essentially the same design in both instances.

That word 'design' cannot be overemphasised as applied to the shape of the boat that we see. Whoever were the people who created these boats that we see painted on such Kimberley rocks, they had clearly reached a stage where they recognised that the shape of a boat's hull had some important

implications for how it handled in ocean-going conditions. While any ordinary hollowed-out log canoe might be serviceable enough for being paddled around lakes and rivers, try putting it anywhere out on the open sea and its scooped-out interior would quickly fill with water at the first wave. The vital design feature was to fit it with a high prow and equivalent stern. By keeping this pointed into the waves the vessel could become a serviceable mode of transport for negotiating the open ocean.

As we shall see later, this awareness of the importance of design rather neatly links in with the Bradshaw people's equally developed recognition of its importance in respect of their crafting of boomerangs. Just as they had learned that different shapes gave their boomerangs different properties for travelling through the air, causing them to design and craft the implements accordingly, so it would seem that they recognised that the shape of a boat's hull determined how well and how safely it would move through water—and again went through much the same design and construction process, except on a bigger scale. And the lessons thus learned were seemingly being disseminated throughout the Bradshaw 'culture'. Whatever the whereabouts within the Kimberley of the 29-occupant boat painting that Walsh showed during his lecture in Brisbane, the high prow and stern design was certainly repeated in that example. Once again, therefore, we seem to be seeing a people who were living at the very cusp of civilisation's development, yet were not living in the Middle East or in Egypt, where we might expect such things, but in backward, 'savage', Ice Age Australia . . .

So if, as we can now be confident, in at least one period of the Bradshaw people's development they had progressed to a surprisingly advanced level in the crafting of boats, this inevitably raises a host of fresh questions about what materials they used for the construction work, and where they obtained these. Again, finding answers to such questions is far from easy. After Walsh's discovery of the boat painting that he showed in the *Hunt for the First Americans* TV documentary, he subsequently found, or became introduced to, three other Kimberley boat paintings, all of which he reproduced in his 2000 book.[10]

These not only again exhibit the upturned prow and stern design but some, such as the painting reproduced on page 110 seem to have been

Extended view of the boat painting panel on the north-facing side of Reindeer Rock. The line of reindeer faces west at right angles from the far left of the picture. Note what may be a second boat with standing figures in the area indicated by the arrow

composed of reed fibres that were lashed together with string. Though Walsh as usual provides no location for this particular boat painting, from independent sources I have subsequently learned that it is sited on the Mitchell River, downstream from the lower falls, and therefore close to our Reindeer Rock discovery.[11] Not least of its intriguing features is that reeds suitable for such a boat construction no longer exist in the Kimberley.

What do we know of other examples of this type of boat-building anywhere else around the world? It only adds to the Bradshaw mystery that ancient Egyptian paintings and reliefs show the stringing together of bundles of reeds for the making of very similar-looking reed boats, some of these depictions showing the boat-builders lashing the ends particularly tightly to create the same curved prow and stern.[12] Other ancient Egyptian paintings show gods and high dignitaries standing upright in (or more accurately, on) such boats in the exact manner of our Reindeer Rock figures.[13] And however dubious boats of reed bundles might seem for crossing oceans, their seaworthiness was well demonstrated back in the

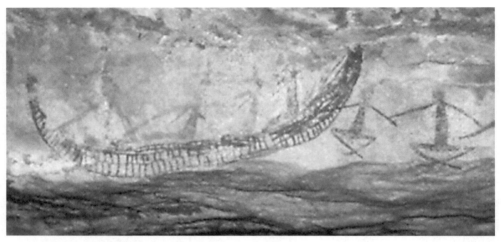

Boat painting on the Mitchell River that seems unmistakably to depict a craft created from bundles of reeds. Photo by Russell Willis

early 1970s when the late Thor Heyerdahl crossed 5000 kilometres of the Atlantic in the first of two carefully researched reconstructions, sailing in *Ra I*.[14]

Furthermore, as Heyerdahl throughout his life found so fascinating, the real puzzle of such reed boats is that they are extraordinarily well distributed around the world. When the first Spanish Conquistadors arrived in South America, they found the Incas were using much the same kinds of boat on Peru's Lake Titicaca.[15] Seris Indians were using such boats on Mexico's Gulf of California. When in 1722 the Dutch explorer Jacob Roggeveen discovered Easter Island in the middle of the Pacific, he found its islanders to be moving around on much the same kinds of reed boat. Ancient Assyrian victory reliefs show such boats being used in the marshes of the Tigris and Euphrates, their occupants standing up on them exactly as on the Reindeer Rock panel.[16] The ancient Dong-son people of Vietnam decorated their ceremonial drums with depictions of their ancestors standing up on boats of similar design. Similarly shaped boats, whether made of reeds or not, can be seen on ancient rock paintings in the Niah cave, Borneo, some levels of which have been dated back to 40 000 BC. To this day on the Indonesian island of Sumatra islanders make rattan ceremonial mats decorated with 'soul' ships with curved prows

on which individuals are depicted standing up in a manner hauntingly reminiscent of the Reindeer Rock depiction. So could the Bradshaw people of the Kimberley have had rather more of an ancestral, cultural link to all these other so widely scattered peoples than anyone has ever yet given ancient Australians credit for?

Whatever the answer, there was also the costuming of the Reindeer Rock boat figures to be considered. Quite unmistakably, two human figures can be seen standing up in the boat's aft section (see detail A overleaf), with vague hints of two more figures towards the prow. The figure that is second from the left appears to be the boat's VIP occupant. No tassels or sashes are evident that would associate the figure with Walsh's Tassel and Sash Bradshaw periods, a feature all the so-far published boat paintings share. The main figure's arms seem to be in the 'Great Mother' pose but while the general handling would put the painting firmly within the Erudite, or highest art epoch in Walsh's scheme, ascribing it to a specific period within this is far from straightforward.

But it is the costume that the 'VIP' figure is wearing that, like the ground line under the 'reindeer', really raises the eyebrows. This looks for all the world like either a long robe or skirt. And the companion standing imme-diately behind the main figure can be seen in a long robe likewise—all in marked contrast to the complete, unabashed nakedness that was the norm for both men and women amongst those Aboriginal tribes encountered by the first Europeans to arrive in Australia.[17] And that long garment surely cannot be ascribed to just a trick of the eye due to the painting's poor condition. For other similar garments are to be found depicted in Bradshaw paintings of the Erudite Epoch, a particularly important example in this regard being a Sash Bradshaw figure that Walsh includes early in his 2000 book and is repro-duced overleaf as interpretative drawing B.[18]

This particular figure sports the ultra-long 'wizard hat' that is so common among Tassel and Sash Bradshaw figures. It has wrist and hand muffs corresponding to those that we inferred on Munurru's 'Bagman' figure. It has a neck attachment forking out into four straps that we may interpret as the strap device by which the ceremonial 'bread' or yam basket received neck/shoulder support[19] and, most importantly, it has a full-length, possibly

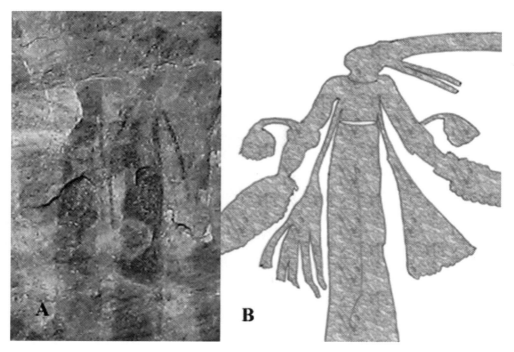

Full-length costumes? (A) Detail of the standing figures in the Reindeer Rock boat panel, showing what certainly seems to be a full-length costume. (B) Interpretative drawing of Sash Bradshaw figure reproduced by Grahame Walsh, again featuring what appears to be a full-length dress or robe

even sleeved, robe or dress. So if the Bradshaw people had developed weaving for their making of bags and baskets, had they also developed adaptations of the same procedure for weaving some kinds of clothing?

Likewise not to be overlooked on the Reindeer Rock boat panel are other figures that are to be seen immediately in front of the boat. Two are stick figures, perhaps corresponding to Walsh's Stick Bradshaw type. The first is standing with what looks to be a sheaf of large, angled boomerangs in his right hand and a barbed spear in his left, this latter pointing downwards.

But altogether larger and more prominent, and matching in size the VIP figures standing on the boat, is a figure with a definite Erudite Bradshaw 'male' hairstyle who is depicted running at full stretch with an extremely long

stride, as if leaping onshore ahead of the boat. The ultra-lively 'action' pose of this individual immediately defines him as belonging to what Grahame Walsh calls the Elegant Action phase of the Bradshaws. As may be recalled from Walsh's sequencing system, Elegant Action Bradshaws followed on from those of the Sash and Tassel variety. As may also be recalled, while Tassel and Sash Bradshaw figures favoured boomerangs, the Elegant Action phase ushered in the multi-barb spear as the new 'in' weapon. And sure enough, this Elegant Action figure brandishes in his right hand just such a spear. As he runs he is holding it forward-mounted between the prongs of what looks like a large tuning fork, while in his left hand he carries a single-sided multi-barb spear, the pointed end of which he is directing downwards.

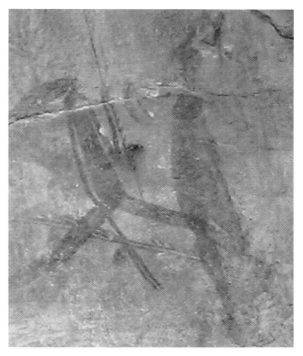

Detail from the boat panel showing running figure with spears. He superimposes a figure probably belonging to the same time as the boat painting proper

The imponderable in all this is the chronological relation between this Elegant Action running figure, which we can readily attribute to a phase in Walsh's chronological sequence, and the figures in the boat, which certainly seem to precede and thereby be older, yet which are altogether more difficult to place.

Whatever the answer, for us on location at Reindeer Rock there was little opportunity for more than the most cursory look at some definite signs of one-time habitation to the main rock's south, including a rock shelter area that still had some grindstones for food preparation in situ.[20] Within a few minutes Tim Anders had us back in the helicopter and heading back south-wards along the winding Mitchell River. Then, on reaching the dramatic

expanse of the falls we began our descent, alighting with the gentlest of touchdowns onto a natural rock platform immediately adjacent to the main waterfall. There already waiting were the bushwalkers whom Tim was scheduled to collect, and it was our turn to take our own walk through Punamii-unpuu, the place where snakes 'meet and show each other'.

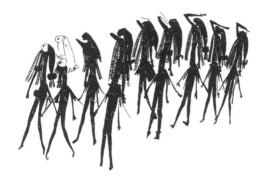

CHAPTER NINE
Time of the spears

From the very exposed and treeless platform onto which we had landed, Lee led us briskly across some relatively straightforward open country until we reached a rocky, sometimes steeply descending track that was our trail back to the camp. This well-trodden route adjoins the Little Mertens Creek, named after Robert Mertens, discoverer of a new species of lizard, and it brought us into an idyllic oasis-like area where a large natural rock pool was surrounded by pandanus and paperbark trees. Towards the far end some natural stepping stones enabled us to cross the water to a large sandstone platform. Behind this ran a long rock wall that even from a distance looked ripe for its bearing ancient rock paintings.

Sure enough, as we scrambled up onto the platform that formed yet another natural 'stage' much like those that we had visited in the Deception Range and Chamberlain Gorge, there before us was one of the best known of all the Kimberley's Bradshaw paintings, the so-called 'Battle Scene'.[1] In fact this descriptive name arises from just two small sections of a collectively huge and bewildering array of figures, some of them small Wandjinas, that would appear to have been added to the wall panel by varying peoples at different times.

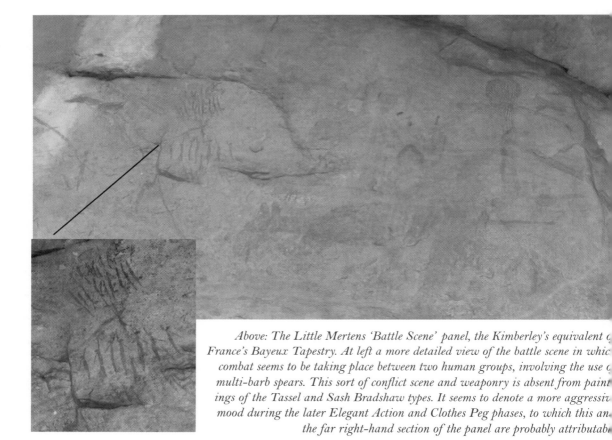

Above: The Little Mertens 'Battle Scene' panel, the Kimberley's equivalent of France's Bayeux Tapestry. At left a more detailed view of the battle scene in which combat seems to be taking place between two human groups, involving the use of multi-barb spears. This sort of conflict scene and weaponry is absent from paintings of the Tassel and Sash Bradshaw types. It seems to denote a more aggressive mood during the later Elegant Action and Clothes Peg phases, to which this and the far right-hand section of the panel are probably attributable.

Western Australian Museum archaeologist Ian Crawford, who first came across the panel more than 30 years ago, has provided an excellent, very balanced description of the upper left-hand corner of the scene:

This appears to show a spear fight between two groups, or possibly two groups spearing a central figure. Each figure has one arm raised above its head and the other arm by its side. Behind each group are barbed spears which could be interpreted as spears which have been thrown and passed through the group. The figures are painted in red, and are faded. The painting technique was as fine as that used in Bradshaw figures but the

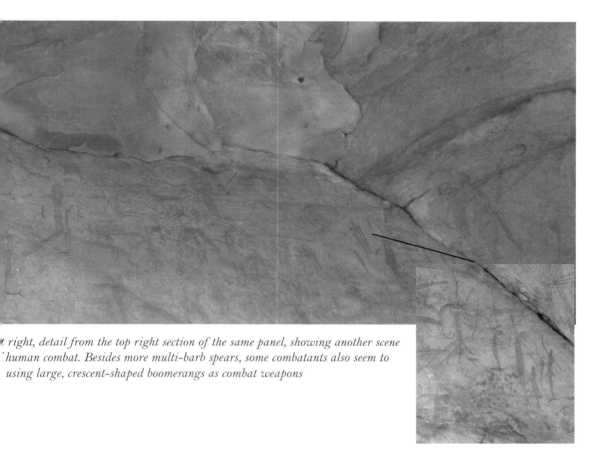

right, detail from the top right section of the same panel, showing another scene `human combat. Besides more multi-barb spears, some combatants also seem to using large, crescent-shaped boomerangs as combat weapons*

figures themselves lack several attributes, for example, the curvaceous lines which in Bradshaws depict the body and limb form, and the figures do not have any regalia. On the basis of technique and the presence of the barbed spears, the figures appear to be roughly contemporary with Bradshaw figures and could be accepted as in a Bradshaw style.[2]

As we noted earlier, the so accomplished and (in Crawford's parlance) 'curvaceous' Sash and Tassel Bradshaw figures are rarely if ever seen armed with anything more dangerous than a small crescent-shaped or angled boomerang as suitable for bringing down birds and small animals. There are essentially no known depictions of them being involved in any kind of inter-human

combat. Only in the later Elegant Action and Clothes Peg phases does the multi-barb spear make a significant appearance, the importance of this Little Mertens-based scene being that it shows this weapon being used in a seriously offensive way against other human beings. Some have suggested the activity to be some kind of dance or ceremony.[3] The early researcher Dacre Stubbs thought that the figures might be swimming, the 'spears' thereby being reeds in the water.[4] But Crawford and Walsh are in rare accord that it depicts some episode of inter-human conflict, and as the Little Mertens panel's spears are self-evidently the same weapon we had seen less than an hour earlier depicted at Reindeer Rock, all logic suggests them to be right.

And much this same 'battle' interpretation would also seem to pertain to the scene in the panel's far right-hand section. There are a few minor differences, such as that the figures are marginally larger, also that the weaponry includes some distinctively crescent-shaped boomerangs as well as more multi-barb spears. But there is the same delicacy of painting technique and the same frenetic action between two groups of combatants, Walsh's description of the lower of these fighting groups being as follows:

> The upraised arms indicate that they have just launched missiles, while the opponents' multi-barb spears can be seen raining down on them. The left figure is shown impaled by two spears. The larger figure wears a swept-back headdress similar to those worn by passengers in some early watercraft depictions.[5]

By that last sentence Walsh was referring to the swept-back headdresses of two or more occupants of the boat in the painting that he showed in the *Hunt for the First Americans* documentary,[6] also to some broadly similar headdresses on several figures in the Mitchell River Bradshaw painting depicting a boat clearly crafted from reeds (see page 110).[7] But much the same headdress can also be glimpsed on the 'VIP' standing figure in our Reindeer Rock boat painting. All these 'boat' paintings, together with the Little Mertens 'Battle' scenes, arguably derive from the Elegant Action and Clothes Peg periods that Walsh has designated as coming after the Sash and Tassel heyday, but before the advent of the Wandjina. All raise the question: do the Little Mertens battle

At Little Mertens Creek, Lee on the platform with the 'Battle Scene' painting, which is located just to her left

paintings represent episodes in a real-life historical struggle between an incumbent Kimberley population and unidentified invaders arriving from across the sea? In which case, might we be able to determine which was the resident population and which the invading newcomers?

Here of considerable interest is that most of today's Kimberley Aboriginal peoples retain a tradition that before their Wandjina ancestors arrived in the region it was occupied by a different people with different customs.[8] There are a variety of versions, but the general gist of the story is that an armed struggle began when Wandjina ancestor Tumbi[9] the owl became abused and injured by the already resident people. Tumbi's kinsmen, the incoming Wandjinas, fought 'a mighty battle' at a place called Tunbai. They outmanoeuvred those who had injured Tumbi, and drove them to their deaths on ground that had been made boggy by dancing brolgas. Thereafter they took over the Kimberley as their own.[10]

But however tempting it might seem to identify the Little Mertens painting as a depiction of this quasi-historic battle of Tunbai, there are some crucial observations concerning the weaponry which militate against this. When the first Europeans began making their way into the Kimberley, the weapons that were being carried by the Wandjina-venerating Aboriginal inhabitants were not multi-barb spears. Instead, as Captain Phillip Parker King's surgeon Andrew Montgomery and British army surveyor George Grey both learned very painfully, they were spears that archaeologists today refer to as 'Kimberley points'—razor-sharp spearheads pressure-flaked in the shape of a leaf, and with similarly razor-sharp serrations at their edges.[11] In other words, the same spear points that we earlier noted as ascribed by archaeologists to the period from circa 3000 BC onwards, marking the arrival of the last pre-European wave of newcomers into Australia.

So if the battle of Tunbai was one which the Wandjina side would have fought with their 'Kimberley point' spears, the battle that we see depicted on the Little Mertens panel can only date from a significantly earlier, pre-Wandjina phase, when boomerangs and multi-barb spears were more the vogue. As we have already seen, while the multi-barb spear makes an appearance during Walsh's Elegant Action Bradshaw phase, only during the succeeding Clothes Peg period does it really come into its own as 'the'

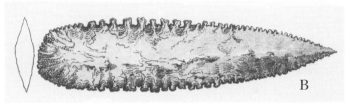

(A) From a painting of the Clothes Peg period, depiction of a typical multi-barb spear
(B) Example of a 'Kimberley point', the beautifully crafted, leaf-shaped spear points which Kimberley Aboriginals used to considerable effect against the first European explorers to arrive in the Kimberley, as illustrated in Captain Phillip Parker King's Narrative of 1838

weapon of the day, albeit without any complete disappearance of the boomerang. So could the Little Mertens panel be documenting an invasion by the multi-barb-wielding Clothes Peg people, ousting the peaceable and boomerang-loving Tassel and Sash Bradshaw people? This would also make sense of the siting of the paintings at the extreme top left and right of the rock panel. Conceivably the Clothes Peg elders created the panel as a 'Bayeux Tapestry' type memorial of their successful takeover of the Punamii-unpuu region, with plenty of space left for the recording of further events in their tribal history. Perhaps the elders of later generations would then have used the panel for giving periodic 'history lessons' while standing on the very same rock 'stage' on which we ourselves were perched, struggling to come up with some meaningful idea of what it all meant.

Suddenly the Clothes Peg people, hitherto perceived by me as artistically way inferior to the Tassel and Sash Bradshaw people, began to assume a rather greater interest than they had previously. After all, Grahame Walsh had similarly noted the very bellicose air that this people had about them. In his words:

> A feature common among the Kimberley Clothes Peg Figures is their almost invariably well-armed appearance . . . Even figures now appearing 'unarmed' are mostly found displaying arm alignments consistent with weapon holding arrangements.[12]

And as we continued our walk back to the campground there was further evidence of the Clothes Peg people's same spear-toting inclinations. On one rock wall a small group of the figures, typified as Clothes Pegs by their 'gingerbread man'-type simplicity, had been painted with what looked like bowler hats on their heads, but with otherwise strangely 'missing' faces. Cross-legged yet 'enthroned', these sat alongside massive multi-barb spears, just as if these weapons were the 'national emblems' of their ascendancy. On another wall another small group of such figures were sitting cross-legged on the ground[13] in the manner popularly associated with Indian fakirs and yogis (though this pose is commonly enough recorded amongst traditional Aboriginal people also). At first sight these harmless-looking 'yogis' seemed to be a rare example of Clothes Pegs lacking any multi-barb spear in their vicinity. But no, closer scrutiny of two faint lines just a short distance above the figures revealed the depiction of spears with telltale rows of barbs. Another notable feature of these figures was their still very Bradshaw-like deep red coloration and their delicacy of execution. These were surely indicative that at least something of the old expertise of the Tassel and Sash Bradshaw people was living on into the Clothes Peg period, even if a very different, more aggressive regime now held sway?

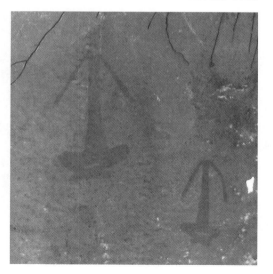

Clothes Peg style figures in yoga pose painted on some of the rock faces in the vicinity of Little Mertens Creek

A couple of hours later we were round the camp fire, with Lee conjuring up a typically amazing assortment of ingredients for a tasty meal, when discussions turned to an intriguing crumb of information that

Tim Anders had imparted during our return flight from Reindeer Rock. Interested in the Bradshaws himself, he had told us of his recently picking up two bushwalkers from a site which he was quite sure Grahame Walsh had not yet found, and which might interest us. This lay an hour's flight westwards towards the Roe River, not far from where Joseph Bradshaw had made his first discovery back in 1891. From the little that Tim had seen of it so far, its most interesting feature was a life-size Tassel Bradshaw figure painted in some kind of yellow ochre, instead of the normal red and black. There were also many other paintings representative of the different art phases. With free time, as it was the end of the season, he could take us to the site—though inevitably we would have to meet the not-inconsiderable charter costs. The upshot of our camp fire parley was that having come thus far into the Kimberley, it was too good an opportunity for us to miss—even though it would mean dropping from our itinerary an excursion northward to the Kalumburu mission station.

After spending another night under the stars, we again awoke to the dawn of a perfect, cloudless Kimberley Dry day. Soon we were airborne on a course that took us south-westwards across a seemingly endless plain of spindly stringy-bark trees, with every now and again a rock outcrop looking as if it had art site or archaeological potential. After some 50 minutes the Prince Frederick Harbour section of the Kimberley coastline came distantly into view. One hundred and eighty-four years before us the redoubtable Captain Phillip Parker King had reluctantly beached his badly leaking survey vessel *Mermaid* off this notoriously tidal part of the coast. While repair work was being carried out King had sent off 23-year-old surveyor John Roe with a small party of rowers to make an upstream reconnaissance of what at that time was an uncharted and unnamed river. On Roe's successful return with his party intact King duly named the river in his honour.[14] Seventy years later Joseph Bradshaw had made his first discovery of 'Bradshaw' paintings along an upper stretch of this same river. Today, however, our mission was to make some fresh discoveries of our own.

Even by Kimberley standards, the Roe River's tributary Wullumara Creek above which we began our descent is remote in the extreme, with no human habitation for hundreds of kilometres in any direction. Yet the

landscape had by now an almost familiar 'feel' to it. A cluster of huge, bizarrely shaped rock outcrops, some resembling huge mushrooms, stood out amidst pockets of oasis-like vegetation, these in their turn contrasting with the semi-arid character of so much of the country that we had crossed during our flight. Our touchdown was on a rock platform that lay some 50 metres from the largest outcrop.

Gathering up our ever-vital backpacks we shouldered our way through some patchy undergrowth and skirted around the outcrop to the side furthest from the helicopter. Although the nearby creek was running at but a shadow of its Wet season volume, the patches of oasis-type vegetation that it irrigated were as beautiful as anything that we had seen back at the Mitchell Falls. Tim directed us to where a wide overhang with a deep recess

At Wullumara Creek, several of the mushroom shaped outcrops that the Kimberley's artists of all periods delighted to use as 'canvases' for their rock paintings. This site lies within a few kilometres of where Joseph Bradshaw discovered the first 'Bradshaw' paintings in 1891

formed a natural shelter area. The ceiling of the overhang was low, forcing us to lie on our backs and slide beneath to be able to view it properly. Upon our doing so, however, both it and the low surrounding walls could be seen to be covered with paintings from every variety of art period. Once again, as at the Chamberlain Gorge, there was that eerie feeling of the presence of the brown-skinned artists who thousands of years ago had lain on their backs on these very same spots to create these paintings. This time Lee had not omitted to bring her camera and while she and Judith clicked away industriously I again found myself quietly assuring those old artists' spirits that we came respectfully, and in peace.

Undoubtedly the largest and the most spectacular of the paintings we viewed in this manner was the 'yellow Bradshaw' that Tim had spoken of the previous day (see overleaf). The head was nearest the exterior of the shelter, with the body stretching into the interior, so that we viewed it 'face to face' as we lay under it. As near as we could determine it was life-size, and unmistakably a Tassel Bradshaw, though definitely not of this genre's highest quality, the anatomical detail being less well defined and the tassels having a 'grass skirt' jauntiness to them. Equally characteristic of a high, albeit not highest, Bradshaw phase was an exaggeratedly long headdress with large whisk-like end decoration. This was neither as upward-pointing as the classic male 'wizard hat' mode, nor as backward-leaning as those that I provisionally identified as female, the gender therefore being 'undetermined'. From armbands at the elbow hung fern-like decorative attachments that Walsh has categorised as 'Willow Leaf'. A curious and yet to be properly understood feature of the figure's hands was that these either ended in crab-like pincers (for which Walsh's publications offered no precedents), or these were very small, thin, crescent-shaped boomerangs—it was impossible to determine which.

Inevitably of major interest was the figure's unusual coloration, being delineated throughout in a yellow ochre, quite unlike any Bradshaw that Walsh had published thus far. We would find similar coloration on smaller Bradshaw figures elsewhere in this same outcrop, the pigment almost certainly being limonite, occasionally found bedded in ochre deposits between layers of white kaolin and red ochre. While one such deposit exists

The near life-size yellow 'grass skirt' Tassel Bradshaw figure at Wullumara Creek, painted by the artist while lying on his back

over 900 kilometres eastwards at Green Ant Creek[15] in the Northern Territory, the fact that the same yellow has been used at this same site for paintings dating from other, later periods suggests that the Wullumara Creek artists had some more local, though as yet unidentified, source.[16]

Besides this yellow colour, another unusual feature was that the figure's limbs had been hatched in transverse stripes, as if the artist was economising on filling in with solid colour throughout. Given this distinctive line-work, and the figure's location on the ceiling of a low overhang that provided maximum protection from direct sunshine and driving rain, there had to be a fighting chance of some facial detail having survived—had facial detail ever been there in the first place. But while something decorative could be vaguely glimpsed all around the crown of the head, there seemed to be absolutely nothing that could confidently be construed as facial features. The possibility remained, therefore, that the Bradshaws might have been intended as faceless Wayang-like 'shadows'.

One feature quite impossible to mistake about this yellow Bradshaw figure was that it was one to which incoming, Wandjina-venerating tribes had taken a great exception. Painted in a red ochre outline, and directly superimposing it, was a Wandjina figure with that genre's characteristic ray-like circular headdress. The sole purpose of this piece of overpainting would seem to have been to 'usurp' the yellow Bradshaw figure's magic, much as incoming Egyptian Pharaohs often had their names cut over those of their predecessors, where these had been inscribed on monuments and temples, in order to 'stamp' their authority over all who had gone before.

But this site was very far from being confined to just Tassel Bradshaws and Wandjinas. Unmistakably of relatively recent origination was a huge multi-coloured ceiling painting of a male sporting a tree-trunk size penis advancing this towards an apparently very receptive female—the sort of sexual explicitness that the 'Bradshaw' culture with its gender-unspecific figures seems to have shunned. Towards the back wall a Rainbow serpent, a highly potent python-like creature of Aboriginal mythology, curled provocatively just a little to the left of the yellow Bradshaw figure's thighs. On an adjoining wall a group of at least three Clothes Peg figures stood in poses that Walsh categorises as 'Standing Wide Spread-Legged'.

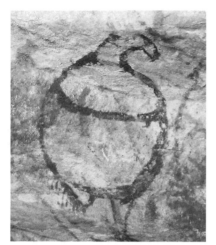

Humpty Dumpty of the bird world?
An unidentified bird species depicted at
Wullumara Creek

On an upper register there were arrayed long-necked tortoises of a kind that Walsh dates to his Archaic Epoch, that is, the era preceding that of the high Tassel and Sash Bradshaws. There were also three figures closely resembling those in the Little Mertens 'Battle Scene', their feet facing in opposite directions, this latter being a characteristic that Walsh associates with their belonging to a phase late in the Erudite period. These figures had a limpness to them as if they were victims of hanging, though it was impossible to be sure.

Another panel featured two birds with parrot-like heads, below which there bellied out enormous, egg-shaped bodies. The birds' chunky legs looked far too large to be retractable for flying purposes, even were there any indication of wings, which there was not. A perhaps extinct flightless species so far eluding identification, style-wise these birds seemed best equatable with Grahame Walsh's Clawed Hand period, which he dated after the era of the Clothes Peg figures but before that of the Wandjina.[17] In a foot-to-foot relation with these birds were depicted some clearly recognisable flying foxes, large fruit-eating bats that are common all around Australia, indicative that the artists were certainly not incompetent in their observations of the wildlife around them.

Along one low wall there was a cluster of lively though poorly defined Bradshaws which stylistically bore quite a close resemblance to those that Joseph Bradshaw had found along the Roe River only a few kilometres distance from us. Further along this same set of walls there were more Clothes Peg figures. Oddly, these were accompanied by large boomerangs, and the figures seemed to be wearing sashes hanging from a clearly defined belt. Equally curious, though we had observed much the same amongst some of the Clothes Pegs along the Little Mertens Creek route the afternoon before, their hands and feet repeatedly seemed either obliterated, or absent. This was a puzzle which Grahame Walsh had likewise repeatedly noted of Clothes Peg figures, assuming that the missing areas had been painted in

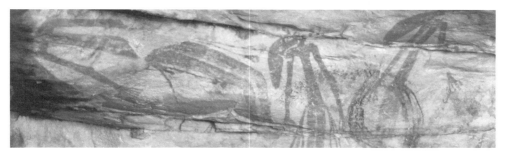

More yellow Bradshaws on a wall forming part of the same rock complex also featuring the yellow 'grass skirt' figure

'fugitive' or less durable colours and had simply abraded away. As we were about to discover, however, another outcrop at this same Wullumara Creek site bore some intriguing and totally unexpected clues as to why this should be the case.

This rock outcrop, smaller than the first, lay some 60 or 70 metres to the north and again featured a low 'on the ceiling' gallery of artworks, to view some of which we were again obliged to lie on our backs. Clothes Peg figures were once more to the fore amongst the usual profusion of other styles. But the interesting feature about these particular Clothes Pegs (see overleaf) was that there was a faint but unmistakable haloing visible in the areas where their feet should have been. Close inspection of this haloing revealed it as an admirably subtle artistic imitation of the stencilled negative hand imprints that we had come across four days earlier along the Chamberlain Gorge. As may be recalled, Grahame Walsh had ascribed these latter hand imprints to the Archaic Epoch preceding the Tassel and Sash Bradshaw era. This had therefore to be considerably earlier than the Clothes Peg era to which these figures above our heads in all other respects clearly belonged.

As cannot be emphasised enough, these were not stencils from real-life human feet. These particular Clothes Peg figures, and the 'feet' belonging to them, were painted substantially smaller than life-size, therefore they could not derive from imprints of actual feet and hands. But the implications are nonetheless profound. Readily explained is why hands and feet are so commonly missing on Clothes Peg figures all around the Kimberley. Walsh

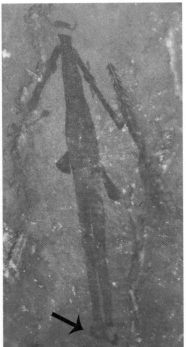

On an outcrop separate from that with the yellow 'grass skirt' figure, one of three Clothes Peg style figures showing pseudo-stencilled foot imprints (arrowed). These seem to have been imitations of the actual stencilled hand and (occasional) foot imprints popular during the Archaic Epoch

had supposed that the paints had simply flaked away because the artists had used 'fugitive' colours. Yet the real reason was surely that the figures' hands and feet were often lightly sketched in negative imprint form, to imitate the real-life stencilled hand imprints that had been customary during the Kimberley's Archaic Epoch. Once this fact is realised, faint indications of pseudo-stencilled hand and foot imprints can be glimpsed on many of the Clothes Peg figures that Walsh reproduces in his books.[18] It is simply that no-one would ever have expected Clothes Peg hands and feet to be rendered in this form, had we not seen the clear examples before our eyes here at this Wullumara Creek 'art gallery'.

So if the Clothes Peg people were imitating this more ancient art form—and from the number of missing hands and feet, they were doing so in quite a big way—what does this tell us about their relationship to those who had lived in the Kimberley back in the Archaic period? Does it mean that the Clothes Peg people may have been not so much invading newcomers, but actually descendants of earlier, Archaic incumbents of the Kimberley who had been supplanted by incoming Tassel and Sash Bradshaw people? A people perhaps not as advanced culturally, had they stayed on somewhere in the background and were they now, thanks to their development of multi-barb spears and some warlike strategies to accompany these, possessed of the wherewithal forcibly to win back their ancestral lands?

Whatever the answer, this clearly once well frequented Wullumara Creek 'art gallery' had yet more artworks awaiting our scrutiny. On the same outcrop bearing the Clothes Peg foot 'stencils' had

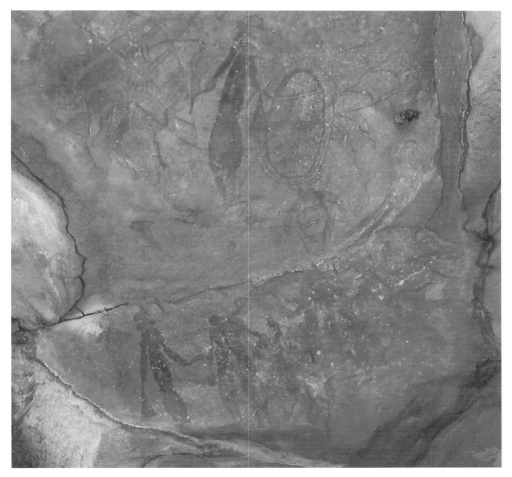

Clothes Peg-style figure of the possible 'Great Mother' type painted high up on the underside of the Wullumara Creek overhang. This and the row of figures below her are very far from the quality of the best Tassel and Sash Bradshaws. Great uncertanity surrounds the identification of the turtle (?) shapes to the right of the main figure

been painted a similarly very simplistic, seemingly naked figure with wide hips and an 'Afro'-type hairstyle. He or (as the wide hips suggested to me) she was holding a large leaf in the left hand and what looked to be a Tassel Bradshaw-type 'tassel' in the right, this latter item thereby seeming to have been something rather more than a mere decorative belt appendage.

Nearby another figure was in the pose that I earlier described as indicative of the archetypal 'Great Mother'. This particular figure again seemed to be wearing full-blown 'clothes'—in this instance a relatively short skirt strikingly reminiscent of the early 1960s 'A' line fashion. To this figure's right was a smaller figure, seemingly male and seemingly unclad, carrying boomerangs. But most spectacular of all was a figure painted beneath a soaring overhang smaller than, though reminiscent of, that at the Chamberlain Gorge (see previous page).

On the lower part of this particular overhang there were some figures belonging to a late or possibly regional phase of the Tassel and Sash Bradshaw periods. Suggestive of this being a regional style, these had that less clearly defined, more impressionistic quality of those first discovered by Joseph Bradshaw. One had its arms in the 'Great Mother' pose, a pair of boomerangs in one hand and either a whisk or a dilly bag in the other. This figure's headdress bore no resemblance to those of the Tassel and Sash phases, instead sprouting out on some kind of stalk like a hat-sized mushroom.

But once again dominating the overhang ceiling was a figure in the 'Great Mother' pose, this particular example again quite unmistakably wearing a full skirt, though longer and more tapering towards the feet than the one of the 'A' line variety. Reminiscent of the manner in which monarchs of later civilisations carried their orbs and sceptres, this particular figure carried in its right hand a crescent-shaped boomerang and in the left a more angular boomerang and dilly bag. Once again there seemed to be a mushroom-like adornment on the head.

Uniquely, immediately to this figure's right was painted something large and oval-shaped with running bands across it. Below this was something rather similar, except that the lower end terminated in a point. Judith suggested that these two features might be the shells of turtles, the lower one including flippers. Kimberley zoologist Len Zell has broadly agreed with this interpretation, remarking that the outer ring on the bigger oval actually corresponds quite well with the Kimberley green turtle's ring of marginal plates. Ian Levy, an Australian geologist with wide experience of ethnic communities around the western Pacific, has also pointed out that for a number of such communities the green turtle shape sometimes associated

with the *tanoa*, the four-legged bowl from which kava is drunk, remains to this day something very special, representing the centre of the tribal communal spirit.[19] The turtle has also continued to be a great food delicacy amongst Aboriginal peoples. So was this particular 'Great Mother' mistress of the turtles?

Whatever the ultimate interpretation, everything about this Wullumara site indicated that in its heyday the communities who lived there enjoyed idyllic, Garden of Eden-like surroundings throughout a series of different periods. They would seem to have grown yams and other tuber vegetables in the vicinity, for one art section included a whole row of such tubers in their various forms. The Worrora, as the site's most recent occupants, would also seem to have associated the site with fertility in all its forms, as indicated, not least, by their so robust depiction of sexual intercourse.

All too obvious to us was that this Wullumara Creek 'art gallery' needed far, far more time to be studied properly, quite impossible with our tight schedule, and indeed quite impractical without the mounting of a special mini-expedition all of its own. As we returned to the helicopter and became airborne Tim took us towards the northward-flowing Mitchell River, then at one point dropped us down below normal cruising height in order to point out some fine Bradshaws that had been painted on a rock wall along the river's side. At Lee's urging he took us down to as low as he dared, then hovered, from which we could just make out that these were Sash Bradshaws of medium quality. This riverside location only served to strengthen our ever-growing impression that boats were the principal means of the Bradshaw people's moving through this ancient landscape.

We had now travelled as far west as we would get during this field trip. As we regained height, and headed onwards towards the campground, we passed over two rows of stones, carefully placed to lead up to what appeared to be an elongated pit, presumably used for ceremonial purposes by Aboriginal inhabitants. People-wise, now only an empty landscape stretched below us. It seemed obvious that it had to have been far more populous at the time of the Bradshaw people, necessitating a climate and a plant environment that was then far more conducive to human habitation than in recent millennia. But still we were accumulating more questions than answers.

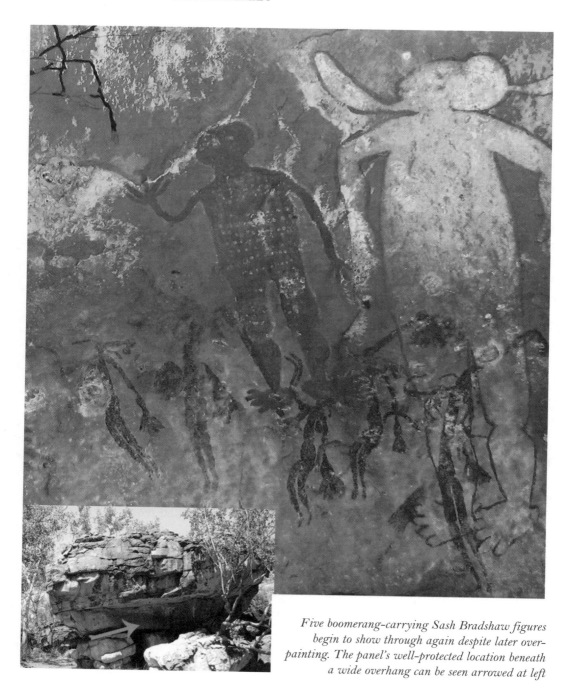

Five boomerang-carrying Sash Bradshaw figures begin to show through again despite later over-painting. The panel's well-protected location beneath a wide overhang can be seen arrowed at left

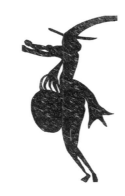

CHAPTER TEN
Odes to the boomerang

On the morning of Sunday 19 September we broke camp, re-packed the Toyota, and Lee began heading us back on the long hard drive eastwards along the same rough track by which we had arrived. To get to the Manning Gorge, our next destination, we needed first to rejoin the Kalumburu Road, then turn southwards towards Derby. Partway towards the Kalumburu junction a sudden above-normal level of rattling proved to be from one of the Toyota's side-lights, which was hanging only by the wires, its retaining screws having sheared from the excessive vibration. After some very temporary on-road attention we therefore stopped at Munurru to effect a more serviceable repair with padding and sticky tape. And because at this site there remained artworks that there had been insufficient time for us to view during our outward journey, Lee decided to use this fresh opportunity to show them to us.

The first that we came to, much like others that we had seen on our initial visit, consisted of a well-recessed wall panel protected by a massive boulder overhang. By far its most obtrusive features were two obviously later Aboriginal paintings. The larger figure, white outlined in red and near life-size, had an outlandish 'creature from outer space' quality to it. The smaller,

a stocky male painted in solid red, was rather more conventional in style. Both figures had clearly been intended to overpower the older paintings on the rock, just as back at Wullumara Creek the Wandjina had been used to usurp the life-size yellow Bradshaw.

And once again it was the Bradshaws that had been overpainted. These consisted of five Sash Bradshaws that had been painted in the darkest mulberry hue on the lower part of the wall panel. Despite their partial obliteration by the overlying figures, they were now insistently showing through as their successors' lesser quality paintwork faded and abraded. All five figures seemed to be male, at least on the basis of their up-thrusting 'wizard' headdresses and their leg deportment. All were depicted upright and facing towards the left, their stylised limb anatomy indicative of their artists having been among the more proficient of the Sash Bradshaw 'school'.

The first, left-most figure was portrayed 'floating' with a crescent-shaped boomerang in his right hand and a dilly, or collecting, bag in the left. From the end of his long 'wizard' headdress there dangled some kind of bag or whisk. The second figure, immediately to the right of the first, remained virtually entirely obliterated above the waist. Even so, there was enough to indicate that he had originally been substantially larger than the first. He had a large, waist-attached sash trailing behind him, and carried at the level of his stomach a large bag or basket of the same kind that we had seen attached to our 'Bagman' elsewhere at this same site. Vague smudges in the area of this individual's right hand suggested that he, too, was carrying a boomerang.

Though the third figure's headdress remained almost entirely obliterated by the smaller Aboriginal figure's massive red ochre foot, he could otherwise be seen to be carrying paired crescent-shaped boomerangs in each hand, with a large dilly bag additionally in his left. From his shoulders there dangled the device that Walsh categorises as a 'Chilli Armpit' decoration,[1] but which seems to have been the attachment apparatus for the 'Bagman' bag or basket, in this instance without this latter being attached. This suggested to me that even when this bag was not actually being carried, its official bearer or 'bagman' wore this hanging device rather in the manner of a mayoral chain of office.[2]

The fourth figure wore an extraordinarily tall, 'wizard hat' type headdress with dangling at its furthest end a much larger whisk or bag than that sported by the first figure. It may be recalled that we had seen much the same end attachment on the 'wizard' headdress worn by the large yellow Bradshaw figure at Wullumara Creek (see page 126), this in fact being a common appendage to such headdresses, recurring in a number of examples in Walsh's books. Although this fourth Bradshaw figure's right hand remained obliterated by the overlying red figure, he too was not without a crescent-shaped boomerang and a dilly bag carried on the left.

The fifth figure, at furthest right, had been created larger than the others, as if he stood more to the foreground. He was clearly doing a very good job of reappearing after what had once been near total obliteration by the 'whitewash' fill with which the larger of the two overlying figures had been coated. He again sported an exaggeratedly long 'wizard' headdress, though the whisk-type attachment that this carried at its end was altogether more modest than his next-door neighbour's. There was a long sash at his waist. He held a small dilly bag in his left hand. And like everyone else depicted in this same scene he also carried boomerangs, in his case a single specimen in each hand, the one in his left appearing to have been particularly well crafted into the most delicate of crescent shapes.

And if this panel had about it an air of its being some kind of hymn or 'ode of joy' to the

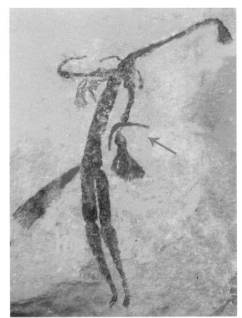

Top: Detail of the fifth figure on the 'hymn to the boomerang' panel, digitally altered to eliminate later, overlying paintwork. Shows (arrowed) a particularly fine crescent-shaped boomerang.
Below: Figure from separate outcrop, lightly photo-edited, also holding superbly shaped crescent boomerang

boomerang, much of this spirit was present in another painting that we came across during this same revisit. A van-sized rock outcrop nurtured beneath its shallow overhang a vertical, light-coloured area that provided so perfect a 'canvas' for a painting, it was as if the rock surface had been specially smoothed and lightened for this purpose, though Lee assured us this was not the case. In its heyday this particular panel had clearly borne a most magnificent scene of possibly three large figures painted to the highest artistic quality. Sadly, vestiges of only one of these survived, and even then little more than the top of the head, denoted by a swept-back headdress, a long arm and a boomerang (see page 137 bottom picture). But again, what a boomerang! Yet another lovingly curved and tapered into crescent shape, it was as if this was the instrument's ultimate design mode.

Immediately again such a depiction indicates that although no boomerang specimen from the time of the Bradshaw paintings has ever been found in the Kimberley—hardly surprising, anything of wood normally being eliminated by termites—the Bradshaw people may nonetheless be perceived as having been absolute masters of good boomerang design. A design, moreover, that embodies essentially the same aerodynamic principles as those by which a helicopter flies, and with returning properties that need mathematical formulae to express them. Even within a single Bradshaw panel painting sometimes several different shapes and sizes of boomerangs are represented, consistent with the Bradshaw people having developed a system of different types for different purposes, every bit as sophisticated as a keen golfer's set of golf clubs.

And it is not as if the Aboriginal peoples encountered by the first Europeans to arrive in Australia were any less proficient in this same department. Amongst them, too, the shape, the size, the thickness and the returnability of each individual boomerang were carefully tailored to whatever purpose the implement was intended.[3] Thus one variety of boomerang was made small, light and angular to hit small and medium-sized birds such as duck. These would readily return to the hand in the event of a 'miss'. Another variety was made slightly larger and heavier, and formed in much the same crescent shape. These were designed to bring down fast-moving wallabies and other young marsupials. Consistent with the matching

pairs that are so often seen in Bradshaw paintings, two identical boomerangs would be carried so that if one missed its mark, the hunter could suitably adjust his throw for the other. Heavier, straighter boomerangs were intended to stun or to otherwise temporarily disable larger animals such as a full-size kangaroo, the hunter then quickly running up and despatching the animal with his spear. For inter-human combat Aboriginal people had yet larger size boomerangs that could batter an opponent as if with a broadsword. There were even sharply angled, thick-bladed boomerangs specially designed to be thrown at large fish when these congregated in shallow water at low tide.

And besides the boomerangs' primary purpose, for different forms of hunting, almost every variety could serve for one or more secondary tasks. At ceremonies, matching pairs could be twirled as batons and clapped together for musical accompaniment in the manner of castanets, something certainly suggested in some Bradshaw paintings,[4] and quite definitely still practised by Aboriginal people living around Australia at the time of first European settlement. Paired boomerangs could be rubbed together to kindle tinder for fires, some museum specimens showing burn marks at one end consistent with such use. Individually they could be used for food plates and for digging up tubers and roots. Light carvings or paintings on their sides could serve as aide-memoire maps of local water-holes.

Obviously, therefore, the boomerang's versatility and sophistication as an instru-ment—particularly if the Bradshaw paintings genuinely date back to the Ice Age, a time normally associated with the crudest of stone

Traditional Aboriginal man with boomerang. The prevalence of boomerangs in the Bradshaw paintings inevitably raises the question of how far back in time boomerang usage can be traced

axes—raises some very interesting questions. Among these are not only how and when it became introduced into Australia but, even more fundamentally, how, when and not least where it first originated anywhere. Such questions we will not fail to address in proper detail later.

But in the interim, quite evident from all that we have seen so far is that there was an extraordinarily long period of retention of much the same shapes and sizes of boomerang, all the way from the time of the Bradshaw people to that of traditional Aboriginal people who were occupying Australia at the time of European contact. This surely suggests there to have been some form of link between the two that was stronger, and lasted rather longer, than Grahame Walsh has so far allowed for?

Ironically that link has actually been weakest in the Kimberley where, in marked contrast to elsewhere in Australia, those Aboriginal people who

Frizzy-haired (left) and 'wizard' headdress Tassel Bradshaw figures side by side on a Munurru panel—indicative of a mixed population?

were encountered by the first European explorers, such as Joseph Bradshaw, were specifically noted not to be using boomerangs.[5] This actually suggests that if we were looking to trace surviving descendants of the Bradshaw people anywhere in Australia the Kimberley might actually be the last place, rather than the first place, to direct our search.

But important also to be allowed for is that even back in the time of the Bradshaw people the Kimberley's population may not have been any one 'pure' genetic strain, but instead a mixture of peoples at different stages of development. And two further art sites at Munurru illustrated this possibility particularly well.

The first of these depicted just two figures belonging to Walsh's Tassel phase that had been painted in red on a rock adjoining the five Sash Bradshaws. Both

figures had been very freely delineated, as if rapidly executed sketches, and neither seemed to be carrying any weapons. The smaller of the two had a classic 'wizard hat' on his head, also a 'grass skirt' style tassel waist attachment. Of altogether greater interest, however, was the larger figure on the left, and in particular his or her hairstyle. This was unmistakably frizzy, therefore atypical of most present-day Australian Aboriginal people (excluding Torres Strait islanders) and much more akin to some of the inhabitants of Papua New Guinea and of other western Pacific islands nearest Australia. While frizzy hair was sometimes indicated in other Bradshaws this particular painting has to be one of the largest and clearest depictions of it. And from the immediate proximity of the 'wizard hat' figure, also from the absence of any weapons, this strongly suggested that the Bradshaw people comprised a mixed population of peoples of both straight-haired and frizzy-haired racial type. It also indicates that they were living in relative harmony with each other, much as (in both instances) still pertains on Papua New Guinea to this day.

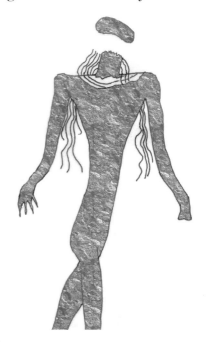

The second painting to suggest such racial mixture was one which Western Australian Museum archaeologist Ian Crawford had published in a scholarly article written back in 1977.[6] Although Crawford quite definitely described it as being at this Munurru site we failed to find it amidst the confusing jumble of different outcrops. However, its appearance is well enough known from Walsh's photographs.[7] Nearly a metre high, this features a single, front-facing, seemingly male figure with his legs depicted in mid-stride, giving him a very dynamic, 'frozen action' quality. As commonly found amongst Walsh's Clothes Peg figures, there is a curious blank space where the facial features should be. Stylistically it is neither wholly Clothes Peg phase, nor is it wholly Elegant Action, but would certainly appear to belong to a time closely following that of the Tassel and Sash Bradshaws.

Interpretative drawing of long-haired figure on the panel that we did not find at Munurru

The particularly special feature to it, however, is the long, wavy hair extending to the waist. Hair of this kind denotes a completely different physical type to the frizzy hair equally clearly depicted on the painting that we were able to examine directly. Self-evidently even many millennia ago the Kimberley was somewhat of a multi-racial society, just as all Australia is today—all causing us to reiterate those ever-nagging questions: who exactly were the Bradshaw people? Where did they come from? And not least, what happened to them?

Our reacquaintance with Munurru completed, we once again rejoined the Kalumburu road, heading south, where soon the acrid stench of bushfires again began assailing our nostrils. Thankfully the road surface was now more regular, and by mid-afternoon we reached the Mount Barnett campground, the recognised base camp for exploring the Manning Gorge. This had more 'facilities', albeit only of the toilet and shower variety, than we had seen at any time since leaving El Questro. To our delight it included a magnificent boab tree, under whose protective branches we duly pitched our tents and as usual dined well. Apart from some unnerving close perambulations by a wild bull—in the Kimberley it has long been common practice to conduct cattle grazing as a free-range endeavour, without the aid of fencing[8]—the night passed uneventfully.

The next morning we donned full bushwalking gear to negotiate the long and in places strenuous terrain leading to the Manning Gorge, where Lee had some more Bradshaw rock paintings to show us. Early along the route, which initially circuited a beautiful lagoon, she pointed out amongst the surrounding rocks another example of classic Wandjina paintings having been completely obliterated by inexpert and insensitive modern day 'restorers'. Further along our track took us across open ground that had recently been ravaged by an uncontrolled bushfire. Alone amidst an otherwise almost entirely blackened landscape there stood a forlorn kurrajong or 'Kimberley Rose', most of its leaves dropped away because of the Dry season, yet still defiantly displaying quite spectacular red flowers. Exactly as in the case of cycad kernels and yams, the kurrajong's seed pods were recognised amongst traditional Aboriginal people as a good food source, and even to have medical properties. Roasted or pounded into a powder they could be used as a flour,

while moistened into a paste this same powder made an excellent poultice for treating boils and open sores.

After further cross-country walking, some of it uphill, and punctuated by frequent recourse to our water flasks, our trail began descending into a gorge even more dramatic and spectacular than that of the Chamberlain. Prosaically named Manning by whites, for local Aboriginal people this is Wadningningnari,[9] meaning where 'she looked back like a snake'. It is revered as a site where one of the creator snakes came to rest. As we walked down a track leading to the riverside, to one side of us there lay a beautiful rock pool, which during the Wet was fed from a spectacular waterfall. Lee pointed out that because of the still indiscriminate burning ravaging the region this waterfall was now drying up much earlier in the year than was once normal. Also the river's edge was becoming increasingly denuded of the shade-giving palms that formerly grew in abundance around it.

But whatever stress the site may be under today there can be no doubt that back in the time of the Bradshaw people Wadningningnari was a palm-fringed paradise of rust-coloured rock, cascading waterfalls, and a river that teemed with fish and bird-life. And if we might by now expect Bradshaw artists to have left on the surrounding rocks some record of their gratitude for nature's gift to them of yet another Eden of this kind, we were not disappointed, even if time had once again taken a heavy toll.

For on the soaring rock wall backing a wide waterside rock platform we came across what had clearly once been some absolutely magnificent Bradshaws. The main panel had been painted on the west-facing rock running parallel with the river and it consisted of at least three life-size figures of Sash or Tassel type, one quite definitely with a long headdress. Even though very little of these could any longer be glimpsed, they had clearly originally been of the highest quality, as befitting such a spectacular geographical setting. Just a little more visible was a male figure with 'wizard' headdress that had been painted on a shallow south-facing side wall. Wearing a sash, and with rather wide hips, he seemed to be flying towards the figures on the main panel, rather in the manner of a heraldic figure or an attendant angel.

But thankfully this was not all that awaited us at Wadningningnari. In a manner typical of the Kimberley the river was not in continuous flow at this

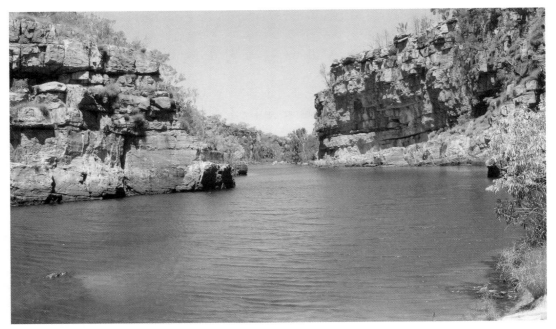

Wadningningnari, renamed the Manning Gorge by white settlers. A view down the gorge from the 'oasis' area with waterfall. Exactly as they did along watercourses elsewhere in the Kimberley, Bradshaw people decorated the rock sides with paintings, often choosing locations with wide platforms suitable for ceremonies to be conducted

stage of the Dry but was punctuated by dried-up sections, as a result of which Lee was able to lead us across to its eastern bank. There after several minutes' walk northwards we came to what at one time had obviously been another stage-like rock platform. This had become broken into large rock fragments, presumably from the force of the river at times of extreme Wets, and probably several millennia ago, judging from the subsequent bacterial build-up on those rock surfaces that had been exposed by the disintegration.

High above this rock rubble there soared another Bradshaw panel, this time one in altogether better condition than those on the west bank. Two Tassel Bradshaw figures with long trailing hairstyles—females according to my provisional interpretation—were looking up towards a commanding figure standing in the now familiar 'Great Mother' pose. All three figures seemed to be wearing full-length dresses, the 'Great Mother' additionally

having a flared 'grass skirt' rather reminiscent of that on the life-size yellow Bradshaw at Wullumara Creek.

But the most important feature of this particular scene was the attitudes of the two subordinate 'females'. These strongly suggested them to be *venerating* the 'Great Mother'. In particular the left of the lower figures was holding up to the commanding figure what appeared to be some kind of flower—perhaps a Kimberley rose? The repetition of the 'Great Mother' pose amongst other Bradshaw art strongly suggested this figure to represent an individual of considerable importance, further indicated by the commanding location in which this same figure was often painted. But this particular example also suggested that this individual was being worshipped. So were we now looking at some seriously compelling evidence for the Bradshaw people having been devotees of some kind of Mother Goddess cult?

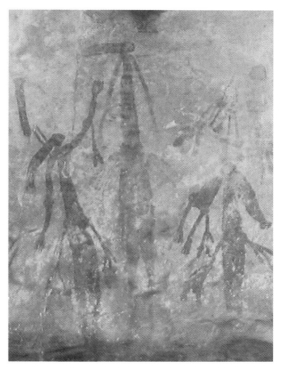

Veneration of the 'Great Mother'? Two Tassel Bradshaw figures behaving in a way suggestive of veneration of the higher central figure, whose arms are in the 'A' gesture associated with the 'Great Mother'

A huge difficulty, as Lee stressed to us, is that deities were not part of traditional Australian Aboriginal culture as this had existed, undoubtedly for thousands of years, at the time of first European settlement. The very male-centred nature of Aboriginal society likewise made the cult of any kind of 'goddess' particularly unlikely.

But this was not to say that Australia has never seen some kind of 'Great Mother' cult at any time in its distant prehistoric past, for there is definite evidence of a one-time much greater female role in early Australian society. A.P. Elkin, a most conscientious early twentieth-century Australian

anthropologist, included in his book *The Australian Aborigines* a five-page section specifically entitled 'The Mother Goddesss Cult'. In this he pointed out that certain rites 'mainly concerned with fertility in man and nature' now carried out by the men were 'originally . . . the possession of the women'.[10] Elkin also pointed out that there was a definite ancient tradition of a mother goddess cult that was particular to northern parts of Australia, from the Kimberley eastwards to Cape York. According to this tradition:

> Kunapipi, also known as Mumina and Kadjeri, and exoterically as 'the Old Woman' travelled across the land with a band of heroes and heroines . . . She gave birth to men and women, and by her ritual acts, caused natural species to appear . . . The fertility-mother concept was probably an importation into Arnhem Land from across the sea, as the myths suggest . . . The mother-goddess or fertility-mother and serpent cult [predominated] in most of the northern half of the Northern Territory and latterly in Eastern Kimberley.[11]

So whether this particular 'Old Woman' was named Kunapipi, Mumina, Kadjeri or something else, were we looking at the Tassel and Sash Bradshaw people's equivalent of a mother goddess on this rock painting high above us in the Wadningningnari Gorge? Whatever the answer, on that particular hot afternoon in the Kimberley the nearby river looked far too inviting not to take a cooling swim. And this we did—again thinking of all those who had done much the same throughout previous millennia—prior to gathering up our backpacks and commencing the long dusty trek back to the Mount Barnett campground.

We had now reached the southernmost part of our tour of 'Bradshaw' territory, and the next morning it was time for us to head back to Kununurra. En route Lee stopped to show us some Aboriginal paintings at a site called Enby Rock. Here there were no Bradshaw paintings. The contrast to some of the so oasis-like sites with Bradshaws could not have been more marked. To me, Enby Rock had an almost palpable sinister feel to it, exacerbated by several 'Ulu' sorcery figures painted as guardians of an area Aboriginal men reserved for male Aboriginal initiates. It was accordingly no surprise to

me to learn from Lee that her Aboriginal colleague Ju Ju 'Burriwee' Wilson adamantly refuses to go anywhere near Enby Rock. Superstition or no, all my sympathies were with Ju Ju!

Descended from Aboriginal Lawmen,[12] Ju Ju shares Lee's deep concerns for the dangers that the Kimberley's ancient paintings and fragile ecosystems currently face from the extinction of their old traditional guardians. Full of smiles when I

The author photographed at Kununurra, the gateway town to the Kimberley, with namesake, 'cousin' Ju Ju Wilson

greeted her as 'my cousin', she expressed her full support for any book that would draw these problems to public attention.

But for the present our Bradshaw adventure trail was far from over, for everything that we had seen so far consisted of inland sites which the Bradshaw people would seem to have reached by river. Now our explorations were to switch to the Kimberley's northern coast, where our base was to be a 'permanent' bush camp picturesquely called Faraway Bay.

CHAPTER ELEVEN
A Bradshaw 'Lost City'?

Having bade temporary farewell to Lee, by breakfast time on the morning of Wednesday 22 September we were aboard a tiny Slingair six-seater Cessna Skyhawk, our destination Faraway Bay, one hour's flying time to Kununurra's north-west. While we were still at low altitude pilot Brendan began pointing out landmarks below us. Not far outside Kununurra we passed over Ivanhoe Crossing, a deep ford over the Ord River which Lee, detouring to show us a billabong, had taken us across at dusk only the night before. In the distance to the west we could just make out the tiny port of Wyndham, tucked into a western arm of the Cambridge Gulf, where Joseph Bradshaw had landed back in 1891 to begin the expedition on which he would discover the first 'Bradshaws'.

A little further to the north came into view Adolphus Island, discovered by Captain Phillip Parker King in 1819. This he had named, along with the Cambridge Gulf itself, after Adolphus Frederick,[1] Duke of Cambridge and viceroy of Hanover, a leading dignitary of the then still very Germanic British royal court. King had circumnavigated Adolphus Island for 25 miles without seeing any sign of life, human or animal, except for a huge colony of bats, which literally blackened the sky on their being disturbed by the rattling of

the *Mermaid*'s anchor. At the head of the gulf to our right we passed Lacrosse Island, where King's crewmen had gleefully caught a magnificent hawk's bill turtle which they found lumbering up the beach. This unlucky creature had provided them with no less than 70 pounds of fresh meat.

When our Cessna had reached the mouth of the gulf, Brendan changed course for us to skirt the Kimberley coastline in a north-westerly direction. On the aircraft's starboard side sparkled the broad expanse of the Timor Sea, our first proper viewing of it at close range. Surveying it from our cruising height of 5000 feet, it needed a major effort of the imagination to appreciate that back in late Ice Age times almost everything that lay below us, as far as the eye could see, comprised a vast plain (see map page 208). Dotted no doubt with lakes, rock gullies and extensions of the present river systems, this had to have been one of the world's most equable and most livable locations at a time when much of the rest of the planet lay shrouded beneath thick ice sheets. If the Bradshaw people had genuinely lived back in that early era they would have been able to walk all the way to New Guinea, to which the Australian continent was then actually joined. If they had wanted to visit what are now the Indonesian islands, these lay only a relatively short boat crossing to the north.

What a difference, therefore, posed by the formidable, empty sandstone fortress-like present-day coastline. Throughout almost its entire 1000-kilometre length from Wyndham westwards, any landward access to the hinterland is difficult in the extreme. When former mining engineer Bruce Ellison, founder of the coastal bush camp to which we were headed, decided to create a 'get-away-from-it-all' mini-resort along this coast, he necessarily arranged for all raw materials, construction vehicles, literally every nut and bolt, to be brought to the site by barge. Likewise when back in 1891 Joseph Bradshaw had a dream of building his 'Marigui' homestead on the shores of the St George Basin, he purchased a schooner, *The Twins*, especially to transport all the materials that he needed.

Brendan gently eased the Cessna down to 2000 feet to show us one of this coastline's major landmarks, the King George Falls; a stunning sight at their height in the Wet, but now altogether tamer. When Captain Phillip Parker King was surveying the coast, this magnificent waterfall complex so impressed him that he named it after England's King George III, then a

deranged octogenarian dying back in distant England. For the Kwini Aborigines inhabiting the area these falls, along with the King George River feeding them, are known as Oomarri,[2] and as with so many other of the Kimberley's watery locations they have rich Dreamtime mythology attached to them.

Given how frequently we have seen the Bradshaw people to have been particularly attracted to waterfalls, Oomarri was certainly no exception. Oomarri's Bradshaw paintings happen to be virtually the only known examples for which Grahame Walsh has himself provided a location, albeit inadvertently. In his 2000 book he reproduced a photo of 'sheer cliff walls' at 'the King George River Entrance',[3] to the left of which can be glimpsed a wall painting of Tassel Bradshaw figures protected by a wide overhang. This same painting can readily be recognised in an excellent close-up later in the book,[4] with no location information provided. Two of the figures wear the identical 'Willow Leaf' armband attachments that we had noted on the yellow 'grass skirt' figure at Wullumara Creek far to the west. Included in this same scene is an extraordinary front-facing, seemingly reptilian-headed figure whom we would meet again, on a different rock face, within the next 48 hours.[5]

Distantly, amidst the sparse green of the landscape stretching out below us there came into view an unnatural-looking buff-coloured rectangle. Though this seemed unbelievably tiny, Brendan calmly assured us that this was indeed where we were about to land. Within what seemed little more than a minute he took us to a perfect touchdown, the Cessna churning up a thick cloud of dust as it taxied back to where a small group of people were waiting beside a vintage, open-top four-wheel drive Toyota. It was Bruce Ellison's wife Robyn who greeted us, though with the apology that she was leaving by the very same aircraft that had brought us in order to spend some time with family members in Perth. We would, however, be well looked after by Bruce and a small team, prime among them Steve McIntosh, whom Lee had already warmly recommended for his enthusiastic knowledge of the many Bradshaw paintings in Faraway Bay's vicinity.

Robyn duly introduced us to Steve, who drove us in the Toyota the five-minute journey to the bush camp. As he nonchalantly negotiated the steep and bumpy track he explained how he had been working as a

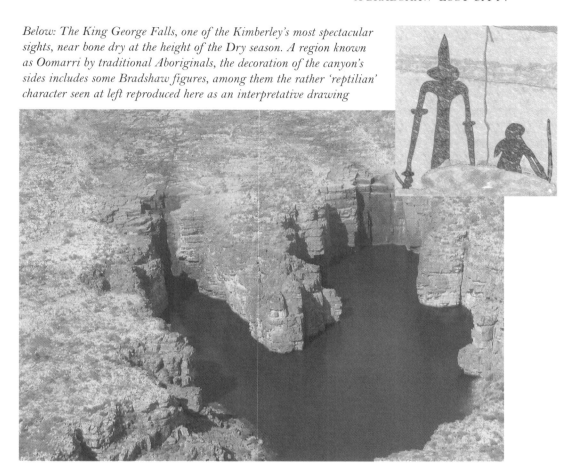

Below: The King George Falls, one of the Kimberley's most spectacular sights, near bone dry at the height of the Dry season. A region known as Oomarri by traditional Aboriginals, the decoration of the canyon's sides includes some Bradshaw figures, among them the rather 'reptilian' character seen at left reproduced here as an interpretative drawing

professional fisherman when Bruce Ellison invited him to work at Faraway Bay catering for those guests wanting to spend most of their time fishing. Because of the short tourist season, also the fact that Faraway Bay never has more than twelve guests staying at any one time, he has plentiful spare time to explore the surrounding hinterland and bays. Lee had been the first to come across Bradshaw sites in Faraway Bay's vicinity, becoming invited to survey these on the Ellisons' behalf.[6] Then as Steve roamed further he kept on finding more.

After a final, roller-coaster descent in the Toyota, Steve brought the vehicle to a halt at what seemed at first sight an unprepossessing collection

Deceptively inviting for a swim—the broad expanse of Faraway Bay, where Bruce and Robyn Ellison chose to build their bush camp. There are Bradshaw paintings even on the rock outcrop in the foreground

of tin-roofed huts scattered each at some distance from the other. The central point, where Bruce welcomed us over brunch, was Eagle Lodge, a broad shady communal area with a long central dining table and a large open kitchen, the roof supported by huge tree trunks. This looked out onto a wide inlet of the Timor Sea that formed one of the most enticing and lyrically beautiful bays that anyone could imagine. Just alongside the dining area lay a rock-pool-like swimming pool which might have seemed superfluous but for the 6-metre-long estuarine crocodiles, the lethal box jellyfish, the venomous blue-ringed octopus and other marine 'nasties' which lurk in the Timor Sea's coastal waters.

After our getting acquainted with our particular 'tin hut'—a very comfortably appointed cabin bedroom with its own private outside shower and 180-degree views of the bay—Steve took us in the Toyota to visit the Bradshaw site most immediately accessible to the bush camp.[7] To reach this involved a ten-minute drive across seemingly trackless bushland leading us to Gumboot Creek, which proved to be yet another classic 'canyon and water-fall' location of the kind so favoured by Bradshaw painters.

At the first, hut-sized rock outcrop that we came to Steve pointed out a figure that was definitely a Bradshaw, though faint and enigmatic. Upright, about half a metre high and seemingly floating in space, the red-ochre-coloured figure was open armed, carried paired boomerangs in each hand,

and a small 'Bagman'-type round bag at the level of the stomach. Whatever may once have existed of the face, someone who clearly held no kind feelings for the Bradshaw people or their paintings had deliberately pounded into oblivion. Almost certainly the figure was a male, judging from the upthrusting 'wizard' headdress, but there was nothing to determine him as either of the Tassel or Sash Bradshaw type, though he certainly seemed to belong to the stage of Walsh's Erudite Epoch.

Undoubtedly the figure's most notable—and most puzzling—feature was an enormous 'whisk'-like attachment at the end of his headdress. Larger than any other example of this that we had previously come across, this one could easily be mistaken for a waterfall behind the figure[8] except that close

On a rock outcrop at Gumboot Creek, a delicately created Bradshaw figure with an extraordinarily exaggerated whisk-like attachment at the end of the headdress. Note the bag-like attachment at the waist, also the paired boomerangs being carried in each hand

inspection revealed the 'flow' to come from the end of the headdress. The painting therefore again raised the still unresolved issue of what such repeatedly exuberant headdress hangings might signify.

Also on this same rock Steve brought to our notice a figure delineated in red, with arms open in the 'Great Mother' gesture, and stick-like legs slightly apart (see overleaf (A)). To the figure's left was a spear-thrower, a device known by Aboriginal people as a *woomera*, and often associated with the multi-barb spears that feature in paintings of the Clothes Peg type. (This was the clearest depiction of a spear-thrower that we had come across so far.) To the figure's right, extending beyond where the hand would be expected, could be glimpsed a vague shape which can be confidently identified as an angle-shaped boomerang because of examples of much the same figure published by Walsh.[9]

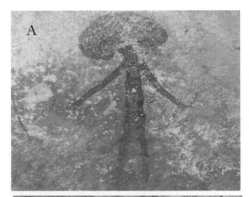

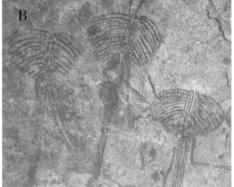

Also at Gumboot Creek, a figure of Clothes Peg type, (A), but with very exaggerated mop-style headdress. (B) Strikingly similar figures found in ancient rock paintings in central Tanzania

Undoubtedly the figure's most distinctive feature, however, was the hairdressing. This sprouted out in a most exaggerated style, resembling something between a brain and the head of a mop. This immediately identified it not only with other Kimberley examples published by Walsh,[10] and with equivalents from the Northern Territory published by George Chaloupka,[11] but also with some strikingly similar examples located much further afield—8000 kilometres across the Indian Ocean in central Tanzania, Africa.[12] In the face of such widespread similarities the alternatives are either that artists working on completely different sides of the Indian Ocean came up with similarly bizarre art forms quite independently of each other—and that has some interesting implications of its own for the human psyche—or that between eastern Africa and western Australia there existed some rather greater contact than has yet been accounted for in our current under-standing of Ice Age intercontinental commu-nications. Could this circumstance somehow be linked to how the East African boab tree came to be introduced into Australia? Still the Bradshaws seemed to be raising far more questions than answers.

On the very next rock outcrop Steve pointed out two very self-important looking Tassel Bradshaw figures that had been painted beneath a wide overhang. On the left stood a tall, upright 'male' with 'wizard hat' and pompoms at his elbows holding what might have been a rod of office in his right hand and a whisk in his left. Facing him was a rather smaller individual, also with a wizard headdress, holding much the same accessories and with a further bag-like object dangling from beneath his armpit. Nearby on another

rock outcrop more Tassel Bradshaw figures had been painted beneath a massive over-hang that had protected them reasonably well. From the very authoritative pose of all these figures it was easy to understand how Joseph Bradshaw had associated Bradshaws with ancient Egyptian art.

Further exploration of the Gumboot Creek environs confirmed it as a gorge and waterfall complex of the kind that had once been much more oasis-like, therefore conforming to the now classic type favoured by the Bradshaw people. This particular foray, however, was but a prelude for the whole symphony of Bradshaw images that Steve planned to show us the next day—at the so-called 'Lost City of the Bradshaws'. This was the site discovered by Steve that I had been looking forward to seeing from Lee's glowing mention of it during our very first telephone conversation.

Early on the morning of Thursday 23 September, therefore, we made our way down the rocky path to Faraway Bay's broad beach where Steve had brought a high-powered fishing boat as close in to the shallows as its draught allowed. As we

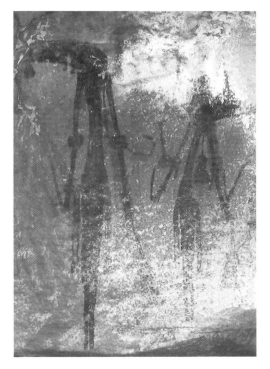

On another rather badly worn rock outcrop at Gumboot Creek two seemingly male Tassel Bradshaw figures, judging by the wizard headdresses and 'parade-ground' stance. Their attitudes are suggestive of the formality more familiarly found in art of the ancient Mediterranean, such as ancient Egypt and Minoan Crete

splashed through the surf and clambered aboard Steve gently eased the vessel clear. Soon we were in deep water where he opened up the twin outboard motors to take us out into the Timor Sea, and after passing some low-lying islands we began heading back towards the mainland. Nosing the boat gently towards a lyrically beautiful stretch of coast where a low cliff of vegetation-covered rocks was fronted by a long sandy beach, Steve dropped anchor and invited us to wade ashore.

For the first time we were approaching a Bradshaw site from the sea—albeit a sea that would have been a lot further away back in the Bradshaw era. So many of the places that we had visited with Lee had been totally deserted, yet somehow this one carried with it all the feel of our being about to explore a Robinson Crusoe uninhabited island. With Steve strolling nonchalantly ahead of us barefoot, we pushed our way through some preliminary undergrowth, then began clambering up a steep rock path that seemed strangely to have been specially prepared as such. Amidst this otherwise so empty landscape the highly polished rocky 'steps' most uncannily evoked the ghosts of thousands of feet—no doubt nimble and barefoot, like Steve's just in front of us—that had ascended and descended them millennia before our time.

A little breathless, we neared the cliff-top's crest. Set off just to the left of our path we noticed a natural rock platform in the manner of a sentry station. On its back wall was a rock art panel that seemed designed for paintings—and, sure enough, had been so used. This had on its right-hand side a faint but unmistakable Tassel Bradshaw figure that had been defaced in much the same manner as the Gumboot Creek figure, though the tassels of the lower half of the body remained distinguishable. To the figure's left there were some strange shapes that seemed to represent two animals one atop the other. Although while we were on site we thought these might be echidna, Australia's equivalent of the hedgehog, more leisurely study later suggested a long-necked turtle[13] lying on its back supported by another the right way up. As earlier mentioned, the long-necked turtle has traditionally been prized by Aboriginal people as a food source, much as Captain Phillip Parker King's men had delighted in the hawk's bill variety that they caught on Lacrosse Island.

Making our way past the 'sentry post' we reached the top of the cliff, where suddenly the view around us opened out to a broad vista of 'block'-like rock outcrops strikingly reminiscent of a small town. It was immediately obvious why Steve and Bruce liked to call this a 'Lost City'.

At the first of the outcrops, tucked away in a crevice, Steve pointed out a fairly nondescript painting of two tall thin figures carrying spears. Leading us across the 'street' he showed us down a 'side street' a broad panel featuring a half life-size Tassel Bradshaw with 'wizard' headdress standing next to a slightly large individual with very 'freaked-out' hair closely reminiscent of

156

the example we had encountered at the Gumboot Creek site. Elsewhere on this same outcrop had been painted, in a cruder style, what seemed to be a row of mice with all the appearance of their having been caught 'freeze frame' on a time-lapse camera.

In many places in the 'streets' and 'piazzas' between the rock outcrops, sorghum grass was growing as high as the tops of our heads. Even so, it needed comparatively little effort of the imagination to envisage at least something of what this place must have been like back in its Bradshaw heyday. In my mind's eye I saw lithe figures everywhere on the rocks around us, calling out to each other, carrying out domestic duties, or quietly creating yet another image of themselves and their lifestyle on the walls.

In the case of the next outcrop, located a short stroll across the first 'piazza' that we had come to, it was necessary to scramble up to a high rock platform to view its artwork. Even so, this was well worth the effort. The most prominent figure was a superb, dark mulberry-colour Tassel Bradshaw with very squarely 'T'-shaped shoulders (see page 159). In this instance its facial features had been spared any vandalism, revealing their shape as rather more reptilian than human. This might have seemed an aberration due to the head being positioned on a long transverse bulge in the rock were it not for the fact that Walsh's photograph of the earlier-mentioned panel at nearby Oomarri shows a very similar looking T-shape shouldered figure. Again there was much the same reptilian face, and (even more curiously) the face was positioned on a very similar long transverse bulge in the rock. Given the relatively close geographical proximity to each other of Oomarri and Faraway Bay's 'Lost City' along the same stretch of Kimberley coastline, there has to be a strong suggestion that this figure represents some archetypal being who was particularly venerated—or indeed feared—by the Tassel Bradshaw people living in this locality.

However, one further detail deserves noting. Walsh has reproduced another T-shape shouldered figure of very similar appearance,[14] though cruder in style, which he identifies to the Clothes Peg period rather than the Tassel Bradshaw of the other two. This makes the location of this particular Clothes Peg of particular interest, should there have been—in this instance at least— such an apparent continuity from the preceding periods. Though this is

Just a few of the rock outcrops that convey the impression of a 'Lost City' from which the site near Faraway Bay takes its name

information that Walsh has not divulged, it in fact has the potential for some far wider significance than pertaining just to the Bradshaws. For far across the Indian Ocean, in the land of the ancient Mesopotamian civilisation of Iraq, there have survived from its very earliest, so-called 'Ubaid phase figurines with much the same reptilian heads and T-shaped shoulders.[15] Curiously, the origins of the 'Ubaid people are somewhat mysterious. Legend relates that their arrival at the mouths of the Tigris and Euphrates rivers was by water from the East at a time sometime before circa 6000 BC—that is, during the immediate post-Ice Age period when so much of the Kimberley became lost to rising sea levels. So should the similarity between the 'Ubaid and the Kimberley figures be dismissed as just another of those ever-accruing coincidences?

That this particular panel on which the 'reptilian' figure was painted, located in a very commanding position in the 'Lost City', had some importance over a long period was indicated by vestiges of several different painting phases. To the reptilian figure's left were faint traces of an older red-coloured figure that, from the arms, might again have been of the 'Great Mother' variety. But this had been overlaid with a much smaller dark mulberry figure, seemingly a hunter carrying a boomerang, while to the reptilian figure's right there were two Tassel Bradshaws that had been

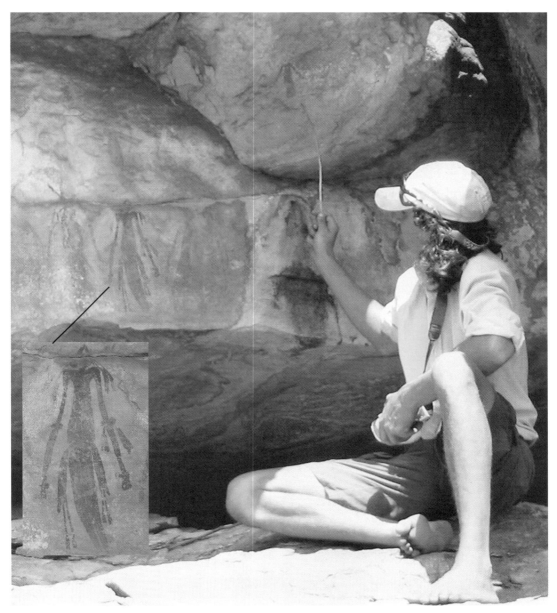

Steve McIntosh pointing out the curious symbol to be found in at least two locations around the 'Lost City'. Highlighted in the inset is a reptilian-looking figure, a similar example of which is at Oomarri further to the east

painted in red but which had become very difficult to distinguish. Steve also pointed out a curious symbol, like a very stylised, triangular tree, to the panel's upper right, which he said we would come across again elsewhere on this site. And looking not dissimilar was a tiny but unmistakable 'Great Mother' figure, with head obliterated, further to the upper right.

A little further on Steve pointed out to us a depiction of a thylacine, the extinct Tasmanian tiger. This particular painting, though little more than a scratching on the rock, was far clearer than the line of these animals that we had seen back at the Chamberlain Gorge, particularly in its depiction of the ears and tiger-like stripes. Comparison to examples that Walsh has reproduced in his 2000 book,[16] which he identifies as belonging to the Archaic Epoch, reveal a striking similarity, though this is one aspect of Walsh's sequencing which remains controversial.

The next rock that we came to carried a lively running 'hunter' figure with an exaggerated hairstyle, brandishing a short spear in one hand and a stick in the other. Painted in a solid red, he seemed to belong to the Elegant Action style, as did other figures of much the same subject nearby. The under-surface of another rock featured turtles, painted in white on a red ground, yet again indicative of turtles being quite a feature of the locality. Nearby an unmistakable Wandjina figure was painted in similar 'white on red' mode, indicative that this site had quite definitely been visited by Aboriginal tribes during recent centuries. But the predominance of Bradshaw-era figures, and the comparatively light amount of overpainting, suggested that the Aboriginal occupation in this area in

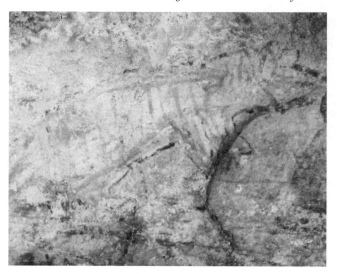

Thylacine at the Faraway Bay 'Lost City'. The tiger-like stripes greatly strengthen the case for this creature being identified with the extinct thylacine

recent times had been altogether thinner than that by the Bradshaw people during the site's heyday.

The next decorated rock that we came to might be described as the 'Harvest Festival Frieze', for arrayed in paint, though of indeterminate date, were 'fruits and vegetables' representative of both sea and land. Among these, readily identifiable from its shape, was the sea cucumber or *bêche-de-mer* that abounds in the shallows all along the Kimberley coast, and indeed elsewhere around Australia. These 'vacuum cleaners of the sea' can be picked up from the seabed by hand, be scooped up by spear-point or, where there is sufficient density, even trawled for. Up to the time of European settlement in Australia, and more sporadically thereafter, Indonesian-based fishermen would regularly call on the Kimberley coast to collect tens of thousands of these creatures. On shore they would boil them in cauldrons, gut them, recook them in mangrove bark to colour them and give them extra flavour, dry and decalcify them in sand, then smoke them in special prefabricated sheds which they had brought with them for this purpose.[17] Finally the finished 'trepang', as they were called, would be transported to China where they would fetch high prices, Chinese chefs and apothecaries working their own magic on them

Indonesian fishermen processing the sea cucumbers into 'trepang' for onward transport to China. From a nineteenth-century engraving

to turn them into soups and aphrodisiacs. The same 'Harvest Festival Frieze' also featured yams, which we earlier remarked on as a plant not native to Australia but which had been brought over and cultivated at some unknown very early stage, generating a special cult associated with its detoxification. There were also images of leaves of the edible pear.

Perhaps the most striking painting on this same outcrop, however, was a magnificent figure of the Clothes Peg variety, making evident that all Walsh's main art phases, from Archaic through to Wandjina, were represented at this single very extensive site. Painted with a yellow ochre body outlined in white, this particular Clothes Peg figure seemed dressed in a full-length robe and sported a huge turban-like headdress.[18] Arguably male, he carried in his right hand exactly the same tree-like symbol that Steve had pointed out to us adjoining the 'reptilian' figure, much like ancient Egyptian figures carry the *ankh* symbol of life. On his outstretched left arm, in the manner of a proud hunter, he held out two fully extended flying foxes, Australia's most prolific and widely distributed fruit bat. A creature hunted by Aboriginal people as a culinary delicacy, the fruit bat was presumably also a culinary choice of the Clothes Peg people. To the left of this figure the artist had included a double multi-barb spear—yet further evidence of just what a potent symbol this weapon represented for the Clothes Peg people.

As we wandered from one rock outcrop to another, finding each with its own individual array of distinctive images, it was more and more obvious that this was some kind of 'National Gallery' of Bradshaw and Bradshaw-related art of the Kimberley. On one rock that commanded a major 'town square' there were three relatively poor Bradshaw figures with wizard-type head-dresses, seemingly of the Tassel type. Altogether better, however, was a wall panel beneath a short overhang on the next outcrop. More clearly discernible because the rock surface was light in colour, the most interesting figure was a 'male' in a wizard headdress carrying paired angled boomerangs, a round 'pompom' at his waist and 'wings' sprouting from his shoulders. Though this particular individual carried none of the waist appendages to identify him as either of Sash or Tassel Bradshaw type, several figures reproduced by Grahame Walsh likewise feature 'wings' and related accessories.[19] Just as in ancient Egyptian art the goddess Hathor was identifiable by her cow's horns,

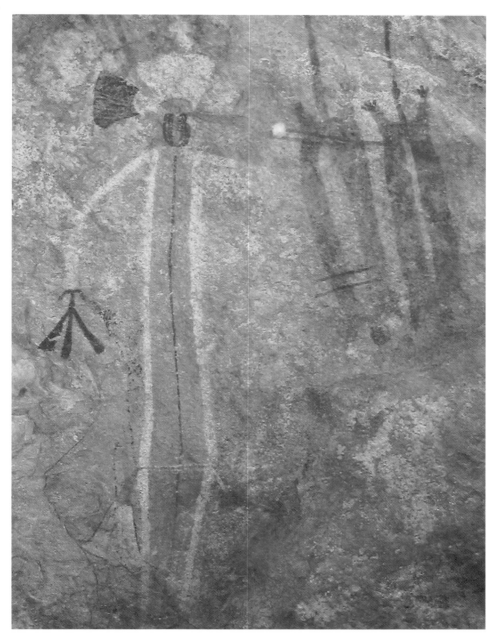

Magnificent Clothes Peg figure at the 'Lost City', holding the mystery symbol and wearing a huge turban-like headdress. He is holding out two flying foxes

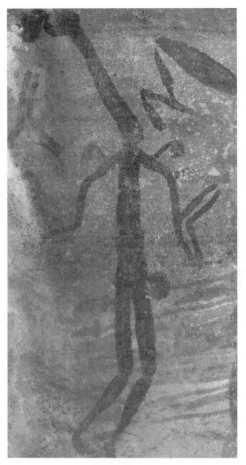

A Bradshaw figure at the 'Lost City' with characteristic 'wizard' headdress, boomerangs and 'wings' but without tassels or sash

and in ancient Greek art Poseidon by his trident, so Bradshaw art seems to have embodied certain recurring accoutrements that determined 'who' each figure was for people living at that time.

Nearby lay a further surprise. One of the outcrops was so designed by nature that within it lay what seemed to be a meaningful room (see page 240). All around the ceiling there were negative hand imprint stencils of the kind that we had first noted with Lee during our first Bradshaw encounter at the Deception Range site far to the Kimberley's east. Judging by their very rubbed condition, they seemed to be of similar antiquity, that is, belonging to Walsh's Archaic Epoch. On the ceiling had been painted in what would seem to have been the Elegant Action style a wallaby dying from a spear plunged into its chest. Adjacent was a Clothes Peg human figure that had been painted in much the same yellow ochre used for the life-size Tassel Bradshaw at Wullumara Creek.

But the really eerie feature was that not only did this 'room' look directly across the square to another major outcrop, it also included a 'throne' formed entirely of stone that seemed specially sited for this purpose. This 'throne' had a highly polished appearance, much like the long flight of 'steps' by which we had ascended from the beach. The 'polish' conveyed the strongest impression that this spot had been used as a seat by *someone* over many millennia, perhaps for giving social or oracular judgments.

However speculative this might seem, curiously the nineteenth-century pioneering explorer George Grey found an almost identical 'throne-room' at

the second Wandjina site that he came to in the course of his explorations 150 kilometres to the south-west back in 1839. According to Grey's account of this:

> One of the party . . . walked straight up the cavern . . . until he reached the slab at the end, and then taking his hat off with a solemn air, seated himself. To his own, and our surprise, his bare head just touched the roof of the cave, and on examining this part we found it fairly polished, and very greasy, from all appearance caused by the constant rubbing against it of the head of a person whilst seated on the rock. This and other circumstances led us to conjecture that the cave was frequented by some wise man or native doctor, who was resorted to by the inhabitants in cases of disease or witchcraft.[20]

While for me likewise there was the strongest temptation to ascribe this particular 'Lost City' 'throne' to some 'priestess' of the 'Great Mother' who sat giving oracular judgments from it, much like the great Delphic and Dodona oracles of western classical antiquity, Lee has rightly expressed caution. It is common for wallabies to take shelter in the shade provided by such caverns and to leave a similar 'polish' where they have rested. Before any well-founded interpretation can be made of this or of George Grey's similar 'throne-room' a proper archaeological evaluation needs to be made. We noted the floor of the 'throne-room' to be littered with innumerable small shells, readily suitable for carbon dating. But what else might lie beneath these deposits to indicate over how long a period this cavern, and other locations like it around the 'Lost City' site, may have been frequented? These are questions which Lee, as a trained archaeologist, is rightly anxious to address from the practical archaeological angle.

There were more Elegant Action figures painted on a ceiling in the next rock outcrop we visited—specifically a group of three (see overleaf). The first figure was a hunter with multi-barb spears in each hand and, additionally, three boomerangs in his left. The second figure, slightly larger, lay without any weapons or semblance of clothing while the third was a kangaroo or wallaby. Nearby there were also two twin-like figures with long hair that had

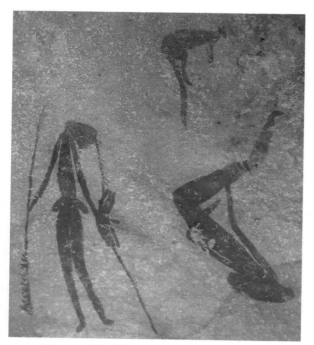

Figures of the Elegant Action style at the 'Lost City'

been painted facing each other, their arms hanging limply down in front of their bodies. Walsh has reproduced several similar examples,[21] calling them Face-to-Face Pairs and describing them as exclusive to the Erudite Epoch—the period from Tassel Bradshaws to Clothes Pegs.

Steve had, however, saved the 'Lost City's' very best quality Bradshaw until last. Our wanderings had taken us on a horseshoe-curved route that had led us back to overlook the sea again, except we were now perhaps 200 metres further to the north. And just as there had been a 'sentry post' at our southern approach to the site, so at this point, albeit without any obvious equivalent pathway downwards, we came across a seemingly twinned lookout post, in this instance with a two-tier rock platform.

The wall of this topmost tier again bore striking images, in this instance created with that curvaceousness of form characteristic of the very finest paintings of the Tassel and Sash Bradshaw periods. The figure furthest to the right, in a dark red, seemed to be clad in little more than elbow armlets. Definitely feminine in body shape, particularly at the hips, 'she' had her arms in that 'Great Mother' pose. By far her most remarkable feature, however, was her headdress. This seemed to be formed of huge fronds of fern that would have made it an immediate prizewinner at any royal Ascot, or Melbourne Cup, race meeting. Two figures to the immediate left, one short, the other nearly the same size as the first figure, had been painted in the same dark mulberry hue as Munurru's 'Bagman'. Both had tassels at their waists, thereby designating the whole composition Tassel Bradshaw. And both had

headdresses of somewhat similar fern-like character to the first, though rather less elaborate.

Exactly as in the case of the figure at the first sentry post, and also the first we had come across at Gumboot Creek, deliberate pounding had obliterated the faces of all three figures. Yet again, therefore, we were seeing that some people later than the time of the Tassel and Sash Bradshaw people had so loathed or feared these latter's artworks that they had felt impelled to defuse them by destructive action. On the underside of the same platform had been painted a number of figures, in different sizes, in the classic 'Great Mother' pose. Some of these seemed to be of Clothes Peg type but none

The panel below has been painted in the finest style of the Tassel Bradshaw period, the most striking feature being the exaggerated, fern-like headdress. Deliberate pounding of the face suggests that this was a figure disapproved by post-Bradshaw era peoples visiting the 'Lost City'

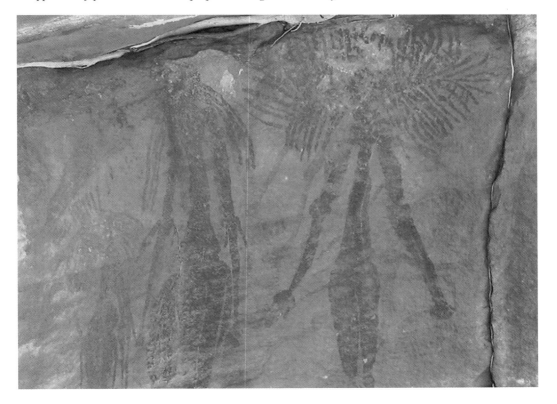

showed the overpainting that had been inflicted on the 'upper deck' Tassel Bradshaws.

As Steve led us back along the 'Lost City's' seaward side, down the same rocky path by which we had ascended, then ferried us back to the bush camp, he explained that he had found the site completely by chance. It had been April 2002, just after the end of that year's Wet season, and as he had skirted the coast he noticed a waterfall and boab, both visible from the sea, that had suggested to him that this might be a likely location for Bradshaw paintings. On his reaching the site itself he found much of the undergrowth had been cleared by a naturally started bushfire that had run through it the previous October, making it relatively easy to explore. At that time of year the 'City's' 'streets' still had a lot of Wet season creek water running through them, from which he surmised that a water supply of this kind would have been semi-permanent back in the Ice Age, giving the whole site an idyllic 'mini-Venice' character. The last 'Ascot Hat' panel he had actually come across during a revisit only three weeks earlier, and he was quite sure that further wanderings would bring to light yet more, similar discoveries.

On the morning of Friday 24 September the sound of Brendan's Cessna making its approach run to Faraway Bay's airstrip was the signal for us to bid our farewells to Steve and Bruce, and to head back to Kununurra. As events would enfold, we came close to being the very last guests to stay at the Faraway Bay bush camp that Bruce and Robyn Ellison had been operating uninterrupted throughout nine seasons. Though the camp had been built to withstand the Kimberley's notorious cyclones, and had survived three, Cyclone Ingrid, which hit it full-on on 15 March 2005, was of rare Category 5 intensity, with winds exceeding 280 kilometres per hour. Despite all possible precautions having been taken, every standing structure was wrecked and every boat wrenched from its moorings and tossed around like matchwood. The two caretakers resident at the time survived only by taking refuge in a shipping container. For just a few days it looked as if the bush camp might never reopen. But buoyed by many generous offers of help, including from Kununurra's Aboriginal community, Bruce and Robyn actually managed to reopen on their scheduled start date for the 2005 season, almost as if Cyclone Ingrid had never happened.

Such an occurrence makes all the more heartfelt our personal indebtedness to Bruce and Robyn Ellison and Steve McIntosh for their kindness during our stay. Likewise, of course, to Lee Scott-Virtue, thanks to whose energy and superb guidance we managed to achieve our dream of getting 'up close and personal' with the Bradshaw paintings of the Kimberley. With Lee's help we were able to cover a large proportion of the Bradshaw people's territory from the Deception Range to the east, to the 'Lost City' to the furthest north, to Wullamara Creek a significant way west, to the Manning Gorge a substantial distance to the south.

From everything that we had seen so far a geographical picture was forming in my mind that the Kimberley's very finest Bradshaw paintings were actually concentrated in the central area represented by the Theda and Doongan cattle stations and the adjoining Drysdale River region. And this territory—arguably the very heartland of the original Bradshaw people—we had of course been partly blocked from exploring.

But what I had not counted on until we had returned to Brisbane was that there was one intrepid Kimberley bushwalker who had been annually taking small groups of bushwalkers into the Drysdale River region—and had some superb photographs to positively prove its status as a centre of Bradshaw artistic excellence.

The dramatic 'lookout post' location of the fern headdress Bradshaw painting reproduced on page167. The painting is on the wall in the area of shadow upper right of the foreground shrub

Russell Willis's bushwalking group making their way along a section of the Drysdale River, an area of the Kimberley with some of the very highest quality Bradshaw paintings

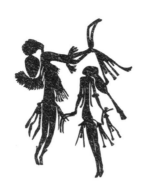

CHAPTER TWELVE
Follow that river

Helped by some lively passenger-seat discussions with Lee during our Kimberley explorations, one fundamental lesson that had become drilled into me was the importance of the Kimberley's rivers to the Bradshaw people. Joseph Bradshaw's first discovery of a Bradshaw painting had been along the sides of the Roe River. The one river on which Grahame Walsh had positively located Bradshaw paintings was the King George.[1] We ourselves had viewed Bradshaws along the gorge of the Chamberlain River, in the environs of the King Edward River (Munurru), along the sides of the Mitchell River (Punamii-unpuu and Reindeer Rock), and at Wadningningnari on the Manning River. The broad trend of all these rivers was to flow from south to north, in the manner of Egypt's Nile. And wherever there were suitable sandstone cliff walls, crannies and outcrops along their banks the Bradshaw people had decorated them with their distinctive paintings.

But the one major north–south-flowing river system to which we had not been able to gain access was that of the Drysdale, bordered for much of its length by the Carson Escarpment, a vast 200-kilometre stretch of cliffline so rugged that a 1901 survey declared the terrain useless. The region duly became designated the Drysdale River National Park, though without the

Western Australian government providing a single facility, track or even official access route. Large sections of the river's valley are completely impassable by horseback or by four-wheel drive vehicle. They can only be negotiated on foot or by boat, and the latter only for a very brief period each year. Not until 1986 did a very well planned expedition[2] manage to make the first modern-era traverse of the Drysdale's 400-kilometre length from Drysdale River Crossing to the sea. They used tough inflatable canoes which they repeatedly had to carry, together with all the rest of their equipment, for up to five kilometres along sections where the river petered into shallow rapids before opening out again into deep pools.

Environmental specialist Joc Schmiechen, a colleague of Lee Scott-Virtue, was on this 1986 expedition as scientific leader. He expected to find predominantly Wandjina paintings, only to discover by far the greater proportion of paintings to be highest quality Tassel and Sash Bradshaw figures. Schmiechen assiduously followed up by leading further expeditions into the area,[3] finding yet more Bradshaw sites of similar excellence and commencing a detailed survey. When reports of these finds were published in a number of newspapers Grahame Walsh's interest was so whetted that he turned up completely unexpectedly on Schmiechen's Adelaide doorstep to find out more. Schmiechen personally led Walsh to many of the best sites, the quality of these being reflected in the fact that nearly half the images in Walsh's 1994 book came from the Drysdale River area.

Meanwhile Russell Willis, a Northern Territory-based bushwalking enthusiast, had learned of Schmiechen's expeditions' findings at a rock art congress held in Darwin in 1988.[4] Having founded the Willis's Walkabouts tour company[5] just two years earlier, he began guiding annual bushwalking groups into the Drysdale from 1989 onward. For each year's expedition Willis had to overcome the lack of any official route leading into the park. During the last decade of the twentieth century the Theda station's then owners, Russell and Peta Timms, happily allowed those wanting to explore the park to use an old cattle mustering track that runs east-west through their property and peters out on reaching the Carson Escarpment. But when in 2001 Maria and Allan Myers purchased Theda station's lease from the Timmses, they prohibited any further use of this track.

In Russell Willis's case the option he actually preferred was to use the only other available route, a very rough track through what had been the Carson River Station—subsequently acquired by the Aboriginal community at Kalumburu—which led to the park's northern end and provided rather more direct access to the Drysdale River. For Willis's 2004 Drysdale expedition he duly flew his group to Kalumburu where an Aboriginal driver had been pre-arranged to drive them to where this track ended and drop them there. For the next fourteen days the bushwalking party of five men and eight women, ranging in age from their thirties to their sixties, thereupon had to make their own way by foot along the Drysdale and Carson rivers. They had to carry backpacks weighing up to 20 kilograms[6] laden with all food, camping equipment, bedding and clothing that they needed, making our mini-expedition with Lee a mere stroll in the park by comparison!

Russell Willis copied to me his digital photographic record of this particular tour's adventures to show the number of high-quality Bradshaw paintings that the itinerary included.[7] On my viewing these images, they immediately reinforced just how important a 'grand central' area the Drysdale River must have been for the Bradshaw people. This led to my asking Russell's permission to use some of the photographs, together with a brief account of this particular group's adventures, as part of my general overview of the Kimberley's geographical spread of Bradshaw paintings, a request to which he very kindly and graciously agreed.

Russell Willis's group arrived on the banks of the Drysdale River mid-afternoon on 6 June 2004. They set up camp nearby and spent the afternoon relaxing and recovering from the drive. Within hours of getting under way the following morning they reached the first art sites. These mainly featured Clothes Peg figures, clear evidence, therefore, that whoever the Clothes Peg people were, they had made their presence felt over a very wide area. Just as we had repeatedly observed of Clothes Pegs in other parts of the Kimberley, the Drysdale's Clothes Peg figures often lacked any indication of hands or feet. This suggested that here in the Drysdale, just as we had observed at Wullumara Creek, the artists may well have indicated these in a light 'stencilled handprint' form, only for the very delicately applied pigment to fall away without any apparent trace.

Russell wanted to show his group some art sites on the other side of the river that Joc Schmiechen had introduced to him some years before. They therefore spent the following day exploring without having to carry packs. The river was exceptionally high after a late Wet so they had to make the crossing with their clothes and boots held over their heads while keeping an eye out for the parents of a tiny freshwater crocodile they had spotted lurking nearby. The particularly large concentration of rock art paintings more than rewarded their efforts. From a low shelter near the river's edge and then up almost to the top of the hill behind, there were more than a dozen major sites.

First there were some striking Wandjinas, with alongside them an image of the very same dumpy, flightless bird that had so puzzled us at the Wullumara Creek site, suggesting that this had not been imaginary. There were also some stick-like figures with exaggerated headdresses carrying boomerangs, and more splendid Clothes Pegs. One of these latter, painted in dark mulberry and with a spear-thrower at the left, wore 'tassels' and a tiny sash much as in the Tassel and Sash Bradshaws, again suggestive of the survival of some kind of cultural continuity, despite whatever change of regime had been imposed by the Clothes Peg people.[8] Another Clothes Peg style figure exhibited a 'pear' body as from the steatopygia (accumulation of fat on the buttocks) common among Kalahari Bushmen.

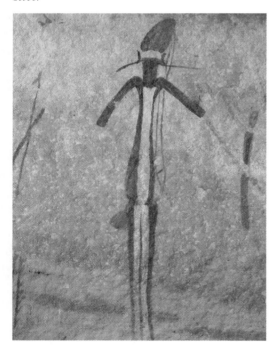

One of a group of Clothes Peg figures that Russell Willis's group came across along the Drysdale River

Not long after packing up and getting on the move on the following day the Willis group arrived at their first really classic Bradshaw, a wall painting of the Tassel Bradshaw variety, each figure having tassels hanging from its waist band (opposite). The largest, at the

furthest left, was also the most enigmatic. The body had two-tone coloration similar to that on the 'Puppet' panel at Munurru.[9] The arms, with streamers hanging from them, were outstretched somewhat reminiscent of the 'Great Mother', but so exaggerated that the resemblance was rather more to a scarecrow, exacerbated by fan-shaped endings where the hands might be expected.

But by far the weirdest feature was the head area. Exactly as we had seen of the 'reptilian' figure at the Faraway Bay 'Lost City', also of the equivalent figure on the rock wall at Oomarri, the figure had been so positioned that its crudely indicated head began precisely where the wall bulged awkwardly outwards just above the level of its shoulders. Given the fact that the artist had plenty of smooth, vertical wall space to get his composition right, and had achieved this perfectly competently in the case of all the lesser figures, his crunching up of the head on this, the panel's seemingly most important figure, seemed odd in the extreme.

To the right of the 'Scarecrow' was a poorly defined front-facing figure with 'wizard' headdress, then further to his right, next to a toy-sized angled

The 'Scarecrow' panel. Note the awkwardly positioned head of the figure at the left, the largest of the group. Because the panel was in shadow, the colours are not representative in this instance

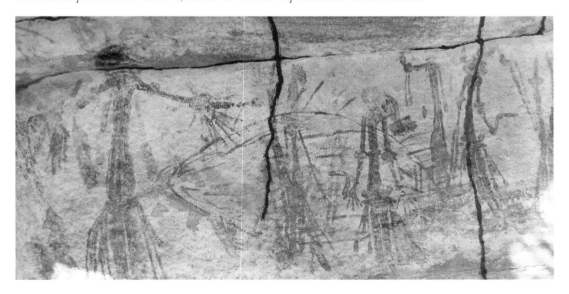

boomerang, was a left-facing figure of the kind I 'see' as female. 'Her' head carried the faint suggestion of a facial profile though, as always, it was impossible to be sure of this. The fingers of her hands were unusually well defined. Hairdressing-wise she wore long hair falling behind her to shoulder length, gathered up at its end by something akin to a large ribbon. At her elbows there were exuberantly ornamental armlets, with two possible breasts indicated at the same height. From her waist hung a tassel at her front and a sash at her back.[10]

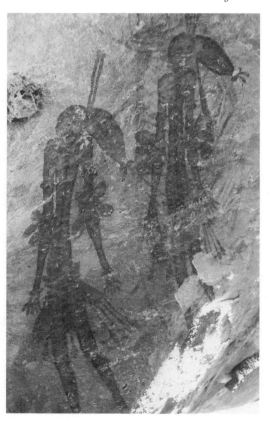

Two of the exceptionally high-quality Tassel Bradshaw figures to be found along the Drysdale River. The prongs on the headdress appear to be a localised feature

Not only was this a depiction of a human figure of the high-quality calibre that so entranced me about Tassel/Sash Bradshaws when I first came across them in Walsh's books, it was far from the only example at this location. On the ceiling a pair of Tassel figures had been painted in an orange-brown ochre with much the same graphic flair and delicacy. These figures again wore elaborate armlets at the elbows, and their hands and their tassels had been particularly beautifully delineated. One of their main differences from the previous figure was a pair of prongs or feathers affixed to the top of their heads in the manner of an American Indian 'brave'. In light of this, and despite their long hair being gathered up at the back much as on my earlier 'female', I found myself in rather more difficulty ascribing a gender to them. They carried no suggestion of breasts. Their knees were set further apart than I associated with the characteristically feminine posture. So even if I were right interpreting a significant proportion of Bradshaw

figures as female, the gender distinctions in certain examples had to be acknowledged as far from clear.

As the next day Willis's bushwalkers pressed further onwards along the Drysdale River, more and more rock paintings from all periods came into view along its banks. On one boulder there was a double row of seeming tally marks as from a notation system. On another panel had been painted a gathering of delightfully observed frogs, delineated in red. Other rocks featured a creature probably identifiable as a fork-tailed catfish, also some wallabies, and a number of negative hand imprints, some with mutilated fingers, others with hand and forearm combined. There were also more Bradshaw figures, some of these with the headdress 'prongs' (as if these were the hallmark of a particular local tribe), and more Wandjina.

Close to where the group was due to camp that night was an Elegant Action scene which Schmiechen had first discovered and Walsh had reproduced in both his books.[11] This showed four wallabies apparently trapped inside some kind of enclosure or net, with hunters around them, and boomerangs and a dilly bag to one side. Another panel in this same vicinity[12] had originally featured a large figure with arms in the 'Great Mother' pose and tassels at the waist. But this had been very forcefully 'usurped' by a Clothes Peg figure, in the vicinity of which was the Clothes Peg people's now expected trademark of a multi-barb spear.

The group of bushwalkers needed to make one last major effort, negotiating some particularly difficult rock ledges, before reaching the Solea Falls, one of the Drysdale's great natural wonders and still in magnificent spate because of that year's late ending to the Wet season. There they camped overnight on adjacent rock platforms, before the next day beginning to head upstream. The following day they reached Planigale Creek, a major Drysdale River tributary with several sets of waterfalls of its own.

The well watered, open country near Planigale Creek was surrounded by numerous rock shelters ideal for preserving rock art. In a small dry side creek not far from its junction with the Planigale was a particularly huge rock 'gallery' dominated by a giant kangaroo-like creature that had been painted relatively recently in bright orange on one rock face. The clear intention had been to usurp a group of Bradshaw figures displaying the most

exaggerated long 'wizard' headdresses, 'wings' and other attachments. There were also Clothes Peg figures, some with *woomeras*, others again with tassel attachments at their belts.

Perhaps one of the most fascinating panels of all was one that at first sight looked to be dominated by the bristles of a big white toothbrush (see below). Via email, I received timely guidance from Lee and from Joc Schmiechen which swiftly determined the 'toothbrush' to be in actuality the remains of the headdress of a giant Wandjina head that had been deliberately painted over some underlying Bradshaw figures. As the white paint of the now long-neglected Wandjina head was powdering away, the Bradshaw figures, just like their counterparts at Munurru, were steadily reappearing.

And what fine Bradshaws they were. They consisted of two figures of the Tassel variety, painted with the greatest delicacy in dark mulberry, the

Left: Two very fine quality Tassel Bradshaw figures reappearing beneath what had been a Wandjina head painted over them, the remains of the latter appearing like the bristles of a toothbrush. The figure at the left is holding paired boomerangs over the figure at right, as if performing some kind of 'boomerang coronation' ceremony. Right: Interpretative drawing of the same figures with overlying paint removed

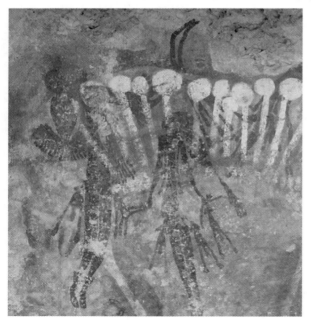
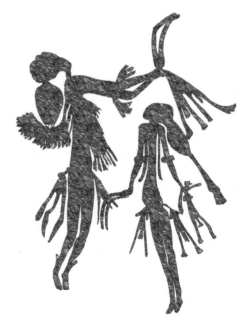

left-hand one of whom instantly reminded me of the so awkwardly posed 'Bagman' at Munurru. He had his arms thrust fully forward and upward, holding aloft boomerangs and a tassel-like device, while his head, for some as yet unfathomable reason, was turned in a completely opposite direction. As for the figure on the right, he stood beneath the boomerangs held by the first, looking leftwards. He was wearing tassels at his belt, and held paired boomerangs in his right hand and a single boomerang and tassel in his left. Such was the theatricality of the first figure's gesture that had he been holding up a crown instead of two boomerangs, he would automatically have been interpreted as officiating at a coronation ceremony. The overwhelming impression, therefore, was of some kind of initiation, perhaps a 'boomerang bestowal' ceremony at the tasselled young man's coming of age. Curiously, at the foot of this image was one of the same tree or tent-like emblems of which Steve McIntosh had pointed out examples at the Faraway Bay 'Lost City'. Elsewhere on this same panel there were hand imprints and early animal images, as if this was a site that had long been held in deep religious awe, to be repeatedly returned to at different epochs.

But at this same location was also, for me, one of the most outstanding and revelatory of all Bradshaw Tassel figures (see overleaf). To me 'she', for that's how I instinctively 'saw' her, irresistibly evoked the title 'La Parisienne'. Though she had been created comparatively large, she seemed to be a preparatory sketch to which infill colour for some reason had never been added, as if left half-finished. Only transverse hatching, for instance, indicated the tassels. Here it was therefore possible to see how the Tassel Bradshaw artists had first drafted their artworks—revealing a mastery of draughtsmanship that would scarcely have disgraced a Paris fashion designer. This impression was further heightened by the figure's very feminine build and deportment, by her long hair, by her elbow and wrist ornamentation, and (quite unmistakably) by a pencil-slim knee-length skirt.

Not least of this figure's outstanding features was her face or, rather, her lack of it. On this particular panel the state of preservation was so good, and the line-work stood out so well against the light background, that had the artist indicated facial features these would surely have been preserved. Yet no facial features were evident. Instead, the face seemed simply to have been

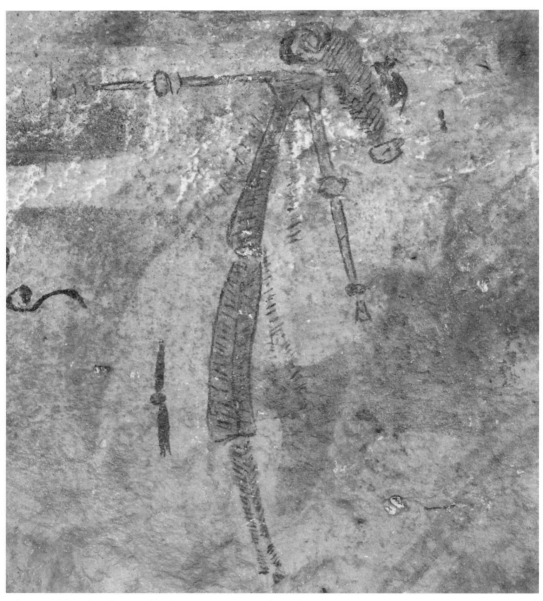

'La Parisienne'—the superbly drawn preparatory sketch for a Tassel Bradshaw figure. This clearly reveals Bradshaw artists' quite exceptional command of line-work. Note the small animal, very likely the individual's personal totem, to the right of the hair

filled in a more solid, browner tone to the line-work used for the rest of the drawing.

Close study of the area around the face also revealed another intriguing element. Nestling just at the edge of the woman's hair, and painted in the same tone as the face, was a creature resembling a mouse. Grahame Walsh in his books had illustrated several examples of such small creatures closely positioned in relation to a figure's head,[13] and although it seems logical to identify them as the totem of the individual represented he declined to enter into any such discussion.

But totem animal seems by far the most logical explanation. Lee had found some similar examples at sites in Faraway Bay's vicinity that we did not reach. Even to this day many Aboriginal people continue to set great store by whatever totem animal they were born with. Kimberley activist Ambrose Chalarimeri notes in the very first paragraph of his autobiography that 'my totem is the *janggao*, a lizard about a foot long'.[14] To an Aboriginal person, their totem, broadly the clan symbol of the family into which they are born, is like their other self. Whatever creature it might be—a small marsupial, a lizard, or a variety of bird—they do not kill or eat it, and it stays close throughout their life, its appearance to them at some timely moment sometimes signifying the presence of danger, or a family fatality. As a typical example, recorded of South Australian Aboriginal man Henry Rankin:

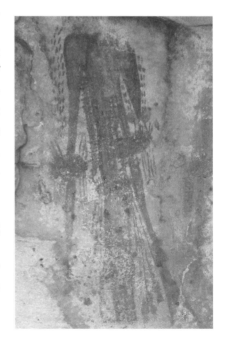

'Headless' Tassel Bradshaw. The artistic quality is exceptional, but no space has been left for the head. Do the dash marks down the side of the body indicate blood, as from decapitation?

> I saw my totem, the Cape Barren goose, coming down the path flapping and dragging his wings, then he turned and went to Adelaide. And I knew that my aunt, old Mildred Rankin, passed away in Adelaide Hospital.[15]

Still at this same gallery there were yet more Tassel Bradshaws, among these four very tiny figures with tall 'wizard' headdresses painted in dark brown (see page 195). As readily gauged from a nearby handprint, these could have been no more than 16 centimetres (or 6 inches) high, yet they had been perfectly delineated, the sort of skill that did not survive into the later Aboriginal era.

Another set of superbly drawn Tassel Bradshaw figures. As in other examples, note the elaborate armlets worn at the elbows that seem to have been important fashion accessories amongst the Bradshaw people

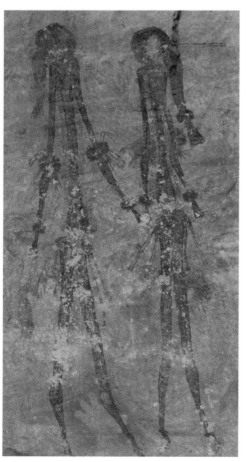

Also of the very finest draughtsmanship was a pair of Tassel Bradshaw figures that had been executed in brown ochre, and with much the same elaborate elbow and wrist ornamentation as 'La Parisienne' (this page and page 188). These seemed to be turning towards each other in the most naturalistic manner. Their hairstyles were what I would designate 'feminine'. And their legs had been drawn slightly parted in the most elegant dancer or fashion model-type stance. If as Walsh proposes these figures were truly to be interpreted as male, Bradshaw men must surely have been among the most effeminate this planet has ever seen.

Russell Willis's group camped overnight by the side of the Planigale Creek, and when next day they moved further up the creek yet more paintings came into view. One beautiful Tassel Bradshaw (see previous page), executed in brown ochre, had again been positioned on the rock leaving insufficient space for its head. But in this particular instance, at least, the artist would seem never to have intended the body to have a head. Paired dash marks extending down the sides of an otherwise beautifully proportioned body suggest blood streaming from the headless shoulders of someone

who had been decapitated. Did this painting perhaps tell some otherwise lost story in the Bradshaw people's mythology?

As the bushwalkers wandered further there were Clothes Peg figures in yet more abundance, evidence that wherever the Tassel and Sash Bradshaw people had established themselves the Clothes Peg people came into that same region and decorated the rocks with equal authority, albeit with lesser artistic flair. One particularly striking Clothes Peg figure had once again been depicted in a full-length dress or robe.

But Bradshaw figures, in their turn, continued not only to be represented, but also to be of exceptionally high quality. At one particularly oasis-like site, with brolgas just as we had seen at Munurru, a panel bore a painting of three figures in an almost identical 'head back, arms forward' pose to that of the Munurru 'Bagman'. They were depicted holding out boomerangs and bulging dilly bags, surely performing some kind of dance celebrating the fruits of the boomerang. As they overlay a simpler but high-quality Tassel Bradshaw figure they must have been painted just a little after this latter. Also in the vicinity there was an 'Ascot Hat' figure strikingly similar to the one that Steve McIntosh had found on the northern 'lookout' at Faraway Bay's 'Lost City'. Painted in that dark mulberry so commonly associated with good-quality examples, this particular Tassel Bradshaw figure, carrying angled boomerangs and dangling dilly bags, had a near-identical 'fern-like' headdress.

All these parallels between one site and another, repeating at sometimes considerable distances across the Kimberley, spelled out the huge importance of our knowing the geographical spread of each particular motif. Only by distinguishing which elements are purely 'localised' and which are spread throughout the Kimberley can a proper picture of the Bradshaw people be built up, and I am deeply indebted to Russell Willis for sharing the images encountered by his group in order for these to be fitted into the overall picture. Given the comparatively short distance that the Willis bushwalkers were able to cover, their photographic record certainly reinforces the view that the Drysdale River was the 'grand central' region where the very finest of Tassel and Sash Bradshaw paintings were concentrated. And it leads us to expect that much that same artistic quality also extended into the 'closed' territories of the Theda and Doongan cattle stations.

The only disappointment from Russell Willis's magnificent collection of photographs was that they included no boat images—simply because the group did not come across any. Thankfully, however, that deficiency has been more than made up by Joc Schmiechen, who besides his earlier-described discoveries in the Drysdale River National Park has also been quietly exploring many more areas of the Kimberley. And along the northern coast, not far from the Mitchell Plateau, he came across two examples depicting figures paddling canoes that are every bit as clear and intriguing as the examples so far published by Grahame Walsh.

In one of these, the paddlers have swept-back hairstyles very similar to those in the boat painting that Walsh showed in the *Hunt for the First Americans* TV documentary. They appear to be carrying in the canoe's hold some kind of plants, possibly yams. In the other painting the boat has a distinctively curved, upswept prow and stern and was unmistakably designed, Viking longboat style, to cope with open sea. Artistically, just as in the case of all other known examples, these two paintings seem to belong to the Clothes Peg period, rather than to that of the high Tassel/Sash Bradshaws. But they still have the highest importance for our understanding of how Australia's earliest migrants may have arrived on the continent—at a time when so much of the rest of the world, including particularly northern

One of two fine paintings of canoes discovered by Joc Schmiechen along the Kimberley's northern coast. Note the same swept-back headdresses as in the first example found by Grahame Walsh. These figures thereby seem to belong to the Clothes Peg period, rather than to the Tassel and Sash Bradshaw era

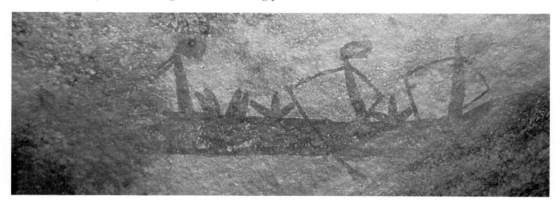

Europe, was living a very primitive existence trying to keep warm amidst an environment dominated by ice.

From all the data and insights that had been so generously provided by key individuals such as Lee Scott-Virtue, Steve McIntosh, Russell Willis and Joc Schmiechen, my researches had now reached the point of making at least some evaluation of what it all meant. Throughout all our Kimberley adventures some key questions kept repeatedly churning in my mind. Just who were the real-life people behind these perplexing styles of paintings: the Bradshaws, the Clothes Pegs and the Wandjinas? What could be said about them and their lifestyles that determined their similarities and their differences from each other? When did they live? What were their genetic roots? What happened to them?

Now it was high time for me to try to come up with some answers.

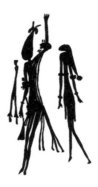

CHAPTER THIRTEEN
Putting people to the paintings

What does the Kimberley rock art record tell us of the region's earliest inhabitants? Because of the difficulties putting a 'hard' date to any one painting or even group of paintings, our main guide is necessarily Grahame Walsh's sequencing system, in which the so-called Archaic Epoch embodies those artworks that he believes to be the oldest. His sub-divisions of this epoch into Pecked Cupule, represented by the sort of peck marks we saw at the Deception Range, and Irregular Infill Animal, large animal depictions that are often difficult to put a chronological style to, have provoked much criticism.[1] The academic arguments surrounding them need not concern us here.

Nonetheless there are certain Archaic Epoch artworks which can altogether more confidently be described as 'pre-Bradshaw', my own preferred label for the very oldest art period. Particularly right for this description are certain stencilled hand imprints, such as those that we noted on the ceiling at the Chamberlain Gorge, which have quite unmistakable Bradshaw figures painted over them. This necessitates that they simply must date before the Bradshaws that overlie them, or at the very latest be contemporary with them.

These pre-Bradshaw hand imprints have a story all of their own to tell about the people responsible for them. This is because several show hands of very robust proportions, with finger spans (the distance between the index finger and the smallest finger) of up to 23 centimetres (8 inches).[2] As my own finger span is no more than 17 centi-metres (7 inches), and I am just under 6 foot in height, at least some of the 'pre-Bradshaw' people must have been considerably taller and more powerfully built than the slight and graceful people typically represented in the Tassel and Sash Bradshaw paintings.

And this anthropological trend is further indicated by pre-Bradshaw imprints of boomerangs that were stencilled in exactly the same manner as the hand imprints—that is, by holding the implement up to a rock wall, then spitting a mouth-held spray of ochre all around it. One example reproduced by Walsh[3] indicates a boomerang that was 91 centimetres long, had a 10-centimetre blade width and a huge crescent-shaped arch spanning 29.5 centimetres. Such a (literally) archaic size and shape of boomerang goes unrepresented amongst the tens of thousands of boomerangs shown in

Interpretative drawing, after a photograph by Grahame Walsh, of a stencilled negative imprint of a huge boomerang that would only have been suitable for a sturdy individual of considerable strength. The overlying Bradshaw figure clearly indicates the boomerang to precede this in date

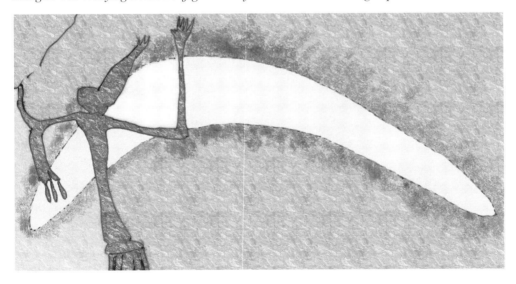

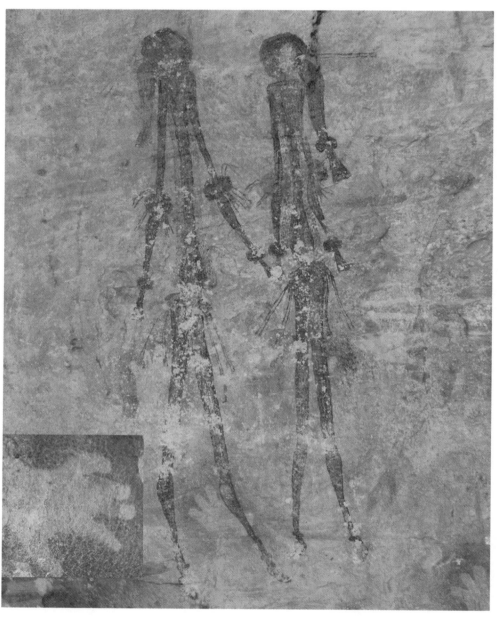

The graceful character of Tassel Bradshaw figures, compared with (inset) the 'Fred Flintstone' appearance of some handprints from the 'Archaic Period'

paintings of the Bradshaw era. And as Walsh has cogently pointed out, great strength would have been needed to launch such a weapon, again inconsistent with the slight physique indicated of the people depicted in the Bradshaw paintings.

So we can confidently infer of the Kimberley's pre-Bradshaw people, purely on the basis of clues from their rock art, that at least some of them were powerfully built and had developed correspondingly powerful boomerangs. Food-wise, the fact that they used such big, weighty boomerangs indicates that they hunted large animals. This is consistent with the various megafauna, or oversized creatures, that are known to have been inhabiting Australia at the time of the first human arrivals, but which quickly became extinct thereafter.[4]

Artistically, it can be inferred that they had already developed skills to formulate serviceable, lasting pigments from natural ochres, using these principally for stencilling imprints of their hands and their boomerangs onto rock surfaces. This automatically links them to other early populations who were creating similar imprints of hands and boomerangs around Australia, for example in the Northern Territory,[5] at the Carnarvon Gorge, Queensland,[6] and also in its near environs in neighbouring Papua,[7] the western side of New Guinea.

More importantly, however, as mentioned in Chapter 5, it also links them to the creators of other examples of such handprints that are to be found at prehistoric sites as far-flung as France and Spain to Australia's west and Patagonia to its east. At Gargas in Spain such handprints, some with similarly amputated fingers, have been dated to as early as 26 000 years old.[8] This immediately raises the issue of where the original human population might have lived to have sparked off these so similar yet so far-flung art forms. And as boomerang stencils are found neither in western Europe nor in South America, arguably this particular variant, along with the actual boomerang invention itself, developed somewhere nearer to Australia, though not necessarily within Australia itself.

Overall, while the pre-Bradshaw paintings provide a few important clues about the people behind them, their general lack of human representations leaves us guessing about a great deal. For instance, we have no idea

how they dressed or what they used for shelter. And while we may assume that they had boats—because they could have arrived in Australia no other way—there are no known boat paintings that can positively be identified to the 'pre-Bradshaw' era.

This lack of evidence is mostly in considerable contrast, therefore, to the Bradshaw people. For when they arrived in the Kimberley they appear to have done so fully formed, that is, with their skills and culture fully developed, having earlier refined these somewhere else other than Australia. Most importantly, their paintings tell us rather more about them than we can learn from almost all the entire rest of the world's prehistoric artists put together. For example, the European painters responsible for the Ice Age art found in the caves at Lascaux, Altamira, Chauvet and elsewhere may have been world class at depicting animals such as horses, bison, bears, ibex and so on, but for depictions of the human form the Kimberley's Bradshaw artists were quite literally in a class of their own.[9] Uniquely in the Ice Age—still assuming that they genuinely lived in the Ice Age—their speciality was to depict themselves, thereby providing a wealth of data that is unparalleled amongst all other societies of such an early time.

First, although we lack any facial detail, physically it can be said with total confidence that they had nothing of the 'Fred Flintstone' build that we have inferred of their predecessors, the pre-Bradshaw people. When the Bradshaw people's art was at its finest, particularly during Walsh's Tassel and Sash phases, the only way to describe their bodies is by adjectives such as lithe, slim and graceful (see page 188). Paintings such as Theda's 'Nine Dancers', also 'La Parisienne' as encountered by Russell Willis's Drysdale River expedition, convey this particularly strongly.

Such gracility inevitably leads to my earlier-mentioned argument that there are too many feminine-looking bodies amongst Bradshaw paintings to justify the 99.9 per cent proportion of males to females claimed by Walsh.[10] To illustrate my point, I look at Walsh's photograph of one Tassel Bradshaw painting of two figures here reproduced as the interpretative drawing opposite.[11] The first of these, standing on the left, has an upthrusting headdress and a general deportment that I have no hesitation identifying as male. In the case of the second figure, however, the hair trails down the back, and

the legs splay out below the knees in a posture that in Egyptian art (at right) is invariably associated with females.

While it is true that in Bradshaw paintings such 'female' figures can sometimes be seen handling boomerangs and/or spears, this constitutes no guarantee of masculinity. Not only is the small size of Bradshaw boomerangs consistent with weapons that women could handle with ease, at least one South Australian legend specifically tells of a tribe in which the women:

> went out meat-hunting each day, armed with men's weapons: spears, spear-throwers and hunting knives. Like men they stalked and speared the kangaroo, and hunted the emu across the plain.[12]

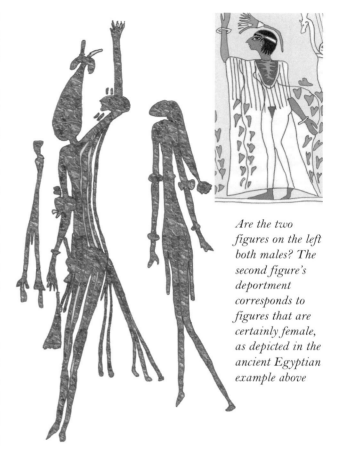

Are the two figures on the left both males? The second figure's deportment corresponds to figures that are certainly female, as depicted in the ancient Egyptian example above

Whatever the actuality on the gender issue—and there are many figures in which the condition is too faint or effaced for anyone to be sure about the presence or absence of breasts—the certainty is that Bradshaw paintings depict a people who set no store by physical brawn. Nor is there a single known painting seeming to celebrate some feat of might or strength.

Additionally the Bradshaw paintings convey that the people behind them greatly valued personal appearance. As we have seen, they are full of 'male' figures resplendent in tall 'wizard' headdresses, also 'females' with long hair gathered at the back in a ribbon. Additionally, many figures have

elaborately decorated armlets at their elbows and tassels at their belts, also large three-pointed sashes, at least some (and quite possibly most) of which may well have been intended for ceremonies rather than anything that they wore for going about their everyday lives.

Of the headdresses, examples of the tall 'wizard' variety would cross the world as a symbol of authority. Tall hats or headdresses from very early times have been found in a trail extending from Indonesia, across to early China, across to the mysterious ancient Caucasians of Urumchi, across to Iran, ancient Turkey and ancient Egypt. The oddity is that Australia's Bradshaw peoples appear to have been altogether in the vanguard rather than the rearguard of the time period for the wearing of this particular item of fashion.

One of several examples of Tassel Bradshaw figures carrying 'tassels' as well as wearing these attached to the waist

Of the tassels, the Bradshaw paintings richly convey their wearers' fondness for these, immediately determining that they have to have mastered the art of string-making as a key component of the tassel's formation. However 'ordinary' the rolling together of some fibres to make string may seem to us, it is only comparatively recently that it has become properly appreciated that this genuinely dates back to the Ice Age. One researcher, Olga Soffer, has particularly noted that on certain western European statuettes, such as the Venus of Willendorf, a skimpy string skirt was indicated. Such a 'primitive' and far from concealing item of dress in fact became widespread, finding its way to Iron Age Denmark, forming an archaic element even perpetuated in some traditional costumes to this day—immediately raising the question of where it originated. So to find Australia's Bradshaw figures exhibiting much this same trend—and quite possibly as early, if not earlier, than anywhere else in the world—inevitably raises

the question of where the Bradshaw people fit into this same stream of world fashion development.

A further aspect is that a number of Tassel Bradshaw figures carry single 'tassels' in their hands, as if these had some purpose beyond mere fashion accessory. The same representations clearly show the tassels as composed of two or three strings to which pellet-like objects have been attached. This bears a striking resemblance to a hunting implement called the bolas, principally known today from its use amongst South American gauchos. On the great South American plains the bolas is thrown at the legs of a fleeing animal, entangling these and thereby trapping it for sufficient time to be captured or killed as required. Could the Bradshaw people have developed the bolas, and be celebrating it in their paintings? Could those 'first Americans' supposed to have migrated from Australia to South America brought knowledge of the bolas with them? Though the bolas is very difficult to identify archaeologically, examples from South-East Asia's darkest prehistory have certainly been found in Korea.[13] And in an Ice Age Kimberley whose then land surface included great plains now covered by the Timor Sea, it could well have been an altogether more potent hunting accessory than it can ever be in today's harsh and rugged environment.

Could the tassel in actuality have been a bolas of the kind still used in South America?

Bolas or no bolas, one implement that we can be sure the Bradshaw people used for food procuration purposes was the small boomerang, as distinct from the cumbersome, heavyweight versions deployed by their predecessors. From the very plenitude and variety of these boomerangs as depicted in the Bradshaw paintings, their makers had quite definitely already

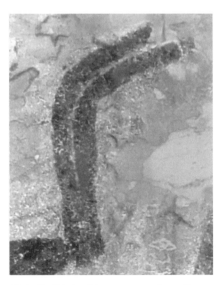

Detail of paired boomerangs from the 'Bagman' painting at Munurru (Photo enhanced to clarify detail)

Shapes of traditional Aboriginal boomerangs as used for hunting birds, from actual examples in the South Australian Museum

developed every shape that would subsequently be used by Australian Aboriginal people continent-wide. Given the abundance of wallabies and edible bird life that we may expect once existed around the Kimberley's oases, it may well have needed only a few minutes' daily boomerang-throwing for a Bradshaw-era food provider to 'bag' enough fresh meat to keep a whole family very well provisioned. Early nineteenth-century Kimberley adventurer George Grey observed the ease with which a south-west Australian Aboriginal hunter used the boomerang against a flock of cockatoos at a tree-lined lagoon:

Perhaps as fine a sight as can be seen in the whole circle of native sports is the killing [of] cockatoos with the boomerang. A hunter perceives a large flight of cockatoos . . . screaming and flying from tree to tree as they make their arrangements for a night's sound sleep. The hunter draws his boomerang from his belt and with a noiseless elastic step approaches the lagoon . . . disturbing the birds as little as possible. Their sentinels, however, take the alarm and . . . with wild cries, spring into the air. At the same instant the hunter raises his right hand high over his shoulder . . . The boomerang quits his hand as if it would strike the water, but when it has almost touched . . . it spins upwards, with inconceivable velocity, and with the strangest contortions. In vain the terrified cockatoos strive to avoid it; it sweeps wildly and uncertainly through the air . . . and with fell swoops is in rapid pursuit of the devoted birds — some of whom are almost certain to be brought screaming to the earth.[14]

By not being obliged to spend many hours a day in the quest for food, the Bradshaw people arguably provided themselves with ample leisure time for activities such as ceremonies and 'the arts' in which they clearly excelled.

From the uniformity of style and the sheer professionalism with which the Bradshaw figures have been painted, there has to be the strong likelihood that their artists were a professional 'caste' who had the time to hone their skills and to pass these on to succeeding generations. This luxury is normally associated with cultures rather more advanced than any small bands of hunter-gatherers.

And even the size and the manner in which the paintings have been executed only add to the impression that the Bradshaw people were small and delicately formed—many of the paintings themselves being of precisely this ilk. One tiny painting that Russell Willis's group came across at Planigale Creek (at right) consists of four minuscule Tassel Bradshaw figures with 'wizard' head-dresses, their arms some 2 millimetres wide, and the entire composition no

Four tiny Tassel Bradshaw figures, their overall size no bigger than that of a human hand, as painted on a rock at Planigale Creek. They are another example of the Bradshaw artists' fine draughtsmanship

bigger than the size of a single hand, yet all perfectly delineated. After Judith and I had finished our Kimberley expedition we briefly visited Oenpelli in Arnhem Land where Aboriginal artist Warren Djorlom showed us traditional Aboriginal painting methods using a blade of grass 'brush' and a jar of ochre (see overleaf). Warren is an excellent artist and he allowed me to try my own hand at manipulating his blade of grass to get some relatively fine brush strokes. While I learned the 'feel' of the blade of grass adequately enough, neither Warren nor I could have accomplished the Planigale Creek 'Wizard Quartet' by such means. It is in a league of prehistoric fine draughtsmanship all of its own.[15]

At Oenpelli in the Northern Territory, Aboriginal artist Warren Djorlom teaches the author the fine art of painting using a blade of grass as brush. Some surprisingly good results can be achieved by such simple means. However, the fine draughtsmanship exhibited by the Bradshaw artists is absent from Aboriginal art as practised at the time of European settlement

Little by little, therefore, we are assembling from the Bradshaw paintings a picture of the people behind them significantly clearer than we were able to do in the case of the pre-Bradshaws. We may infer the Bradshaw people to have been graceful in build and manner, delighting in 'fashion' accessories, clever at creating boomerangs, proficient as artists. We may infer that they enjoyed dressing up for ceremonies, equally that they enjoyed music (for there are depictions of paired boomerangs seemingly being used as castanets to accompany singers).

In earlier chapters we found clues in the paintings that they may have developed ways to detoxify cycads and yams, very possibly planting these latter as 'crops'. We also noted signs that they domesticated as a dog the

now extinct thylacine, or Tasmanian tiger. Their depiction of a possible 'Earth Mother' cult may have been linked to these pioneering steps in plant and animal domestication—though the evidence is nowhere near as clear as we might wish. Rather more positively, the 'floating figure' that we saw at the Deception Range, and that which Joseph Bradshaw discovered on the Roe River in 1891, are but two of a whole genre of such figures suggestive that the Bradshaw people may have had shamans claiming to be able to perform out-of-the-body travelling.[16] This may thereby link them in some as yet undetermined way to the various tribal peoples of Africa, of South-East Asia and elsewhere, who continue to have individuals claiming similar powers.

As in the case of pre-Bradshaw people we may strongly suspect that the Bradshaw people built and used boats. This is because they appear to have arrived in the Kimberley fully developed from somewhere else, also their art is so commonly found located along the region's riverbanks. So hopefully there may sooner or later turn up a boat representation firmly attributable to the high Bradshaw period, most examples so far found seeming costume-wise to belong to the later Clothes Peg era, though this may simply be because they are showing an everyday activity rather than a ceremonial one.

It would be wonderful, likewise, for a Bradshaw painting to be found that clearly depicts a Bradshaw dwelling place. So far not a single known painting depicts anything of this kind, though as it happens we may actually have evidence of such habitation quite independent of any paintings. As may be recalled from Chapter 2, back in the 1950s Father Ernest Worms was in the habit of going 'walkabout' collecting whatever scraps he could of the folklore of those north-west Australian Aboriginal tribes living the traditional lifestyle.

One such tribe was the Bardi,[17] living just to the south-west of the present-day Kimberley on the northernmost tip of the Dampier Peninsula. An elderly Bardi related to Worms a story that he had been told by his then 60-year-old father back in 1915 concerning some very early people in the Kimberley region who were called 'Guri', or 'Giro'. These 'Guri' were very small in stature, thereby immediately equating them with the small size we have inferred for the Bradshaw people. They seemed to have come from

across the sea, for Worms' informant called them *binarara*, meaning 'salt-water men'. They were apparently 'very clever and deft at making good hair belts and "shells" to hang in front of their bodies', neatly reminding us of the belts that all Bradshaw people wore at their waists and the baskets that the 'bagmen' carried in front of their bodies. Supposedly, the Guri were 'able manufacturers of boomerangs and ornaments', another striking parallel with the Bradshaw people.

Most notably of all, however, these tiny people apparently lived in 'large communal grass huts' which were instrumental in their downfall. For the Bardi were thereby able to surprise them at night while they were all asleep in the one big grass hut. According to the Bardi man's story:

> The small people were sleeping and snoring. The Bardi speared many of them. Then they gathered sticks and burned down the grass house.[18]

Here the major point of interest is that any such living in communal grass huts has never formed part of the culture of Aboriginal people as known from any of the tribes extant on the Australian mainland at the time of first European settlement.[19] So for an Aboriginal person to speak of the tiny Guri people as having had such a dwelling suggests a genuine memory, however difficult it may be to believe that such a tradition could have been handed down from as long ago as the Ice Age.

The second point is that to this day on New Guinea, and also on the Indonesian islands, there are tribes whose traditional dwellings are 'long houses' of precisely the kind described by Worms' informant. So is this a clue that the Bradshaw people's origins lay in some such more northerly location, their migration to Australia's Kimberley perhaps having temporarily been successful, only ultimately to be cruelly ended by a more aggressive people exterminating them with spears?

A particularly interesting aspect of the Bardi man's story is that he characterises the Guri people by their making boomerangs and their conquerors by their having spears. These are precisely the chief weapons that we have already noted to distinguish the Bradshaw people from their prime successors, the Clothes Peg people.

Now the Bardi man was of course telling of just one localised incident. It would be obviously oversimplistic to suggest that a people who had spread themselves as extensively over the Kimberley as the Bradshaw people could possibly have been wiped out by one single 'long house' massacre. Arguably the raid in question was one of many that happened over a wide area and a long period whereby the peaceable culture of the Bradshaw people steadily lost ground to invading Clothes Peg people. Grahame Walsh has assembled an elaborate series of sub-phases post-dating the Tassel and Sash periods, amongst which he enumerates the so-called Elegant Action figures in which the people depicted wear rather less and engage in rather more energetic action than has been seen previously.

But from even the most cursory quantitative sampling of the Kimberley's rock art, the really big art period shift was from what I have simplistically termed the Bradshaw era, characterised by a clearly very peaceable people living by the light boomerang, to what Walsh has labelled the Clothes Peg era, characterised by an altogether more aggressive people imposing their will on others under threat of the multi-barb spear.

And no painting more richly conveys this 'new' Clothes Peg people's spear-brandishing than a magnificent multi-figure panel which Grahame Walsh apparently discovered during his 2003 season in the Kimberley, a photograph of which was included in the *Weekend Australian* article featuring his patronage by Australia's mega-rich.[20] In the course of my preparing this book I contacted that article's photographer, Peter Eve, for permission to reproduce this photograph—permission he expressed his readiness to grant, except that the Myerses, as leaseholders of the land on which the photograph was taken, needed to be consulted first. Predictably, the instruction came back that any such permission should be withheld.[21] Accordingly Judith and I have made an interpretative drawing (see overleaf) from the newspaper reproduction, which more than suffices to convey the painting's salient details.

What we see on the panel are at least 27 figures that stylistically exhibit many affinities to the Elegant Action phase that Walsh associates still with the Bradshaw people, except that the hairstyles, the two-tone rendering of some of the figures and not least the weaponry all indicate that we are

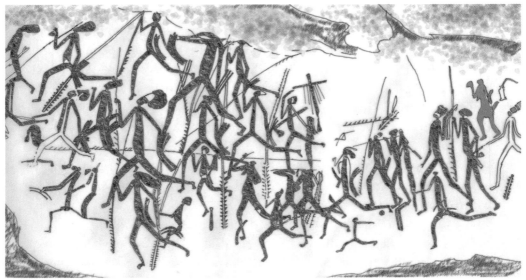

People of the Clothes Peg era—or is it the Elegant Action era? —bristling with multi-barb spears, the introduction of which seems to have marked the end of the era of the Tassel and Sash Bradshaw people. Note in some figures the swept-back hairstyle exhibited in some boat paintings—and a complete absence of the 'wizard' headdresses and long hairstyles worn by the Bradshaw peoples. Interpretative drawing, after a photograph by Peter Eve, of a panel painting found by Grahame Walsh in 2003

looking at people of the new Clothes Peg regime. Their very clearly depicted hairstyles are of the swept-back type seen on the boat paintings including that at Reindeer Rock.

Although some of the panel's figures are notably carrying sheaves of boomerangs, not only are these now bigger and more angled than those of the Bradshaw era—as if the Clothes Peg people had developed them as human combat weapons—virtually every figure, including some that seem to be female, bristles with one or more multi-barb spears. In the middle of the scene one figure appears to have an axe hafted onto a long handle. There seem to be certain indications of rank, one large figure having a particularly bushy two-tone headdress, while others are plain and flat-topped.[22]

From the fact that it is the Clothes Peg people who are most strongly associated with the boat paintings, an easy inference would be that they must have overcome the Bradshaw people by invading the Kimberley from across

the Timor Sea. But against this argument is their
harking back to the pre-Bradshaw stencilled hand
motif of the kind that we saw in the paintings at
Wullumara Creek. This suggests that their roots
were with the pre-Bradshaw people in or around
the Kimberley, their ancestors possibly having
been pushed to lesser locations when the Bradshaw
people arrived in the region. Given some subse-
quent reciprocity between the two peoples, the
Clothes Peg people may well have learnt much
from the newcomers, biding their time until the
circumstances were right for them to seize
power—much the same situation as independently
suggested by Worms' Bardi elder's story.

*Clothes Peg style figure seeming
unmistakably to be wearing some kind
of dress or skirt. From a painting at
Wullumara Creek*

While the Clothes Peg people had hardly the
'Parisian fashion house' flair of their Bradshaw
counterparts, they were hardly of the lowest
order of human development either, arguably
having absorbed some of the refinements the
Bradshaw people had introduced. Thus we saw
earlier that some Clothes Peg figures were
depicted wearing what it is difficult to interpret
other than as some kind of woven garments. They certainly had skilfully
constructed seaworthy boats significantly superior to the mostly crude
dugouts found amongst Australia's pre-European settlement Aboriginal
people. They practised some kind of religion. They had either developed or
had learnt from someone else how to make a *woomera* or spear-thrower for
launching their multi-barb spears against a human enemy. And these multi-
barb spears are themselves of considerable interest, suggesting some far-
flung links, for similar prehistoric designs have been found as far afield as
Denmark[23] where the Maglemosian culture—dateable to circa 10 000 BC—
intriguingly fabricated them from deer antlers.

But the Clothes Peg people's regime, in its turn, came to an end, for
reasons as yet far from clear. In Walsh's sequence of painting styles, he has

Example of a leaf-shaped spearhead as picked up by Steve McIntosh in the environs of Faraway Bay. These, like the Wandjina paintings, are associated with the last pre-European arrivals in the Kimberley

argued for there to have been a subsequent Clawed Hand period, but this is very thinly represented. For all broad purposes, by far the most significant subsequent phase was that of the Wandjina people, whose regime would continue into the time of European settlement.

The Wandjina paintings, with their huge owl-like heads, are so different from what had gone before that they certainly denote the incursion into the Kimberley of another people. As we noted earlier, these may well have arrived in association with the circa 3000 BC migration wave that brought the dingo and the earlier-mentioned leaf-shaped spear into Australia. At Faraway Bay, Steve McIntosh showed us an example of one of these leaf-shaped spearheads that he had picked up in the vicinity of the beach next to the resort. This had been beautifully shaped by skilful pressure-flaking that represented an artistry all of its own.

A description by Joseph Bradshaw's cousin Aeneas Gunn of some Wandjina-venerating tribesmen's attempted surprise night attack on Bradshaw's short-lived Marigui homestead may suffice as a haunting picture of how this still very Stone Age weapon was used. Alerted by some unnatural-sounding owl calls, Gunn and his companions grabbed their rifles and pointed these out towards where the nearest 'owl' sound seemed to be coming from just beyond a beam from the house lights:

> A sound came from the dark side . . . An instantaneous photograph of a magnificent savage, bedizened with red ochre and decked with lines and bands of white bird down, flashed on my mind as he sprang, with spears, throwing stick and shield in hand, across the shaft of light . . . For an instant my finger quivered on the hair trigger, and then a sharp bark rang out . . .[24]

It was just one small incident in that series of Europeans v. 'savages' encounters which would have such tragic consequences for the entire traditional Wandjina culture. Just as surely as the Wandjina had supplanted the Clothes Peg people, the Clothes Peg people had supplanted the Bradshaw people and these in their turn had supplanted the pre-Bradshaw people.

Throughout this book our main concern has been with the people behind the Bradshaw paintings, our attention having so far been focused predominantly on whatever data can be gleaned from the paintings themselves. But now it is high time to determine how this remarkable people can be fitted into the broad chronology of Australia's prehistory and in particular whether they, their boomerangs and their precocious artistic talent really can date as far back as the Ice Age.

The world's oldest known boomerang—reliably dated to between 20 000 and 30 000 years ago—and of a shape strikingly similar to examples depicted in the Kimberley's Bradshaw paintings

CHAPTER FOURTEEN
Putting dates to the paintings

Having established an undoubtedly very oversimplified sequence for Kimberley rock painting styles as:

1. Pre-Bradshaw;
2. Bradshaw;
3. Clothes Peg; and
4. Wandjina.

our next task is to try to fit the first three styles into their appropriate time-slots. The Wandjina overpainting of these occurred much later, possibly as late as 3000 BC, and is not the concern of this particular book.

As we noted much earlier in this book, Grahame Walsh had tried to determine the Bradshaw paintings' date by two scientific methods. The first of these involved taking a pigment sample from a painting, then having the age of this pigment calculated in a radiocarbon dating laboratory. From the outset this method lacked a meaningful scientific base regarding the materials sampled, and it produced dates far too 'young' to be taken seriously.[1] The second method involved extracting quartz grains deeply embedded in a

mud wasp's nest overlying a Bradshaw painting, then using a scientifically respected, though controversial, technique to calculate when those quartz grains had last been exposed to light. However, the result arrived at, circa 15 500 BC,[2] did not date the painting, for the mud wasp might have built its nest when the paint was hardly dry, or it might have done so when the painting was already ten millennia old. At best, the method determined the Bradshaw paintings to date back at least 17 500 years. For a firmer-based way of setting a broad chronological timeframe for the paintings, there needed to be some alternative approach.

Throughout this book we have noted that the very plenitude of the Bradshaw paintings (and the Clothes Pegs similarly) suggest them to have been painted at a time when the Kimberley's climate was rather more conducive to human habitation than its present Wet and Dry extremes. At site after site that we visited with Lee Scott-Virtue, Lee very cogently emphasised how 'oasis'-like they would once have stayed all the year round, however unpromising they might appear today. And when we look at what modern-day climatologists have deduced for the highs and the lows of the Kimberley's liveability within the last hundred millennia, a reasonably clear picture begins to emerge.

At around 60 000 BC, a date now being regarded increasingly seriously as that of Australia's first human occupation, the sea levels around Australia had dropped to around 100 metres lower than they are today. This meant that the Kimberley stretched in the form of broad plains some 110 kilometres north of its present coastline, the next-door Northern Territory joining up to what is today the island of New Guinea to form one big 'Greater Australian' landmass sometimes called Sahul. Freshwater lakes flourished along coastal areas that the sea has since flooded, and also much further inland in what today are areas which are arid in the extreme.

During the circa 30 000 to 20 000 BC period this then much larger Kimberley—perhaps some 700 000 square kilometres, or roughly the size of Turkey—was particularly attractive to human presence, with plenty of grassland and abundant year-round moisture levels to maintain deciduous trees and food plants. By contrast to the surrounding Ice Age world, in which huge tracts of the Northern Hemisphere were covered by thick ice sheets, it

has to have been a real 'Garden of Eden'. But starting at about 20 000 BC Australia's freshwater lakes began to dry up and its drought-intolerant plants to die off, a desiccation process that in the Kimberley would continue for ten millennia. In the meantime, from 13 000 BC onwards when the Ice Age ice sheets began to melt, periodically releasing billions of gallons of fresh water, the world's sea levels rose in unavoidably catastrophic fits and starts. In the then Kimberley, the Timor Sea spilled inexorably across its broad plains, at much the same time breaking into what had previously been a freshwater lake to form the present Cambridge Gulf. Overall, 'Greater Australia' lost no less than three million square kilometres of its former landmass, stabilising at something of its present-day climate and coastline only around 6000 BC.

So if the optimum period for the peopling of the Kimberley was between 60 000 and 20 000 BC, what do we know from Australian archaeology of what was happening amongst the continent's human occupants during that time? Needing immediately to be said of Australia in general, and of northern Australia in particular, is that archaeological investigation is in its infancy compared to, say, Europe. Besides the costly logistics of getting supplies to archaeological teams working in remote areas, present-day Aboriginal people—who have already suffered more than enough from whites—regard any disturbance of their ancestors' bones as an assault, and they have achieved legislation protecting their rights on such matters. For any archaeologist, obtaining permission to investigate any site, however productive its potential, is fraught with considerable bureaucratic difficulties.

Unsurprisingly, therefore, most of Australia's more meaningful dis-coveries of human remains are ones that took place more than three decades ago. In the late 1960s Melbourne-based anthropologist Alan Thorne inves-tigated the Kow Swamp in north-west Victoria, a remote region some 45 kilometres north-west of Echuca and 15 kilometres from the banks of the Murray River. He turned up some 40 skeletons of men, women and children who had lived and died somewhere between 13 000 and 9500 years ago.[3] Their burials had included the use of red ochre, the very same material that was used as pigment in rock paintings. And from their unusually thick, archaic-looking skulls and their generally large, heavy bones, their build was

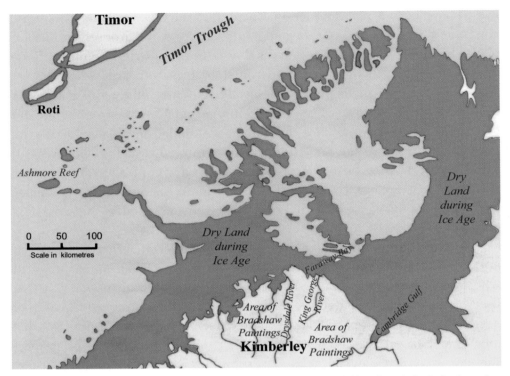

The Kimberley of the Bradshaw people? Map showing in dark blue the Kimberley's altogether greater landmass before a huge area of plain became drowned by rising post-Ice Age sea levels

clearly of a robust, rugged variety consistent with the 'Fred Flintstones' whom we associated with the Kimberley's 'pre-Bradshaw' phase.

At much the same period Jim Bowler, a Canberra-based geomorphologist, was exploring the surrounds of Lake Mungo, one of a New South Wales complex of inland lakes[4] that dried up during the 20 000–10 000 BC desiccation, when he noticed some protruding burnt bones. With great prescience he had the whole bone-bearing section cut out *en bloc* and transported to Canberra, where a team of archaeologists led by Alan Thorne painstakingly 'excavated' this with all the benefits of their working in laboratory conditions.

Thorne duly determined the bones to have belonged to a young woman who had been cremated circa 23 000 BC, the world's earliest known example of such a practice. Then in 1974, again at Lake Mungo, a further, more

complete skeleton came to light, 5000 years older than that of the young woman, followed by further fragmentary bones representative of around 100 individuals. All had apparently been preserved by the surrounding soil's unusually high alkalinity. All had had red ochre sprinkled on them, exactly as at the Kow Swamp site. And despite some disagreements over dates, there is currently a general consensus that the oldest of these bones date to around 40000 BC. By far their greatest interest, however, is that they show the Lake Mungo people to have been of a very delicate and 'gracile' build—the specific description that archaeologists have consistently used of them. They therefore

From a 1970s British Sunday newspaper, an early report of Dr. Jim Bowler's Lake Mungo discoveries. Some Lake Mungo skeletons exhibit much the same gracile bone structure as that indicated in the Bradshaw paintings

very readily correspond to the physique that we have inferred for the Bradshaw people. Even their food remains,[5] amongst which the largest represented edibles were wallabies, are consistent with what could be caught with no more serious a weapon than a light boomerang.

The fact that Lake Mungo's light-bodied, modern-looking population dated older than Kow Swamp's robust, archaic-looking 'Fred Flintstones', while it has troubled some archaeologists, is of no special concern to us. The sample of ancient bones found so far is much too small for determining which group may have arrived in Australia first. In any case in 1980 an extremely 'robust' skull was found not far from Lake Mungo,[6] dating to circa 30000 BC, bringing the two populations closer to each other in date. The one certainty is that by 30000 BC two then still distinct populations, one of a very slight build, the other altogether more thick-set and primitive-looking, were both at large on the Australian continent and had already percolated well to the

south. And we have, of course, already inferred the existence of precisely such groups at some undetermined time in the Kimberley solely on the basis of the pre-Bradshaw and Bradshaw paintings.

So what of human remains in the Kimberley itself? While as yet no bones from any equivalent early period have been found there, evidence of very ancient human activity, albeit extremely sparse, most certainly has. As recently as the early 1990s Canberra-based archaeologist Sue O'Connor exca-vated a site called Carpenter's Gap, a few kilometres to the south-west of the Manning Gorge, where she not only found remains of human occupation datable back to circa 38 000 BC[7] but also, from the very same oldest layer, a slab fallen from the roof that someone had painted with a red pigment.

As has been recognised by the international rock art specialists Paul Bahn and Jean Vertut,[8] this actually constitutes the earliest evidence for rock painting that has so far been found anywhere in the world. We may not be able to tell whether the slab in question bore a painting from the pre-Bradshaw or Bradshaw period. But we can certainly say that rock painting of one or other phase was already under way no later than 38 000 BC. It is even very likely that Australia's first inhabitants arrived on the continent already practising rock painting. Ochre suitable for rock painting purposes (though it could also have been used for body paint or burial rituals) was found even in the oldest layer of the oldest known human occupation site anywhere in Australia. This was the Malakunanja II rock shelter in the Northern Territory, dating back to between 43 000 and 50 000 BC. Another Kimberley site investigated by Sue O'Connor was a rock shelter on Koolan Island in the Buccaneer Archipelago just a little to the west of the Mitchell Plateau, where she again found evidence of occupation stretching back to much the same early period as at Carpenter's Gap.[9]

For determining a lower age limit for when the Bradshaw and Clothes Peg paintings were created, the main clue is that the Kimberley's earliest human occupation sites clearly and consistently show a prolonged hiatus or abandonment coinciding with the 20 000–10 000 BC desiccation phase that climatologists identified as marking the end of the region's 'Garden of Eden' era. As veteran Australian archaeologist Mike Morwood of the University of New England has specifically remarked, the 'Bradshaw Period rock paintings

must precede this hiatus'.[10] So they date either before 20000 BC, or quite definitely before the desiccation that began at that time really had a chance to gain a grip, which Morwood sets at around 17000 BC.

If, as seems likely, the Clothes Peg period paintings also need to be incorporated into the period before the desiccation—and their plenitude suggests that they could have been around for easily three or four millennia—then the time of the Bradshaw paintings needs to be pushed back further still. Effectively the period between 30000 and 20000 BC appears to be the broad 'window' for when the Bradshaws were painted—thereby automatically ranking them amongst the oldest known rock art found anywhere in the world, and (as earlier noted) technically of a superior artistic quality to anything found elsewhere.

So is there any hard *archaeological* evidence independently corroborating Australia having at such an early time a population as advanced as the rock paintings suggest? In fact there is. In 1965 young Australian graduate archaeologist Carmel White (now Schrire) was excavating at a rock shelter near the East Alligator River in the Kakadu National Park in Australia's Northern Territory. She came across a collection of fifteen stone axe heads which, from organic materials in the archaeological layer at which they were found, could be firmly dated to between 16000 and 21000 BC.

While stone axe heads are almost two-a-penny amongst the artefacts that are found from the days of our earliest ancestors, these particular specimens were of a different order. Each blade's upper part had been specially grooved for a handle to be attached, and its edges had been specially ground on an abrasive stone such as sandstone, causing them to be known technically as ground-edge axes or hatchets. But what really set the 1960s archaeological community abuzz was that never previously anywhere in the world had such axes been found dating back as early as the Ice Age—and most certainly not from anywhere as 'backward' as Australia. As remarked by Australian archaeologists John Mulvaney and Johan Kamminga: 'It was believed previously that grinding stone into axe heads and wood-working tools was a marker for Neolithic farming societies, as it was in Europe.'[11]

Since the time of Carmel Schrire's discovery, Ice Age date examples exhibiting similar grinding have in fact been found at two specifically

Australian archaeologist Carmel Schrire, excavating in the Northern Territory, discovered examples of axe heads dating before the end of the Ice Age. Above is an example discovered by Steve McIntosh in the environs of Faraway Bay

Kimberley sites, Widgingarri, near Derby, and Miriwun, south of Kununurra, and also at Sandy Creek in northern Queensland.[12] Steve McIntosh picked up an example during his wanderings around Faraway Bay, though because it was not found in an archaeological deposit it cannot be considered datable.[13] Were such axes used for tree felling, boat-building, or other forms of crafting? We simply do not know. But definitely of significance is that other ground-edge axes of Ice Age date have turned up on Papua New Guinea, also in the Niah cave, Sarawak, Borneo, dated to circa 13 000 BC, and even as far as Japan, where they date back to 30 000 BC. So if we are looking to ground-edge axes as evidence of precocity in the Ice Age Kimberley, yes, they are to be found there, but they should not be thought of as exclusive to that region. There are signs that during the Ice Age a much wider western Pacific community may have been similarly precocious in at least that same respect.

In any case, the ground-edge axe features in Bradshaw paintings only rarely, at the very best. The main known examples are the one which Walsh showed in the course of his April 2004 lecture, and also what seem to be at least two large and small hatchets of probable ground-edge type that can be seen in the multi-figure Clothes Peg panel reproduced in the previous chapter. Altogether more prominent as artefacts in the Bradshaw technological repertoire were, of course, boomerangs. Almost every painting exhibits one or more examples of these implements. Overall they represent an extraordinary variety, including ones crafted in the shape of the 'crescent moon' that would have demanded the most delicate craftsmanship. So how can we be sure that boomerangs of any kind, let alone ones of such skilful workmanship and design, could have been made anywhere in the world as long ago as the Ice Age?

Even from the earliest days of my tackling this question, there was no suitably definitive tome properly tracing how, when and where the first boomerang might have been invented. The best authority that I came across was a slim volume published by the South Australian Museum,[14] where probably the world's finest collection of boomerangs is housed. But even this was far from exhaustive.

Nonetheless it soon began to emerge that even though the boomerang is comparatively rarely represented in prehistoric rock art much beyond 1000 kilometres outside Australia's present-day geographical borders, it has been around for a long time—and scattered very far across the world. When in the sixteenth century the Spanish Conquistadors began their invasions of Central and South America, they found the surprisingly advanced Hopi Indians of Arizona to have long been using boomerangs. In 1962 an oak boomerang dating from the Iron Age was unearthed in coastal dunes near Velsen in the Netherlands.[15] In the 1920s, when Egyptologist Howard Carter was opening up Pharaoh Tutankhamun's tomb at Luxor, he came across a complete case of boomerangs that had been included amongst the items provided for the young monarch's after-life.[16] Other ancient Egyptian boomerangs can be seen in tomb paintings dating back to circa 3000 BC.

World distribution of boomerangs, showing them widely scattered across the world, including Arizona, Egypt, the Netherlands and Scandinavia

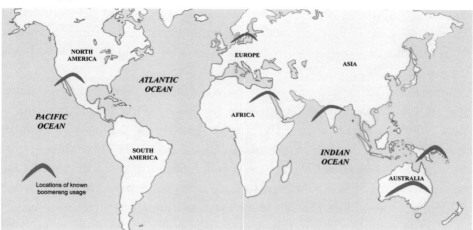

The shape of Australia's oldest boomerang, 10 000 years old, as found in the Wyrie Swamp, South Australia, in 1973

Although mostly of relatively simple design, these are nonetheless thought to have had proper returning properties.

The oldest actual boomerangs ever found in Australia came to light in 1973, unearthed by archaeologist Roger Luebbers in the Wyrie Swamp, 400 kilometres south-east of Adelaide. Just as unusual soil alkalinity had preserved the Lake Mungo bones, so at the Wyrie Swamp the naturally occurring peat had preserved no less than three specimens, all dating as far back as 8000 BC. One particularly fine example, made of 'drooping she-oak',[17] though it was of a broadly crescent shape still lacked that distinctive 'new moon' pointedness which characterises the finest Bradshaw painted examples. And of course even 8000 BC still falls some while after the end of the Ice Age rather than before it.

Accordingly, nothing short of astonishing—indeed every bit as astonishing as our finding of the 'reindeer' at Reindeer Rock—is just where the world's oldest known boomerang would turn up, and the form that this would take. A crow's flight of no less than 15 000 kilometres north-west of the Kimberley lie southern Poland's Tatra Mountains, in wintertime a popular destination for skiing enthusiasts. In the Tatras' foothills lie two very Kimberley-like rock outcrops, the Obłazowa and the Kramnica, standing like sentinels on opposite sides of the picturesque Białka River. And it was in 1985, while exploring beneath the Obłazowa Rock, that Kraków-based archaeologist Pawel Valde-Nowak and other specialists came across a small, room-like cave reminiscent of that which we found at Faraway Bay's 'Lost City'.

Painstaking excavation by Valde-Nowak and his team[18] duly revealed several different layers representative of the cave having had human occupants at different periods during the late Ice Age. By far the most interesting layer, however, was that which the team called Level VIII. This they attributed to the early so-called Gravettian period, belonging to an advanced Late Stone Age culture which is known to have been widespread across Europe from France to southern Russia. In Gravettian times unknown individuals had collected boulders from the nearby Białka River to form a kind of

shrine within the cave. Among the objects that they had also brought to this spot were reindeer antlers—for the Polish archaeologists nothing special as this was a region in which such deer had flourished. Rather more startlingly, there were also digit bones amputated from a human thumb and a human finger. These Valde-Nowak himself quickly associated with Europe's Ice Age rock paintings of 'positive and negative presentation of the human hand, often with incomplete fingers, seen in Palaeolithic artwork from caves . . . such as Gargas, Pech Merle, Cosquer, or lately Chauvet'.[19] Valde-Nowak's only omission was to mention that similar missing finger hand imprints are to be found in Palaeolithic Australia.

However, by far the most stunning object found in the Obłazowa Rock shrine—and one that Valde-Nowak most certainly did not fail to associate with Australia[20]—was a boomerang, and not just any ordinary wooden boomerang of the kind that had been found from ancient Egypt and in South Australia's Wyrie Swamp. This particular specimen had been painstakingly crafted in ivory, from a mammoth's tusk, the mammoth having been still extant during the Gravettian people's time. Someone had chosen to carve this boomerang in the semblance of a perfect 'crescent

Between 20 000 and 30 000 years old, the superbly crafted ivory boomerang discovered beneath the Obłazowa Rock in Poland. Its crescent shape is a perfect match for examples depicted in the Bradshaw paintings of the Kimberley

moon'—that is, identical to boomerang examples that we have seen among the Bradshaw paintings, such as in the five-figure 'Ode to the Boomerang' panel at Munurru.

Most extraordinary of all, however, was the date to which the Polish archaeologists attributed this unique find. A small fragment of its ivory was submitted to Oxford University's accelerator mass spectrometry radiocarbon dating laboratory, the same laboratory which worked on the Turin Shroud. This fragment produced a reading of around 16 000 BC, which even as it stood dated the boomerang back to the Ice Age, making it already by far the oldest known anywhere in the world. But because the amputated thumb bone and the other associated objects dated to circa 30 000 BC, the correct era for the Gravettian people, Pawel Valde-Nowak and his colleagues suspect the occurrence of one of those glitches that so repeatedly beset radiocarbon dating results. Accordingly they have reckoned the true date of the Obłazowa boomerang to have been likewise around the 30 000 to 20 000 BC period, that is, the very same period to which we have already been leaning for the Bradshaw paintings.

So called 'Mimi' figures are among several of the Northern Territory art styles with counterparts in the Kimberley, the most notable exception being depictions of fish and animals as if seen via X-ray, as shown below

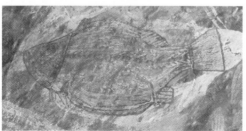

In fact there is one further approach that again supports such a dating. As earlier mentioned, the Kimberley's next-door neighbour, the Northern Territory, has very ancient rock paintings of its own. George Chaloupka, a 1950s migrant from Czechoslovakia who became curator of the Northern Territory's museum in Darwin, has extensively studied these. And just as Walsh assembled a sequence for the

Kimberley rock paintings, so Chaloupka has done much the same for the various styles of rock paintings that he has found in and around Arnhem Land.

The era that Chaloupka calls 'Pre-Estuarine' is of the greatest interest because within this he has identified a number of phases, three of which very broadly, though nonetheless perceptibly, correspond to our simplified version of Walsh's sequence for the Kimberley paintings.

First there was a preference for stencilled hand and boomerang imprints obviously equivalent to our pre-Bradshaw phase, though it also included the beginning of a painting type absent from the Kimberley—depictions of animals and fish as if seen via X-ray.

This stencilled hand phase was followed by a 'Dynamic' one in which the artists began favouring the painting of human beings, depicting them carrying boomerangs and wearing some elaborate ceremonial apparel, including long headdresses and sashes. Present-day Aboriginal people refer to such figurative depictions as 'Mimi', recalling the Mimi as an early, highly artistic people who taught them many of their present-day skills such as hunting, the preparation of foodstuffs and the composition of songs and dances for open-air ceremonies.[21] This Dynamic phase in the Northern Territory is readily equivalent to that of the Bradshaws in the Kimberley.

Painted on a rock at Ubirr in Arnhem Land what Chaloupka terms 'Dynamic' figures—running figures with multi-barb spears, readily corresponding to those of the Kimberley's Elegant Action phase between the high Bradshaw and Clothes Peg periods

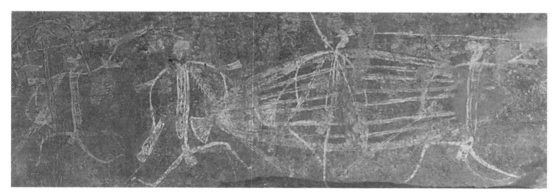

A third phase was one in which the humans were depicted brandishing multi-barb spears accompanied by the occasional spear-thrower—obviously equivalent to our Clothes Peg period. All three of these phases Chaloupka determined as having preceded what he called the Estuarine period, when the sea began separating Australia from New Guinea and Tasmania—that is, the ending of the Ice Age period that the latest climatological studies show to have been from circa 13 000 BC onwards. Although Chaloupka has avoided quoting hard dates within the pre-Estuarine period, his Dynamic phase is set sufficiently early in his sequence that it has to fall in much the same circa 20 000 BC period that we have been increasingly leaning towards for the Bradshaws.

In fact I am not alone in pointing out the importance of such parallels between the rock painting of the Kimberley and Arnhem Land. Darrell Lewis of the Australian National University has particularly strongly castigated Grahame Walsh for his failure to give them greater attention in the cause of a better understanding of both sets of paintings' dates and their relation to each other.[22] However, there is one instance of such links that not even Lewis has yet spotted.

In 1973 German-born scholar Eric Brandl[23] produced a book of drawings that he had made from paintings of the Dynamic type that he found in Arnhem Land. Browsing through this, I noticed that one drawing,[24] from a painting that Brandl had found at Deaf Adder Creek in western Arnhem Land, had a familiar look to it. It depicted exactly the same 'boomerang coronation' ceremony scene that Russell Willis and his party had come across in its 'Bradshaw' guise during their explorations of the Drysdale River's Planigale Creek (see page 178). From the very unnatural way that the left-hand figure has his head thrown back and arms thrust forward in both examples (as also in the Munurru 'Bagman'), it is clear that back in Bradshaw/Dynamic era times people could move from the Kimberley to Arnhem Land and still see much the same ceremonies being performed.

This strongly suggests one relatively uniform culture, albeit with stylistic variations, prevailing across a broad swathe of northern Australia back in Ice Age times, very likely extending as far east as Queensland. And as Lee Scott-Virtue and Joc Schmiechen have pointed out to me, there are many other examples supportive of such trans-regional parallels.[25] So, if from

Chaloupka's sequence the Deaf Adder Creek Dynamic painting should be dated to somewhere around 20 000 BC, then we should have yet more confidence for slotting the Bradshaws into much that same era.

And once we can *reliably* ascribe the Bradshaws to that early period, then suddenly they can assume so much more than just very localised Australian interest. For the vast majority of westernised people across the world, even with all our modern-day communications, their understanding of the beginnings of what we call our 'civilisation' continues to be Euro-centred. In the crudest terms, they imagine that our ancestors spent the Ice Age mostly huddled in southern European caves and Middle Eastern rock shelters, creating some creditable animal paintings along with developing a few other skills. Then around 10 000 BC they invented the bow and arrow, moved out into the vast grasslands opened up by the Ice Age's ending, and around two millennia later began founding the first towns and cities. Against this historical backdrop the world at large has dismissed Australia as a completely isolated and irrelevant backwater where one of humanity's most primitive

At left, figures of the Dynamic phase as found at Deaf Adder Creek in western Arnhem Land. The left-hand figure has his head thrown back and is holding a boomerang over the second figure in a pose strikingly similar to the Bradshaw painting, seen at right, found by Russell Willis's party along the Drysdale River

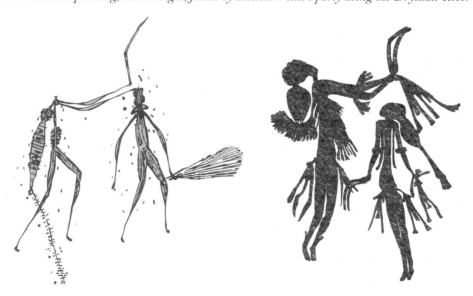

peoples scratched out the most meagre of existences, continuing that way until the first Europeans began introducing proper 'civilisation' to them during the last three centuries.

But in the light of the Bradshaws even possibly dating to between 30 000 and 20 000 BC, suddenly a whole new perception begins to emerge. If the painters of the Bradshaws were anything like contemporary with the Europeans who painted the great animal paintings of the Lascaux and Chauvet caves, then these Ice Age Australians can hardly be perceived as the latter's poor relations. Rather, they can be seen as often in advance of the westerners in a great deal. Such advances might include string-making, plant cultivation (the growing of yams in an orderly fashion), animal domestication, food processing (the detoxification of yams and cycads), basketry, weaving (the making of full-length garments), boat-building, wood-crafting (in order to create boomerangs) and, not least, superbly observed depictions of the human figure.

However, before we become too precipitately lured into looking to Australia's Kimberley as some lost 'cradle of civilisation', a highly important note of caution is needed. As we have earlier noted, the Bradshaw people were not actually indigenous to Australia. They came into the country from somewhere else, seemingly having already developed a lot of their culture, including their boomerangs, in that as yet undetermined other place. So could that 'other place' have been from where the Gravettian people of Ice Age Poland likewise managed to derive their so similarly shaped boomerang? What about the pre-Bradshaw people, who after all had their own versions of boomerangs, albeit a lot cruder? Where might they have come from, given that they were producing negative hand imprints so similar to those that were being created at *much the same time* in the caves of Western Europe? And what do we know about present-day Aboriginal people and whatever clues to their ancestry that may be locked in their genes?

It is suddenly apparent that we need to be looking to the latest findings on prehistoric genetics, and generally to be asking a lot more questions of the prehistory of peoples in Australia's near vicinity than we have been raising hitherto.

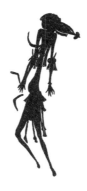

CHAPTER FIFTEEN
Putting genes to the paintings

If there is one universal truth behind the history of the world's paintings, it is that they themselves, just like the artists responsible for them, have families, and sometimes quite far-flung ones. When in the 1870s Parisian artist Edgar Degas began creating some unusually intimate paintings of women bathing, his inspiration came from across the world, in the form of Japanese prints of such subjects then reaching the west via burgeoning trade links with Japan. Three and a half centuries before Degas, when the great German artist Dürer painted a figure of the Biblical Adam, his source was an Apollo Belvedere statue that had been created in Rome fourteen centuries before. This in its turn had been copied from a since lost Greek bronze statue that dated four centuries earlier still. So when we come across certain recurring motifs in the Kimberley's most ancient paintings, it seems a worthwhile exercise to look for where, and how far, such motifs might be found well beyond the Kimberley.

As we noted towards the end of the previous chapter, the 'boomerang coronation' ceremony Bradshaw painting that Russell Willis's group found in the Kimberley's Drysdale River region has an uncannily similar Dynamic figure counterpart at Arnhem Land's Deaf Adder Creek. This immediately

enables us to infer some strong cultural, and very probably genetic, roots between the peoples of the two regions. So what about the pre-Bradshaw and Bradshaw paintings' recurring motifs of stencilled hands, stencilled boom-erangs, depictions of boats with upswept prows, 'mother goddess' figures, individuals wearing sashes, and so on? How many of these can we find turning up outside the Kimberley's immediate environs, and what might this suggest to us of the pre-Bradshaw and Bradshaw peoples' genetic roots?

Stencilled hands, as we have already noted, are commonly found right across northern Australia, with plenty of examples in the Northern Territory and extending round to Queensland. Unfortunately, because the practice has survived into relatively recent times—not to mention its prolif-eration bewilderingly far across the world—at best, as any kind of genetic indicator, it can only confuse.

It is nonetheless well worth pointing out that if we look to Australia's north we immediately find examples that are of very equivalent antiquity. Within the last few years French archaeologists Jean-Michel Chazine and Luc-Henri Fage have been leading expeditions to the island of Borneo,

A small selection of the hundreds of stencilled handprints Chazine and Fage found in Borneo—thought to date to much the same period as their equivalents in the Kimberley

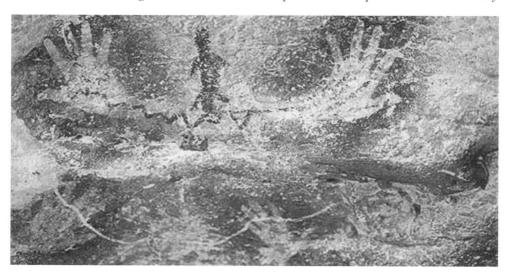

beyond Java to the Kimberley's north-west.[1] Borneo, it may be recalled, was one of those 'precocious' places where an example of a ground-edge axe was found dating back to the Ice Age. And deep in its interior Chazine, Fage and their colleagues have been exploring cave complexes that are exceptionally rich in art similarly dating as far back as the Ice Age. Although their discoveries have yet to be published in definitive form, preliminary press reports make it clear that they have found at least a 1000 hand imprints of exactly the same stencilled 'negative' variety so prevalent in the Kimberley and the Northern Territory. Some of the caves have high ceilings, and just as we observed of those hand imprints that were superimposed by the 'Great Mother' figure on the ceiling at the Kimberley's Chamberlain Gorge, some of those in Borneo are sited 10 metres from floor level—raising similar questions concerning how the hands' owners managed to reach such heights.

But by no means all the images that Chazine and Fage have found have been hand stencils. They have come across animals depicted in a distinctive X-ray style that they themselves recognise as having some striking similarities to examples previously supposed to be unique to Australia's Northern Territory. As may be recalled from the previous chapter, George Chaloupka includes in his early phases an X-ray category which has no Kimberley equivalent. This finding has caused even Chazine, completely unprompted, directly to suggest that the Borneo cave artists and their Australian counterparts may have been 'cousins' in some as yet undetermined way.

During Chazine and Fage's 2001 Borneo expedition, at a cave called Gua Tamrim (*gua* means 'cave' in Indonesian), they found paintings described as of 'long, thin human figures, many of them wearing . . . long, elaborate headdresses'. These obviously sound rather promisingly similar to the Bradshaw figures, though to what extent they actually are must be determined upon their publication.

But it was Chazine and Fage's casual listing of some animals that they had found represented in another Borneo cave, Gua Masri, which proved to be my cue to search the nearest reference data. Chazine and Fage enumerated 'flying lizards, *deer*, pigs, bovine creatures . . .'. On my first reading of the report, before our visit to Reindeer Rock, I had taken no special notice of the 'deer' mention. And even up to the time of my re-reading it, actually

while revising this chapter, it had not occurred to me that Borneo, which directly straddles the Equator, might possibly include deer amongst its fauna. As I quickly discovered in fact it has two species, one of these a diminutive mouse deer, but the other the sambar,[2] one of the larger of the world's deer varieties and with at least a broad superficial resemblance to a reindeer. Most prevalent in India, where it is one of the tiger's favourite delicacies, it is spread quite widely across Asia, and even today also survives on Borneo.

Modern-day artist's drawing of Sambar deer, seen at left, compared to two of the horned animals painted on the Kimberley's Reindeer Rock, seen at right.. To have seen such a creature the Kimberley artist would have had to cross the Timor Sea

From the moment that I first saw a photograph of a sambar deer, with its antlers that can grow up to a metre long, it was quite apparent that it had to be the same species as in that long line of the creatures represented on Reindeer Rock. Equally obvious was that in order for any Australian to have viewed sambar deer back in the Ice Age he or she had to have under-taken a trans-oceanic boat journey. It was surely no coincidence, therefore, that Reindeer Rock actually included a depiction of a boat journey on its northern side. So here was the strongest possible indication that back in the Ice Age either the artist who had painted Reindeer Rock, or someone closely associated with them, had visited Borneo, or at least 'Borneo' as it existed at that time.

This immediately makes it imperative for us to be aware of Australia and its nearest neighbours' geography during the period before circa 13 000 BC when all coastlines became drastically changed by the Ice Age's nine-millennia melt. Prior to that time, as we have already seen, Australia still had Tasmania firmly attached to it, and it was equally firmly joined to New Guinea by a land bridge where today lies the Gulf of Carpentaria, the whole ensemble being technically known as Sahul.

Present-day Indonesian islands such as Timor, Flores and Sulawesi (the former Celebes) were even then still fully separate islands, because of steep surrounding oceanic shelves. But an altogether different situation pertained to Borneo (the world's fourth largest island), to Java, to Sumatra, and also to the Malay/Thai peninsula. These were all firmly joined to what are today Vietnam, Cambodia and Thailand—and thereby to the Asian continent—making up a huge subcontinental landmass known as Sundaland. Such a single landmass, as distinct from today's fragmented islands, could of course have enabled herds of sambar deer to wander down from what is today Borneo possibly to as far south as where Java now stands. On the way, they would have had to cross three large rivers that then existed on that landmass. But at Java the approximately 100-kilometre Timor strait that had decisively

Australia and island South-East Asia as they would have looked back in the Ice Age, showing the shorter distance anyone from the Kimberley would have had to travel to view a sambar deer

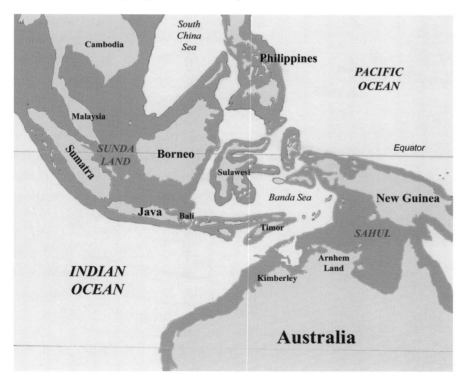

kept Australia's marsupials and South-East Asian placental mammals apart throughout millions of years would quite unquestionably have stopped them.

So for our Kimberley-based artist, or whoever briefed him on his work, to have seen a herd of sambar deer, he or his close associate must have made a purposeful voyage to South-East Asia, as it existed then, at some time relatively close to when the painting was created. As our best assessment of Reindeer Rock's 'reindeer' and 'boat' paintings was that they belong to the Clothes Peg period,[3] this could only mean one of two things, either that Clothes Peg invaders migrating from South-East Asia brought with them into Australia some memory of the fauna that they had left behind in their homeland, which they duly recorded on the boulder at Reindeer Rock, or that during the Ice Age they were making regular round trips between the Kimberley and the South-East Asian mainland as this existed at that time. Either way, all that we have previously glimpsed of some kind of maritime-based association between South-East Asia and the Kimberley rock painting artists can now be treated with altogether more confidence.

Top: Typical 'soul ship' or 'Boat of the Dead' from South Sumatra. Middle: the Reindeer Rock boat painting. Bottom: Just a small selection of boat paintings in the Niah cave, Borneo

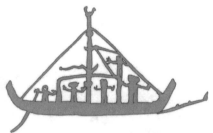

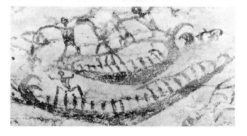

Once that mental bridge is in place connecting the Ice Age Kimberley and Ice Age South-East Asia, then all sorts of links that would otherwise seem very tenuous quickly begin to fall into place. Thus, as we noted much earlier in this book, the motif of figures standing up on a boat with upturned prow and stern, as can be seen immediately adjoining the reindeer on Reindeer Rock, may now be perceived as not any mere 'one-off' by some unknown and geographically isolated artist, but as belonging to a 'family' with the longest possible 'family tree'.

'Boats of the Dead' are quite unmistakably a central motif of the folklore of South-East Asian islanders, and also their neighbours along the mainland South-East Asian coastline, stretching way back into prehistory before later religions such as Hinduism, Buddhism and Islam became introduced into the region. And it is again on Borneo that we find one of the closest and most ancient parallels to the Ice Age boat paintings of the Kimberley. Towards the island's north lies the Niah cave, the very same cave in which was found one of those so 'precocious' ground-edge axes as described in the previous chapter. Now a tourist attraction accessible by a raised plankway over dark forest swamp, followed by a stiff climb up cliffs, the Niah cave has been occupied by humans as far back as 40 000 BC according to its controversial first excavator, Tom Harrison.[4]

For us the cave's most interesting feature consists of numerous depictions of high-prowed boats loaded with up to 20 people each that can be seen decorating its walls. As widely recognised by specialists in Asian studies, even if these are less than a quarter of the age claimed by Harrison for the cave's earliest occupation levels, they still represent one of the oldest and most powerful visual forms of South-East Asia's 'Boats of the Dead' motif, deeply rooted as this is in the local peoples' psyche and folklore with any number of textiles and woodcarvings throughout the whole region attesting to this.

Similar images can be found in designs on Sumba Island in the Lesser Sunda islands[5] immediately across the Timor Sea from the Kimberley, and on woven cloths that are a famous traditional product of Lampung in Sumatra.[6] Across the Makassar Strait from Borneo, on the island of Sulawesi, the Toraja people to this day build their houses with roofs in the shapes of high-prowed boats. These, they say, symbolise the boats in which their long-deceased ancestors travelled to reach their present home, and in which all must travel to rejoin them. As a Torajan priestess's incantation has described this:

Now we are on the ridge of the roof
We are above, on the roof
Blow wind from the sea
Carry us over the earth . . .
Row, ye birds of bright plumage

Use the oars ye ospreys,
The rainbow is our conveyance
The rails of the bridge are of gold[7]

Several modern-day specialists in South-East Asian studies have noted that this very same theme is reflected on the South-East Asian mainland, in the form of magnificent Bronze Age drums known as Dong-son drums.[8] Dating only from around the middle of the first millennium BC, but undoubtedly based on much more ancient themes, these were named after the village of Dong-son in North Vietnam where the first known examples were found buried in a rice field. But many other examples have turned up throughout the islands of South-East Asia, including Sumatra, Java, Sumba and the South Celebes,[9] suggesting that they were transported and traded with across great distances. A repeated motif on the drums is boats with upswept prows on which figures are depicted standing upright, exactly as in our Reindeer Rock depiction.

Equally pertinently, repeated on the drums nearly as many times as the 'boat' is a line of deer,[10] again reminding us of that previously enigmatic line of deer on Reindeer Rock. And the great advantage of having the Toraja and other seemingly related cultures to call upon is that we can glean from their folklore what the deer meant. In South-East Asian mythology deer were associated with the rainbow (notably mentioned in the Torajan priest-ess's incantation), this being the bridge by which the celestial boat carries its occupants into the land of the dead. So could the line on which Reindeer Rock's deer are standing have been intended as the top edge of a rainbow? Hitherto Reindeer Rock's paintings have seemed mute and unintelligible. But suddenly we have opened up for us from the still living art and traditions of the peoples of South-East Asia a means to begin to be able to 'read' them in a way that might previously have been supposed impossible.

Once the Reindeer Rock panel begins to be intelligible, there opens up also the possibility of being able to do much the same with many other of the Kimberley paintings and those who created them. For instance we may recall from Chapter 13 that the Bardi elder interviewed by Father Ernest Worms mentioned that the people responsible for the Bradshaw paintings had lived

communally, in large grass huts. Such long houses are traditional to this day in communities right across island South-East Asia, notable among these being the Dayaks of Borneo, the Bataks of Sumatra, and numerous other such peoples. Just as in the case of the Toraja, many of these peoples' houses have boat-shaped roofs.

Similarly, now we have compelling indications that there was maritime activity between the Kimberley and island South-East Asia even back in the Ice Age, the identification of the puppet on the panel at Munurru, along with its counterparts documented by Grahame Walsh, can be treated with that much more confidence. For island South-East Asia boasts not only the earlier-mentioned wayang puppets of Java, but also the famous puppet dance with *sigalegale* puppets that is traditional to the Batak people of Sumatra. These string-operated puppets, carved of wood and dressed in traditional costume, were normally used at funeral services, where they were made to dance to the music of flute and drums. Quite possibly they were used shaman-istically, as a vehicle for the dead person to speak at his or her funeral service. So the Kimberley's rock paintings may well offer important clues to how and where all such puppets had their origin.

Particularly strengthened by a boat travel connection between the Kimberley and the world outside Australia, there is one parallel that I had noticed on the very first day of my acquiring a copy of Grahame Walsh's 2000 book. At that stage, for all I knew, it might have been attributable merely to coincidence and to my overactive imagination. On page 139 Walsh reproduced a Sash Bradshaw panel full of so many interesting-looking figures that I could not understand why he had neither reproduced it larger, nor drawn more attention to it.

In the centre of a row of highest quality figures was one (overleaf, left), that immediately stood out for me as being associated with the ancient Earth Mother of western Asia, even more than the figure with arms held out-stretched in the semblance of a capital 'A' that we came across so repeatedly at the Chamberlain Gorge and elsewhere. The pose, in this instance, was one in which the arms were outstretched level with the shoulders, except with slightly dropped elbows, almost in the semblance of someone being crucified. The figure carries a pair of crescent-shaped boomerangs in one hand and a

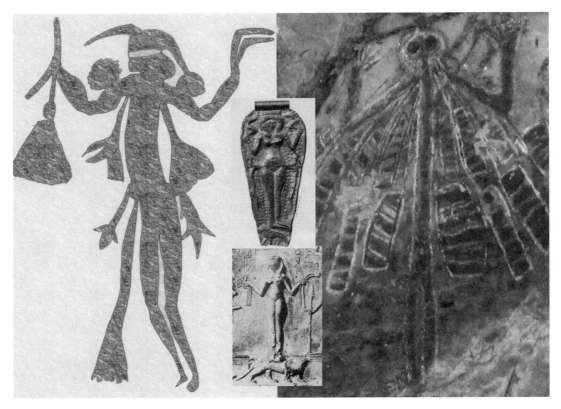

Left: Sash Bradshaw figure in arms outstretched mode, from the Mitchell River region of the Kimberley, after a photograph by Grahame Walsh. Right: The Arnhem Land 'Great Mother' Warramurrungundji, as painted on the Injalak rock complex in Arnhem Land. Insets: Top: The Syrian goddess Asherah, from a figurine in the Louvre, Paris. Below: The Egyptian fertility goddess Qudshu, from a relief in the British Museum, London

more angular one in the other, also at least three dilly bags, two seemingly from some point on the head or upper body. Elsewhere on the panel there are more Sash Bradshaw figures with dilly bags, one with the classic 'Bagman' straps with no bag or basket attached, the other with an enormous bag-like attachment to the headdress.

For me, very obvious was that this outstretched-arms figure bore the most striking resemblance to any number of second millennium BC Syrian figurines of the fertility goddess Asherah, in which she is depicted in exactly

this manner except that instead of the boomerangs she holds snakes. The ancient Egyptian goddess Qudshu was represented likewise, there being an excellent example, dating from circa 1400 BC, preserved in the British Museum. And these are but comparatively late expressions of this same goddess's much older cult, spread widely across the East under a bewildering variety of 'goddess' names.

A major problem for my associating Grahame Walsh's Sash Bradshaw figure with these western Asian and Egyptian examples, quite aside from a wide difference in date, was that within Australia I was completely out on a limb identifying the outstretched-arms figure even as female, let alone as a Great Mother. Grahame Walsh made this quite clear when I ever so gently broached the issue with him in the course of our 1 May interview. The best that I learnt from him, and only from my sneaking a peek at the label on a slide he produced showing the figure in greater close-up, was that the panel painting in question was located somewhere on the Mitchell River.

Then, while Judith and I were exploring high up on Arnhem Land's Injalak rock complex with Aboriginal artist Warren Djorlom as our guide, we came across precisely the same kind of Arnhem Land parallel for this Kimberley outstretched-arms figure that had similarly been found in the case of the 'boomerang coronation' ceremony scene.[11] The Injalak figure (opposite right) that Warren Djorlom pointed out to us was painted not only with outstretched arms in almost exactly the same pose as Walsh's Mitchell River figure, likewise holding paired boomerangs, it also bristled with no less than fifteen dilly bags that were suspended by strings from the head.

Exactly as in the case of so many Bradshaws, this particular figure had no breasts to distinguish it as female. But Warren Djorlom quite unprompted and unhesitatingly identified it as the great Earth Mother whom some of the region's Aboriginal groups knew as Warramurrungundji, others as Imbrombera. As we learnt not only from Warren, but from more formal book sources, the myth surrounding this Arnhem Land Great Mother was that back in the Creation time she had arrived from the direction of Indonesia at a period when the country was suffering great drought.[12] Her arrival coincided with the sea invading to reach its present level and all the springs and waterholes becoming refilled. She brought with her dilly bags full of yams

suspended from a head-ring, and in the course of her journey southwards she met up with a male partner, from which encounter sprang children. Thereupon she taught these offspring how to plant yams and to prepare them as food, and also instituted the totem cult. This same great Fertility Mother is known among a number of other northern tribes, a further name for her being Yamidj, she who 'calls to people towards the end of the wet season that the *anginjdjek*, the round yams that Aborigines call "cheeky", are ready to be dug out and eaten'.[13]

Once again, parallels deriving from outside the sphere of the Bradshaw paintings were beginning to make these latter speak. The similarity of Walsh's Mitchell River outstretched-arm Bradshaw figure to that on Arnhem Land's Injalak rock was simply too close for the Bradshaw example *not* to represent the Great Earth Mother. And as we have seen earlier in this book, based on hard botanical evidence, yams simply have to have been introduced into Australia by human agency from South-East Asia. The Kimberley and Arnhem Land paintings illustrate visually what had independently been recorded by Aboriginal myth—that Ice Age northern Australian people's roots lay north of the Timor strait in what was then Sundaland.

The fact that Warramurrungundji brought the bagged yams in on a head-ring immediately offers an explanation for why, in the course of our Kimberley expedition with Lee Scott-Virtue, we came across so many instances of individuals carrying large appendages from the end of their 'wizard' headdresses, there being another particularly fine example on Walsh's Mitchell River panel (see opposite). My personal hunch is these were shaman-like priests wearing 'token' single bags containing yams in commemoration of Warramurrungundji's great feat back in Creation days. But whatever the validity of this notion, it is surely no coincidence that to this day in the Indonesian sector of New Guinea women of the Dani tribe carry bags suspended by string from their heads. These they specifically use for carrying vegetables to and from market,[14] yams being a particularly important crop in New Guinea.

Once we begin to appreciate the proximity between the old Sahul continent and the Sundaland subcontinent during Ice Age times, and the altogether better climatic conditions that then prevailed in the region compared to the ice-locked nature of much of the rest of the world, then its suitability

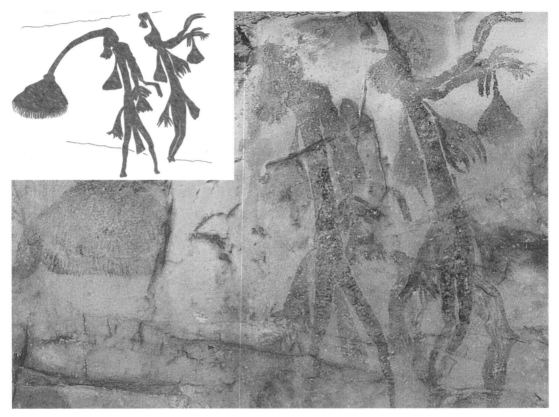

A Sash Bradshaw figure, on the same panel as that of the arms-outstretched figure on page 230, showing a bag-like attachment on a string from the head

for early maritime and other development becomes more and more obvious. With all that is today the Java Sea then having been dry land, the one major waterway of significance would have been the Banda Sea which, with protective land all around it, would have been an ideal nursery for people learning all that could be done in boats. To this day its waters are placid and gale-free, while the forests along its shores abound in *Dipterocarpus* trees that can reach 40 metres high and provide ideal timber for boat-making and other kinds of woodcraft.[15]

Archaeologically the Banda Sea region has been all too little explored. However, one certainty is that back in the very same circa 20000 BC period

Corm →

Above: textbook illustration of a taro plant with its corm, with (below) what Walsh calls a 'heart-shaped' motif that is a recurring feature among the Bradshaw paintings

that we have associated with the Bradshaw paintings, certain Ice Age peoples in its near environs were cultivating the taro, another very edible West Pacific root vegetable similar to the yam. The evidence takes the form of residue clinging to artefacts found in a cave on Buku Island at the northern end of the Solomon Islands east of New Guinea.[16] Cutting off the leafy head of a taro plant and popping it into the ground to create another taro may not be exactly in the rocket science league for the development of agriculture. Nonetheless, it represents one of the earliest forms of plant cultivation known anywhere in the world. And what Walsh calls 'heart-shaped motifs' that crop up in a number of Kimberley paintings,[17] another example of which we came across at Faraway Bay, bear some striking resemblances to taro corms.

To the Ice Age peoples of the then northern Australia and the then south-eastern part of South-East Asia, the Banda Sea would have provided all the trading and communications benefits that in much later millennia the Mediterranean would provide for the people surrounding its shores: the ancient Egyptians, Greeks, Romans and so on. In such a light the Bradshaw and related peoples of the Kimberley may well be perceived as having been rather less any kind of land-based Australian 'kingdom' and rather more the southern rim of a sea-oriented 'empire' of the Banda Sea.

Such an idea in fact has the strongest support from an all-too-little-known Oxford University environmental specialist, Dr Jonathan Kingdon.[18] Taking his cue from the now widely recognised premise that every human being alive today is descended from ancestors who lived in Africa 100000 years ago[19]—ancestors whose closest living relatives are the Khoisan Bushmen of the Kalahari desert—Kingdon has tried to define the route that these first migrants took out of Africa. He has suggested that they hugged the coast eastwards towards South-East Asia and Australia, following what were then more southerly shorelines across the Persian Gulf, around India and onwards. Wandering the beaches, reefs and mudflats, and crossing broad river estuaries, they would have enjoyed a plentiful and healthy diet from the abundance of seafood and bird-life that they were able to gather along the way. Unavoidably exposed to considerable sunshine during the long hours they spent beachcombing, they would necessarily have developed very black skins as protection. They would thereby have become the world's first truly black people, it being increasingly recognised that our humankind's natural 'starting' skin colour is a mid-brown, as exhibited by the Kalahari's Khoisan, extremes of black and white being adaptations to overabundant sunshine and to lack of it respectively.

According to Kingdon's hypothesis, these early black migrants can be expected to have much revered the moon, because of its control over the tides on which their foraging lifestyle depended. Arguably, this is why the great Earth Mother fertility deity has essentially the world over always been associated with the moon rather than the sun. Kingdon has envisaged this people as having been the world's first to develop boats. Probably they began them as floating platforms on which to load the seafood they collected, then gradually developed them into proper sea-going craft in which they could explore and exploit their environment with far greater ease and safety than by venturing into the thick forests covering the land. He has also conceived them as big pioneers in using fibres to make string, rope netting and other basics.

Kingdon's argument is that many of these developments would have happened when the migrants reached and settled in the Banda Sea region, this being perhaps several millennia after their ancestors left Africa. He has

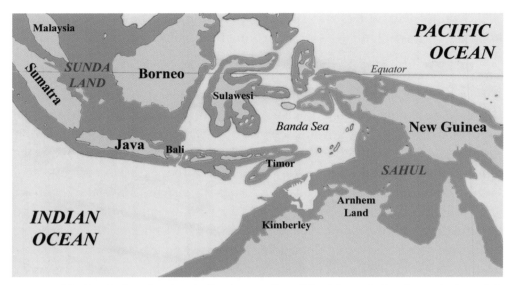

The Banda Sea, showing the Ice Age coastlines. Was this sea the Ice Age equivalent of the Mediterranean as a communications hub for the early peoples who settled around it, including the Bradshaw people of the Kimberley?

accordingly dubbed those who settled around the then Banda Sea region as the Banda people. And without Kingdon—to the best of my knowledge— even being aware of the Kimberley's Bradshaw and related paintings, he could hardly have written a better account of the 'Garden of Eden'-type region and culture from which the peoples responsible for those paintings arguably originated. For to this day much of island and coastal South-East Asia's rich mix of cultures revolves around water and boats. Among these are sea-gypsies such as the Bugis (of 'bogey men' fame), who travel the waters in graceful praus that nineteenth-century naturalist Alfred Russel Wallace greatly preferred to the noisy steamers back home in Victorian England:

> how comparatively sweet was everything on board . . . no paint, no tar, no new rope . . . no grease or oil or varnish; but instead of these, bamboo and rattan and choir rope and palm thatch: pure vegetable fibres which smell pleasantly, if they smell at all, and recall quiet scenes in the green and shady forest.[20]

The Bugis' origins lie deep in antiquity, with undoubtedly infiltrations from a whole mix of peoples, ranging from frizzy-haired Melanesians, to long-haired Veddoid Indians, to slant-eyed Mongoloids, who made their way into the Banda region in the course of the millennia. Each would have their own prior developments somewhere along that coastal route east out of Africa. From a much later period, for instance, early Chinese sources refer to a mysterious and ancient South-East Asian people called *k'un-lun*, whom they described as having black skins and frizzy hair and who had continued to make themselves responsible for much of South-East Asia's boat transport at that time.[21] Also worth a reminder is that Worms' Bardi informant had specifically described the Guri people behind the Bradshaw paintings as having had unusually black skins.

A Thai 'floating market' near Bangkok—one of numerous examples of how the lives of many of South-East Asia's peoples revolve around water and boats

All of this correlates readily enough with the origin of Australia's Aboriginal peoples, as this is becoming increasingly understood from genetic studies. As we have noted, the most recent pre-European migrant wave into Australia, the people who brought in leaf-shaped spears and the dingo, made their entry only within the last 5000 years. But quite evident from the 200-plus Aboriginal languages' near total lack of affinity with any other of the world's languages is that the generality of their origins within Australia stretch back considerably futher than this.

In the field of Australian genetic studies one of the most important contributions in recent years has been from Alan Redd of Pennsylvania State University, Pennsylvania, USA and Mark Stoneking of Leipzig, Germany.[22] Redd and Stoneking took DNA samples from Aboriginal people of north-west Australia (that is, the environs of the Kimberley), from Arnhem Land,

from the central desert area, and from the continent's south-east. They also took samples from a number of different Asian populations, including several in India, the South-East Asian mainland, Indonesia, New Guinea, the Philippines and China. From Redd and Stoneking's analyses of where mitochondrial sequences matched and did not match, they found that there had been at least three separate, major waves of migrations into Australia, all well prior to the modern-era migrations from Europe. Whereas the Aboriginal Australians' genetic connections with their nearest neighbours on New Guinea are relatively weak, by far their closest ties are with certain very long-established populations of southern India.

In fact, some kind of Indian link has been suspected for a long time, linguists having noted that among all the world's known languages, those of Australian Aboriginal peoples exhibit ties closest to India's ancient Dravidian language than to any other, albeit faintly, as if from a very long time ago. Anthropologically, similarities have also been noted between India's ancient Vedda peoples and certain Australian Aboriginal peoples. Arguably it was one of these three waves, perhaps from a group that had lingered some while in India, developing themselves somewhat in the process, before moving on, that was responsible for the long-haired strain that we see in the Bradshaws proper.

Evidence of ancient boomerang usage is relatively lacking amongst the Ice Age sites of island South-East Asia (with the exception of Irian Jaya—now known as the province of Papua New Guinea—which was still part of Australia during the Ice Age).[23] Yet one of the most fascinating and compelling aspects of Redd and Stoneking's DNA findings is that it happens to be precisely in India where we can pick up again the boomerang trail that the Bradshaw paintings so tantalisingly pose.

In the South Australian Museum's already-mentioned very fine boomerang collection there is a specimen[24] that was obtained not from Australia but from Madras, southern India, where one Edgar Thurston purchased it back in 1905. This boomerang is known to have come from the Piramalai Kallar tribe that live in isolated provinces to the west of Madurai, southern India. And quite extraordinarily, and again without any known prompting from the Bradshaw paintings, American geneticist Spencer Wells has

discovered it to be individuals of the Piramalai Kallar who have DNA strands bearing the closest similarities to ones from Aboriginal Australians. It is Wells' view, synchronising with Kingdon's, that early peoples from Africa moved through India on their way to colonise Australia, with some staying behind in India to leave the current-day Piramalai Kallar descendants.

Boomerang of the Kallar people, south India. Drawing after a specimen in the South Australian Museum, Adelaide

So could it have been that while the 'out of Africa' migrants were lingering on India's then coastal plains, someone either invented or refined already existing designs of the boomerang? Inspired perhaps by the acquired veneration for the moon, was it in India that the crescent-shaped boomerang was first crafted? Could such designs thereupon have made their way eastwards as part of the repertoire of those who ultimately reached the environs of the Banda Sea, crossing quickly southwards, it would seem, to become such a prominent part of the culture of the 'Bradshaw' people of the Kimberley? Equally intriguingly, did someone else from that original, boomerang-developing settlement in India move north-westwards, skirting the Himalayas in some way, at what must still have been a very early time, for a boomerang again of the crescent-shaped type ultimately to reach southern Poland and become part of the repertoire of the Gravettian people there?

Extraordinarily, in ways that would never have been supposed remotely possible two decades ago, we are now beginning to gain some quite unexpected rewarding glimpses of the lives and movements of our Ice Age ancestors. Such glimpses are revealing them to have been altogether more advanced and mobile than any people of the classic 'Fred Flintstone' mould many of us learnt about in childhood. So who knows what further insights may become possible during the next two decades?

But for now we have one further major question to explore. Why was it that when the Clothes Peg people eclipsed the Bradshaw people, no-one anywhere around Australia would ever again produce paintings of such precocious quality—at least, until the coming of the Europeans? What actually happened to the 'civilisation' that was the Bradshaw people?

Abandoned—the mysterious 'throne room' forming the room-like interior of one of the rock outcrops at the Faraway Bay 'Lost City'. Inset is the view from the 'throne'. While this particular site has not been excavated, at others in the Kimberley archaeologists have found clear indications of abandonment circa 16 500 BC—at the onset of the Big Cold Dry. Note the handprints at the lintel height

CHAPTER SIXTEEN
Tracing where they went

If we are searching for when northern Australia lost the environmental conditions that made it such a 'Garden of Eden' for the Bradshaw people, we need look no further than the earlier noted circa 20 000 BC climatic downturn, one which became particularly extreme from around 17 000 BC. As in one of its several dying throes the Ice Age went into maximum refrigeration mode, the whole world suffered average temperature drops of 8 degrees Celsius. And Australia was particularly badly affected. Almost the entire continent turned not only very cold but extremely arid, its formerly verdant centre becoming 'a vast dustbowl of swirling sand dunes where vegetation could not survive . . .'.[1]

Scanty though the archaeological record is, the effect of this Big Cold Dry on Australia's human populations was nonetheless very marked. Wherever archaeologists have excavated sites that were occupied during the Ice Age, they have found them to have been abandoned synchronous with the onset of the Big Cold Dry, and for a very long time. In the Kimberley Sue O'Connor's excavations of two rock shelters north-east of Derby, Widgingarri 1 and 2, have shown that after their continuous occupation throughout the 26 000 BC to circa 16 500 BC period, they thereafter became abandoned for no less than eleven millennia.

Fascinatingly, even the Bradshaw paintings themselves bear invisible testimony to their having been through such prolonged dry conditions. As noted from when we first were able to view on-site the examples along the Chamberlain River, one of their most mysterious characteristics is the way that their paint has become indelibly bonded to the rock, as if it has received some kind of natural laminate. This same characteristic essentially pertains to all Bradshaws and to no Wandjinas, and by far the best explanation for it has come from the international rock art specialists Paul Bahn and Jean Vertut.[2] They have pointed out that in certain environmental conditions, specifically intense and prolonged aridity, a 'siliceous coating' will form over rock surfaces. As they have further noted, the period immediately following 16 000 BC was the only one during our humanity's existence when northern Australia had cold dry conditions prevailing sufficiently long—over several millennia—to have had formed such a coating. So this coating not only protected the Bradshaw paintings, its presence strongly corroborates that they date from before 16 000 BC should any such further corroboration still be needed.

But the Big Cold Dry that thus 'laminated' the Bradshaws was merely the first of the horrors that awaited the peoples of Australia and its neighbours at the end of the Ice Age. From around 13 000 BC sea levels began rising, making big inroads into what had formerly been dry land, inevitably uprooting all those communities who might well have moved to the coasts specifically to escape the worst effects of the drought. Then around 11 000 BC there was a Little Cold Dry, ending around 10 000 BC with another surge in sea levels. This surge was so big that it seems to have been at this point that New Guinea and Tasmania began parting company from the former Sahul to go their own separate ways. Very likely the Kimberley simultaneously started to lose much of its coastal plains, these together with its broad river deltas, freshwater lakes and no doubt many more rocky art galleries all disappearing beneath a now seriously land-devouring Timor Sea.

Across that sea on Sundaland this vast region likewise began breaking up into the present-day Indonesian islands, with Borneo, Sumatra, Java and Bali being merely the larger of these islands to be formed by this process. With three major river systems being overrun, almost inevitably the

catastrophes that happened amongst the traditionally coastal and riverside communities would have been on a scale many, many times greater than the 2004 Boxing Day tsunami tragedy. A further major sea level surge happened around the 6000 BC period, occasioned by the collapse of two massive glacial lakes across the Pacific in Canada. When all finally settled down around 5000 BC Australia's status was much revised, as has been neatly summarised by archaeologist Jim Allen of Australia's La Trobe University and by Peter Kershaw of the University of Melbourne:

> Greater Australia was reduced in area by more than three million square kilometres—an area much larger than Mexico. Three major landmasses existed where previously there had been one . . . Coastal sites were either submerged or preserved on islands, while sites of the former arid interior became coastal . . . In places the postglacial marine transgression reduced the width of the coastal plain by up to several hundred kilometres, thus presumably drowning many Pleistocene [Ice Age] sites in the process.[3]

Needing particularly to be appreciated amidst all this devastation is that the twin scourges of prolonged drought and land-devouring flood almost certainly destroyed all that may well have been best about the Bradshaw people and their culture, leaving what exists today as the merest vestiges. Ninety-five per cent of Australia's present-day population, and all its biggest cities, lie within just a few kilometres of the continent's coastlines. Try to imagine the effect of Sydney, Melbourne, Adelaide, Perth, Darwin and Brisbane all disappearing beneath the waves to leave just the dusty ruins of a few inland towns such as Alice Springs. A completely inadequate picture would be left for some archaeologist trying to make sense of it 10 000 years into the future. What we have lost of the Bradshaw culture may well have been of proportionate magnitude.

So where might there have survived remnant pockets of the Bradshaw and Clothes Peg peoples? The very last place to look for them might seem to be amongst those Aboriginal people who occupied the Kimberley after the 16 000 BC to 5000 BC 'Dry' and 'Flood' era had ended. There can be very little doubt that the Wandjina-venerating tribes who began settling in the

region from after that time were markedly different from those who had gone
before. As we have already seen, their speciality was the leaf-shape stone-
pointed spears, with a notable absence of the prolific boomerang usage
that had so typified the Bradshaw people. Instead of their being slightly built
and small as earlier inferred for the Bradshaw people, early photographs and
physical descriptions (that is, from before the racial intermingling that has
occurred over the last century) indicate them as unusually tall and well built.
This, for instance, is Joseph Bradshaw's cousin Aeneas Gunn writing in 1899:

> Frequently the height of the northern native runs up to and over six
> feet . . . The average North Australian native is a tall, broad-shouldered
> fellow, with a fine chest and muscular development, and in physique is a
> much finer type than his southern brother.[4]

Across Australia there are certainly Aboriginal peoples whose folklore
conveys memories of their ancestors having been in the country at the time
of the Big Dry and Big Flood events. Thus, as may be recalled from the
previous chapter, some of the peoples of Arnhem Land have stories that it
was during a Big Dry that the Great Earth Mother Warramurrungundji
came over the sea bearing her yams. All around Australia there are
Aboriginal traditions conveying memories of certain islands having once
formed part of the mainland, only for the sea to rush in and separate them.
The Montgomery Islands off the Kimberley, the Torres Strait Islands off
north Queensland, Kangaroo Island off South Australia and Rottnest Island
off Perth all have traditions to this effect.[5] And Aboriginal peoples of
Australia's southern coast between Gippsland and the Nullarbor Plain
specifically recall a time when the sea level was lower and the coast extended
much further out, over land now covered by sea.[6]

Headdresses remarkably similar to the 'wizard' hats worn by Tassel and
Sash Bradshaw figures were certainly also being worn by Aboriginal people
for special ceremonies as late as the last century, some of these even in the
Kimberley. Photographs of what was variously called the Molonga or Mund-
lunga ceremony show male performers wearing long pointed headdresses,
some ending in tassels (see inset opposite).[7] Another such photograph, dating

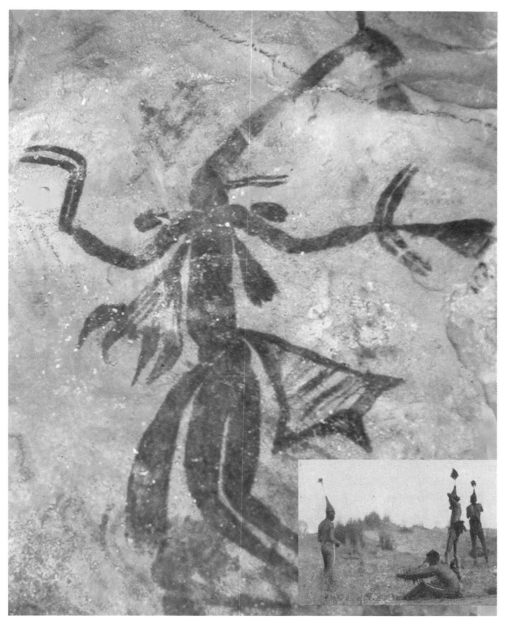

Evidence of some continuity of headdress? A 'wizard' headdress on a Sash Bradshaw in the Drysdale River National Park and (inset) similar headdresses worn by Aboriginal performers at a Molonga ceremony, central Queensland, early-1900s

circa 1920, shows male dancers at the Kimberley's Pago, or Drysdale River mission, again with very pointed, conical headdresses.[8] Joseph Bradshaw specifically noted of Aboriginal people he encountered during his preliminary reconnaissance expedition:

> We noticed one man in particular who had two huge appendages extending upwards and obliquely outwards from the top of his head, about 3 feet long, but whether they were made up from the wings of a large bird, or were pieces of bark we could not ascertain, as he kept in the background far up the range.[9]

The headdresses are not as elaborate as those depicted in Bradshaw paintings. Nonetheless, could they be at least a vestigial survival from ceremonies that were performed back in the Ice Age?

If we are looking for a surviving small, black Aboriginal tribe consistent with what Father Worms was told about the people who painted the Bradshaws, then it is worth noting that in the middle of the last century two South Australian anthropologists, Norman Tindale and Joseph Birdsell, traced to a remote rainforest area near Lake Barrine in northern Queensland a relic pygmy population. The tallest adult males were between 140 and 150 centimetres high (4 feet 6 inches to 5 feet), with the women between 15 and 30 centimetres shorter. According to Tindale:

> Their small size, tightly curled hair, child-like faces, peculiarities in their tooth dimensions and their blood groupings showed that they were different from other Australian Aborigines and had a strong strain of Negrito in them. Their faces bore unmistakable resemblances to those of the now extinct Tasmanians, as shown by photographs and plaster casts of the last of these people.[10]

These 'Barrineans', as Tindale and Birdsell dubbed them, seem to have been of the same variety as other so-called Negrito peoples to be found in similar small pockets on New Guinea, in the Philippines, on mainland South-east Asia and on the Andaman islands between India and Burma.

Their ancestors may have been one of the very early groups to leave Africa and make that long trek around the Indian coastline and onward. And they may well explain the frizzy-haired people noted in some of the Bradshaw paintings alongside those clearly with much longer, straighter hair. But not only have the Barrineans themselves now effectively died out as a still identifiable genetic type, there is little other than physique to suggest that any of these Negrito peoples might have had the authors of the Bradshaw paintings as their ancestral heritage.

A more productive region for inquiry may well therefore be on the South-East Asian rather than on the Australian side of the Timor Sea. As was argued in the previous chapter, the Bradshaw and other peoples of the Ice Age Kimberley may well have had a rather closer association with peoples of similar pioneering maritime development clustered around the Banda Sea than they had with anyone further inland on the Australian continent. For even from the perspective of art, it is notable that only northern Australia had any significant figurative art during the Ice Age, and nowhere further south.[11]

Once we begin considering South-East Asia for vestigial traces of Bradshaw culture, again some promising leads begin to open up. Thus there can be little doubt that amongst the myriad of different cultures, each with their own individual ancestral histories, scattered around the South-East Asian islands and mainland, some preserve folk memories that seem unmistakably to date back to the Big Flood time. For instance, on the island of Nias, west of Sumatra, they recall how: 'Great ancestor Baluga Luomewona caused the oceans to rise, the water rose to cover all but the tops of two or three mountains.' The peoples of the Malay Peninsula relate how: 'the ground we stand on is merely a skin covering an abyss of water. Long ago Pirman, the deity, broke up this skin, flooding and destroying the world.'[12] Most specific of all, the Tanimbar people of the islands west of New Guinea actually tell how their cult hero Atuf used his spear to slice off the Indonesian islands of Bali, Sumba, Flores and Timor from their big northern neighbour Borneo. As we have already seen, such a slicing-off is precisely what happened in the wake of the end-of-Ice Age flooding. The Balinese likewise have a tradition that Ubud's famous split gate marks the splitting of Bali from Java, as again

indeed happened during that same end-of-Ice Age fragmenting of the old Sundaland.[13] Exactly as in the case of similar traditions preserved by Aboriginal Australians, it is difficult for us to comprehend that these could be passed orally from generation to generation throughout more than ten millennia. Yet the traditions speak for themselves.

Culturally the associations are there. In the case of the Flood memories, the common bond seems to be not so much a genetic bond as a language family. There are in fact more Flood stories that are told in languages of the Austronesian language family—the South-East Asian equivalent of the Indo-European ancestral to most living languages of Europe—than in any other language family anywhere else in the world.[14] Austronesian languages not only include many of those spoken around island and mainland South-East Asia, but also amongst a part of New Guinea's population and far out into the islands of the Pacific, these having been carried as far as Easter Island by Polynesian seafarers. There is even a very isolated pocket across the Indian

Left: A magnificent Maori war canoe, representative of Polynesians' advanced seafaring capabilities, as preserved at Waitangi, New Zealand
Right: Classic figure of the South-East Asian type decorating the Grand Palace, Bangkok, Thailand. Note the sash, armlets and elaborate headdress. Although this particular figure is relatively recent, does at least something of its origins have a link to the Bradshaws?

Ocean on Madagascar, which we may recall as an ancestral home of the Kimberley's boab trees.

Immediately, therefore, we are confronting a language group exhibiting a strong maritime heritage. This is very obviously true of the Polynesians, whose spectacular ocean-going ventures into the Pacific were bolstered by formal schools teaching how to navigate by the stars. Although the Polynesians' activities were comparatively late, from the first millennium BC onwards, they were preceded by earlier Lapita people. From the fourth millennium BC these were traversing a wide area of the west Pacific, taking their very distinctive pottery with them, the Lapita peoples' sea-going origins again stretching yet further back into prehistory's mists. Such maritime tendencies are also very true of Austronesian-speaking peoples on the Indonesian islands and in mainland countries such as Thailand. In the latter, the traditional royal barges bear the most striking similarities to vessels depicted in the Kimberley boat paintings. And living on water, as exemplified by Bangkok's famous 'floating markets' (see page 237), is a way of life that many Austronesian-speaking children become introduced to before they can even walk.

If we are looking for the gracility exhibited by the people of the Bradshaw paintings, then once again our attention is focused on Austronesian-speaking South-East Asia. These traits are most certainly to be found in the very graceful physical type seen amongst many Indonesian, Cambodian and Thai peoples—even though it must be recognised that all comprise mixtures of later immigrant groups, just to complicate the genetic picture. This characteristic gracility is accentuated by much the same fondness for elbow ornaments, for ankle ornaments and for similar accessories that we have seen of the Bradshaw people. Even the sash of the Sash Bradshaws is worn today in many of the traditional dances that are performed in Thailand, Cambodia and elsewhere.

A very wide arc of regional art tradition reflects this same broad trend. The superb figurative scenes that are represented on the great temples of Borobudur in central Java and Angkor Wat in Cambodia are less than two millennia old and their themes are mostly from the Hindu and Buddhist religions, dating much later than the time of the Bradshaw people. Yet

distantly in these and, it should be noted, also in some of the early art of Sri Lanka and southern India, there can be seen a number of figurative traits suggesting that these artists really were heirs to what the Bradshaw people had been painting on rock walls so many millennia before.

As we noted earlier in this book, among the more difficult to believe aspects of the Bradshaw paintings is that they embody certain motifs which seem to have travelled, not just across to South-East Asia, but much further north-westwards to reach the great early civilisations of the Mediterranean and the Near East, albeit after many millennia. Prime among these are the two different forms in which the Great Mother was depicted, the first with arms near fully outstretched in what Walsh has called the 'W' angle, the second in what I have called the 'A' angle.

Among examples of the former reaching the Mediterranean and Near East there are the Syrian Asherah and Egyptian Qudshu images noted in the previous chapter. But there are also Minoan counterparts such as the famous 'snake goddess' statuette found at Knossos on the island of Crete, it being worth noting that the Minoans were a very seafaring people whose origins and language remain unknown. In all these examples, the common denominator 'fertility goddess' holds out the snakes in a manner identical to the way we see the Bradshaw 'Great Mother' holding out her boomerangs. There has to be a suspicion that as this motif steadily moved westwards throughout many millennia some-one from a non-boomerang culture misinterpreted the boomerangs and replaced them by snakes.

In the case of the 'A'-angle depictions of 'Great Mother'—the most common of those encountered during our tour with Lee—perhaps the most intriguing example to be found amongst the later ancient peoples of the Mediterranean is a cult statue known as the Artemis of Ephesus. The origins of this certainly stretch back into the mists of prehistory. Although the original statue has long since been destroyed, a copy made in Roman times has preserved its appearance (see opposite). As can be seen from this, the goddess has a headdress formed of what seem to be several head-rings of the kind used for suspending dilly bags. Perhaps her most notable feature, however, consists of some fifteen or more oval-shaped protuberances

hanging all around her chest. These have attracted any number of speculations about their identity, from breasts, to eggs, to bulls' testicles. As far as I know, no-one has ever suggested they might be dilly bags. Yet given the identical pose of the arms, and the equally identical 'Great Mother' status, could this statue embody a memory harking across many millennia all the way back to Ice Age Australia?

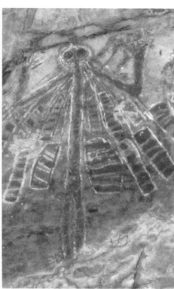

Left: Roman copy of the ancient cult statue of the Artemis of Ephesus. There has been speculation concerning the objects depicted hanging around her chest. Could they have had their origin in dilly bags as carried by the early Australian 'Great Mother' Warramurrungundji?

However wildly speculative this might sound—and scepticism is readily to be expected—I am fortunately not alone in sticking my neck out with an argument along these lines. Now returned to England, to be based at Green College, Oxford, Dr Stephen Oppenheimer was for decades a physician living and working in South-East Asia. In 1998 he launched a thick, closely referenced volume, *Eden in the East: The Drowned Continent of South-East Asia*, in which he argued for precisely such influences passing from east to west.

Taking his cue, as I have, from the huge population upheavals with which the Ice Age ended in South-East Asia, Oppenheimer envisages the beleaguered peoples of the Austronesian-language heartland—a heartland in which we would include the Kimberley—having spread to all points of the compass. They would have travelled westwards to the Middle East, and not least eastward to the Americas, in the wake of their displacements. Such a spread, it should be noted, would only have been possible for a people already highly proficient in making and navigating ocean-going boats.

A great advantage of Oppenheimer's thesis is that it owes nothing to any Bradshaw considerations, being based instead almost entirely on the east-to-west transmission of myth, buttressed by evidence from linguistics and from genetics, all pointing in the same direction. For instance, the Biblical story of Cain and Abel, essentially of two warring brothers, one an agriculturalist, the other a livestock farmer, might be thought as Jewish as you can get—except that so far as the Mediterranean world is concerned, it is common also to ancient Egypt and Mesopotamia. But as Oppenheimer has established, it can also be found far out into the Polynesian Pacific, in Austronesian-speaking New Guinea, on the islands of Indonesia and India. In the eastern versions, notably including the Indian, its association with a Flood strongly dates it back to the end of the Ice Age. Arguably the story was then brought from South-East Asia westwards on the boats of those who survived all the splintering of the continents. According to Oppenheimer, the Greek myth of the goddess Diana being surprised while bathing with her maidens similarly traces back to a root myth of South-East Asian origin. Genetically, Oppenheimer found markers showing

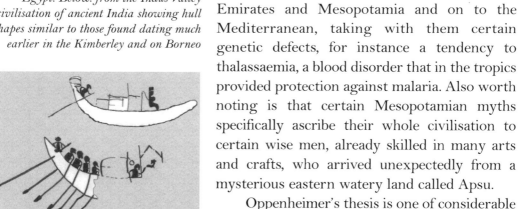

Top: Early depictions of boats in ancient Egypt. Below: from the Indus Valley civilisation of ancient India showing hull shapes similar to those found dating much earlier in the Kimberley and on Borneo

how people from island South-East Asia ventured through India to the United Arab Emirates and Mesopotamia and on to the Mediterranean, taking with them certain genetic defects, for instance a tendency to thalassaemia, a blood disorder that in the tropics provided protection against malaria. Also worth noting is that certain Mesopotamian myths specifically ascribe their whole civilisation to certain wise men, already skilled in many arts and crafts, who arrived unexpectedly from a mysterious eastern watery land called Apsu.

Oppenheimer's thesis is one of considerable complexity, which needs a book all to itself to explain it properly. But if we include the Kimberley of the Bradshaw paintings in the region from which all the east-to-west influences originated, it shows that that region may

well have played a far more seminal part in the development of global civilisation than anyone has previously considered possible.

There is also the fact that the earliest known ships of the ancient Egyptians, the Mesopotamians, the Indus Valley civilisation and others, all bear striking similarities to those we have seen of the Ice Age boat painters of the Kimberley, and Indonesian islands such as Borneo. With the Polynesians these same designs later likewise made their way eastwards across the Pacific. So could all these boat designs have had their origin in that Banda Sea/Austronesian language heartland to which our Bradshaw people belonged before their displacement?

All of this naturally leads to the question of whether, in all their scattering to the world's four corners in the course of the Big Dry and Big Floods, any vestige of the Bradshaw people might very early have made their way to America. As may be recalled from an earlier chapter, my very first acquaintance with Bradshaw paintings arose when BBC TV producer Jean-Claude Bragard sent me a copy of his documentary *Hunt for the First Americans*. In this, Grahame Walsh showed a boat painting from the Kimberley which the accompanying TV narration presented as powerful evidence that Ice Age Australians could have travelled by boat all the way across the Pacific to South America.

Another key component of this same program consisted of evidence from Walter Neves, an anthropologist in São Paulo, Brazil, who was trying to evaluate certain skulls holding claim to being the oldest ever found in America. The prevailing wisdom on how America was colonised is that when the Ice Age ice sheets began melting, Siberian hunters of Mongoloid type crossed the land bridge that then joined Siberia and Alaska, following big herds of mammoth and bison that were doing much the same. Those immediately post-Ice Age Siberians thereupon became ancestors of all 'native' Americans known today, these collectively sharing certain genetic characteristics such as broad faces, lank black hair and the typically Mongoloid epicanthic fold to the eyes. Some of these characteristics are thought to have been acquired during the Big Cold Dry.

But the problem for Neves was that the unusually old skulls that he was studying simply did not conform to this otherwise universal Mongoloid type.

The very oldest skull, dating from circa 9500 BC and deriving from Brazil's Lagoa Santa region, was that of a young woman whom he and his co-researchers dubbed 'Luzia'. This was painstakingly reconstructed by Richard Neave of Manchester University Medical School, the now famous British medical artist specialising in recreating faces from ancient skulls. Neave's reconstruction revealed a countenance with distinctive eyebrow ridges and a pronounced jaw quite unlike the North Asian Mongoloids theoretically ancestral to all native Americans, and altogether more characteristic of the facial features of Africans and Australian Aboriginal peoples. Comparison of Luzia's physiognomy with that of Tiwi Islanders on the Bathurst and neighbouring islands off Australia's Northern Territory suggested a close match. Given Grahame Walsh's evidence of Ice Age Australian boat-building activities, an Australian origin for 'Luzia' was what Neves and his colleagues opted for.[15] This also made sense of other already well-known anomalies such as the huge sculpted heads of the ancient American Olmec people of the jungle lowlands around the Gulf of Mexico, which similarly indicated Negroid features.

From our point of view, a further tantalising link lies in the fact that Brazil has its own Kimberley not far from where 'Luzia' was found, in the remote São Raimundo Nonato region of the state of Piaui. Just like the Kimberley, this has vast rock shelters where the original inhabitants portrayed themselves in a very lively manner living

'Luzia', one of the oldest known skulls found anywhere in America, as reconstructed by Richard Neave. This shows facial features quite different from the normally more Mongoloid characteristics of native Americans. Walter Neves and others have suggested that Luzia belonged to a group who made their way across the Pacific from Australia

amidst a variety of animals, including some long since extinct such as the giant sloth. Little of the Bradshaw peoples' exceptional artistic skills are evident, and even less their accessories, this seeming to have been a people, like later Aboriginal Australians, who went totally naked. Nonetheless it remains possible that these were of the pre-Bradshaw ilk, particularly as one archaeologist, Nede Guidon, dates some of the signs of human settlement to as far back as 48 000 BC. And this would similarly make sense of otherwise inexplicable stencilled handprints found deep to the south, in Patagonia. As was suggested in the *Hunt for the First Americans* documentary, these peaceable Ice Age Brazilians, just like the similarly peaceable pre-Bradshaw and Bradshaw people, probably possessed no weapons for inter-human conflict. So it would have been all too easy for the incoming Siberians to exterminate all those they found in their path, there being some suggestion of just a few survivors who ended their line only comparatively recently in the environs of Tierra del Fuego.[16]

Whatever the answer in the case of the 'first Americans'—another vast subject that inevitably demands a book all to itself—it can now be said with confidence that Australia's Kimberley was no isolated and uninteresting backwater of the Ice Age world. It has within its bounds the world's largest collection of Ice Age figurative art, and it holds vital strands for the origins of other cultures and civilisations right across the world. It and its paintings are undoubtedly of World Heritage significance. So how can the world now be made to wake up to recognise this fact?

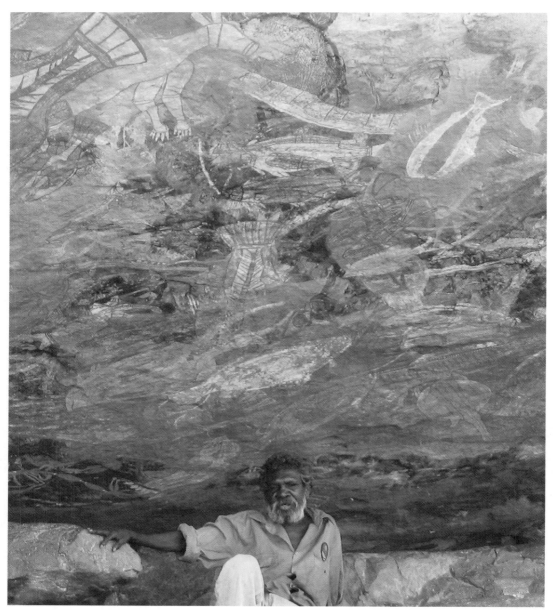

Aboriginal artist Warren Djorlom, heir to a rock painting tradition dating all the way back to the Ice Age

CHAPTER SEVENTEEN
Window on the world's oldest culture

As noted earlier, the twentieth-century Kimberley Aboriginal people questioned about the Bradshaws were unanimous in declaring that the paintings had nothing to do with them. Father Worms wrote in 1955:

> The present natives are of the opinion that another people, who occupied this district long before their arrival, produced them.[1]

Ian Crawford remarked in 1968:

> . . . the Bradshaw figures are of no importance to the Aborigines . . . What man, they say, would bother to paint the pictures . . . The paintings are 'rubbish paintings', illustrating nothing of interest or value . . . [2]

Likewise Billy King, elder of the Kimberley's Ngarinyin people, told Grahame Walsh, 'The Bradshaws are not part of our law, we don't know nothing about them.'[3]

Much the same attitude seems to have prevailed as late as 1993, when Aboriginal book publishers Magabala issued *Yorro Yorro: everything standing*

up alive, Spirit of the Kimberley,[4] co-authored by Ngarinyin elder David Mowaljarlai, the same individual responsible, on the Aboriginal side, for the 1987 ruination of several Wandjinas. While acknowledging this book as 'arguably the most definitive Aboriginal perspective on Kimberley culture so far presented,'[5] Grahame Walsh pointed out that it carried 'not so much as a mention' of the Bradshaw paintings.

More recently, however, in a climate in which politically minded Aboriginal people are ever more energetically working with white lawyers to claim back ancestral lands lost to European colonisation, there has been a significant and, one can only remark, suspicious change of tune. In 2001 *Yorro Yorro* was re-issued in a revised edition announcing on its flyleaf:

> In this new edition an intriguing and revealing chapter has been added in the form of a conversation about the famed Bradshaw rock paintings, recorded not long before the close of Mowaljarlai's life.[6] From this it emerges that . . . Aboriginal people of the region did in fact have a place in their history and culture for these graceful and enigmatic images, and a name for them—the Guyan Guyan.

In the published transcript of this conversation, tape-recorded by Mowaljarlai's co-author Jutta Malnic, Mowaljarlai quite unmistakably spoke of the Bradshaws as if these belonged to his Wandjina-venerating Ngarinyin culture. And his motivations were transparent enough to elder Billy King, who darkly commented in 1998:

> Never even talk about Bradshaw paintings before, but when a little bit of money was attached to it, they come and tell a whole lot of stories about it. Well, that stories not true![7]

Even though Mowaljarlai and Billy King are both now dead, this new fashion for trying to claim the Bradshaw paintings as part of Aboriginal culture shows no signs of going away. In 2000 German film-maker Jeff Doring issued a lavishly illustrated coffee table book, *Gwion Gwion,*[8] its title being just a variant spelling of the 'Guyan Guyan' or 'Guyon Guyon' name that is

becoming increasingly advanced as the politically correct way to refer to the Bradshaw paintings. According to Doring, the Ngarinyin people have hitherto been reluctant to share intimate knowledge of their culture, their ancestors' authorship of the 'Gwion Gwion'/Bradshaw paintings being just one of the 'secret' matters on which they had held back.[9]

In much this same vein Aboriginal author Ambrose Chalarimeri has recently set up the following notice at Oomarri:

> This is Oomarri.
> Birthplace of Ambrose Mugala Chalarimeri. Man from the Sunrise Side.
> Elder of the Kwini tribe.
> Traditional owner and author.
> WA government appointed Warden of this area.
> Oomarri is a most sacred and spiritual place belonging first to me, Ambrose Mugala, and then to the Kwini tribe. Nobody should come here, camp here, remove any object or take any photographs or images of the Guyon-guyon rock paintings without my written permission in accordance with the amended Aboriginal Heritage Act 1974/95.[10] . . .

Harmless though such a notice might seem, it immediately sets some distinctly alarming precedents. Can we now expect similar notices to spring up at Bradshaw sites all over the Kimberley, each with their own claims of personal ownership? Chalarimeri, no friend of Ju Ju Wilson (the daughter of an Aboriginal Law man), is far from being alone on such issues and is in any case merely the opposite side of the coin to Allan and Maria Myers' determined denial of public access to the Bradshaw paintings on the stations they lease. So where does some sanity lie in the midst of all this fortress-building in the Kimberley wilderness?

First, any squabbling over what name should be applied to the Bradshaw paintings should not be allowed to distract from the central issue. If Kimberley Aboriginal people had some long-established, commonly agreed name for the paintings—one, say, corresponding to the 'Mimi' label applied to certain Northern Territory rock art figures—I would unhesitatingly adopt this name and drop Bradshaw. However, there is no commonly agreed

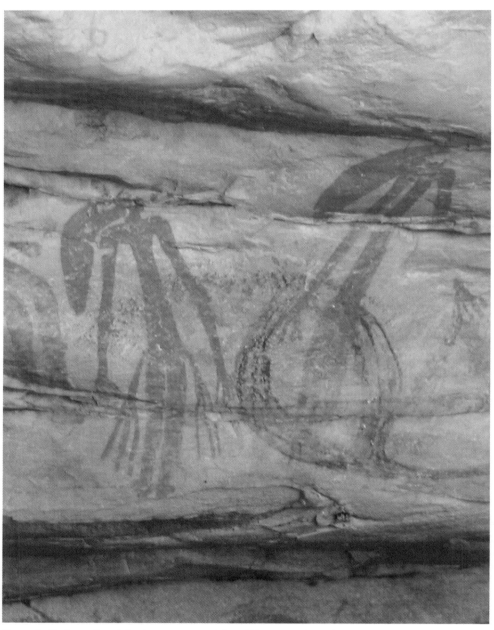

Part of all Australians' heritage—some of the Yellow Tassel Bradshaw figures at the Wullumara Creek site

Aboriginal name for the paintings. Back in the 1950s traditional elders of Chalarimeri's own people, the Kwini, told Father Ernest Worms, 'They call both paintings and painters *giro giro*', '*Guyon guyon*' going unmentioned. Germany's Frobenius expedition, who were no Anglophiles, directly sought an Aboriginal equivalent to 'Wandjina' for the paintings, only to settle for Bradshaw because they had no established Aboriginal name. Mowaljarlai and Chalarimeri could not even agree on the meaning of Guyon Guyon, Guyan Guyan, or whatever other variant of this anyone may care to choose.[11]

Far more important is for Aboriginal people to appreciate that they have no need to dredge up memories of association with the paintings, whether such memories might be true or false, just to suit lawyers eager to help them pursue land rights claims. The Bradshaw paintings are a priceless and inalienable part of their culture even without their retaining some clear ancestral tradition of who painted them and when. Present-day English peoples' connections to their Stonehenge ancient monument provide a very useful analogy on this point. England, like Australia, has had several waves of immigrants, most of whom, such as the Latin-speaking Romans, the German-speaking Angles and Saxons, the Norse-speaking Vikings and the French-speaking Normans, arrived well after Stonehenge was built. Today, however lustily those immigrants' descendants might sing 'Rule Britannia' and 'Jerusalem' at London's 'Last Night of the Proms', not one of them possesses some family tradition recalling how Stonehenge was built and for what purpose. Yet if anyone were to suggest that Stonehenge should be dropped from England's heritage there would be the most fearsome national outcry. Exactly the same situation pertains to the Kimberley's Bradshaw paintings. They belong to every Aboriginal Australian's heritage—that is, to all Aboriginal people living anywhere around the country, not just to those in the Kimberley—and arguably every white Australian's as well. When all else is said and done, we are *all* immigrants.

Despite all the huge environmental changes that Australia went through during the Ice Age's last throes, collectively Aboriginal Australians' traditions can and do stretch all the way back to that very early era, and thereby back to the time of the Bradshaw people. As Australian author Jennifer Isaacs has noted,[12] certain Aboriginal myths describe a time when

central Australia's now chronically arid MacDonnell Ranges were decked with a multi-coloured covering of wild flowers, and when the plains north of Alice Springs were green with herbs and grasses.[13] Such descriptions can only be recalling the environment of these places during the Ice Age.

Likewise amongst New South Wales Aboriginal people there are traditions of highly aggressive giant kangaroos that would attack and crush human victims using very powerful arms, characteristics quite different from any known living kangaroo species, all of whose arms are comparatively weak. Such traditions seem unerringly to recall the time of Procoptodons, enormous (up to 200 kilograms in weight), meat-eating kangaroo-like creatures that had long, strong 'arms' with which they could reach high above their shoulders.[14] Since the last known Procoptodon died sometime between 23 000 and 17 000 BC, the New South Wales Aboriginal story has been passed down relatively unchanged through some 700 generations, an oral transmission feat reducing the Bible almost to the status of yesterday's newspaper.

The very fact that the boomerang, that quintessentially Aboriginal icon, is so well represented in both the pre-Bradshaw and the Bradshaw paintings again shows that collectively present-day Aboriginal Australians retain the strongest links with their continent's earliest 'human era' past. Of course the people in the Bradshaw paintings exhibited certain cultural differences from the lifestyle of Aboriginal Australians as this was being practised at the time of the first European colonisation. But with the massive environmental changes that took place, combined with the influx of new waves of immigrants who brought different tools and weapons, the dingo, and so on, these differences were merely of much the same order as between, say, Romans and Vikings.

Understandably some may perceive the Bradshaw people as having been substantially more 'advanced' than the very naked Aboriginal people encountered by Australia's first European colonists, and wonder why this should be so. While what 'culturally advanced' actually means is always very debatable, a certain degree of regression is in fact only to be expected given the huge environmental changes that were suffered by the Australian landscape, and the continent's altogether greater isolation when sea levels rose so sharply at the end of the Ice Age. Thus as archaeologists working on Tasmania have

shown, a certain degree of 'de-skilling' quite definitely happened amongst the Tasmanian Aboriginal people from the time that they became physically cut off from their mainland counterparts by exactly the same circumstances. Whereas from circa 7000 to 3500 BC the Tasmanians were using bone tools, including awls, and needles for sewing, from around 3500 BC they abandoned their usage of such implements. Whereas they had been fish-eaters, they gave this up. Their one-time usage of spear-throwers went the same way. Nor did they continue to use fire for landscape 'cleansing' in the way that their mainland counterparts did. As has been remarked by the South Australian Museum's Tim Flannery:

> The most plausible explanation seems to lie in the unique isolation and small population size of the Tasmanians. The theory goes something like this. A small group of people is less likely to come up with technological innovations than a larger group. If the group is completely isolated, then new ideas cannot reach it. Because of this, innovation in material culture is slowed. Because the population is small, activities and knowledge may be lost simply through the early death of skilled people before they can pass their skills to the next generation.[15]

If this is a micro-model for what happened on the Australian mainland, it is important not to regard this as some 'decline of civilisation' after the 'advanced' Bradshaw era but, rather, as an intelligent, well-considered adaptation to markedly changed circumstances. For as was readily recognised by the more perceptive of early Europeans encountering Aboriginal Australians, these were a people of deep-rooted wisdom and presence who wore their nakedness and their homelessness with positive equanimity and nobility. In the words of the admirable Captain James Cook, writing from the perspective of his encounters in 1770:

> They are far happier than we Europeans. They live in a tranquillity which is not disturbed by the inequality of condition. The earth and sea of their own accord furnish them with all things necessary for life. They covet not magnificent houses . . . They lie in a warm and fine climate and enjoy a

very wholesome air, so that they have very little need of clothing . . . Many to whom we gave cloth . . . left it carelessly upon the beach and in the woods as a thing they had no use for. In short they seemed to set no value upon anything we gave them . . . This in my opinion argues that they think themselves provided with all the necessaries of life and that they have no superfluities.[16]

This 'Garden of Eden'-like existence could not, of course, last once Europeans began claiming ownership of Australian land, an eventuality which would bring with it consequences possibly deadlier even than any end-of-Ice Age Big Dry or Big Flood. Following the arrival of the first British convict-carrying ships in 1788, European diseases began spreading amongst the Aboriginal tribes, who had no resistance to them, just as had happened to native American 'Indians' when the Spanish and Portuguese began invading America three centuries earlier. And however relatively benign may have been the British style of colonialism, gun-toting attitudes on the part of incoming 'Joseph Bradshaws' were rife, and undoubtedly played their part. Within a century Aboriginal people were systematically robbed of the ancestral sites they held sacred, 'taught' to wear clothes, forced to work to white orders, and pushed to Australia's extremities. Every Tasmanian of unmixed Aboriginal ancestry was dead by 1876.[17] In a manner most whites simply could not comprehend, the damage to the whole Aboriginal psyche was dire in the extreme. As Australian Prime Minister Paul Keating, to his great credit, acknowledged on his launching the International Year of the World's Indigenous Peoples in 1992:

It was we who did the dispossessing. We took the traditional lands and smashed the traditional way of life; we brought the diseases, the alcohol; we committed the murders; we took the children from their mothers; we practised discrimination and exclusion. It was our ignorance and our prejudice, and our failure to imagine these things being done to us. With some noble exceptions, we failed to make the most basic human response and enter into their hearts and minds. We failed to ask: 'How would we feel if this were done to me?' As a consequence, we failed to see that what we

were doing degraded all of us . . . Imagine if ours was the oldest culture in the world and that we were told it was worthless . . . Imagine if we had suffered the injustice and then were blamed for it . . . Gradually we are beginning to see Australia through Aboriginal eyes, beginning to recognise the wisdom in their epic story.[18]

The ancient culture of the Aboriginal people of Australia is indeed a highly worthy one. As a people they have been most tragically wronged, and theirs is an epic story. And integral to both the culture and the story are the Kimberley's Bradshaw paintings. As was quite evident even from the relatively brief and peripheral tour that Judith and I ventured on with Lee Scott-Virtue, the paintings collectively comprise not only the world's biggest outdoor art gallery, but also the oldest. While in age they are on a par with the great Ice Age cave paintings of Lascaux, Altamira and Chauvet, if representation of the human figure is art's highest expression, as I am certainly not alone in upholding, they are actually far superior. World pre-history has no parallels even remotely comparable in age and skill. Truly the Bradshaw artists were the Ice Age's Michelangelos.

This immediately redoubles the need for some serious concerns for the future welfare of these so precious, so precocious works of art, existing as they do in their tens of thousands, exposed 24 hours a day to one of the harshest climates in the world and spread out over a terrain substantially larger than the entire United Kingdom. They are physically impossible to keep under the 'controlled climate conditions' normally so beloved of the world's art conservators. Likewise they are equally physically impossible to keep under any kind of lock and key, even were some such 'security' arrangement appropriate for them, which it is not. So how on earth can you possibly protect them?

Grahame Walsh's attitude, in which he is not alone, is that if only the paintings' locations can be kept secret, and the general public resolutely kept out of any cattle stations on which they are sited, then this must seriously limit the numbers of people able to gain access to them, thereby minimising any possible harm.[19] This was why he has quite deliberately omitted any location information in his otherwise 'definitive' books. This was certainly

265

Maria Myers' stated reason for why she refused me access to Theda to study even a single painting on that station. The combined Walsh–Myers perception is that despite the Kimberley's remoteness, the ever-burgeoning tourism in the region poses the biggest threat to the paintings' safety. So the more tourists who can be kept away from more paintings, the better.

Such a policy provokes the strongest opposition from Lee Scott-Virtue and from her Aboriginal associate Ju Ju Wilson, both of whom, unlike either Walsh or Myers, are permanent longstanding residents of the Kimberley. For Lee and for Ju Ju, by far the greatest immediate danger to the Bradshaw paintings comes not from tourism but from the randomly lit bushfires with which the region is repeatedly ravaged, fires that we ourselves saw at close hand during our visit.[20] As has been pointed out by earlier-mentioned Aboriginal writer Ambrose Chalarimeri, often, though far from always, the culprits are Aboriginal people now living a westernised life who have lost all sense of responsibility for the landscape that their ancestors so cherished:

> I see people drive around mostly on weekend, throw the match while they drive, maybe a whole box of matches and then just drive off. We seen people make fire in the road when their vehicle broke down, parents sitting down right by the roadside, their children went around with fire sticks and light the bush here and there, wherever they wanted, and parents never said nothing.[21]

Fires of this kind can burn over huge areas for three or more months. Their debris chokes and poisons the Kimberley's waterways, and their frequency robs many precious tree species of that vital opportunity to regenerate which can make all the difference between survival and extinction. And the fires are also extremely bad for all the region's rock paintings. If the flames get too close to the rock surface, as can happen whenever a site is allowed to get too overgrown with vegetation, even the Bradshaws with their 'laminate' have no protection. As Lee Scott-Virtue and Ju Ju Wilson have documented from actual examples,[22] the intense heat fragments the painted rock surface, causing it to slough away like sunburnt skin, and a 20000-year-old painting can be irretrievably reduced to rubble.

The rock outcrop bearing the 'Bagman' painting (arrowed) at Munurru, showing the proximity of vegetation to the rock face. In the event of a bushfire there may be irretrievable damage to a Bradshaw painting dating back to the Ice Age

The sensitivity of traditional Aboriginal people to such dangers is exemplified by a story told by archaeologist Ian Crawford of when in 1963 he and an accompanying archaeological team arrived by boat in the Kimberley. Their purpose was to study a variety of Wandjina paintings called Kaiara, representing spirits responsible for generating winds and cyclones. The archaeologists happened to light their camp fire rather carelessly close to the paintings, arousing the wrath of an Aboriginal guardian who began issuing dire warnings of the Kaiara spirits' intentions to wreak vengeance. When the sky unexpectedly darkened and a wind picked up, Crawford and his companions quickly took the hint and abandoned all intentions to remain a moment longer at the site.[23]

Not least of the sad aspects of Crawford's story is that even within the four decades that separate us from that incident, the Kimberley has lost the last of such traditional guardians. That is not to say that there are not

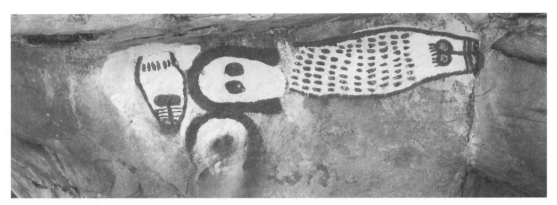

Example of the crude over-painting with Dulux that has ruined historic Wandjina paintings

living Aborigines like Ju Ju Wilson and Ambrose Chalarimeri who from their different standpoints care deeply about such matters, and who do their best to preserve some semblance of guardianship. But with the old traditional lifestyle destroyed, there are simply too many who do not care and too few who do. And of course the same severance of most modern-day Aboriginal people from their traditional roots has also led to the disastrous over-painting of Wandjinas, as described in an earlier chapter.

Prime though the fire danger is among the hazards that currently confront the Bradshaws, in fairness to Grahame Walsh and to Maria Myers it has to be acknowledged that dangers from burgeoning tourism can by no means be discounted entirely. Far across the other side of the Indian Ocean, in Africa's Sahara desert, are the so-called 'Tassili Frescoes', ancient rock paintings which although of post-Ice Age date hail from when the Sahara was still verdant enough to support elephant and giraffe. A French cavalry officer, Henri Lhote, first brought these to world-wide public attention back in the 1950s,[24] and they were subsequently accorded UNESCO World Heritage status. Like their Kimberley counterparts, they are sited in such remote and rugged terrain that the logistical difficulties of getting to them might have been expected to limit abuses from tourism, but not a bit of it. These were London photo-journalist Marion Bull's outraged comments following a recent visit she made in Lhote's footsteps:

The past 45 years of tourism and scientific intervention to preserve and record them have resulted in nothing less than tragedy. Here is a UNESCO World Heritage Site, but try telling that to a thug wiping them with water to get a better colour for a photo. Whole frescoes have simply faded away—or even been removed, rock and all. Ancient artefacts, which used to be commonly found around the sites, have been pilfered.[25]

That the Bradshaw paintings need protection from such dangers is a matter on which I stand 100 per cent united with Grahame Walsh and Maria Myers. Where we differ is on how that protection can best be achieved. From my perspective, shared wholeheartedly with Lee Scott-Virtue and with others, any long-term concealment of sites' locations is not only an exercise in futility, it is also seriously counterproductive.

It is futile because the location of many Bradshaw paintings is already too widely available in the public domain for any real turning back of the clock, however much Walsh and Myers may wish otherwise. Archaeologist Ian Crawford has freely noted the broad locations of Bradshaw paintings in his books and scholarly articles, and other academics have done likewise. Several four-wheel drive tour companies include photos of Bradshaw paintings, with locations, in their advertising of tours to the Kimberley. The Mount Elizabeth station, on the Gibb River Road, offers a tour to visit a superb Bradshaw figure draped with a long net that Walsh features in both his books[26] without declaring how or where it can be seen. The boat tour company Kimberley Cruising includes a number of Bradshaw paintings, with locations, on its Internet website. Ultimately to suppose that you can restrict the disclosure of locations of tens of thousands of paintings, in a region larger than the entire United Kingdom, is to bury your head in the sand.

Such location concealment is also counterproductive scholarship-wise, because even on the most basic level of our being able to refer between one painting and another, without location information we become obliged very clumsily to quote pages and plate numbers in Walsh's books. Without some broad awareness of where the paintings are located one from another—I am not suggesting the publicising of GPS references—we have no way of detecting trends linking one site to another, no way of relating a painting's subject

to the landscape for which it was created. We cannot deploy a hundred other approaches, from plotting the incidence of 'totems' to identifying localised fashions, that are otherwise normal in our trying to evaluate data from the ancient past.

Archaeologists loathe the trade in looted antiquities, fed by wealthy American dealers and collectors, because the sellers invariably refuse to

The importance of context. Dozens of Bradshaw paintings are scattered around the rock outcrops in this section of the Faraway Bay 'Lost City', as discovered by Steve McIntosh (standing in foreground). Arrowed is the section of the paintings reproduced in detail on page 159. Plotting the locations of such panels, both in relation to each other and to the surrounding geography, can provide archaeologists with vital clues for a better understanding of the Bradshaw people and their paintings' meanings

disclose where the artefact came from. This may be because it was excavated illegally, or because they do not want anyone else to find their particular 'goldmine', but either way the archaeologist is robbed of that most vital information component: context.

Throughout this book I have meted out more than enough criticism of Grahame Walsh on this and other matters, and it is important at this point to redress the balance. Walsh has certainly not spent his quarter-century-plus researching the Bradshaws in the expectation of academic distinctions—even though he has not declined an honorary DLitt—nor for pecuniary gain, even though he has courted multi-millionaires. No-one has more lived and breathed the Bradshaw paintings than Grahame Walsh, or is ever likely to.

As he himself has described his literally thousands of hours spent camping on the same rock floors as the Bradshaw people:

> I'm not pretending to be Aboriginal, but if you want to understand something, you've got to live it. When you're there you understand it and you see that a lot of what I'm saying makes a lot more sense than much of the wankery people are putting forward who have never actually experienced it or spent time at the sites.[27]

Walsh says that his photographic archive totals some 1.2 million items, which even of itself represents an absolutely extraordinary, unqualifiedly herculean achievement. It can only be hoped that, even as this book goes into production, the Myers–Bradley–Murdoch group are putting in place some long-term plan for that archive, perhaps by its housing in a Grahame Walsh Bradshaw Research Centre, thereby obviating Walsh's publicly stated inclination to have his entire collection destroyed within 24 hours of his death. This highly sensitive matter, one which lies at the very core of Walsh's complex psyche, can only be resolved between Walsh and those patrons who have funded the assemblage of that collection over the years. For him to carry out his threat to have his life's work destroyed would be an act of huge ingratitude towards those helpers, quite aside from the irreparable loss to human knowledge.

But Walsh aside, the more immediately pressing priority is that of the future of the Kimberley itself and its 'housing' of what can now be recognised as the world's oldest and largest outdoor art gallery. For just how bad things stand at present conservation-wise was very forcibly brought home to Lee, to Judith and myself at two of the sites we visited, particularly Munurru, where we saw evidence of work in hand to erect railings and other barriers to keep visitors from getting too close to badly peeling Wandjina paintings.

It is not that there was no need for some protective measures. Particularly at Munurru there has been a tendency for some of the more 'cowboy' tour operators to drive their four-wheel drive vehicles right up to the rock art sites, the dust they churn up inevitably having a deleterious effect, particularly on Wandjinas.

But these particular barriers were the most crudely put together constructions of green-painted metal and barbed wire, obtrusive, incongruous and totally inappropriate amidst the otherwise pristine landscape. To Grahame Walsh's credit, he himself showed how such things could be done much more sensitively, and with environmentally appropriate materials, during the time he worked on the rock paintings at Queensland's Carnarvon Gorge. By contrast, all that we saw at Munurru was the result of some remote bureaucracy throwing a few dollars at a work gang to carry out the most cursory and half-hearted attempts at 'conservation'. And the Kimberley deserves better. Much, much better.

For, on a national level, Australians now need urgently to wake up to the fact that they have right in their own backyard a most extraordinary national treasure in the Bradshaw paintings of the Kimberley. Enigmatic though the paintings remain, they provide not only Australia's but the world's clearest window on the lives of our ancestors back in the Ice Age—a window that, with the right protection and nurturing, is capable of providing far greater illumination than it has yielded hitherto.

Currently only 5 per cent of the Kimberley is protected as national park,[28] and that in name only. A much, much bigger vision is needed for its long-term future. Back in the early 1990s Lee Scott-Virtue's colleague Joc Schmiechen prepared for his Master of Environment Studies degree a meticulously researched report, 'Drysdale River National Park: Visitor Management and Aboriginal Heritage Issues', setting down a series of recommendations which, while focused on the Drysdale, had important lessons for the future of the Kimberley as a whole.[29] Schmiechen's recommendations included a proper park management plan, formal, detailed recording of certain key sites, Aboriginal involvement at all levels, a commonly agreed policy between station owners, protocols for tour groups, provision of a strictly limited number of signs and information points, all while providing the most minimal infrastructure and the fewest number of facilities consistent with maintaining the park as far as humanly possible as a pristine, untouched wilderness.

Not only has all too little been done to implement Joc Schmiechen's recommendations, the situation that he was addressing thirteen years ago has

actually deteriorated. Two months after Russell Willis had led his June 2004 expedition along the Drysdale River he was informed that the Kalumburu Aboriginal community had decided to close the Carson River track into the Drysdale River National Park, this decision, coming on top of Maria Myers'

Top: Unsightly green painted metal railings paying lip service to 'conservation' in the Kimberley. Bottom: Grahame Walsh's altogether more sympathetically designed walkway with wooden rails at Carnarvon Gorge

closure of the track through Theda, thereby closing the entire park to any kind of vehicular access. The only way that this particular park can now be accessed is by float plane landing on a suitable length of river, safe and practicable only during the earliest part of the Dry season.

Similarly retrograde has been Maria and Allan Myers' decision to prohibit public access to the excellent and previously readily accessible Bradshaw sites on the Theda and Doongan stations. In August 2004 Maria Myers ignored my request for a face-to-face meeting, by which I hoped she might impart at least some clue concerning when these sites might become reopened for anyone with a serious interest in the Bradshaws, quite aside from the public at large. It seems to me entirely wrong that the future of artworks so central to all Australians' heritage should be accessible only to a few.

In the past the suggestion has from time to time been raised that almost the entire Kimberley might be made a kind of safari park with the aim of protecting its unique combination of Ice Age rock art and wilderness beauty.[30] This should immediately quash a number of mining ambitions, some in the vicinity of Faraway Bay, which

can only be deleterious to the area's abundant rock art sites[31] and which have been energetically resisted by Bruce and Robyn Ellison of Faraway Bay.

Cattle station-wise the Myerses and other so-called 'owners' have only leasehold title to the properties they operate. Not only do these leases come up for renewal in 2015, they principally pertain to the ever-questionable viability of the raising of cattle on the properties,[32] not to the translation of the stations into commercially operated rock art museums. If the latter really is the way that the Kimberley is to go, then the cattle stations' territorial barriers need to come down. And perhaps almost the entire area encompassed by the Bradshaws needs to be managed as one single, state-operated entity in much the manner that South Africa manages its Kruger wildlife park.

Once such a state-operated entity were established—and the formulation of this is something that should be done with station 'owners', Aboriginal groups, politicians and local government officials all working in much-needed cohesion—this could properly foster the central recording of all rock art sites within its domain. While this is theoretically supposed to happen even at present, under the auspices of the Western Australian government's relevant departments, in practice it falls well short of what is needed.

Once a proper recording set-up is in place, this should enable researches by individuals such as Lee Scott-Virtue and others—researches currently all too often being done on a shoestring, self-financed basis—to be properly administered and funded. Proper recording of sites is also the necessary first step in addressing the checking of the current deterioration of the Wandjina paintings, paintings whose need for conservation is actually considerably more acute than the Bradshaws. And once sites are properly recorded, informed decisions can be taken on which ones might be most suitable for the crucial archaeological excavations by which we may ultimately be able to learn more about the people behind the paintings.

Here, as in many other instances, is where intelligent Aboriginal involvement and cooperation is vital at all levels. Precisely because Aboriginal people have been so cruelly robbed of their age-old traditional means of learning about their own heritage, it is all the more important that they should be encouraged to welcome rather than to fear the work of the

archaeologist. And on the archaeologist's part it should be fully understood and accepted that any and all human remains found should be treated with the greatest respect, and when work is completed equally respectfully returned to the location where they were found at the earliest opportunity.

Once a proper regulatory body is in place, then it should also be possible to regulate tour operators rather better than pertains at present. A proper code of behaviour is needed to be accepted and to be followed by all those taking parties of visitors through the fragile environment of the Kimberley, backed up with entry permits which can be refused or withdrawn should the code be found to have been breached. Such improved regulation of tourism should also ultimately facilitate better control of the bushfire menace.

In short, the time has come for the Kimberley, one of the world's last true wildernesses, blessed with the world's largest and oldest outdoor art gallery, to be no longer overlooked as too remote and empty for anyone to care about. In the Kimberley, Australia has the opportunity to redress some of its early environmental mistakes, as well as to learn more about a human past far older and richer than anyone might have conceived possible just a few decades ago. For Judith and myself to have had the opportunity to explore that art-filled wilderness, as we did under Lee Scott-Virtue's expert guidance, was one of the most rewarding and enriching experiences of our lives. Australia is a free country and that

Typical road conditions in the Kimberley—a deceptively fragile environment through which tour operators need to move with care

same magic world is there for others to explore. But it is a world ever to be cherished and, as we would most strongly recommend, best explored under the tutelage of guides as caring and as well informed as Lee, Russell Willis and Steve McIntosh.

Of course there will be many, particularly those living overseas, who will never be able to make that necessarily difficult journey and explore the Bradshaw paintings at first hand. But if for them this book has at least opened their eyes to these extraordinary artistic creations by our Ice Age ancestors, then it will have more than fulfilled its dream.

Thickets of Pandanus along a stretch of the Kimberley's Pentecost River. A surviving relic of the 'Garden of Eden' surroundings that the Bradshaw people once enjoyed in much greater plenty

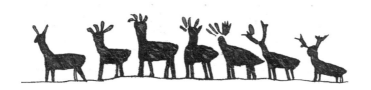

PICTURE CREDITS

The majority of photographs throughout this book are by Judith Wilson. The pictures on pages 27, 237, 248 and 274 are by the author. In the case of the remaining photographs, permission for reproduction is gratefully acknowledged from the following:

Dr.Lawrence Blair: p.87

John Bradshaw: p.18

Jean-Michel Chazine & Luc-Henri Fage: p.61 F; p.222

Professor Michael D. Coe (Yale University): p.61 B and D

Freda Oppenheimer: p.226

Dr. Robert Paddle (*The Last Tasmanian Tiger: The History and Extinction of the Thylacine*, Cambridge University Press, 2000, p.53); p.75 (This photo has been deliberately flipped left to right for comparison purposes)

Adrian Parker: p.20

John Prag (Manchester Museum) and Richard Neave: p.254

John Robinson (Bradshaw Foundation): p.31

Joc Schmiechen: p.38; p.85; p.100 (right); p.188; inset; p.245

Lee Scott-Virtue (Kimberley Specialists): p.63

Dr. Pawel Valde-Nowak (Institute of Archaeology and Ethnology, Polish Academy of Sciences, Kraków), p.204; p.215

Russell Willis (Willis's Walkabouts): p.40; p.110 (Walsh's photo of this same panel is left-to-right flipped compared to Willis's, there being some disagreement which is the correct view), p.170; pp.174–6; p.178 (L); pp.180-2; p.188.

The several interpretative drawings of Bradshaw paintings reproduced throughout this book have been prepared as original artwork by the author and by Judith Wilson from photographs by Joc Schmiechen, Grahame Walsh, Russell Willis, Peter Eve and Judith Wilson. These have involved a varying degree of interpretation of details that are sometimes damaged or indistinct on the original paintings, and may therefore differ from equivalent Grahame Walsh interpretative drawings. In keeping with the subject matter, a 'rock face' mechanical tone has mostly been supplied in lieu of the all-black silhouette favoured by Walsh. In the case of the drawings from photographs not by Judith Wilson the source photos are as follows:

p.28: J. Schmiechen; p.37: G.Walsh, 2000, pl.496; p.46: ibid, pl.51;

p.87: J.Schmiechen; p.92: G.Walsh 2000, pl.342; p.106 B, ibid, pl.521; p.112: ibid, pl.70; p.151: ibid, pl.408; p.141: ibid, pl.451; p.178: R.Willis; p.187: G.Walsh 2000, pl.142; p.191: ibid, pl.485; p.192: ibid: pl.394; p.200: Peter Eve, *Weekend Australian* magazine, October 25-6, 2003, p.20; p.230: G.Walsh 2000, pl.204; p.234: ibid, pls. 182, 183.

pp.1, 194 and 239 are drawings by the author after boomerang specimens in the South Australian Museum reproduced in P.Jones, 1996; p.8 is after A. Piankoff, *The tomb of Ramesses VI*, I, New York, 1954, fig.80; p.23 is from a photograph reproduced in Mary Durack, 1969; pp.14–15 are from G.Grey, 1841, vol I; p.61 A, is after R. Bohigas et al., 1988; p.61C is after a photograph reproduced with source in C. Flon, 1985, p.359; p.77 is from G. Chaloupka, 1993, pl.43; p.86, middle, is from a photo of 1860 by Cephas Kassian; p.93 is from the Museum für Volkerkinde zu Leipzig, Germany; p.101 is a drawing by the author after a photograph in H.I. Jessup, 1990, p.186; p.106 from P.E. Newberry, *Beni Hasan* I, London, 1892; p.121 B is from a drawing in P.Parker King, 1827; p.139 is from an early postcard; p.154 B is from D. Coulson & A. Campbell, 2001, fig. 159; p.161 is an engraving from *The Queen* 8 February, 1862; p.191, inset, is a drawing by the author of a twentieth century Dynasty painting in tomb 113, Thebes, Egypt, after an early nineteenth century drawing by J.G. Wilkinson; p.219 is after E. Brandl, 1988, fig.79; p.224 is a drawing by C. Ferguson; p.234 (above) is a drawing by the author after a textbook illustration in Jaw-Kai Wang (ed), *Taro: a review of colocasia esculenta and its potentials*, University of Hawaii Press, Honoloulu, 1983; p.245, (inset), is from a photograph in A.P. Elkin, 1964; p.252 (top) is a drawing by the author after a pre-Dynastic textile from el-Gebelein, Egypt in the Museo Egizio, Turin; (bottom) is a drawing by the author after an Indus civilisation relief.

Every reasonable effort has been made to contact all copyright holders, but in instances where these have proved untraceable or have failed to respond the author and publishers will be pleased to insert appropriate acknowledgment in future editions.

NOTES

Chapter 1

1 Per Michaelsen and Tasja W. Ebersole, 2000, p. 33.
2 A.R. Wallace, 1876.
3 Estimates vary, and inevitably depend on the route adopted by Australia's first human settlers and its timing. But any crossing from South-East Asia would have involved traversing at least 100 kilometres of open ocean, even when the Asian and Australian continents were at their closest as a result of sea levels being at their lowest.

Chapter 2

1 G. Grey, 1841, vol. I, pp. 125–6.
2 ibid., pp. 201–3.
3 ibid., p. 214.
4 ibid., p. 215, footnote alluding to Ezekiel chapter 19, verses 14 and 15.
5 G. Grey, 1838, footnote by the Royal Geographical Society editor.
6 Protestant missionary Howard Coate, with a party of companions, rediscovered the site in 1947. Ian Crawford of the Western Australian Museum was the first professional archaeologist to visit it in 1965—see I. Crawford, 1968, p. 64.
7 Thomas Worsnop, 1897.
8 Erich von Daniken, 1972 and 1973.
9 In the Aboriginal languages *Wandjina* means 'near-water'.

10 A. McGregor and Q. Chester, 1992, p. 125.

11 E. Hill, 1951.

12 Bradshaw's own description of himself in his lease document with the Western Australian government, October 1890.

13 Article by Bradshaw's cousin Aeneas Gunn published in the *Prahran Telegraph* Saturday 9 September 1899. This was one of 24 articles by Gunn published in that journal, also the *St. Kilda Advertiser* and *Malvern Argus* between May and November of the same year. These articles have recently been republished, with an excellent introduction and explanatory notes, in T. Willing and K. Kenneally, 2002. In recent correspondence Bradshaw's great-nephew John, who has conducted some in-depth research on his ancestor, has pointed out to me that Gunn tended to over-romanticise. At least by the standards of the time Joseph was not especially trigger-happy, and preferred to resolve conflict peaceably wherever possible.

14 The original 121-page diary 'Journal of an expedition from Wyndham to Prince River District' is today preserved in the Mitchell Library, Sydney, ref. B967. It is also available as microfilm CY Reel 1515.

15 Joseph Bradshaw, 1892, p. 100.

16 ibid., p. 101.

17 See Megan Anderson, 1998.

18 However, in describing his 1891 expedition to the Kimberley, Bradshaw noted that the local Aboriginal people 'indicated . . . the locality where we were, the creek and the direction of their camp by the name "Marigui".' Bradshaw went on: 'The . . . word may have a common origin with "marega" which, according to Dampier and King, was the name applied to the coast opposite this region by the Malayan cruisers for more than 200 years past.' Joseph Bradshaw, 1892, p. 99.

19 University of Adelaide anthropologist Charles Mountford remarked on these as 'one of the finest examples of Aboriginal art, in which action is portrayed, known to the writer'. See C.P. Mountford, 'Examples of Aboriginal art from Napier Broome Bay and Parry Harbour, North-Western Australia', *Transactions of the Royal Society of South Australia*, vol. 61, p. 38. But Mountford never ever ventured into the Kimberley to see the originals for himself.

20 Agnes Schulz, 1956, p. 12.

21 As remarked by Schulz, 'there is no room for them in present-day aboriginal culture. Felt to be foreign and strange, they are given little attention by the aborigines who interpret them all and sundry as *d'imi* [*Djimi*] bush spirits'. Schulz, 1956.

22 ibid., p. 49.

23 E.A. Worms, 1955, p. 547.

24 ibid., p. 554.

25 ibid., pp. 558–9.

26 ibid.

27 *Ungarinjen* in the original.

28 *Gwini* in the original.

29 ibid., p. 547.

30 Quoted in 'Before History', an article in *Hemisphere—An Aboriginal Anthology*, Curriculum Development Centre, ACT, 1981. I am indebted to Joc Schmiechen for providing a copy of this article.

31 D. Stubbs, 1974, p. 36. In 1980 Stubbs completed *Kimberley Mystery Paintings*, a book specifically devoted to the Bradshaws, but this was never published.

Chapter 3

1 Recently retired as Professor at the Australian National University, Canberra.

2 R.G. Roberts, Rhys Jones & M.A. Smith, 1990.

3 See for instance S. Oppenheimer, 2003.

4 Ian Crawford, 1968, chapter 10, also same author, 1977.

5 Short for *Macrozamia*, a family of cycads of which there are several varieties in the Carnarvon Gorge area. Macrozamia cones produce nuts which are poisonous if ingested.

6 G. Walsh, 2000, p. I.

7 G. Walsh, 1994.

8 John Robinson very kindly supplied background details of the formulation of the Bradshaw Foundation, and its publication of Grahame Walsh's book, as follows:

> Grahame Walsh agreed to the publication on the condition that he had nothing to do with the editing or printing. It was decided to print a run of 1500 books and distribute them through Beaver Gallery Canberra. The trustees of the Bradshaw Foundation Geneva were to be President Robert A Hefner III, Chairman Damon de Laszlo, Giles Mead, Michael McGuire, Bruce and Janie Dyson, Michael Ball and John Robinson. Grahame Walsh, John and Anne Koeyer and Ron and Betty Beaver were appointed Honorary Trustees of the Bradshaw Foundation Geneva. All profit from the sale of the book was to be handed to Grahame Walsh to aid his discovering new sites and further documentation. This job was handled by Bruce Dyson and Beaver Gallery for no fee. On top of this profit the Mead Foundation gave further funding to Grahame and Giles Mead left him a legacy in his will. The book was completed in 1993 and launched at the International Rock Art Conference held that year in Flagstaff, Arizona. The Bradshaw Foundation paid for Grahame to attend the conference and also make a trip with John Robinson to meet Andreas Lommel in Munich as well as a visit to the Frobenius Institute in Frankfurt. The foundation also arranged for Grahame Walsh to give a lecture on the Bradshaw paintings at the Royal Geographical Society in

London. In 1994, on account of the situation that had arisen between Grahame Walsh and the Kimberley Aborigine Lands Rights movement, the Bradshaw Foundation decided to split into an International branch based in Geneva and an Australian branch based in Melbourne to handle the profits from the book for Grahame Walsh. This Australian branch was to be run by Bruce Dyson and Dame Elisabeth Murdoch.

9 Quoted in Nicolas Rothwell, 2003, p. 22.

10 G. Walsh, 2000.

11 John Robinson has pointed out to me that some photographs can be viewed on the Bradshaw Foundation's Internet site <www.bradshawfoundation.com>.

12 This date derives from findings at the Carpenter's Gap shelter. See O'Connor, 1995.

13 In this respect they are not to be confused with the grinding hollows often found individually on rock platforms, uncontroversially associated with food preparation and the grinding of pigments.

14 Paul Taçon et al., 1997.

15 G. Walsh, 2000, p. 134.

16 C. Higham, 1998.

17 H. Lhote, 1959, p. 24.

18 J. Flood, 1995, p. 225.

19 G. Walsh, 1994, p. 280.

Chapter 4

1 This I have learned to be something that he says every year, always managing to go on a fresh expedition regardless!

2 N. Rothwell, 2003, p. 22.

3 ADFAS, at the Brisbane Convention and Exhibition Centre, Friday 16 April 2004. I am grateful to Chairman Philip Courtenay for allowing me to attend.

4 His 1988 book on the generality of Australian rock art is altogether more readable.

5 For example, <www.rangeroverclub.org.au/articles/Kimberley>.

6 Another exception is the Mount Elizabeth station, which has some Bradshaws, though lesser in quality and number to those on Theda.

7 G. Walsh, 2000, p. 430.

8 Kimberley Specialists' business address is PO Box 738, Kununurra, Western Australia 6743. They offer a number of pre-set tours in addition to individually tailored ones, and have an excellent website at <www.kimberleyspecialists.com>.

Chapter 5

1 Pat Lowe, 1998, p. 9.

2 This is an average—estimates vary widely.

3 For an excellent, easy-to-read discussion, see Pat Lowe, 1998, pp. 14, 15 and elsewhere. According to Lowe, p. 19, Broome botanist Tim Willing has performed one practical demonstration of the genetic closeness. He grafted branches from Madagascar's *A. madagascarensis* onto a rootstock of Australia's *A. gregorii*, whereupon just three weeks later the first shoots of leaves began appearing at the ends of the grafted branches.

4 ibid., p. 15. The 1993 specimen was found at Cervantes, a little to the north of Perth. Another was found in 1930 at Scott River, near Augusta, both well to the south of the Kimberley.

5 Les Hiddins, 1981. Naturalist-photographer Len Zell and geologist Ian Levy have expressed much the same view in correspondence.

6 According to Mary, a Gwini Aboriginal woman interviewed by Pat Lowe (see note 1), modern-era Aboriginal people used fibre from both the boab's bark and its roots for cord-making. The strips of fibre were 'pounded with a rock to "make them like wool", which could then be rolled against the thigh into a long string or thicker rope' (Lowe, p. 46). Such string was used to make shoulder straps for bark containers in which babies or food might be carried, in the manner of a shopping bag. Thicker versions could be used as rope to tie up canoes.

7 Josephine Flood, 1995, p. 152.

8 G. Chaloupka, 1993, pp. 80, 232.

9 G. Walsh, 1999, pp. 41ff.

10 Information on recent findings in Borneo can be found on the Internet site <www.kalimanthrope.com>.

11 A. Leroi-Gourhan, n.d.

12 Christine Flon (ed.), 1985, p. 359.

13 Peter Turner et al., Lonely Planet, *Indonesia*, p. 997.

14 E.J. Brandl, 1988.

15 A.P. Elkin, 1964, p. 181.

16 H. Pedersen & B. Woorunmurra, 1995, p. 21.

17 G. Walsh, 2000, captions to plate 212, 233 and many more.

Chapter 6

1 I.M. Crawford, 1968, p. 85.

2 G. Walsh, 2000, p. 163.

3 L. Barham et al., 1999, p. 84.

4 G. Walsh, 2000, p. 163, pl. 257.

5 ibid., p. 218, pl. 349.

6 Some peoples, too fearful even to address her by name, referred to her simply as 'the Throne'. To those living in Turkey she was Cybele or Kubaba or Myrene or Hepat,

depending on their district and epoch. To the Sumerians she was Inanna. To the early Egyptians she was Neith, then later Anath and Ishtar. To the Canaanitic and Syrian peoples she was Astarte and Asherah, to the Greeks Artemis. For further discussion, see chapter 15 of my *Before the Flood*, Orion, London, 2001.

7 Statuettes created by the very maritime-minded Minoan people of Crete (whose origins are mysterious) represented their Great Mother in this very same pose. See for example Arthur Cotterell, 1979, p. 163. Likewise the ancient cultic statue of Artemis at Ephesus, which though lost, is known from a Roman copy.

8 M. Gimbutas, 1989.

9 G. Walsh, 2000, p. 218, caption to pl. 349.

10 Richard Macey, 'DNA puts mother of all dingoes at 3000 BC', *Sydney Morning Herald*, 30 September 2003, reporting on research carried out by University of New South Wales geneticist Alan Wilton and Professor Peter Savolainen of the Royal Institute of Technology in Sweden, from a study of the mitochondrial DNA of 211 dingoes representative of all Australian states.

11 That is, an animal that bears its young in pouches, in the manner of kangaroos and koalas.

12 This said, there are rumours that small pockets of survivors may still exist. Currently a reward is being offered in Tasmania for the capture of a live specimen, but the likelihood of anyone being able to claim this reward is very remote.

13 Quoted in David Owen, 2003, p. 48, after *Papers and Proceedings of the Royal Society of Van Diemen's Land*, 2, pp. 156–7.

14 G. Chaloupka, 1993, p. 52, p. 43.

15 Marsden Hordern, 2002 edition, illustration following p. 298.

16 *Crocodylus porosus.*

17 *Crocodylus johnstoni.*

18 Judith Ryan with Kim Akerman, 1993.

19 T. Flannery, p. 225. The sedimentologists suggest a period between 120 000 and 60 000 years ago. However if, as is likely, this change is due to the hand of man, then 60 000 years ago is the likeliest.

20 Tim Flannery, 1994, p. 225.

21 E. Giles, 1889, and Captain James Cook, quoted in T. Flannery, p. 217.

22 T. Mitchell, 1848, quoted in T. Flannery, p. 223.

23 Quoted of Lieutenant Henry Bunbury in J. Mulvaney & J. Kamminga, 1999, p. 60.

24 R. Jones, 1969.

Chapter 7

1 G. Walsh, 1994, p. 113, pl. 13; 2000, p. 371, pl. 556.

2 L. Blair, 1988, p. 47.

3 Loro (also Ratu) Kidul is associated with the 'taming' of many creatures from swifts harvested for their tasty nests (used in bird's nest soup) to red sea-worms.

4 *The Kimberley featuring the Gibb River Road*, Hema Maps, 6th edition.

5 To Myers I simply referred to it as the nine-figure panel reproduced on p. 371 of Walsh's 2000 book.

6 Email message received 16 August 2004.

7 See Chapter 3, the remarks that Myers made in an interview with journalist Nicolas Rothwell of the *Australian* newspaper, published 25–26 October 2003.

8 Email message, 17 August 2004.

9 Ngauwudu Management Plan, published by the Kimberley Land Council on behalf of the Wunambal Aboriginal Corporation, January 2001. Accessible on the Internet.

10 I.M. Crawford, 1977.

11 *Pandanus spiralis.*

12 G. Walsh, 1994, p. 211, pl. 62; 2000, p. 291, pl. 450.

13 In depictions of the Roman god Mercury (Greek Hermes), he is characteristically represented with wings at his ankles, denoting his role as 'messenger of the gods'.

14 See Chapter 8 for further discussion.

15 Walsh called it 'Watusi', the explanation apparently to appear in a yet-to-be published 'Handbook of Rock Art Terminology'—see G. Walsh, 2000, pp. 291 and 295.

16 I am entirely happy to interpret this particular figure as male.

17 His most relevant sentence is: 'The size and cumbersome nature of the object is such that one would assume it probably represents some form of decorative rather than functional apparel' (G. Walsh, 2000, p. 291). He then goes off into an extraordinary digression concerning Mayan art depicting human excrement.

18 It should be noted that some at least are Tassel Bradshaws—to me obviating the quite unnecessary chronological distinction that Walsh has tried to make between Sash and Tassel Bradshaws.

19 Published only in his 1994 book, p. 210.

20 These straps are clearly enough visible in Judith's photographs, as indeed they are in Walsh's. Besides this, Walsh really should have quite independently inferred the straps' presence from a photograph of a similar bag-carrying figure reproduced earlier in his book (G. Walsh, 2000, p. 215, pl. 342), where the strap support system is quite unmistakable.

21 This word repeatedly occurs in nineteenth-century descriptions.

22 Jennifer Isaacs, 1980, p. 126.

23 Ray Sumner, 1993, p. 16.

24 See in particular E.J.W. Barber, 1991, also J. Adovasio et al., 1996.

25 *Cycas lane-poolei.*

26 *Cycas basaltica.*

27 They are descendants of ancient plants known as Bennettitales, dating back to the Mesozoic era 200 million years ago.

28 From the potent cancer-producer methylazoxymethanol (MAM).

29 Moya Smith, 1982.

30 George Grey, 1841, vol. 2, pp. 64–5.

31 Jennifer Isaacs, 1980, p. 127.

32 *Dioscorea bulbifera.*

33 Aeneas Gunn, article in the *Prahran Telegraph*, Saturday 28 October 1899, repro-duced in Willing & Kenneally, 2002, p. 61.

34 D. Thomson, 1983, p. 105.

35 Jennifer Isaacs, 1984 (my edition a 2002 reprint), p. 75.

36 *Dioscorea transversa.*

37 G. Walsh, 1988, p. 223, pl. 174; Walsh, 2000, p. 57, pl. 85.

38 N. Rothwell, 2003.

39 Joc Schmiechen, who led Grahame Walsh to many of the locations of the Bradshaw paintings he published, shares my view that Sash and Tassel Bradshaws may well have been broadly contemporary with each other.

40 G. Walsh, 2000, p. 359, pl. 538; p. 360, pl. 539; and p. 326, pl. 497.

41 It is worth noting that, according to A. McGregor and Q. Chester, 1992, p. 127: 'The Wandjina paintings are believed to be the shadows of ancestral beings cast against the rock in the course of their travels across the land. At the end of each Wandjina's active life its spirit became part of the earth, its shadow on stone becoming a painted image at the place of its death.'

Chapter 8

1 Technically, bauxitic laterite.

2 *Bubalus quarlesi.*

3 *Bubalus depressicornis.*

4 Walsh remarks of his example (see note 5): 'It seems likely that this example currently represents the world's earliest record of the development and use of a ground line, in prehistoric art.' G. Walsh, 2000, p. 342.

5 H. Schäfer, 1986.

6 G. Walsh, 2000, p. 342, pl. 521.

7 Currently close to extinction, the latest threat to its survival being the arrival in the Kimberley of the prolific and highly poisonous cane toad. Seven decades ago Queensland sugar cane farmers disastrously imported the cane toad from South America in an unsuccessful attempt to eradicate beetles affecting their crops.

8 G. Walsh, 2000, p. 342.

9 See G. Walsh, 2000, p. 33, pl. 51 and fig. 28.

10 G. Walsh, 2000, pp. 31–2, pls 43–50 and figs 22–7.

11 Information kindly provided by Russell Willis of Willis's Walkabouts, featured in chapter 12 of this book.

12 G. Ashe et al., 1971, p. 135, ill. 119.

13 ibid., p. 149.

14 Thor Heyerdahl, 1970. Ten months later Heyerdahl sailed 6100 kilometres across the widest part of the Atlantic in his vessel *Ra II*.

15 G. Ashe et al., 1971, p. 142 (see also illustration on pre-Inca pot, p. 141).

16 ibid., p. 142.

17 Virtually the only exceptions were some southern tribes who during winter months wore blanket-like cloaks to keep out the cold.

18 G. Walsh, 2000, p. 51, pl. 70.

19 Walsh describes this frequently recurring feature as 'Chilli Armpit' decoration without trying to evaluate its function.

20 Similar stones are depicted in David Andrew Roberts and Adrian Parker, 2003, p. 79. In the same publication grinding holes are shown on p. 8.

Chapter 9

1 G. Walsh, 1994, pl. 94; 2000, p. 195, pl. 317; and p. 196, pl. 318. Besides omitting the panel's location, Walsh illustrates and discusses the two scenes without revealing their close contextual relationship to each other.

2 I.M. Crawford, 1977, p. 361.

3 D. Welch, 1997, p. 90.

4 Dacre Stubbs, 1980, Kimberley Mystery Paintings, unpublished manuscript in Grahame Walsh's 'Takarakka Archives', referred to in G. Walsh, 2000, p. 196.

5 G. Walsh, 2000, p. 195.

6 Ibid., pp. 19 and 33, pl. 51.

7 Ibid., pp. 18 and 32, pl. 46.

8 Elaine Godden & Jutta Malnic, 2001, p. 40; also I.M. Crawford, 1968, p. 42 & Jennifer Isaacs, 1980, p. 72.

9 This character is also variously rendered as Dumbi, Tumbi, etc. I have followed Jennifer Isaacs' rendition.

10 ibid., p. 25.

11 At the time of European contact these blades were made from flint-like stones, but when these first Europeans began leaving broken bottle glass lying around, this material too was fashioned similarly.

12 G. Walsh, 2000, p. 190.

13 Ibid., p. 260, pl. 398.

14 A characteristically modest Roe declared himself unworthy of the honour, insisting that it should go instead to his much-loved parson father, James Roe, back in Newbury, Berkshire, England.

15 E.J. Brandl, 1988.

16 Before the time of European settlement, Aboriginal peoples are known to have traded ochre over great distances across Australia, but this does not seem to have been the case here.

17 For comparable images, see G. Walsh, 2000, p. 208, pl. 334.

18 For example, G. Walsh, 2000, p. 173, pls 277 and 278.

19 Ian Levy points out that the traditional *kava* is served from a turtle shell known as a *tanoa*, and 'nobody can tell lies when attending a *tanoa* ceremony because to do so is to betray the entire village. The turtle is also the favourite food and usually a feast accompanies a turtle capture. Even today, the sheer glee when a turtle is caught is amazing—a very deeply felt part of an ancient coastal/seaborne hunter-gatherer culture.' Email correspondence with Ian Levy, November 2004.

Chapter 10

1 G. Walsh, 2000, p. 96, under 'Elbow and Arm Decorations'.

2 A very clear example of this can be seen in G.Walsh, 2000, p. 139, pl. 205.

3 P. Jones, 1996.

4 See for example G. Walsh, 2000, p. 125, pl. 195.

5 Joseph Bradshaw noted of the Aboriginal people who shadowed him and his companions during their 1891 expedition 'none had boomerangs'. Bradshaw, 1892, p. 99.

6 I.M. Crawford, 1977, p. 359, fig. 3.

7 G. Walsh, 1994, pl. 65, pp. 216–17; Walsh, 2000, pp. 292, 293, pls 451 and 454.

8 A. McGregor & Q. Chester, 1992, p. 90.

9 D. Mowaljarlai, 2001, p. 221. Wadningningnari means 'she looked back, like a snake'.

10 A.P. Elkin, 1964 (4th edition), p. 257.

11 ibid., pp. 255–8.

12 Ju Ju Wilson's surname derives from the white father who adopted her.

Chapter 11

1 1774–1850.

2 A. Chalarimeri, undated, p. 3.

3 G. Walsh, 2000, p. 225.

4 ibid., p. 267, pl. 408.

5 The modern-day Aboriginal activist Ambrose Chalarimeri, who proudly claims Oomarri as his birthplace in 1940, has illustrated the same painting in his

autobiography, together with another which identifies pl. 26 of Walsh, 1994, pp. 138–9 as also to be located at Oomarri.

6 L. Scott-Virtue, 2001.

7 In fact an isolated rock immediately overlooking the camp carries some paintings, but Gumboot Creek is altogether more extensive.

8 This I certainly did, until Lee corrected me.

9 See G. Walsh, 2000, p. 203, pls 326–8.

10 ibid., p. 203, pls 326–8; p. 227, pl. 364; also p. 176, pl. 283. The only location details Walsh gives are that they are 'Eastern', which he defines as east of the King George River.

11 G. Chaloupka, 1993, p. 127.

12 See David Coulson & Alec Campbell, 2001, pp. 136–7, figs 159–61.

13 *Chelodina rugosa.*

14 G. Walsh, 1994, pp. 220–1, pl. 67.

15 L. Woolley, 1982, p. 28.

16 See G. Walsh, 2000, p. 397, pl. 579, with also two other examples as pls 577 and 578.

17 J. Mulvaney & J. Kamminga, 1999, p. 413.

18 For an almost identically executed figure, though outlined in brown rather than white and with the right hand area obliterated, see G. Walsh, 2000, p. 221, pl. 355.

19 See for example G. Walsh, 2000, p. 275, pls 422 and 423, pl. 423 being particularly close to our 'Lost City' example.

20 George Grey, 1841, vol. 1, p. 215.

21 G. Walsh, 2000, p. 366, pl. 550 is the closest example to that at the 'Lost City' site.

Chapter 12

1 This is because, despite his 'no locations' policy, this particular location can be inferred from illustrations in his 2000 book, as described early in the previous chapter. In fact, as has been pointed out by Joc Schmiechen, Walsh has also discovered Bradshaw paintings on the King Edward, Roe and Prince Regent rivers, to name but a few.

2 This expedition was under the auspices of Operation Raleigh, a three-year venture for which Prince Charles was patron. This encouraged groups of young people aged 18 to 25 from mainly Commonwealth countries to undertake science, adventure and community programs under expert leadership. The venture operated for two years in Australia, with the Drysdale River expedition one of its earliest and most successful efforts.

3 J. Schmiechen, 1993. The further expeditions were in 1988, 1991 and 1992.

4 First Australian Rock Art Research Association (AURA) Congress, Darwin, August 1988.

5 Willis's Walkabouts is based at 12 Carrington Street, Millner, NT 0810 Australia. The company specialises in walking tours in the Kimberley and the Northern Territory, but also runs occasional tours outside Australia, including South America and South Africa. It has an excellent website at <www.bushwalkingholidays. com.au>.

6 Russell Willis's backpack started out at about 25 kg. The next heaviest would have been about 20 kg and the lightest about 14 kg.

7 These paintings, it should be made clear, were not new discoveries by Willis and his party. They had been located and surveyed by Joc Schmiechen during expeditions he conducted in the 1990s.

8 See G. Walsh, 2000, pp. 222–3, pl. 68 for another even better example of Tassel Bradshaw type tassels on a Clothes Peg.

9 When Russell Willis's group viewed this panel it lay in shadow, muting colour differences.

10 Yet another example therefore of sash and tassels on the same figure, clouding Walsh's chronological distinction between the two types of adornment.

11 G. Walsh, 1994, pp. 252–3, pl. 83.

12 ibid., pp. 266–7, pl. 90; Walsh, 2000, p. 221, pl. 255.

13 See several examples in G. Walsh, 2000, pp. 322–4 (e.g. pl. 493), 328–9, 330–1; also G. Walsh, 1994, pl. 21, 'turtle' next to headdress of female figure carrying long flail; pl. 22, 'mice' either side of the conical headdress of aerial figure carrying double boomerangs, and pl. 23, 'mouse' to right of left-hand figure with conical hat. See also G. Walsh, 2000, pl. 194, flowers either side of tassel female towards left of scene. Chaloupka notes on p. 112: 'In two examples [of the Dynamic Figure period] a flying fox is depicted sitting on the hunters' headdresses, symbolising perhaps their totemic affiliation.'

14 A. Chalarimeri, n.d., p. 3.

15 A story of Henry Rankin of Port Macleay, South Australia, recorded by Diana Conroy and published in J. Isaacs, 1980, p. 174.

Chapter 13

1 For example, Darrell Lewis, 1997, p. 3, 'While applauding Walsh for his meticulous attention to detail . . . I am sceptical of the complex style sequence he has proposed.'

2 G. Walsh, 2000, pp. 114–15.

3 ibid., 2000, p. 115, pl. 142.

4 For an excellent account of these see T. Flannery, 1994, chapter 11.

5 G. Chaloupka, 1993, pp. 80, 232.

6 See p. 27.

7 G. Chaloupka, 1993, p. 123.

8 J. Clottes et al., 1992.

9 In Europe human representation is mostly confined to figurines such as the famous prehistoric Venus of Willendorf, and the occasional engraving on bone.

10 Walsh quoted this proportion in his ADFAS lecture, but also mentions similarly high proportions in G. Walsh, 2000, p. 231. It is noteworthy that even in the case of the later Wandjina figures of the Kimberley, these too are depicted without clear indications of their gender. As noted by McGregor & Chester, 1992, p. 125: 'Most Wandjinas are depicted asexually. Sexual detail is infrequent. Genitals and breasts are usually omitted . . .'.

11 G. Walsh, 2000, p. 318, pl. 485.

12 J. Isaacs, 1980, p. 166, after Daisy Bates, *Tales Told to Kabbarli: Aboriginal Legends collected by Daisy Bates, retold by Barbara Ker Wilson*, Angus & Robertson, 1972.

13 Information from the Korea-Middle East Association at <www.komea.or.kr/e-history.asp>.

14 George Grey, 1841, vol. 2, pp. 281–2. Here some terminology has been modernised to conform to present-day styling.

15 This view is supported by A. McGregor and Q. Chester, 1992, who note on p. 133: 'Deft and graceful fine lines were achieved with brushes of unknown construction. Perhaps they used feathers? The chewed end of a twig or a piece of cane grass, often used for the detail on Wandjinas, would most likely have been too coarse for such fine delineation.'

16 See Josephine Flood, 1995, pp. 268–9 in which she mentions the psychotropic plant *pituri*, which Aborigines appear to have used to induce hallucinogenic sensations. According to Flood: 'It induced voluptuous dreamy sensations according to Walter Roth, and was found highly intoxicating by explorer W.J. Wills.'

17 Worms called them Bād. I have substituted the most common present-day rendering.

18 E. Worms, 1955, p. 564.

19 One qualification to this has been drawn to my attention from late reading of McGregor and Chester's excellent 1992 book. In this they note that John Lort Stokes, who explored the west Kimberley coast in 1838 aboard HMS *Beagle*, found some remarkable huts on Bathurst Island:

> . . . here we found several native habitations of a totally different and very superior description to any we had hitherto seen in any part of Australia: they bore a marked resemblance to those I had seen on the S.E. coast of Tierra del Fuego . . . Stout poles from 14 to 16 feet high formed the frame to these snug huts —for so indeed they deserve to be termed—these were brought together conically at the roof; a stout thatching of dried grass completely excluded both wind and rain, and seemed to bespeak the existence of a climate at times much more severe than

a latitude of 16 degrees 6' south would lead one to anticipate. (Stokes, 1846, vol. I, pp. 172–3)

20 N. Rothwell, 2003, p. 20.

21 This instruction was conveyed to Peter Eve by Susan Bradley as manager of the Theda and Doongan stations.

22 These are very similar to headdresses that Walsh describes as Eastern Bradshaw type, as seen by us at the Chamberlain Gorge.

23 S. Piggott, 1961, p. 31, pl. 15. The 'harpoon head' as it is called in European archaeological contexts was found at Løjesmølle, Zealand, Denmark.

24 A. Gunn in T. Willing & K. Kenneally, 2002, p. 54.

Chapter 14

1 Alan L. Watchman, 'Dating Rock Art', article in G. Walsh, 2000, pp. 38–41.

2 Richard G. Roberts, 'Thermoluminescence Dating of Kimberley Rock Art', article in G. Walsh, 2000, pp. 46–9.

3 See J. Flood, 1995, pp. 59–62.

4 Known as the Willandra Lakes.

5 Wallaby, wombat, native cat and small animals such as rat kangaroos and lizards; also (from the lake) fish, frogs, freshwater mussels and crayfish.

6 As the fiftieth set of human remains found in the Willandra Lakes region, this specimen is known as WLH 50. Datings vary, circa 30 000 BC being on the conservative side. See Josephine Flood, 1995, p. 69 and J. Mulvaney & J. Kamminga, 1999, p. 165.

7 S. O'Connor, 1995.

8 P. Bahn & J. Vertut, 1997.

9 S. O'Connor, 1989.

10 Michael J. Morwood & Douglas R. Hobbs, 'The Archaeology of Kimberley Art' in G. Walsh, 2000, p. 37.

11 J. Mulvaney & J. Kamminga, 1999, p. 221.

12 ibid.

13 Grahame Walsh also seems to have found one 'in the remote King River area of far east Kimberley'. This he reproduces in G. Walsh, 2000, p. 33, pl. 52.

14 P. Jones, 1996.

15 F. Hess, n.d.

16 N. Reeves, 1990, pp. 175–6.

17 *Casuarina stricta.*

18 P. Valde-Nowak, A. Nadachowski & Teresa Madeyska, 2003.

19 ibid., p. 70.

20 Unaware of the Kimberley examples, he associated this with Queensland specimens.

21 G. Chaloupka, 1993, p. 64.

22 Darrell Lewis, 1997, p. 2.

23 E.J. Brandl, 1973.

24 ibid., p. 42, fig. 79.

25 As Joc Schmiechen has pointed out to me, nothing corresponding to Bradshaw or Dynamic figures has yet been found in the Victoria River region between the Kimberley and Arnhem Land, despite its sandstone-bearing prolific later art. But as both he and Walsh have suggested, this may be because the properties of the rock have been less conducive to the older figures' preservation.

Chapter 15

1 Information about the expeditions to Borneo by Luc-Henri Fage and Jean-Michel Chazine can be found in French and English at the Internet website <www.kaliman-thrope.com>.

2 *Cervus unicolour.*

3 See chapter 8.

4 T. Harrison 'The Caves of Niah: A History of Prehistory', *Sarawak Museum Journal* VIII, 1958, pp. 549–95.
 —'New Achaeological and Ethnological Results from Niah Caves, Sarawak', *Man*, Lix, 1959, pp. 1–8.

5 S. Oppenheimer, 1998, p. 88.

6 ibid., the motif used for the jacket of Oppenheimer's *Eden in the East.*

7 Anthony Christie, 'The diverse traditions of South East Asia' in S. Piggott (ed.), 1961, p. 299.

8 ibid. See also S. Oppenheimer, 1998, p. 88.

9 A useful map appears in C. Flon, 1985, p. 291.

10 See the cover of the drum of Ngoc Lu in C. Flon (ed.), 1985, p. 291.

11 The same painting is reproduced in G. Chaloupka, 1993, p. 46.

12 I have conflated here two different versions of the story quoted in G. Chaloupka, 1993, p. 46. See also similar versions in J. Isaacs, 1980, p. 58. Isaacs specifically notes Warramurrungundji's origins as 'from over the sea from the north-west, in the direction of Indonesia'.

13 G. Chaloupka, 1993, pp. 83–4.

14 See Lonely Planet, *Indonesia*, p. 997.

15 Paul Johnstone, 1980, pp. 211–12.

16 This has been dated to between 27 000 and 18 000 BC. See T. Loy et al., 1992.

17 G. Walsh, 2000, pp. 128–9.

18 J. Kingdon, 1993.

19 S. Oppenheimer, 2003; S. Wells, 2002.

20 A.R. Wallace, 1869, p. 341.
21 Anthony Christie in S. Piggott (ed.), 1961, p. 292.
22 A.J. Redd & M. Stoneking, 1999.
23 Numerous boomerang stencils have been found at Teluk Berau, formerly known as the MacCluer Gulf.
24 Catalogue number A3960.

Chapter 16

 1 T. Flannery, 1994, pp. 182–3.
 2 P. Bahn & J. Vertut, 1997, p. 35.
 3 J. Allen & P. Kershaw, 1991, article in *Journal of Marine Archaeology*, vol. 2, July, pp. 8–9.
 4 Aeneas Gunn writing in *Prahran Telegraph*, 17 June 1899, reproduced in T. Willing & K. Kenneally, 2002, p. 30.
 5 J. Mulvaney & J. Kamminga, 1999, p. 121. Regarding Rottnest Island, a British settler, G.F. Moore, recorded in 1830: 'The natives have a tradition that Rottnest, Carnac and Garden Island once formed part of the mainland, and that the intervening ground was thickly covered with trees, which took fire in some unaccountable way and burned with such intensity that the ground split asunder with a great noise, and the sea rushed in between, cutting off these islands from the mainland.'
 6 See Jennifer Isaacs, 1980, p. 26. She relates how the Kurnai of Victoria believed that long ago there was land south of Gippsland which the sea has now covered; also the Mornington Peninsula Aboriginal people recall a previously flat and fertile hunting area which the sea flooded.
 7 See A.P. Elkin, 1964, photograph opposite p. 218.
 8 A. McGregor & Q. Chester, 1992, p. 110.
 9 J. Bradshaw, 1891, p. 99.
10 N. Tindale & H.A. Lindsay, 1963, p. 30.
11 See a useful map to this effect in E. Godden & J. Malnic, 2001, p. 10.
12 T.H. Gaster, p. 99.
13 S. Jumsai, 1988, p. 11, shows a photo of the Split Gate at Ubud.
14 S. Oppenheimer, 1998, p. 279.
15 W.A. Neves & H.M. Pucciarelli, 1991.
16 Stephen Oppenheimer notes on p. 204 of *Out of Eden*: 'Only one other modern group has retained a similar degree of robusticity to Australians and New Guineans, namely the Tierra del Fuegans of South America, and they are now practically extinct.' Charles Darwin painted a vivid picture of a remnant population of Tierra del Fuegans that he and the crew of the *Beagle* encountered when they anchored in the Bay of Good Success in December 1832.

Chapter 17

1 E. Worms, 1955, p. 555.
2 I. Crawford, 1968, p. 86.
3 G. Walsh, 2000, p. I (Preface).
4 D. Mowaljarlai & J. Malnic, 1993.
5 G. Walsh, 2000, p. 444.
6 He died in 1996.
7 G. Walsh, 2000, p. 444. The interview was recorded on 15 September 1998.
8 J. Doring, 2000.
9 This lavishly produced book has superb colour photography throughout. It includes some paintings of Bradshaw type, along with later Aboriginal paintings and many very contrived 'ethnic' photos of a small group of Ngarinyin people who went 'tribal' for the camera. But it curiously includes not a single Bradshaw painting of the most advanced variety. This has caused Lee Scott-Virtue to suggest that there may be a significant difference between what the Ngarinyin term 'Gwion Gwion' paintings and what we would define as classic 'Bradshaw'.
10 Shown on the SBS TV documentary *Riddle of the Bradshaws*, 2004.
11 According to Mowaljarlai, 'That first word *guya* means "go". And the last part, that *–yan*: with a purpose. *Guyan*: "you go and look for"' (D. Mowaljarlai & J. Malnic, 2001, p. 222). But according to Chalarimeri it means 'the people from a long time ago' (A. Chalarimeri, n.d., p. 81).
12 J. Isaacs, 1980.
13 T.G.H. Strehlow, 1947.
14 See T. Flannery, 1994, p. 123.
15 ibid., pp. 267–8.
16 J.C. Beaglehole (ed.), 1955, p. 399.
17 Truganini, said to have been the last Aboriginal Tasmanian of unmixed ancestry, died in 1876. However, today over 7000 Tasmanians identify an Aboriginal heritage and there has been recent evidence that some present-day Tasmanians carry genes from the original inhabitants. See Presser et al., 2002.
18 Quoted in Pedersen & Woorunmurra, 1995, p. 200.
19 He stated this directly in a letter to Chris Done, Regional Manager of the Kimberley for the Western Australian government's Department of Conservation and Land Management, sent 18 August 1991: 'I believe that across the board (at this particular time in history) the greatest protection which can be offered to the Kimberley [sic] rock art is lack of documented site location detail.' This letter is reproduced in Appendix 6: 3 of Schmiechen, 1992.
20 L. Scott-Virtue and Ju Ju Wilson, n.d.
21 A. Chalarimeri, n.d., p. 118.

22 L. Scott-Virtue and Ju Ju Wilson, n.d.
23 I.M. Crawford, 1968, p. 74.
24 H. Lhote, 1959.
25 Marion Bull, article in the London *Sunday Times*, 13 October 2002.
26 G. Walsh, 1994, pl. 14; Walsh, 2000, p. 254, pl. 389.
27 Article by Susan Bradley, 'Recognition at Last', published in the *Kimberley Echo*, 14 October 2004.
28 J. Schmiechen, 1995, p. 71.
29 J. Schmiechen, 1992.
30 In March 1992 the Wilderness Society launched a proposal entitled 'A World Class Aboriginal-owned Wilderness National Park and Marine National Park in the North Kimberley'. This plan, embracing 4 500 000 hectares, encompassed existing parks, Aboriginal reserves, vacant crown land and smaller sections of pastoral leases. It also included an additional 3 500 000 hectares of marine national park. As remarked by McGregor and Chester (1992, p. 198): 'As a single entity, it would be the largest park in Australia and one of the biggest in the world.'
31 L. Scott-Virtue, 2001.
32 'Some 50 per cent of the Kimberley is held under pastoral lease. But only 7.6 per cent of this is considered to be high quality for grazing, and this is mostly concentrated along the Ord and Fitzroy river valleys.' A. McGregor & Q. Chester, 1992, p. 192.

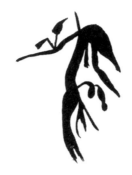

BIBLIOGRAPHY

Adovasio, James, M., Olga Soffer & Bohuslav Klima, 'Upper Palaeolithic fibre technology: interlaced woven finds from Pavlov I, Czech Republic, c. 26,000 years', *Antiquity*, 70, no. 269, Sept. 1996, pp. 526–34.

Anderson, Megan, 1998, 'A magical trek uncovers a lost world', Big Weekend (The *West Australian* newspaper), Saturday 7 February 1998, p. 5.

Ashe, G., Thor Heyerdahl & others, 1971, *The Quest for America*, Pall Mall, London.

Bahn, Paul, & Jean Vertut, 1997, *Journey through the Ice Age*, Weidenfeld & Nicolson, London.

Barber, E.J.W., 1991, *Prehistoric Textiles: The Development of Cloth in the Neolithic and Bronze Ages with Special Reference to the Aegean*, Princeton University Press, Princeton, N.J.

Barbier, Jean-Paul & Douglas Newton (eds), 1988, *Islands and Ancestors: Indigenous Styles of South-East Asia*, Thames & Hudson, London.

Barham, Larry, Philip Priestley & Adrian Targett, 1999, *In Search of Cheddar Man*, Tempus Publishing, Stroud, Glos.

Beaglehol, J.C. (ed.), 1995, *The Journals of Captain James Cook on His Voyages of Discovery*, Hakluyt Society, Cambridge.

Bednarik, R., 1994, 'Taphonomy of palaeoart', *Antiquity*, 68, pp. 68–74.

Blair, Lawrence with Lorne Blair, 1988, *Ring of Fire*, Bantam, London.

Bradley, S., 2004, 'Recognition at Last', *Kimberley Echo*, 14 October.

Bradshaw, Joseph, unpublished private journal, 1891, Mitchell Library, Sydney.

——1892, 'Notes on a recent trip to Prince Regent's River', *Royal Geographical Society of Australia (Victorian Branch) Transactions*, 9, pt 2, pp. 90–103.

Bragard, Jean-Claude, 1999, *Hunt for the First Americans*, BBC TV.

Brandl, E.J., 1973, *Australian Aboriginal Paintings in Western and Central Arnhem Land: Temporal Sequences and Elements of Style in Cadell River and Deaf Adder Creek Art*, Aboriginal Studies Press, Canberra.

Chalarimeri, Ambrose Mungala, undated, *The Man from the Sunrise Side*, Magabala Books, Aboriginal Corporation, Broome, Western Australia.

Chaloupka, George, 1993, *Journey in Time*, Reed, Chatswood.

Choy, Lee Khoon, 1976, *Indonesia Between Myth and Reality*, Nile & Mackenzie, London.

Clottes, J., H. Valladas, H. Cachier & M. Arnold, 1992, 'Des dates pour Niaux et Gargas', *Bulletin de la Société Préhistorique Française*, 89, pp. 270–4.

Coates, Austin, 1974, *Islands of the South*, Pica, New York.

Cotterell, Arthur, 1979, *The Minoan World*, Guild Publishing, London.

Coulson, David & Alec Campbell, 2001, *African Rock Art: Paintings and Engravings on Stone*, Harry N. Abrams, New York.

Crawford, I.M., 1968, *The Art of the Wandjina: Aboriginal Cave Paintings in Kimberley, Western Australia*, Oxford University Press, Melbourne.

—— 1977, 'The relationship of Bradshaw and Wandjina art in north-west Kimberley' in P.J. Ucko (ed.), *Form in Indigenous Art*, Australian Institute of Aboriginal Studies, Canberra, pp. 357–69.

Davidson, D.S., 1936, 'Australian throwing sticks, throwing clubs and boomerangs', *American Anthropology*, 3(1), pp. 76–100.

Dixon, R.M.W., 1980, *The Languages of Australia*, Cambridge University Press, Cambridge.

Doran, Edwin, Jr, 1981, *Wangka: Austronesian Canoe Origins*, Texas A & M University Press, College Station.

Doring, Jeff, 2000, *Gwion Gwion, Secret and Sacred Pathways*, Könemann, Köln.

Durack, Mary, 1969, *The Rock and the Sand*, Constable, London.

Elkin, A.P., 1964 (4th edition), *The Australia Aborigines: How to Understand Them*, Angus & Robertson, Sydney.

Feuerstein, Georg, Subhash Kak & David Frawley, 1995, *In Search of the Cradle of Civilization: New Light on Ancient India*, Quest Books, Wheaton, Ill.

Flannery, Timothy Fridtjof, 1994, *The Future Eaters: An Ecological History of the Australasian Lands and People*, Reed, New Holland, Sydney.

Flon, Christine (ed.), 1985, *The World Atlas of Archaeology*, English translation of *Le Grand Atlas de l'archéologie* created by Encyclopaedia Universalis, Mitchell Beazley, London.

Flood, Josephine, 1990, *The Riches of Ancient Australia: A Journey into Prehistory*, University of Queensland, St Lucia, Australia.

—— 1995, *Archaeology of the Dreamtime: The Story of Prehistoric Australia and its People*, HarperCollins, Sydney.

—— 1997, *Rock Art of the Dream Time*, HarperCollins, Sydney.

Freeman, Michael & Claude Jacques, 1999, *Ancient Angkor*, Thames & Hudson, London.

Gaster, T.H., 1969, *Myth, Legend and Custom in the Old Testament*, Harper & Row, New York.

Giles, E., 1889, *Australia Twice Traversed*, Low, Marston, Searle & Rivington, London, republished by Doubleday in 1979.

Gimbutas, Marija, 1989, *The Language of the Goddess: Unearthing the Hidden Symbols of Western Civilisation*, Thames & Hudson, London.

Godden, Elaine & Jutta Malnic, 2001, *Rock Paintings of Aboriginal Australia*, New Holland Publishers, Sydney.

Grey, George, 1838, 'A Brief Outline of the Recent Expedition to the North-west Coast of Australia …', *Journal of the Royal Geographical Society*, 8, pp. 954–9.

—— 1841, *Journals of Two Expeditions of Discovery in North-West and Western Australia during the Years 1837, 38 and 39*, 2 vols, T. and W. Boone, London.

Grimble, Rosemary, 1972, *Migrations, Myth and Magic from the Gilbert Islands: Early Writings of Sir Arthur Grimble, Arranged and Illustrated*, Routledge & Kegan Paul, London.

Hancock, Graham, 2002, *Underworld, Flooded Kingdoms of the Ice Age*, Michael Joseph (Penguin Books), London.

Hess, Felix, n.d., 'A returning boomerang from the Iron Age', *Antiquity*, 47, pp. 303–6.

Heyerdahl, Thor, 1952, *American Indians in the Pacific: The Theory behind the Kon-Tiki Expedition*, Allen & Unwin, London.

—— 1958, *Aku-Aku: The Secret of Easter Island*, Allen & Unwin, London.

—— 1970, *The Ra Expeditions*, Allen & Unwin, London.

—— 1986, *The Maldive Mystery*, Allen & Unwin, London.

Hiddins, Les, 1981, *Survive to Live: An analysis of survival and its relationship in northern Australia*, Commonwealth Government Printer, Canberra.

Higham, Charles & Rachanie Thosarat, 1998, *Prehistoric Thailand: From Early Settlement to Sukhothai*, Thames & Hudson, London.

Hill, Ernestine, 1951, *The Territory*, Angus & Robertson, Sydney.

Hordern, Marsden, 1997, *King of the Australian Coast: The Work of Phillip Parker King in the* Mermaid *and* Bathurst *1817–1822*, Melbourne University Press, Melbourne.

Isaacs, Jennifer, 1980, *Australian Dreaming: 40 000 Years of Aboriginal History*, Lansdowne Press, Sydney.

—— 1984, *Australia's Living Heritage: Arts of the Dreaming*, J.B. Books, New Holland, Sydney.

Jessup, Helen Ibbitson, *Court Arts of Indonesia*, Asia Society Galleries, New York in association with Harry N. Abrams, New York 1990.

Jett, Stephen C., 1991, 'Further Information on the Geography of the Blowgun and its Implications for Early Transoceanic Contacts', *Annals of the Association of American Geographers*, 81 (1), pp. 89–102.

Johnstone, Paul, 1980, *The Seacraft of Prehistory*, Routledge & Kegan Paul, London.

Jones, Rhys, 1969, 'Fire-stick Farming', *Australian Natural History*, September, pp. 224–8.

Jones, Philip, 1996, *Boomerang: Behind an Australian Icon*, Wakefield Press, Adelaide.

Jumsai, Sumet, 1988, *Naga: Cultural Origins in Siam and the West Pacific*, Oxford University Press, Singapore.

Keen, Ian, 2004, *Aboriginal Economy and Society: Australia at the Threshold of Colonisation*, Oxford University Press, South Melbourne, Victoria.

King, Captain Phillip P., 1827, *Narrative of a Survey of the Intertropical and Western Coasts of Australia performed between the years 1818 and 1822*, John Murray, London.

Kingdon, Jonathan, 1993, *Self-made Man and his Undoing*, Simon & Schuster, London.

Kirch, P.V., 1997, *The Lapita Peoples: Ancestors of the Oceanic World*, Blackwell, Oxford.

Kirk, Robert & Emóke Szathmary (eds) 1985, *Out of Asia: Peopling the Americas and the Pacific*, Journal of Pacific History, Canberra.

Kumar, G., 1996, 'Daraki-Chattan: a Palaeolithic Cupule Site in India', *Rock Art Research*, 13/1, pp. 38–46.

Lamy, Lucie, 1981, *Egyptian Mysteries: New Light on Ancient Knowledge*, Thames & Hudson, London, reprinted 1994.

Lawrence, Peter, 1964, *Road Belong Cargo: A Study of the Cargo Movement in the Southern Madang District, New Guinea*, Melbourne University Press, Melbourne.

Layton, Robert, 1992, *Australian Rock Art: A New Synthesis*, Cambridge University Press, Cambridge.

Leroi-Gourhan, André, 1967, *Treasures of Prehistoric Art*, trans. from French by Norbert Guterman, Harry Abrams, New York.

Lewis, Darrell, 1997, 'Bradshaws: The View from Arnhem Land', *Australian Archaeology*, vol. 44, pp. 1–16.

Lewis, David, 1978, *The Voyaging Stars: Secrets of the Pacific Island Navigators*, Collins, Sydney & London.

Lhote, Henri, 1959, *The Search for the Tassili Frescoes: The Story of the Prehistoric Rock Paintings of the Sahara*, trans. from French by Alan Houghton Brodrick, Hutchinson, London.

Lowe, Pat, 1998, *The Boab Tree*, Lothian, Port Melbourne, Victoria.

Loy, Thomas H. et al., 1992, 'Direct evidence for human use of plants 28 000 years ago: starch residues on stone artefacts from the northern Solomon Islands', *Antiquity*, 66, pp. 898–912.

McCarthy, F.D. & N.G.W. Macintosh, 1962, 'The archaeology of Mootwingee, western New South Wales', *Records of the Australian Museum*, 25 (13), pp. 249–98.

McConvell, P., 1994, *Archaeology and Linguistics: Understanding Ancient Australia*, Oxford University Press, Oxford.

—— 1996, 'Backtracking to Babel: The chronology of Pama-Nyungan expansion in Australia', *Archaeology in Oceania*, 31, pp. 125–44.

McGregor, Alasdair & Quentin Chester, 1992, *The Kimberley: Horizons of Stone*, Hodder & Stoughton, Sydney.

Macey, Richard, 2003, 'DNA puts mother of all dingoes at 3000 BC', *Sydney Morning Herald*, 30 September.

Meacham, William, 1984, 'On the improbability of Austronesian origins in South China', *Asian Perspectives*, 25, no. 1, p. 100.

Michaelsen, Per & Tasja W. Ebersole, 2000, 'The Bradshaw rock art system, NW Australia: A window into material culture, social and belief systems of hunter-gatherers in Kimberley during the last Ice Age', *Adoranten*, pp. 33–40.

Mountford, C.P., 1937, 'Examples of Aboriginal art from Napier Broome Bay and Parry Harbour, North-Western Australia', *Transactions of the Royal Society of South Australia*, 61, pp. 30–40.

Mowaljarlai, David & Jutta Malnic, 1993, *Yorro Yorro: everything standing up alive, Spirit of the Kimberley*, Magabala Books Aboriginal Corporation, Broome, re-issued in 2001 as *Yorro Yorro: Everything standing up alive, Rock art and Stories from the Australian Kimberley*, with a new chapter featuring Mowaljarlai referring to the Bradshaws as belonging to his people's culture.

Mulvaney, John & Johan Kamminga, 1999, *Prehistory of Australia*, Allen & Unwin, Sydney.

Neves, W.A. & H.M. Pucciarelli, 1991, 'Morphological affinities of the first Americans: An exploratory analysis based on early South American human remains', *Journal of Human Evolution*, 21, pp. 261–73.

Nichols, Johanna, 1992, *Linguistic Diversity in Space and Time*, Chicago University Press, Chicago.

O'Connor, S., 1989, 'New radiocarbon dates from Koolan Island, West Kimberley, WA', *Australian Archaeology*, 28.

—— 1995, 'Carpenter's Gap rockshelter 1: 40,000 years of Aboriginal occupation in the Napier ranges, Kimberley, W.A.', *Australian Archaeology*, 40, pp. 58–9.

Oppenheimer, Stephen, 1998, *Eden in the East: The Drowned Continent of Southe-Est Asia*, Weidenfeld & Nicolson, London.

—— 2003, *Out of Eden: The Peopling of the World*, Constable, London.

Owen, David, 2003, *Thylacine: The Tragic Tale of the Tasmanian Tiger*, Allen & Unwin, Sydney.

Peck, C.W., 1933, *Australian Legends, Tales Handed Down from the Remotest Times by the Autochthonous Inhabitants of Our Land*, Lothian, Melbourne.

Pedersen, Howard & Banjo Woorunmurra, 1995, *Jandamarra and the Bunuba Resistance*, Magabala Books Aboriginal Corporation, Broome, Western Australia.

Perry, W.J., 1918, *The Megalithic Culture of Indonesia*, Manchester University Press & Longmans, Green & Co., London.

Piggott, Stuart, 1961, *The Dawn of Civilization: The First World Survey of Human Cultures in Early Times*, Thames & Hudson, London.

Presser, John C., Albert J. Deverell, Alan J. Redd & Mark Stoneking, 2002, 'Tasmanian Aborigines and DNA', *Papers and Proceedings of the Royal Society of Tasmania*, 136, pp. 35–6.

Redd, Alan J. & Mark Stoneking, 1999, 'Peopling of Sahul: mtDNAvariation in Aboriginal Australian and Papua New Guinean Populations', *American Journal of Human Genetics*, 65, pp. 808–28.

Reeves, Nicholas, 1990, *The Complete Tutankhamun*, Thames & Hudson, London.

Roberts, David Andrew & Adrian Parker, 2003, *Ancient Ochres, The Aboriginal Rock Paintings of Mount Borrodaile*, J.B. Books, Marleston, South Australia.

Roberts, Richard G., Rhys Jones & M.A. Smith, 1990, 'Thermoluminescence dating of a 50 000-year-old human occupation site in northern Australia', *Nature*, no. 345, pp. 153–7.

Roder, J., 1939, 'Rock pictures and prehistoric times in Dutch New Guinea', *Man*, 39, pp. 175–8.

Rothwell, Nicolas, 2003, 'The matron & the maverick', *The Weekend Australian Magazine*, 25–26 October 2003, pp. 19–22.

Ryan, Judith with Kim Akerman (eds), 1993, *Images of Power: Aboriginal Art of the Kimberley*, National Gallery of Victoria.

Schäfer, Heinrich, 1986, *Principles of Egyptian Art*, Griffith Institute, Oxford.

Schmiechen, Joc, 1992, Drysdale River National Park: Visitor Management and Aboriginal Heritage Issues, unpublished report, dissertation for the degree of Master of Environmental Studies, Mawson Graduate Centre for Environmental Studies, University of Adelaide.

—— 1993, Shadows in Stone: A report on Aboriginal rock art survey expeditions 1988 and 1991, Drysdale River National Park, Kimberley, Western Australia, unpublished report to Department of Conservation and Land Management, Kununurra and to the Australian Institute of Aboriginal and Torres Strait Islander Studies, Canberra.

—— 1995, 'Drysdale River National Park, Western Australia: Aboriginal Cultural Heritage, Management Problems and Potential' in *Management of Rock Imagery*, eds G.K. & L.A.Ward, Occasional AURA Publication no. 9, Melbourne.

Schulz, Agnes Susanne, 1956, 'North-West Australian Rock Paintings', *Memoirs of the National Museum of Victoria*, no. 20, pp. 7–57.

Scott-Virtue, Lee, 2001, *An Archaeological Interpretation of the Faraway Bay Creek Rock Art*, Kimberley Specialists, Kununurra, Western Australia.

Scott-Virtue, Lee & Ju Ju 'Burriwee' Wilson, undated, The Impact of Fire on Rock Art Sites: Evidence from the Kimberley, Western Australia, Kimberley Specialists, Kununurra, Western Australia.

Service, Robert F., 1996, 'Rock chemistry traces ancient islanders', *Science*, 274, pp. 2012–13.

Smith, Moya, 1982, 'Late Pleistocene zamia exploitation in southern Western Australia', *Archaeology in Oceania*, 17, pp. 109–16.

Solheim, Wilhelm, 1994, 'South-East Asia and Korea: from the beginnings of food production to the first states' in *The History of Humanity: Scientific and Cultural Development vol. I: Prehistory and the Beginnings of Civilisation*, Unesco/Routledge, London, pp. 468–81.

—— 1996 'The Nunsantao and North-South Dispersals', *Indo-Pacific Prehistory Association Bulletin 15*, 2.

Stokes, J.L., 1846, *Discoveries in Australia, With an Account of the Coasts and Rivers Explored and Surveyed During the Voyage of the H.M.S.* Beagle *in the Years 1837–43*, vols 1 & 2, T & W Boone, London.

Strathern, Andrew et al., 2002, *Oceania —An Introduction to the Cultures and Identities of Pacific Islanders*, Carolina Academic Press, Durham, North Carolina.

Strehlow, T.G.H., 1947, *Aranda Traditions*, Melbourne University Press, Melbourne.

Stubbs, Dacre, 1974, *Prehistoric Art of Australia*, Macmillan, Sydney.

Sumner, Ray, 1993, 'Amelie Dietrich and the Aborigines', *Australian Aboriginal Studies*, no. 2, pp. 2–19.

Sykes, Bryan, 2003, *The Seven Daughers of Eve*, Bantam, London.

Taçon, Paul S.C., Richard Fullager, Sven Ouzman & Ken Mulvaney, 1997, 'Cupule engravings from Jinmium-Granilpi (northern Australia) and beyond: exploration of a widespread and enigmatic class of rock markings', *Antiquity*, 71 (274), pp. 942–65.

Thomson, Donald, 1983, *Donald Thomson in Arnhem Land*, compiled & introduced by Nicolas Peterson, Currey O'Neil, South Yarra, Victoria. (This is a posthumous compilation of Thomson's writings.)

Tiley, Robert, 2002, *Australian Navigators*, Kangaroo Press, Sydney, New South Wales.

Tindale, N. & H.A. Lindsay, 1963, *Aboriginal Australians*, Jacaranda Press, Brisbane.

Turner, Peter et al., 1997, *Indonesia*, Lonely Planet, Hawthorn, Victoria.

Valde-Nowak P., A. Nadachowski & M. Wolsan, 1987, 'Upper Palaeolithic boomerang made of a mammoth tusk in southern Poland', *Nature*, 329, pp. 436–8.

Valde-Nowak, P., Adam Nadachowski & Teresa Madeyska, 2003, Obłazowa *Cave: Human Activity, Stratigraphy and Palaeoenvironment*, Institute of Archaeology and Ethnology, Polish Academy of Sciences, Krakow, Poland.

Van Heekeren, H.R., 1972, *The Stone Age of Indonesia*, Verhandelingen van het Koninklijk Instituut voor Taal-, Land- en Volkenkunde 61, The Hague.

Von Daniken, Erich, 1972, *The Gold of the Gods*, Souvenir Press, London.

—— 1973, *In Search of Ancient Gods*, Michael Heron and Souvenir Press, London.

Wakankar, Vishnu S. & Robert R.R. Brooks, 1976, *Stone Age Painting in India*, D.B. Taraporevala, Bombay.

Wallace, Alfred Russel, 1869, *The Malay Archipelago: The Land of the Orang-utan and the*

Bird of Paradise: A Narrative of Travel with Studies of Man and Nature, Macmillan, London.

—— 1876, *The Geographical Distribution of Animals, with a Study of the Relations of Living and Extinct Faunas as Elucidating the Past Changes of the Earth's Surface*, republished by Hafner, New York, 1962.

Walsh, Grahame L., 1988, *Australia's Greatest Rock Art*, E.J. Brill-Robert Brown and Associates (Aust.) Pty Ltd, Bathurst.

—— 1994, *Bradshaws: Ancient Rock Paintings of North-West Australia*, Carouge-Geneva, Bradshaw Foundation/Edition Limitée, Switzerland.

—— 1999, *Carnarvon and Beyond*, Takarakka Nowan Kas Publications, Carnarvon Gorge, Queensland.

—— 2000, *Bradshaw Art of the Kimberley*, Takarakka Nowan Kas Publications, Toowong, Queensland.

Welch, David, 1990, 'The bichrome art period in the Kimberley, Australia', *Rock Art Research*, 7 (2), pp. 110–24.

—— 1993a, 'Early "Naturalistic" human figures in the Kimberley, Australia', *Rock Art Research*, 10 (1), pp. 24–37.

—— 1993b, 'The early rock art of the Kimberley, Australia: Developing a chronology' in Jack Steinbring et al., *Time and Space: Dating and Spatial Considerations in Rock Art Research*, AURA Publication no. 8, Australian Rock Art Association, Melbourne, pp. 13–21.

—— 1993c, 'Stylistic change in the Kimberley rock art, Australia' in *Rock Art Studies: The Post-Stylistic Era or Where do we go from Here?*, eds M. Lorblanchet & P.G. Bahn, pp. 99–113.

—— 1997, 'Fight or Dance? Ceremony and the Spearthrower in Northern Australian Rock Art', *Rock Art Research*, 14 (2), pp. 88–112.

Wells, Spencer, 2002, *Journey of Man: A Genetic Odyssey*, Allen Lane, London.

Willing, Tim & Kevin Kenneally, 2002, *Under a Regent Moon: A historical account of pioneer pastoralists Joseph Bradshaw and Aeneas Gunn at Marigui Settlement, Prince Regent River, Kimberley, Western Australia 1891–1892*, Department of Conservation and Land Management, Western Australia.

Wilson, Ian, 2001, *Before the Flood*, Orion, London.

Windschuttle, Keith, 2002, *The Fabrication of Aboriginal History: Vol. I, Van Diemen's Land 1803–1847*, Macleay Press, Sydney.

Woolley, Sir Leonard, 1982, *Ur of the Chalders*, revised and updated by P.R.S. Moorey, Herbert Press, London.

Worms, E.A., 1955, 'Contemporary and prehistoric rock paintings in Central and North Kimberley', *Anthropos*, 50 (4–6), pp. 546–66.

Worms, E.A. & Helmut Petri, 1998, *Australian Aboriginal Religion*, Nelen Yubu Missiological series no. 5, Leura, New South Wales.

Worsnop, T., 1897, *The Prehistoric Arts, Manufactures, Weapons, etc., of the Aborigines of Australia*, Government Printer Adelaide.

Wunambul-Gambera Aboriginal Corporation, 2000, *Ngauwudu Management Plan*, November.

Young, Michael W & Julia Clark, 2001, *Anthropologist in Papua: The photography of F.E. Williams, 1922–39*, Crawford House, Adelaide.

Zell, Len, 2003, *A Guide to the Kimberley Coast Wilderness—North Western Australia*, Wild Discovery, <www.wilddiscovery.com.au>.

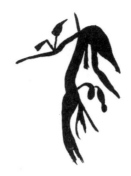

INDEX

DATE DUE

3/ 21/11			
APR 1 8 2011			